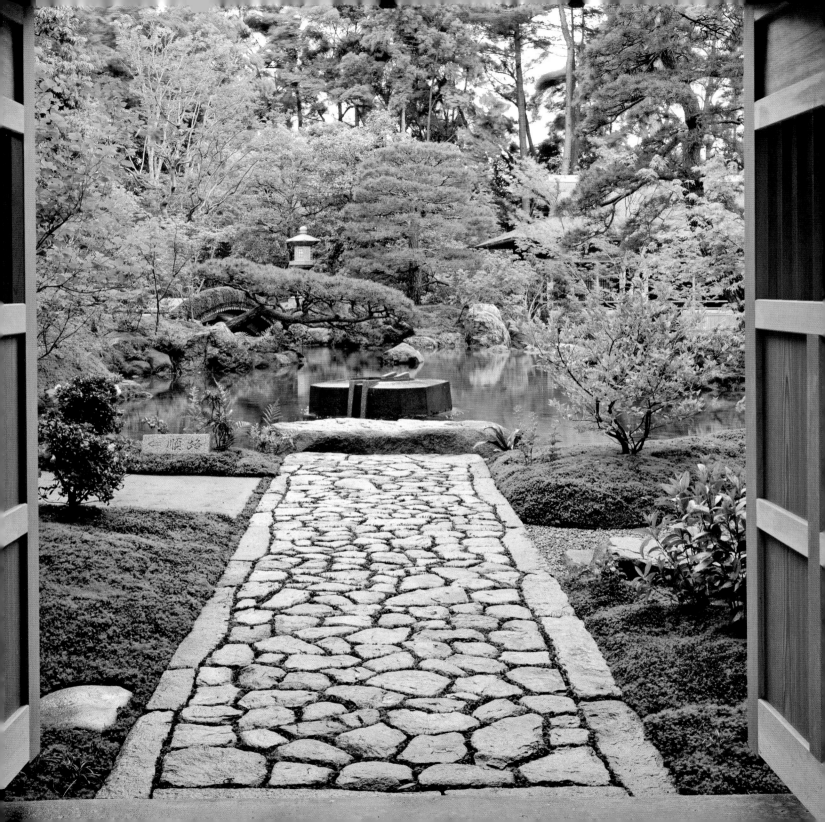

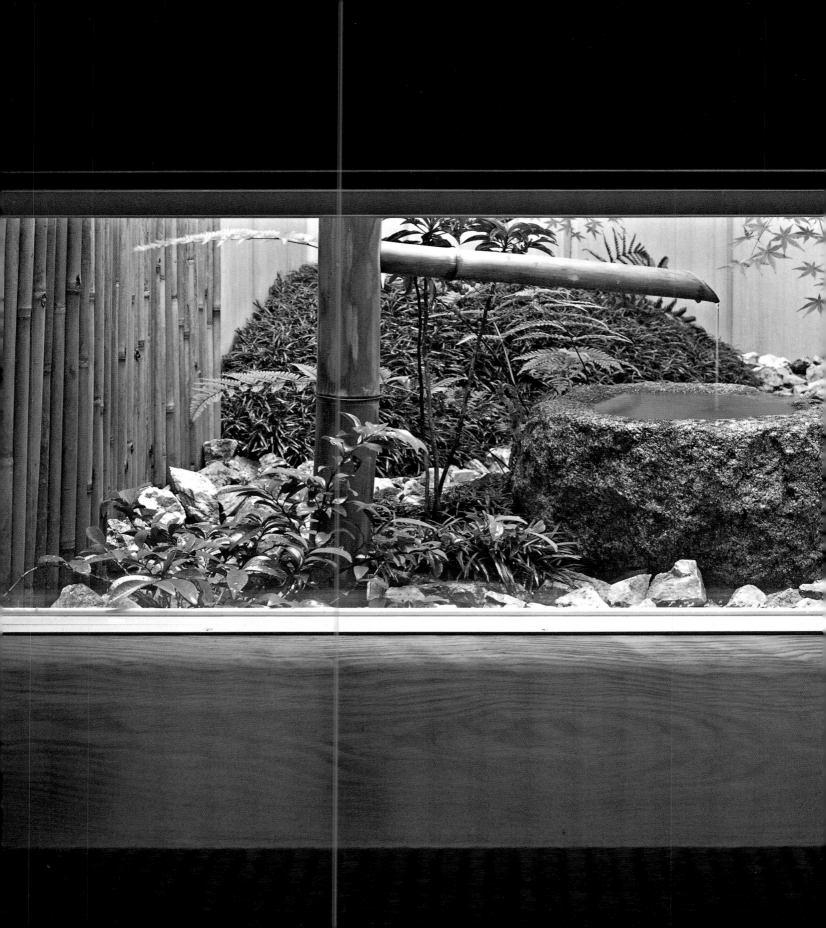

zen gardens

THE COMPLETE WORKS OF **SHUNMYO MASUNO**
JAPAN'S LEADING GARDEN DESIGNER

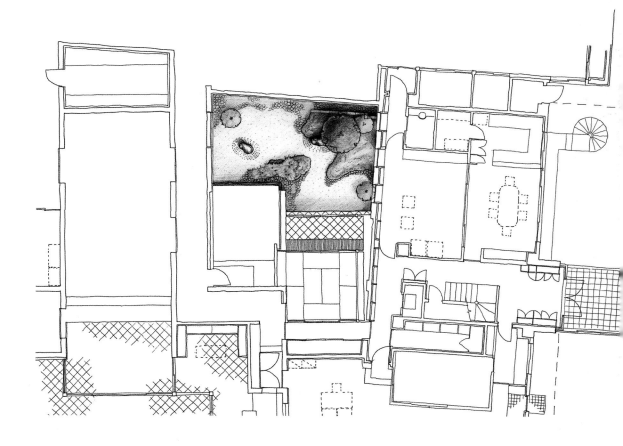

TUTTLE Publishing

Tokyo | Rutland, Vermont | Singapore

Published by Tuttle Publishing, an imprint of Periplus Editions (HK) Ltd.,
www.tuttlepublishing.com

Library of Congress Cataloging-in-Publication Data

Locher, Mira.
 Zen gardens : the complete works of Shunmyo Masuno, Japan's leading garden
designer. — 1st ed.
 p. cm.
 Author: Mira Locher.
 Includes bibliographical references.
 ISBN 978-4-8053-1194-3 (hardcover)
1. Gardens, Japanese—Zen influences. 2. Gardens — Design. 3. Masuno, Shunmyo.
I. Title. II. Title: Complete works of Shunmyo Masuno, Japan's leading garden designer.
 SB458.L63 2012
 635.9'77373 — dc23
2012010733

ISBN 978-4-8053-1194-3

Distributed by
North America, Latin America & Europe
Tuttle Publishing
364 Innovation Drive, North Clarendon, VT 05759-9436 U.S.A.
Tel: 1 (802) 773-8930; Fax: 1 (802) 773-6993
info@tuttlepublishing.com; www.tuttlepublishing.com

Japan
Tuttle Publishing
Yaekari Building, 3rd Floor, 5-4-12 Osaki, Shinagawa-ku, Tokyo 141-0032
Tel: (81) 3 5437-0171; Fax: (81) 3 5437-0755
sales@tuttle.co.jp; www.tuttle.co.jp

Asia Pacific
Berkeley Books Pte. Ltd.
61 Tai Seng Avenue #02-12, Singapore 534167
Tel: (65) 6280-1330; Fax: (65) 6280-6290
inquiries@periplus.com.sg; www.periplus.com

First edition
15 14 13 12 10 9 8 7 6 5 4 3 2 1

Printed in Singapore 1206CP

Front endpaper The evening light shimmers in the quiet reflecting pool of
the Shōka no Niwa (Ascension Garden) in the Yūkyūen garden at the Hofu
City Crematorium.

Page 1 The *naimon* (inner gate) of the Kantakeyama Shinen at the Samukawa
Shrine opens toward the eight-sided stone marker indicating the source of
the water in the Namba no Koike pond.

Page 2 A simple bamboo spout drips water into the *chōzubachi* (water
basin) in the Shōjutei garden at the private residence Rifugio.

Page 3 The Suitōkyosei courtyard garden provides views of refined nature
from the head priest's office and the adjoining tatami room at the Gionji
temple reception building.

Right A *nobedan* (stone walkway) and stepping-stones lead to the
shihō hotoke tsukubai chōzubachi (four-sided Buddha water basin) in the
Mushintei garden at the Suifūso guesthouse.

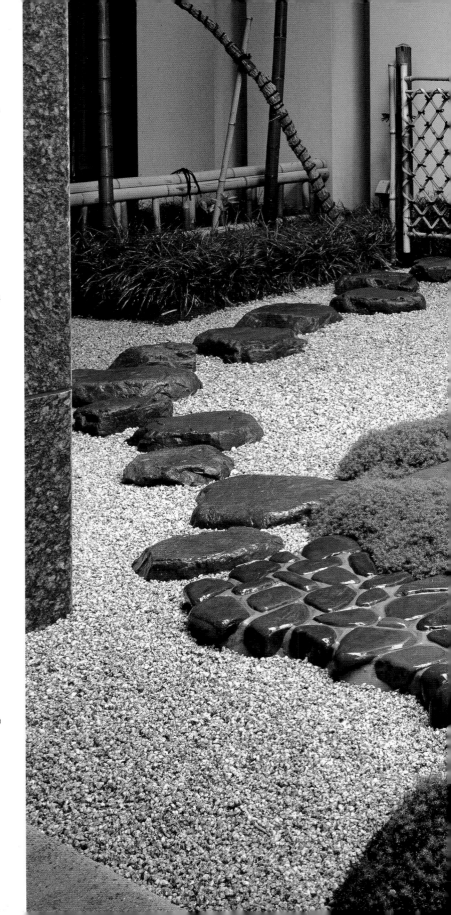

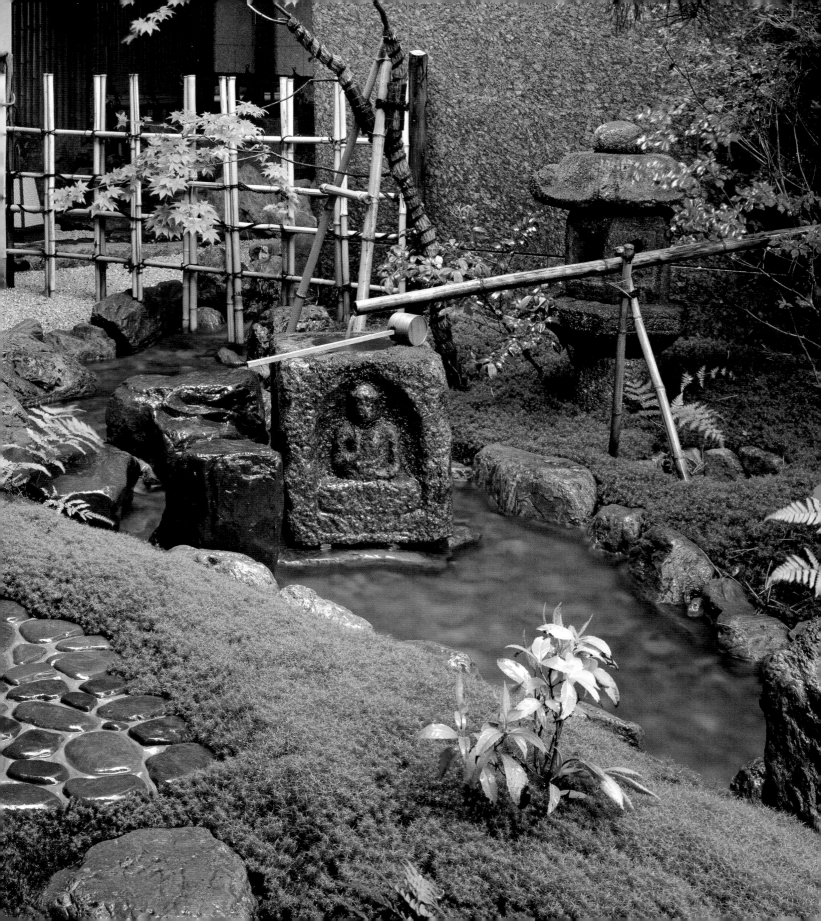

contents

TRADITIONAL GARDENS

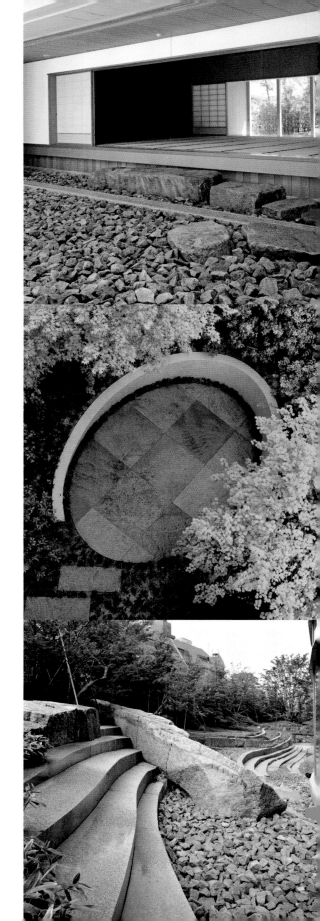

MODERN GARDENS

GARDENS OUTSIDE JAPAN

FOREWORD BY
SHIGERU UCHIDA

This is entirely my own personal opinion: however, by coming into contact with many designs, I have become aware that there are two directions for design themes. They are the way to grasp a "thing" or "object" as a subject and the way to consider a "relationship" as a subject. Supposing we call the former "object as precedent," the latter can be called "relationship as precedent." Japanese culture is that in which everything is "relationship as precedent."

Many Western cultures can be seen as cultures with "object as precedent." However, in that case the "thing" is the subject; by no means is it the predicate.

In relational philosophy, formerly a relationship firstly had independent content, and it was thought that within that content, that relationship came into being. However, recently it is thought that it is "unequivocal only because of the relationship."

The "relationship as precedent" is predicate logic. First of all, more than the subject, the predicate is valued. Independent meaning is removed from all things, then things come into existence only in the situation they fall into and in the circumstance of a relationship. Things do not always display their fixed nature. Depending on the situation things fall into and the circumstances, even if they are the same, they create different meanings.

The first obstacle encountered in symbolic logic is probably when the concept of subject and predicate appeared within "predicate logic." In the words "I am a designer," first of all "I" exists, whether that existence is "designer" or "man" or else "Japanese person" is realized as a modifier or as a predicate. In any case, to begin with, there is a subject, one's identity is ensured. With regard to that, a pattern of something that can be described is in the background.

However, in predicate logic it becomes "subject is change." If that is the case, the situation changes completely. Namely, where the modifier of being a "designer" does not change, but the changing of "I," which becomes the subject, is required. In other words, in "predicate logic" the important thing is the modifier "designer." The meaning of this content becomes the modifier. In Japanese culture, a relationship is such.

The rock arrangements in the gardens of Masuno Shunmyo also are thus. In regard to rocks as a subject, that predicate relationship of how they are arranged is important. The project of the Kantakeyama Shinen at the Samukawa shrine, through phase one and phase two, is an enormous undertaking. This kind of garden project is not formed with just one point of view. Most essential in Masuno's garden design is the division of land. Namely, depending on the spatial composition of the site, first the framework is formed. Here is a *chisenkaiyushiki-teien* (pond stroll garden), and attached to it are a *chaya* (tea pavilion) and *chashitsu* (teahouse). Furthermore, there is a Zen garden, and as an extension of the main hall [of the shrine], there also are the Kantakeyama mountain, a *chinju no mori* (sacred grove), and the Namba no Koike pond. A major theme is how to create a relationship between each of these things that has its own individual meaning. Moreover, on top of these relationships, each of their parts also comes into existence. The relationships of these parts and the overall relationship of many elements—these

are composed depending on Masuno's studied intention.

For example, the relationship of the *ryūmonbaku* [literally, "dragon's gate waterfall"] and the stone bridge depends on the combination of rock arrangements and water, giving the viewer a profound impression and sense of grandeur. Also the contrast of the natural rock of the *ryūmonbaku* and the rectilinearly hewn stone bridge produces a feeling of tension in these surroundings.

Also more pure than anything is the scenery from the Warakutei tea pavilion (*chaya*). Compared to the teahouse (*chashitsu*), that pleasure of the tea pavilion, the abounding sense of entertainment in the variation of the pond garden, is expressed. Even so, Masuno's architectural skill truly is to be admired. To say what is good, it is the superb relationship between the garden and the architecture. This is because it is architecture made by the designer with the garden as the theme. It is easy if we say the relationship to the garden is superb, but that atmosphere exists because the architecture does not forcibly assert itself, yet it isn't restrained. The relationship of the architecture and the pond as viewed from the garden is something truly beautiful. Also, when the garden is viewed from the interior horizontal opening, that horizontality comes together with the garden and rushes inside the room.

I also want to verify [these relationships in] other projects, but I'll keep it to this. What one can feel from Masuno's projects regards "relationality" and "object-ness." However, so there is no misunderstanding here, in many cases depending on their complementarity, things are completed. What is important here is which thinking comes first. In all Japanese culture, relationality comes first.

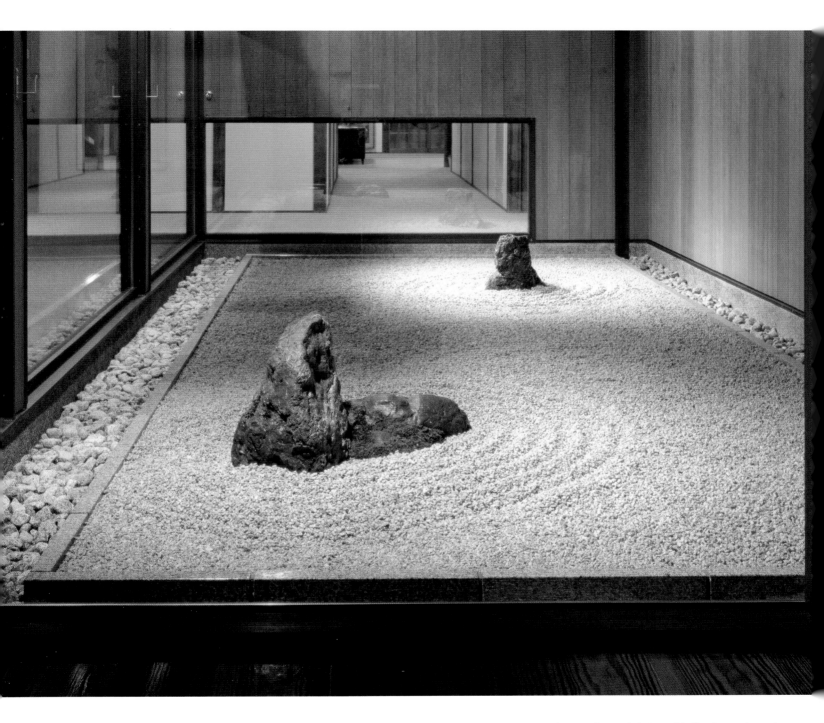

Pages 6-7, clockwise from top left: The contemporary *karesansui* (dry) garden at the Suifūso guesthouse, *chōzubachi* (water basin) at the Chūraitei private garden, the Japanese garden at the Canadian Embassy in Tokyo, the Yūsuien garden at the Erholungspark Marzahn, the Kanzatei garden at the Cerulean Tower Tokyu Hotel, and the Yui no Niwa Shinshūtei private garden.

Above Nighttime lighting softly illuminates the rock arrangements and raked gravel of the Chōsetsuko courtyard garden at the Ginrinsō Ryōkan.

Two Pairs of Straw Sandals: Zen Priest Garden Designer **Shunmyo Masuno**

"The garden is a special spiritual place where the mind dwells."[1] For Shunmyo Masuno, this is the ultimate meaning of the Zen garden, coming from years of training, both as a Zen Buddhist priest and as a garden designer. These two roles are inseparable in his life, as he describes with the Japanese expression "wearing two pairs of straw sandals" (*nisoku no waraji wo haku*).[2] Garden making is a form of mental and physical training for Masuno, an act of self-cultivation akin to the training of a martial artist. Such acts of self-cultivation are required in the practice of Zen Buddhism.

The oldest son of the head priest at Kenkohji temple in Yokohama, Masuno was almost assured a future as a Zen priest, for the first-born son typically follows in his father's footsteps. Growing up on the extensive wooded grounds of the temple, Masuno was always near nature, unlike many of his peers, who grew up in urban neighborhoods. When he was eleven years old, he traveled with his family to the ancient capital of Kyoto, where they visited a number of important Zen temple complexes that house significant gardens, including Daisenin (constructed in 1513 CE) and Ryōanji (from 1488 CE). These Zen gardens fascinated him, and he wondered why Kenkohji temple, which was full of trees and other greenery, had no such organized garden space.

By the time he was in junior high school, Masuno was tracing photographs of famous Zen gardens, and in high school he was sketching his own designs. This was the point when he met his future mentor, garden designer Saito Katsuo. Saito had been retained by Kenkohji to shape the temple garden, and Masuno asked for the opportunity to assist him. Although Masuno had no formal training in garden design at that time, Saito must have sensed his enthusiasm and strong work ethic and allowed the young man first to

Left Shunmyo Masuno saws off the branches of bamboo stalks to use in the construction of a garden fence.

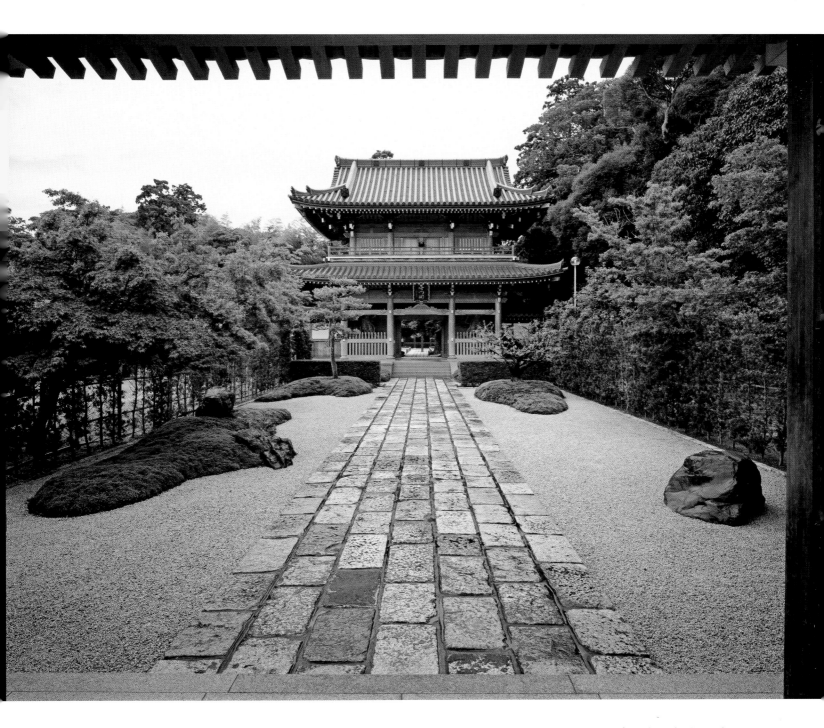

Above The view from the Saikenji temple entrance
leads south through the Baikatei approach garden to
the stately *sanmon* (main gate).

observe his work and later to be his apprentice.

Saito himself had found his way to garden making informally, starting with his father's work as a gardener. Born in 1893, Saito had only an elementary education, but he liked to study and had a strong intellect. His education came from visiting the traditional gardens in Kyoto and studying them firsthand and then by designing and making gardens himself. Saito lived until 1987, still designing gardens into his nineties, many with the assistance of Masuno.

The lessons that Masuno learned from Saito are numerous, and many were transformative for him. Saito taught him that when the workers are on break having tea, Masuno should come up with thirty different designs for a group of rocks or plants. He instilled in Masuno the need to genuinely and fully understand the site—"if you don't know the site, you can't design the garden."[3] Saito emphasized that the way to understand and remember the site is by making sketches and notes, not by taking photographs. For the important elements in a garden, the designer must go to see them in situ, to measure and sketch them where they are found—and then these elements must be placed in the garden directly by the designer. These are the lessons Masuno considers every time he designs a garden.

With the strong foundation he received from Saito's teaching, Masuno entered the Department of Agriculture at Tamagawa University to study the natural environment. After graduating in 1975, he continued his apprenticeship with Saito, and then in 1979 Masuno began intensive Zen training at Sōjiji temple in Yokohama. In 1982 he founded Japan Landscape Consultants Limited and three years later was appointed assistant priest under his father at Kenkohji temple. In this way, he continues moving ahead with his "two pairs of straw sandals," sometimes stepping forward with one pair and sometimes the other, but always wearing both.

As Masuno continued his duties as assistant priest and his work as a garden designer, he augmented his understanding of the Japanese sense of aesthetics and values by learning the art of the tea ceremony (chadō or sadō, literally "the way of tea") along with other traditional arts. He studied the writings of Zen scholars such as thirteenth-century Zen monk and garden designer Musō Soseki and Zen priest Ikkyū Sōjun from the fifteenth century. Both Musō and Ikkyū thought and wrote profoundly about Japanese aesthetics and Zen Buddhism. Ikkyū taught Zen to Murata Jukō, who was integral in the formation of the wabi-cha style of tea ceremony[4] by incorporating Zen ideals into the art. Masuno explains, "Murata developed the heart of the host to humbly receive guests as an expression of oneself in Zen. This strong emotional tie of Zen and tea has survived through the centuries."[5]

As he continued his training, Masuno developed his own design process steeped in Sōtō Zen principles. In Sōtō Zen, enlightenment (satori) is achieved through disciplined training, including zazen meditation, but also through the completion of everyday tasks. It is the repetition and refinement of these acts that leads to a greater understanding of the self and eventual enlightenment. Masuno states, "Designing gardens for me is a practice of Zen discipline."[6] This correlates to the ideas of Musō Soseki, who wrote in his Dream Dialogues (Muchū mondō), "He who distinguishes between the garden and practice cannot be said to have found the Way."[7] In other words, for the garden designer who is a practitioner of Zen, garden making—both design and construction—must be understood as a vehicle for the attainment of truth in Zen.

Right The Ōhiroma hall at the Suifūso guesthouse opens toward the east for a view of the karesansui (dry) garden representing the kusen-hakkai, the nine mountains and eight seas of the Buddhist universe.

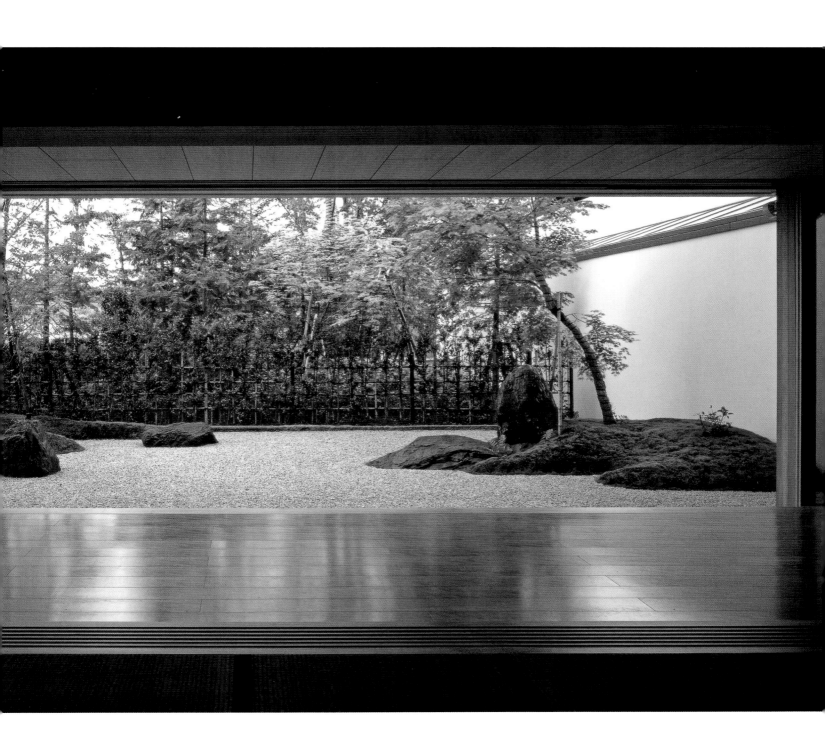

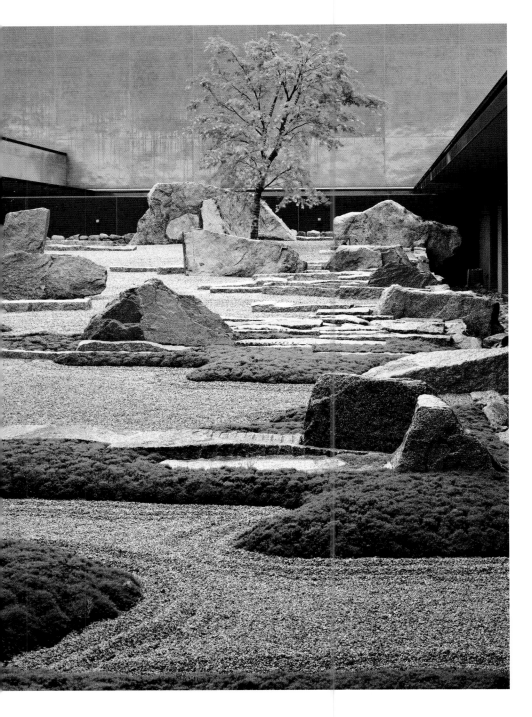

Understanding garden making as an act of Zen Buddhism is an important point when considering the definition of a Zen garden in the twenty-first century. Many gardens in Japan and abroad, especially in the United States and Europe, have been labeled "Zen" or "Zen-style," but according to Masuno, only those created by a disciplined practitioner of Zen Buddhism truly are Zen gardens. In the West, the often copied simplicity and tranquility of the Zen garden may be sufficient to give an initial appearance of the garden being "Zen." However, the quality of "Zen" goes beyond mere appearance. Hisamatsu Shinichi, a scholar of Japanese aesthetics has identified seven different characteristics particular to Zen arts: asymmetry (*fukinsei*), simplicity (*kanso*), austere sublimity or lofty dryness (*kokō*), naturalness (*shizen*), subtle profundity or deep reserve (*yūgen*), freedom from attachment (*datsuzoku*), and tranquility (*seijaku*).[8] These are qualities that result from the mind (both the mental state and the spirit or *kokoro*) of the artist and the process of designing. Masuno notes that in the West, gardens often are an expression of an interior idea and are treated as rooms.[9] This is very different than his own process of design, which begins by the designer emptying his mind and listening to the site and the context in order to allow the design and its inherent aesthetic qualities to grow from the place rather than be applied to it.

"Zen aims to teach one how to live, so it has no form," notes Masuno.[10] Yet from the late twelfth century, Zen monks began to experiment with artful expressions of the Zen mind. The initial medium they chose was ink brush painting (*sumi-e*). At the same time, Zen Buddhist gardens were designed based on Chinese poetry and garden design. When the essence of Zen expressed through *sumi-e* was combined with

Above Cloud-like beds of ground cover are interspersed with layers of gravel and roughly textured mountain-like rocks in the Tabidachi no Niwa (Garden for Setting Off on a Journey) in the Yūkyūen garden at the Hofu City Crematorium.

garden making, the result was the dry landscape garden (*karesansui*).[11] The *karesansui* garden, the most renowned of which is the garden at Ryōanji that Masuno viewed as a boy, is now the garden type most closely associated with Zen Buddhism. However, by no means are all Zen gardens dry landscapes. Water is a key element in many of Masuno's gardens, as well as those of his influential predecessors, including Musō Soseki, who designed the Zen garden at Saihoji temple (from 1339 CE), famous for the thick carpet of moss covering the banks of its quiet stream and pond.

Many Zen gardens are constructed within small contained spaces, such as the Ryōanji garden, which is built on the south side of the abbot's quarters, with garden walls on the other three sides. These diminutive gardens typically convey important Zen principles such as emptiness (*kyo*) and infinite space. Emptiness often is expressed as *yohaku no bi*, literally the "beauty of extra white," referring to the beauty in blankness or emptiness. "Emptiness is the fountain of infinite possibilities."[12] Infinite space is especially powerful when expressed within a contained area. "Large revelations often occur in very small places, sometimes as the result of a radical shift in scale and perspective."[13] Although small Zen gardens may be spaces of revelation, the size of the garden alone does not define it as Zen.

Common to all Zen gardens is the incorporation of the "heart" (*kokoro*) of the rocks, trees, and other materials that comprise them.[14] The word that Masuno uses to express the "heart" of the materials, *kokoro*, also can be translated to mean "mind" or "spirit." According to Zen Buddhism, each material has its own spirit, which must be respected. Therefore each rock or tree must be understood for its own unique characteristics. When Masuno speaks of his gardens being

"expressions of [his] mind," he is referring to his own *kokoro*—which is rooted not in the head but in the heart.[15] Masuno's gardens, therefore, are a dialogue between his *kokoro* and the *kokoro* of each of the elements in the garden.

The idea of garden design as a dialogue between the designer and the elements in the garden is clearly stated in the first known Japanese garden manual, the eleventh-century *Sakuteiki* (*Memoranda on Garden Making*). "*Ishi no kowan wo shitagau*," or "Follow the request of the stone,"[16] implies the requirement to have a dialogue with the elements in the garden in order to

have a complete understanding of the unique character of each element. Philosopher Robert E. Carter notes, "In Western cultural climates, one would be looked at with the greatest of suspicion upon speaking of initiating a dialogue with rocks or plants."[17] It is this dialogue between the designer and the rocks and trees in the Zen garden that creates timeless beauty and profound spiritual depth in the garden. Masuno notes,

> Obviously, there is a great difference between a form that only sets out to be

beautiful and one in which body and soul are united at the time of its creation. Even if the completed forms are very nearly the same, the impression of the viewer should differ greatly, too, because the mental energy that exists within the work is different: . . . if a garden has no soul, then even though it may catch the attention of many people for a time, they will completely forget about it as soon as something new comes along.[18]

As "*ishi no kowan wo shitagau*" suggests, this dialogue with the elements of the garden initially focused on the choice and siting of rocks. Rocks have long been revered in both Japan and China, where the prototypes for Japanese gardens developed. Before Buddhism entered Japan from China and Korea in the sixth century, rocks were venerated in Japan in the vernacular Shintō religion. They were believed to be "the medium of divine connection."[19] Deities were understood to reside in natural features, such as rocks known as *iwakura* (literally "rock seat"). These rocks often had distinctive features relating to their size, shape, color, or markings. These unique qualities distinguished the rocks as special, and therefore they were treated with great respect.

From ancient times in China, rocks were afforded a similar respect, as they were understood to contain the essential energy of the earth, the *qi* (or *ch'i*, *ki* in Japanese). These rocks were placed in gardens, first in China and later in Japan, so people could enjoy them and contemplate their power. "The garden thereby becomes a site not only for aesthetic contemplation but also for self-cultivation, since the *qi* of the rocks will be enhanced by the flows of energy among the other natural components there."[20]

Above The carved stone *chōzubachi* (water basin) in the Fushotei garden rests on a rough rock base at the edge of the *engawa* (veranda) of the Renshōji temple reception hall.

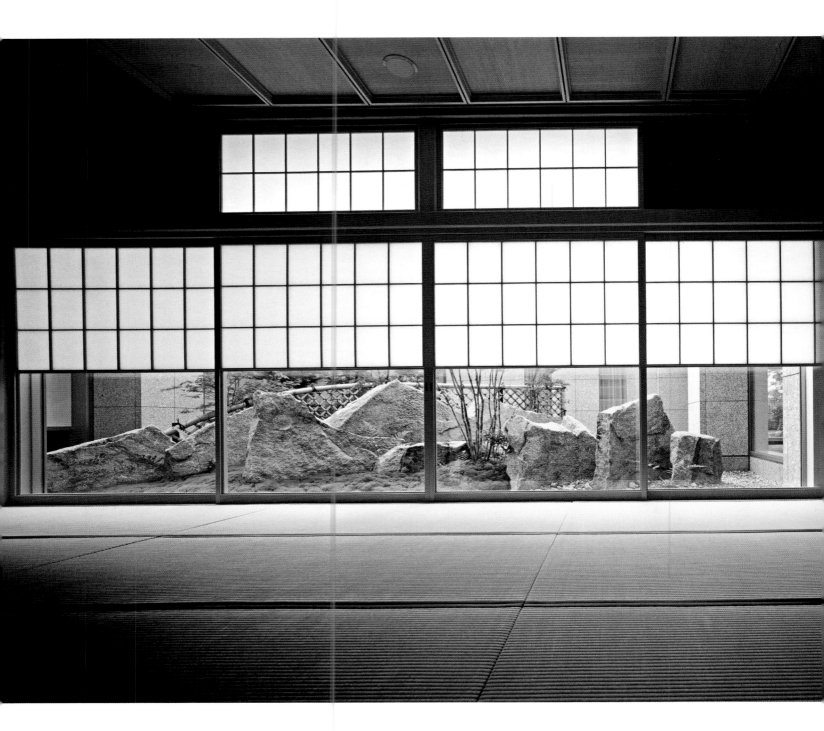

Above *Yukimi-shōji* ("snow-viewing" sliding screens)
reveal a view to mountain-like rocks backed by a
kōetsuji-gaki ("lying cow–style" fence) made of bam-
boo in the courtyard garden at Hotel Le Port.

These early leanings in both China and Japan toward understanding and respecting rocks for their unique qualities naturally led to rocks playing an important role in Japanese gardens. Garden making started in Japan with the introduction of Buddhism from China and incorporated Chinese cultural ideas and forms. Therefore, the first gardens in Japan were much like their Chinese counterparts. Gardens built for the court nobility featured meandering streams, ponds, and distinctive rock outcroppings. Initially the garden forms were close imitations of Chinese garden types, but by the end of the Heian period (794–1185 CE) in Japan, the Mahayana Buddhism that had been introduced in the mid-sixth century gave way to the Pure Land school of Buddhist thought, and garden designs changed to reflect these new ideals.

Pure Land gardens were paradise gardens. Built for aristocrats on their sprawling estates, a typical paradise garden featured a large pond on the south side of a *shinden*-style building, with a central hall flanked by pavilions extending into the garden. Small islands, sometimes connected to the shore by bridges, punctuated the smooth surface of the pond. These gardens were designed to be enjoyed both by moving through the space, on foot or by boat on the pond, as well as by viewing from the adjacent mansions. The relationship between the surrounding *shinden* buildings and gardens was integral to the designs. Exotic and unique plants and rocks filled these gardens, evoking the sense of a sumptuous paradise, the Buddhist Pure Land.

By the mid-thirteenth century, gardens in Japan like those designed by Musō Soseki at the Saihoji temple began to show a change from an image of an otherworldly paradise to finding delight in splendors more closely related to this

life. Rocks continued to play a major role in these gardens, and the first hints of the Zen gardens appeared as dry waterfalls constructed of rocks in gardens like Saihoji. By the late thirteenth and early fourteenth centuries (the end of the Kamakura period and into the Muromachi era), Buddhist priests were active in designing and making gardens. These priests became known as *ishitate-so* ("stone-laying monks"), for although they were charged with designing the complete garden, finding appropriate rocks and siting them properly in the garden were considered their primary responsibilities. This name for the garden makers proves the continued importance of rocks in the gardens in Japan.

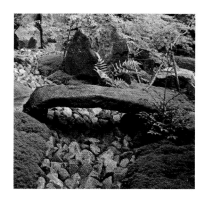

Many of the gardens from the late fourteenth and fifteenth centuries, including those at Kinkakuji (constructed in 1397 CE) and Ginkakuji (from 1482 CE), known as the Golden Pavilion and Silver Pavilion respectively, still showcase aspects of Pure Land aesthetics, such as pleasure pavilions set within extensive gardens. Paths lead between grouping of rocks and plants, passing ponds and passing over streams on stone or wood bridges. But by the late fifteenth century, gardens such as

Above A river of rocks runs under an asymmetrical stone bridge, spanning banks of lush moss in the Fushotei garden at the Renshōji temple.

Ginkakuji started to incorporate other design principles, including miniaturization and compositions of dry rock arrangements, which became hallmarks of Zen gardens.

Zen Buddhism took hold in Japan during the Muromachi period (1392–1568 CE) and began to influence the arts. Buddhism had been introduced into Japan partly for its system of education, which included a written language. Temples were places of learning, and monks spent time studying Buddhist texts. The arts, including painting and sculpture stimulated by Chinese Buddhist aesthetics, flourished at the temples. Under Zen Buddhism, the arts developed distinctively, reflecting the ideas of discipline of the mind and the body that were important in Zen. Enlightenment came from within through strict training. Zen focused on understanding (and through the arts, expressing) the spirit embodied in all things. Meditation was the vehicle for achieving this, and artistic practices, like brush painting, served as training. In the Zen arts, ornament was eschewed in favor of simplicity, and a tendency toward abstraction developed.

During this time Zen monks, inspired by Chinese Sung era paintings of craggy mountains and winding rivers, began to create gardens reflecting the landscapes in the paintings. These gardens often were made using only a few materials— rocks, pea gravel, and perhaps a few plants. By the late fifteenth century, the *karesansui* (literally, "dry mountain water") gardens at Daisenin at the Daitokuji temple and at Ryōanji, two of the most well-known gardens of this style, expressed landscapes very abstractly utilizing miniaturization and symbolism. Rock groupings were situated to represent landscape elements such as islands and waterfalls, but they also could be representational, depicting an image of sacred Mount Shu-

misen, the center of the Buddhist universe, for example, or perhaps even the Buddha. These *karesansui* gardens were not used for entertainment and enjoyment as previous gardens had been. Rather they had strong religious connotations and were used by the monks for meditation. Garden historian Loraine Kuck describes the Zen ink brush painting that inspired these gardens—but she easily could be describing the gardens themselves. "Simple as were these materials, in the hands of a master they were capable of suggesting the mistiness of distant mountains or rivers, the bold forms of rocks and crags, the dark textures of pines, and the whiteness of a waterfall."[21]

Another garden type that developed under the influence of Zen Buddhism was the tea garden. As the *wabi-cha* style of tea became fully developed in the late sixteenth century (the Momoyama period), ceremonial teahouses and gardens were constructed to fit into existing estates, often tucked into an unused corner. These gardens typically express a refined or restrained nature and are designed around a pathway, the *roji* (literally "dewy ground"), leading

from an entry gate past a waiting bench to a small teahouse. "The *roji* was a carefully designed environment, a corridor whose true purpose was to prompt the mental and spiritual repose requisite to the tea gathering."[22]

Although the *karesansui* Zen gardens moved away from replicating known landscapes in miniature form to representing an abstract idea of a landscape, and the more naturalistic tea gardens acted as a series of physical and mental thresholds, the key to the design of all Zen gardens was the human attitude to nature. From early times, the Sakuteiki had advised to design a garden by "Paying keen attention to the shape of the land and the ponds, and create a subtle atmosphere, reflecting again and again on one's memories of wild nature."[23]

Wild nature in Japan can mean steep heavily forested mountains, rivers flowing swiftly along rocky banks, rough winding coastlines, and small islands full with greenery. These are some of the natural elements that inspire garden designers, but the Japanese attitude toward nature also is an important influence. This notion is deeply rooted in the Shintō reverence for nature as well as the idea supported by both Shintō and Buddhist teachings that humankind is not separate but rather a part of nature, combined with a profound respect for the power inherent in nature. Shintō focuses on particular objects in specific places, like the sacred *iwakura*. However, the typhoons, earthquakes, volcanic eruptions, and tsunami that are part of life in the island country categorically demonstrate nature's force—a force with which the Japanese people have learned to coexist. Thus the attitude toward nature is very specific to an unchanging place—a rock or a waterfall, for example—while also being bound up with changing and unpredictable natural

Above A sculpted stone marker, one side roughly textured with the marks of the artist's hand-work and the other side smoothly polished to a reflective surface, expresses the connection between old and new at the Opus Arisugawa Terrace and Residence.

Right The design of the Fūma Byakuren Plaza at the National Institute for Materials Science expresses the spirit of the scientists working nearby and features a meandering river of small rocks connecting gridded and grass-covered surfaces.

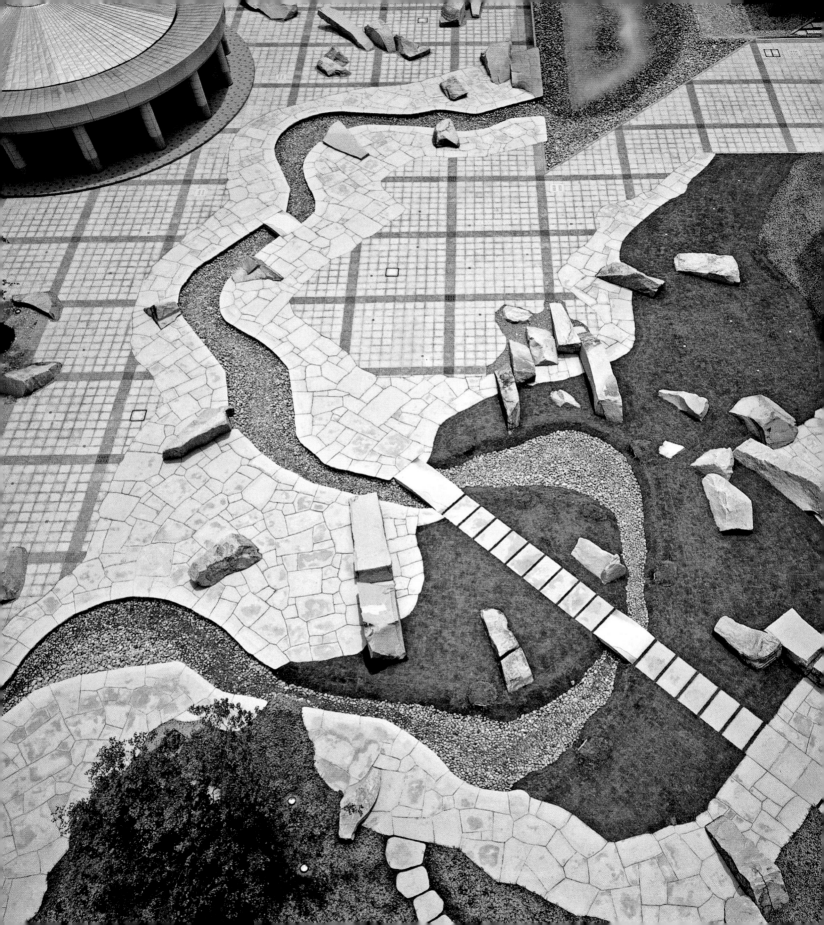

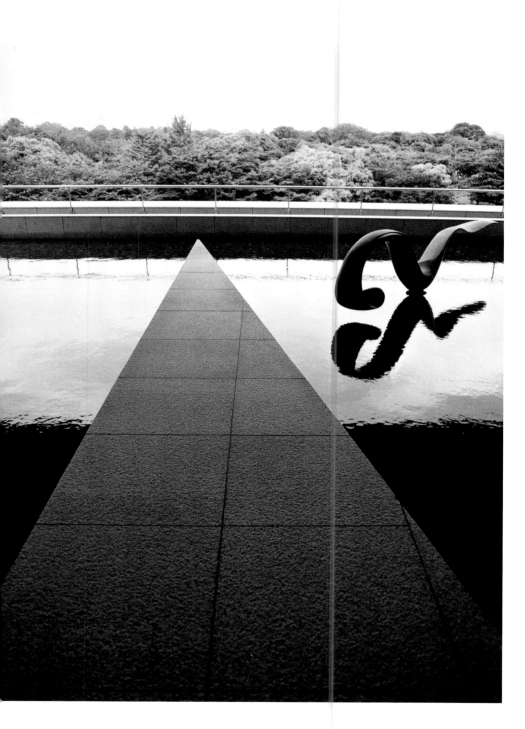

Above A sharp peninsula of stone projects over a still reflecting pool representing the Pacific Ocean in the fourth-story garden at the Canadian Embassy in Tokyo.

conditions. The Japanese garden "displays a design logic which is intimately bound up with the genius loci of the Japanese landscape—in other words, with the essence of the country as it appears to the human imagination."[24] This essence incorporates both elements understood to be mostly unchanging together with those that are transient and impermanent.

"The Japanese find beauty in impermanence, the constant transformation. The light and shadow, winds, the flowing of time, the changing of seasons. . . . I find it so appealing that we are part of this vast nature, with its state of constant change and uncertainty of the times."[25] This "constant transformation" or impermanence of all living things is expressed by the Buddhist concept of *mujō* (transience). *Mujō* is integrated into every garden with the seasonal transformations of the flowering plants and colored leaves of the trees, as well as the ever-changing shadows cast by the trees and rocks. While transience is an important principle in both garden design and garden viewing, other aesthetic concepts, such as the seven identified by Hisamatsu Shinichi also are at work in gardens. Of those, *yūgen* is important in connecting the viewer of the garden to the *kokoro*—the spirit—of the garden elements. *Yūgen* has been translated as "subtle profundity,"[26] "a profound and austere elegance concealing a multilayered symbolism,"[27] and "the mood of great tranquility."[28] "*Yūgen* is called into being by atmosphere, one of hazy unreality that creates in a mind attuned to it the feeling of kinship with nature, the sense of one's spirit merging with the spirits of other natural things and the eternal behind them all."[29]

Without training and study, *yūgen*, like many other Zen aesthetic principles, is not an easy concept to grasp. According to Masuno, the creation of a garden or other artistic work embodying

such principles, such as the choice of rocks and plants to create the atmosphere of the Zen garden, comes only through *kankaku* (feeling or sense) and *kunren* (training or discipline).[30] The point of incorporating these principles is not for the sake of the principles themselves, but rather to create a place where people can leave behind the *yutakasa* (richness, abundance) of everyday life that is strongly focused on goods and consumption. Instead, while experiencing the garden, visitors can encounter their "*kokoro no yutakasa*" (the richness of their spirit).[31]

Whether designing a traditional garden, a modern garden, or a garden overseas, creating Zen gardens that allow people to reflect on how to live their lives well every day is Shunmyo Masuno's goal. "Zen is ultimately a way of discovering how one should best live. By viewing a garden, viewers question themselves if they are walking the correct path. They search for the unmoving truth inside the garden, the place where serenity and calmness are reclaimed. The delusions and the answers are all within ourselves."[32]

Above The contrasting colors and forms of two rocks placed in front of a dark stone wall at the Nassim Park Residences evoke the feeling of the power of nature.

Notes on Language

Japanese names in the text are written to follow the typical Japanese order of the family name followed by the given name (the opposite of English). An exception is Shunmyo Masuno's name which is written with his given name, Shunmyo, followed by his family name, Masuno. Shigeru Uchida's name is treated similarly.

Japanese words used in the text are written in Roman script (*romaji*), based on phonetic pronunciation using a modified Hepburn system. Consonants are pronounced similarly to English, with g always hard. A macron is used to denote a long vowel sound, except for words such as Tokyo and Kyoto, which have become common in English, and the word *torii*, which is commonly written with *ii* rather than *ī*. An exception is Kenkohji, the temple where Masuno presides as head priest, which uses an *h* following the *o* rather than a macron. Vowels are pronounced as follows:

a is ă as in *father* (ā denotes a lengthened sound; also written as aa)
i is ē as in *greet* (ī denotes a lengthened sound; also written as ii)
u is ū as in *boot*
e is ĕ as in *pet* (also written as é)
o is ō as in *mow* (ō denotes a lengthened sound, also written as oo or ou).

The glossary includes Japanese characters for each word—kanji ideographs originally from China and the two *kana* syllabaries based on phonetics, *hiragana* (now used for Japanese words or parts of words for which there is no kanji) and *katakana* (now used primarily for foreign words).

Japanese nouns can be either plural or singular.

For clarity, I have included the word *temple* following the name of a temple, for example "Ryōanji temple" and "Daisenin temple," even though *ji* in Ryōanji and *in* in Daisenin mean "temple." Similarly, the word *garden* may follow the name of a garden, as in "Yūkyūen garden" or "Baikatei garden," although *en* and *tei* mean "garden."

I utilize the definitions of *rock* and *stone* laid out by David A. Slawson in *Secret Teachings in the Art of Japanese Gardens: Design Principles and Aesthetic Values* (p. 200). He states, "Japanese *ishi* (*seki*) I translate as 'rock(s)' when they are used in the garden to suggest rock formations in nature, and 'stone (s)' when they are used (for their naturally or artificially flattened upper surfaces) as stepping-stones or paving stones, or when they have been sculpted (stone lanterns, water basins, pagodas) or split or sawed (stone slabs used for bridges, paving, curbing)."

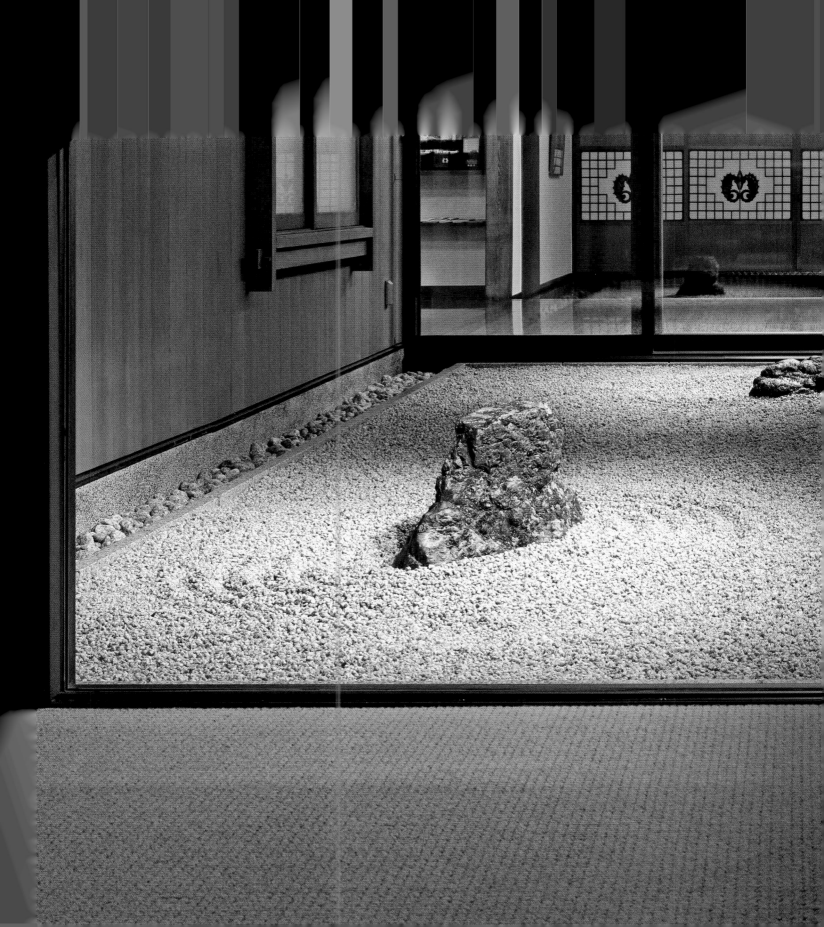

TRADITIONAL GARDENS

TRADITIONAL ZEN GARDENS IN THE 21st CENTURY

"In Japanese culture," writes Shunmyo Masuno, "rather than emphasizing the form of something itself, more importance is placed on the feeling of the invisible things that come with it: restrained elegance, delicate beauty, elegant simplicity and rusticity."[1] The invocation of these qualities is deeply rooted in Japanese aesthetics and is a central tenet in the traditional arts of calligraphy, flower arrangement, tea ceremony, and garden design, among others.

In his gardens, Masuno creates these feelings by emphasizing the design of the atmosphere of a place, rather than the shape of a space or object. Of course, it is possible to achieve this with contemporary materials and compositions as well as long-established elements and arrangements, but in many of his gardens Masuno makes a conscious choice to utilize traditional materials and compositional devices—to create a "traditional" garden. But what is a traditional Japanese garden in the twenty-first century—and what is its role in contemporary life?

First, it is necessary to explore the concept of tradition. A tradition is not understood as such until it is viewed from a perspective outside the culture. Until there is something different with which to compare or contrast a traditional belief or practice, such conventions are not considered "traditional"—they are customary everyday practices, part of a living history developed slowly over time. When an outsider or someone who has experienced a different manner of doing things is able to see the belief or practice in the context of a greater realm, only then it becomes possible to understand it as "tradition." This is exactly what occurred in Japan during the Meiji period (1868–1912), when, after more than two centuries of self-imposed isolation, Japan opened its ports to trade with the

outside world and suddenly had a great influx of Western ideas and goods. Everyday life began to change, and with it the traditional practices were recognized by their dissimilarity to the new ideas entering the country.

Once a practice or belief is identified as traditional, the tradition does not necessarily end. However, the perpetuation of the tradition becomes a conscious, intentional act. The practice or belief may continue unchanged, as a simple copying of what has come before, or it may necessarily entail the continued development of that practice, especially if the essence of that tradition relies on its further development.

A traditional Japanese garden built today falls under that second category, of continued development. Because a traditional Japanese garden is designed to fit a particular context and place, it is illogical—and without doubt some would argue impossible—to replicate a historic garden. The designer must use the proper ingredients and adapt the recipe to the specific conditions of a given site.

Gardens were formed by making use of the natural scenery and geographical features, and adjusting the garden to suit the surrounding environment. . . . They are designed to merge with the surrounding scenery. When trimming trees in gardens, it is the same: Parts that stand out are trimmed closely and carefully, but parts that are connected with their surroundings are trimmed so they gradually adapt to the surrounding nature.[2]

While background trees are shaped to blend into their surroundings,

Previous page Three carefully arranged rocks in a bed of raked gravel in the Chōsetsuko courtyard garden at the Ginrinsō Ryōkan condense the essence of the universe into a few simple elements.

Above A beautifully shaped pine tree growing on an island of moss is balanced with a rough rock rising from the pond in the garden at the Kyoto Reception Hall.

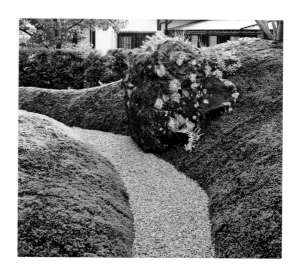

prominent trees in Japanese gardens are pruned and trained to bring out their unique characteristics. This close and careful trimming of these trees is an example of "a highly conscious aesthetic of naturalism," described by garden historian Lorraine Kuck as having developed with the influence of Zen Buddhism from "a simple love of nature."[3] This "highly conscious aesthetic of naturalism" is fundamental to all traditional gardens in Japan, but it is applied differently in each garden depending on the designer's concept and the elements utilized in the design. For example, in his traditional gardens Shunmyo Masuno utilizes the time-tested elements and materials of this aesthetic—water in waterfalls, streams, and ponds; rocks for dry waterfalls, streams, oceans, and rock groupings; and plants for ground cover, focal-point plantings, and arrangements of flora. Yet each use of these elements is different and distinct, emphasizing the unique character of each garden.

Historical garden manuals, such as the eleventh-century *Sakuteiki* (*Memoranda on Garden Making*), the oldest known treatise on garden design, teach the skill of observing nature to learn how to place rocks in a stream or prune a tree to appear natural. These observations have led to the development of specific elements, such as waterfalls or rock arrangements, which can be adapted to a particular context. For example, in the Kantakeyama Shinen garden at the Samukawa Shrine, Masuno features a waterfall in the *dan-ochi* (stepped falls) style, while in the garden at the Kyoto Prefectural Reception Hall, he incorporates a *nuno-ochi* ("cloth veil" falls) waterfall. Each such traditional element is chosen for its particular visual and auditory role within the specific garden. It is Masuno's design skill that brings together these traditional elements in a unified and bal-

anced composition that imparts an aesthetic of elegance, beauty, simplicity, and rusticity.

With this close connection to the formal elements of historic gardens, the traditional Japanese garden plays a distinct role in contemporary life. Industrialization and human progress have produced an enormous number of new materials and design ideas, yet it is clear from Shunmyo Masuno's prolific practice that there still is a desire to build new gardens in the traditional style. It must be more than mere nostalgia for the old ways of doing things that inspires clients to request a traditional garden or inspires Masuno to design one. Certainly, in the case of a garden at a Buddhist temple, it is logical to expect a traditional garden if the temple buildings are constructed in a traditional style, such as those at Gionji and Gotanjōji. However, for a private client with a contemporary house, as is the case of the Shojutei and Chōraitei gardens, the style of the garden is not required to mimic the style of the architecture but must complement it. The traditional garden is desired not specifically for its style, but rather for its ability to connect the owners with nature and in doing so provide both a sense of tranquility and an opportunity for deep self-reflection.

This connection to nature and the sense of serenity and self-reflection that accompany it go back to the inherent role of nature in Japanese culture, born out of the conditions of the natural environment in Japan. At the same time, the time-honored elements and symbols of traditional Japanese gardens continue to create the invisible qualities of "restrained elegance, delicate beauty, elegant simplicity and rusticity."

Above left Water drips from a bamboo spout into the carved stone *shihō hotoke tsukubai chōzubachi* (four-sided Buddha water basin) in the Mushintei garden at the Suifūso Guesthouse.

Above right In the Keizan Zenji Tembōrin no Niwa at the Gotanōji temple, a gravel stream cuts through moss-covered mounds punctuated with large roughly textured rocks.

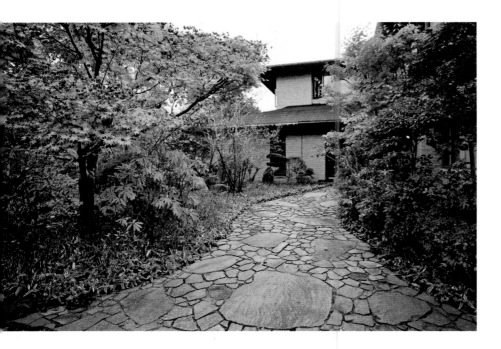

滄晴園
SŌSEIEN

RETREAT HOUSE
KANAGAWA PREFECTURE, 1984

Nestled on a hilltop with long views to the surrounding mountains, the garden was named Sōseien by the owners, meaning "refreshing clear scenery." Serving three different functions, the tripartite garden encircles the guesthouse run by the Tokyo Welfare Pension Fund and leads down the hill as the entry path. First, the entry path sets the mood, giving the visitor a sense of winding through deep mountains. Next the main garden opens out from the lobby and restaurant spaces with a series of low horizontal layers that mimics cloud formations and draws in the nearby mountains. Finally, the garden viewed from the traditional Japanese baths provides a more private, secluded scene of nature highlighted with a swiftly flowing waterfall and a quiet pond.

Flat stones in a random informal (sō), pattern form the surface of the entry path. Large stones commingle with small ones as the path meanders up the gentle slope. Closely trimmed bushes interspersed with multihued trees and a few large rocks are carefully positioned to appear natural and provide changing focal points along the path. Before long, a glimpse of the building emerges among the greenery. While the end of the path is visible, the main garden is not yet revealed, giving a

Above The stone-paved approach to the guesthouse at Sōseien creates the feeling of wandering along a forested mountain path.

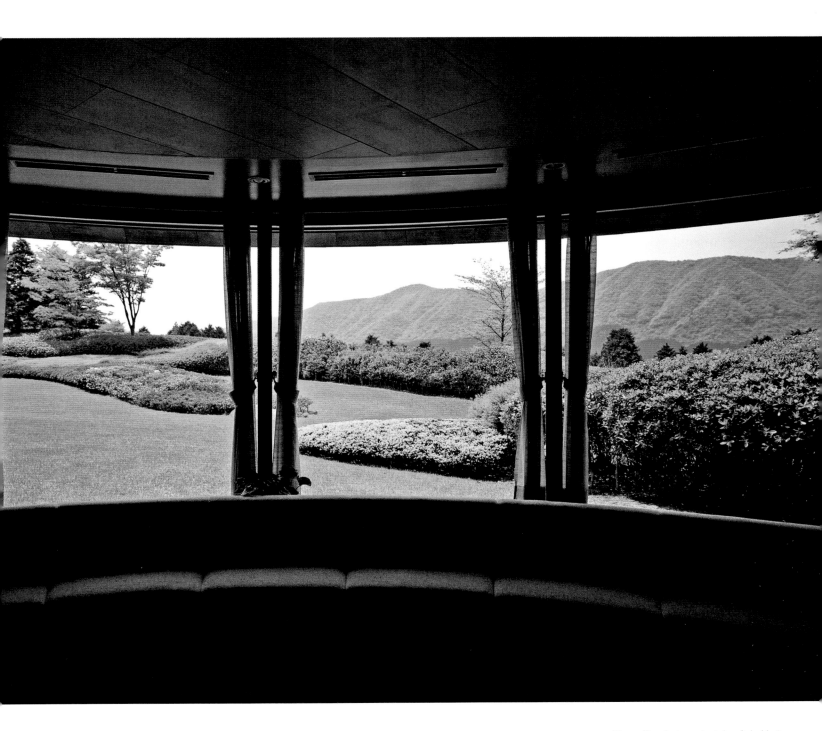

Above The design principle of *shakkei* (borrowed scenery) is used to incorporate the distant mountains into the composition of the garden, as viewed from the lobby.

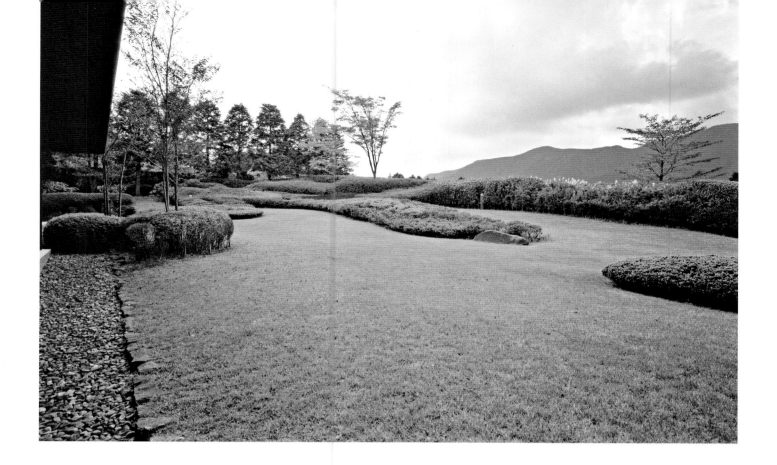

feeling of pleasant anticipation. This sense of a relaxed tension, created during the walk up the path, allows both a physical and a mental transition. While physically moving up the hill, the mind is invited to take in the surrounding nature and release the cares of the day. The sensation of relief combined with expectation increases with each step closer to the guesthouse.

A sequence of entry spaces continues that transition from outside to in and from the activity of daily life to relaxation. Once inside the guesthouse, a right turn into the lobby opens up a vista of the main garden with the mountains beyond. Designed to bring the faraway views of the mountains into the garden—a design principle known as *shakkei* (borrowed scenery)—the main garden features a grassy lawn interspersed with low, cloud-like layers of closely clipped hedges and a few strategically placed trees and rocks. The low mounds of dense hedges are made up of many different types of plants, primarily yew and azalea, chosen for their varied seasonal colors. At the end of one central mound, a low dark angled rock interrupts the soft flow of the greenery.

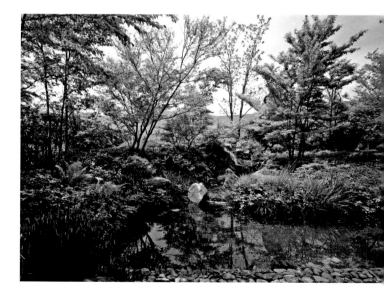

Top A layer of gravel creates the transition between the guesthouse and the garden and also functions to absorb rainwater dripping off the eaves.

Above When viewed from the bathing areas, the spaces of the garden constrict, with the trees, rocks, and ground cover reflected in a small pond and the mountains visible between the trees.

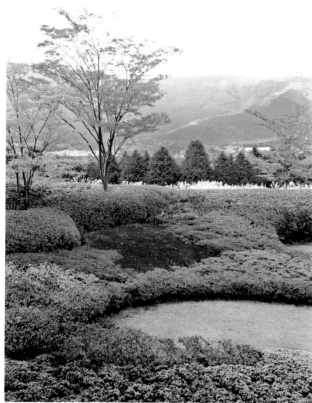

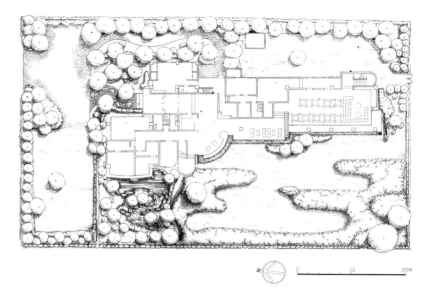

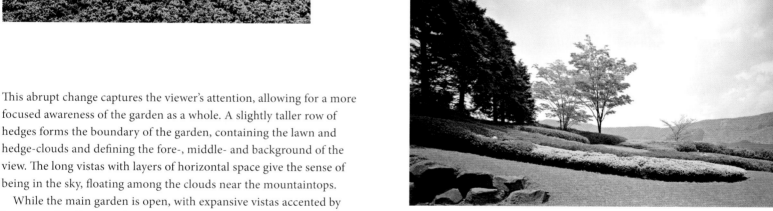

This abrupt change captures the viewer's attention, allowing for a more focused awareness of the garden as a whole. A slightly taller row of hedges forms the boundary of the garden, containing the lawn and hedge-clouds and defining the fore-, middle- and background of the view. The long vistas with layers of horizontal space give the sense of being in the sky, floating among the clouds near the mountaintops.

While the main garden is open, with expansive vistas accented by low mounds of hedges, the garden viewed from the baths allows only momentary glimpses of the mountains beyond. Evergreen and deciduous trees, planted to give privacy while not completely blocking the view, form the background of the compressed spaces of the garden. A stream meanders along rocky banks toward a waterfall, which opens out into a pond in the foreground. The curves of the stream together with the fingers of land create layers of space, giving the garden a feeling of depth and great size. Bushes, ferns, and ground cover are closely planted to reflect the dense vegetation of a lush mountain scene. They vary in scale to support the concept of spatial layering—an important

design principle executed differently in each of the three parts of Sōseien.

The layering of space in the Sōseien garden produces a sense of spatial depth that stimulates the viewer's imagination. "Making people imagine the part they can't see brings out a new type of beauty."[1] The three varied parts of the Sōseien garden allow the viewer three different ways to exercise the imagination, experience this sense of beauty, and reconnect with nature.

Top left The hedges are planted and trimmed to appear monolithic in their cloud-like forms, but they consist of many different types of plants, which give variety in their leaf shapes and colors throughout the seasons.

Top right The site plan of the Sōseien retreat house shows the open areas of the garden relating to the public spaces of the building and the more compact garden spaces near the private areas.

Above right The rough texture and dark color of the rocks in the foreground provide contrast to the gentle slope, curved forms, and muted colors of the hedges and distant mountains.

銀鱗荘

GINRINSŌ

COMPANY GUESTHOUSE
HAKONE, KANAGAWA PREFECTURE, 1986

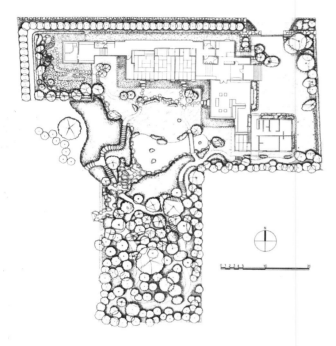

Located in the mountain resort area of Hakone, the Ginrinsō garden is
designed with the site and the specific visitors in mind. The garden comple-
ments a guesthouse for the company from which the garden gets its name—
a company that originally made its money from herring fishing. The guest-
house, planned for workers who typically go for a relaxing weekend stay, has
a design reminiscent of a traditional *sukiya*-style inn, which spreads across
the top (the north side) of the T-shaped site. The garden wraps the perimeter
of the site but mostly extends out to the south, along the stem of the T.

The primary views of the main area of the garden are visible from the guest-
rooms and the common spaces. Traditional tatami-matted guestrooms offer
framed scenes of the expansive lawn leading to a pond, which is backed by a
hill featuring a tall two-tiered waterfall. The hill emphasizes the vertical dimen-
sion of the garden and also gives the suggestion of something beyond.

Above The guesthouse building sits on
the north edge of the T-shaped site,
with a gravel court on the east side in
front of the entry and the main gar-
den stepping uphill from the building
on the south side.

Above The garden path starts from the
curved bridge at the edge of the pond near
the guesthouse and climbs through the
garden to the top of the waterfall for a view
back to the guesthouse and the mountains
beyond.

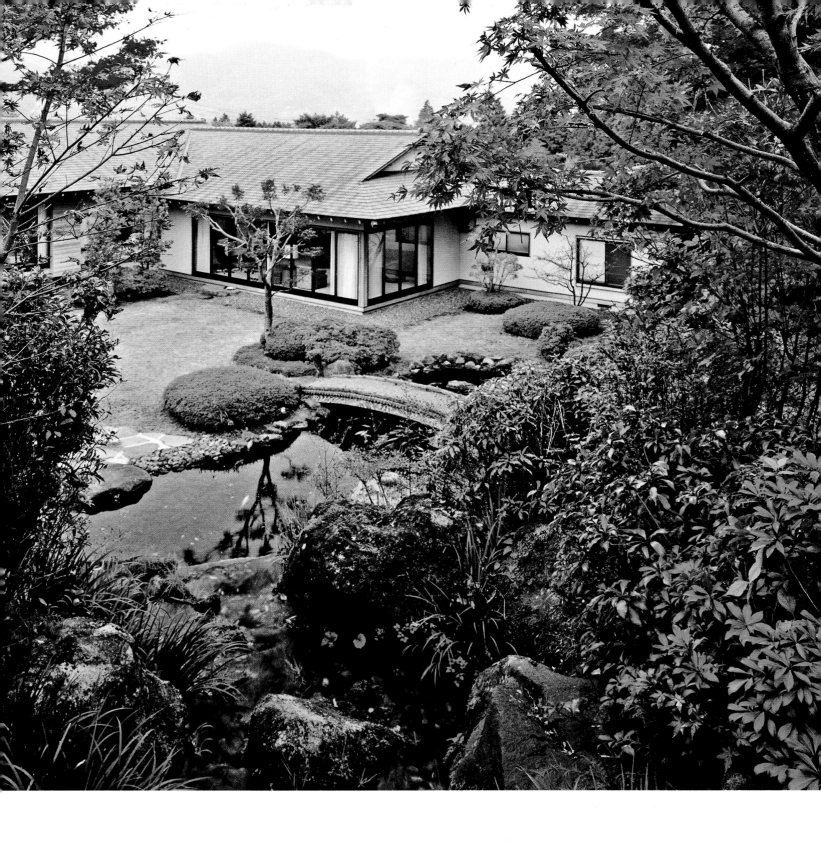

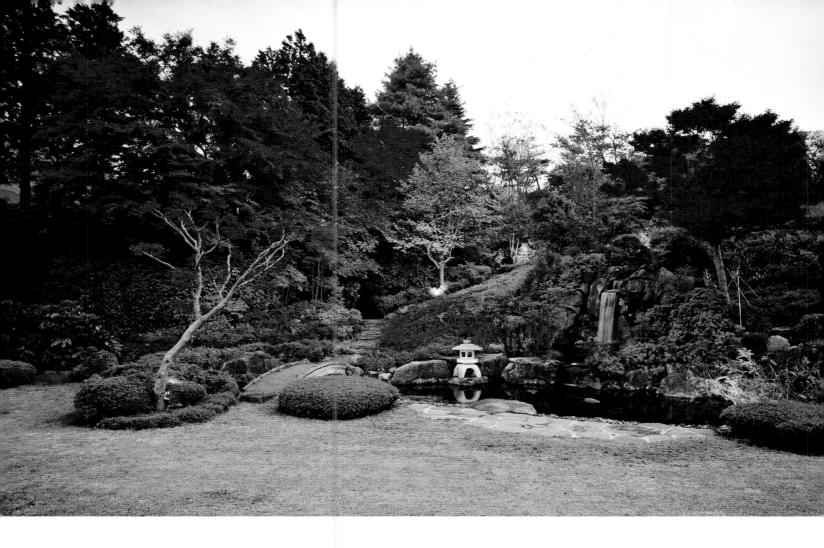

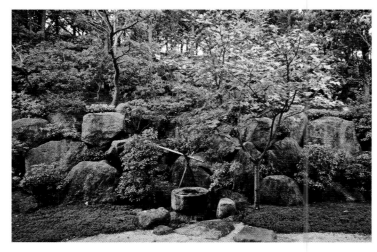

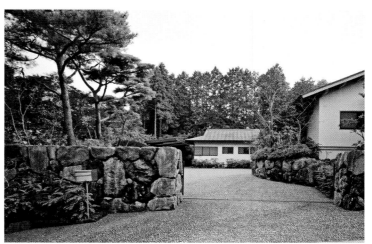

Top Subtle nighttime lighting enhances the colors and forms of the main elements of the garden, creating views different from those seen during the day.

Above left The garden visible from the bathing spaces features a cylindrical stone *chōzubachi* (water basin) and a single maple tree in front of an arrangement of rocks and shrubs with trees behind.

Above right Sturdy rock retaining walls contain the garden and border the gravel-covered approach and entry court of the Ginrinsō guesthouse.

Opposite page left With its tall height and continuous sound, the stepped waterfall is a focal point in the garden and also draws the viewer's eye into the high depths of the garden.

Carefully composed for balanced views when seen from both the interior of the guesthouse and while walking through it, the garden offers a variety of experiences—both for the eyes and the mind.

Stepping-stones lead from the guesthouse out to the garden, where the visitor can traverse the lawn and then cross the pond on a gently curving bridge. From the pond, a gravel path climbs up and continues behind the hill. It winds through dense masses of clipped azaleas and loops through a heavily wooded section of the garden, reminiscent of a mountain trail. The path continues to the top of the hill—the starting point for the ten-meter-high waterfall, where views unfold back to the guesthouse and the mountains beyond. The path provides varied scenes and moments of discovery, from the quiet solitude of a secluded mountain trail to a moment of pause on the bridge, observing the colorful ornamental carp in the pond and listening to the water splashing off the rocks in the waterfall.

Tucked into the northwest corner of the site, a smaller garden designed to be viewed from the baths is much more enclosed and private, separated from the main garden by a wall. It features rough rocks set into a hill and interspersed with plants, as well as a stone *chōzubachi* (wash basin), reached by stepping-stones leading through the pea gravel surface in the foreground. Low mounds, green with ground cover and interposed within the pea gravel, form the base of the rocky hill. A few special trees, chosen for their form and seasonal color, are strategically placed on the hill for visual emphasis and focus.

As visitors generally arrive on a Friday evening and depart on a Sunday, the main area of the Ginrinsō garden incorporates subtle lighting for nighttime viewing. Concealed in hedges and behind rocks, the lighting apparatus is imperceptible during the day. At night, it illuminates specific trees and objects, like the curving bridge and the stone lantern positioned at the edge of the pond between the bridge and the waterfall. The lighting pattern is varied during the two nights of a visitor's stay, allowing the pleasure of discovering different ways to see and experience the garden.

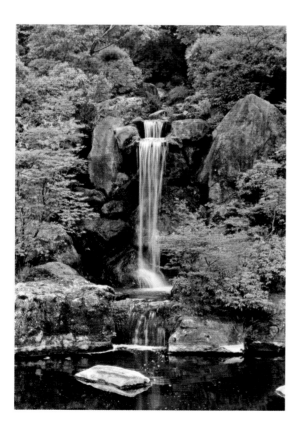

Right The gently arched bridge connects the lawn adjacent to the guesthouse to the meandering path, which steps up the hillside through the hedges and into the densely planted trees.

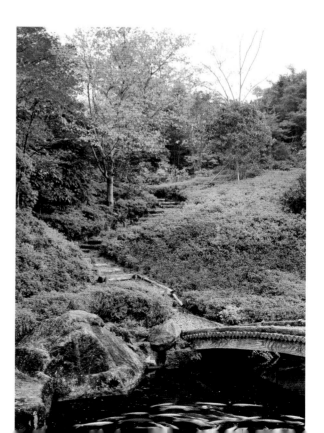

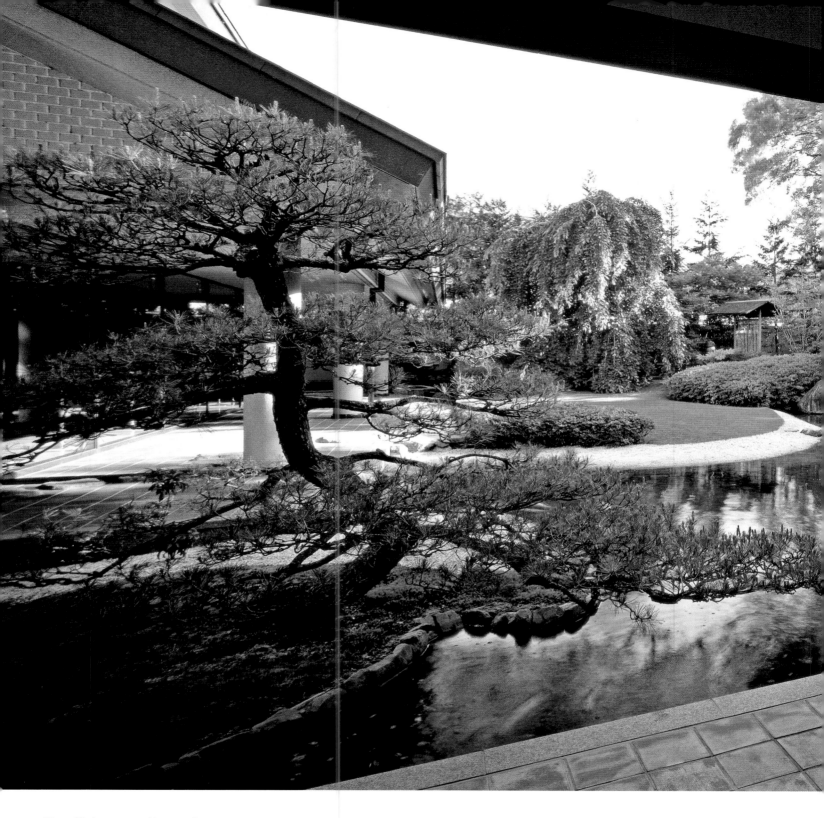

Above Tiled terraces and long roof eaves extend the interior space of the reception buildings into the garden, while the pond and islands of the garden move under the terraces to bring nature inside.

京都府公館の庭
KYOTO PREFECTURAL RECEPTION HALL KYOTO, 1988

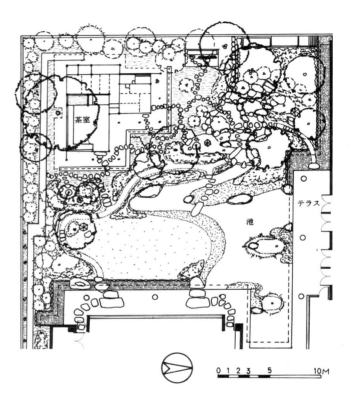

The Kyoto Prefectural Reception Hall is an oasis hidden in the middle of the city of Kyoto. The building houses two main functions: a multi-purpose hall open to the public, which allows only a glimpse into the surprising natural scenery of the garden, and a formal reception room used to entertain dignitaries visiting from abroad, which opens out to the lush welcoming greenery. Designed with layers of spaces ascending a gentle hillside and defined by the varied heights of shrubs and trees, the garden appears much larger than its actual size.

A terrace faced with a grid of stone tiles extends from the reception hall out toward the garden. A gentle expanse of grass and water,

Above right The teahouse nestles into a high corner of the garden, with the pond at the opposite lower corner adjacent to the reception hall.

bounded on one side by a wing of the L-shaped building and edged with rounded bushes and leaf-filled trees, greets the visitor in a welcoming gesture of openness and abundance. Although the sharp geometry of the terrace contrasts the gentle character of the garden, it has a strong spatial and physical connection to the garden. At one end the pond slips underneath the stone platform, while at the two locations where doors open from the hall onto the terrace, textured stepping-stones break into the gridded stone surface and lead into the garden.

Designed both to be observed from inside the hall and while follow-ing the paths that lead through it, the garden offers a variety of multi-sensory experiences. Two primary focal points—a waterfall at one side of the garden and a teahouse at the other—are nestled within the lush trees. The traditional design of the teahouse contrasts the reception hall building, giving foreign visitors a glimpse into Japan's history. Water cascades over the falls into the stream meandering down the hillside, guided by rough stone borders and edged with azalea bushes and other greenery, providing a soothing backdrop of natural sounds. The paths lead through the layers of the garden, first across the open expanse of

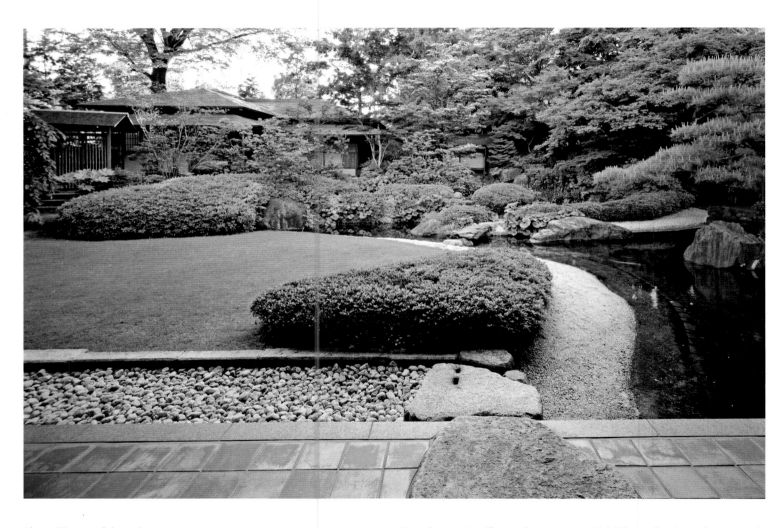

Above Glimpses of the teahouse, with its entrance gate set off to one side, are visible across the lawn in the foreground and beyond the hedges and trees in the middle ground of the garden.

Opposite page top The rough textures and varied shapes of the stepping-stones contrast with the grid of the tiled terrace and bring the garden space under the eaves of the reception hall.

Right The garden slopes down toward the reception spaces with layered hedges and a meandering stream that flows into the pond and under the terraces anchored by islands.

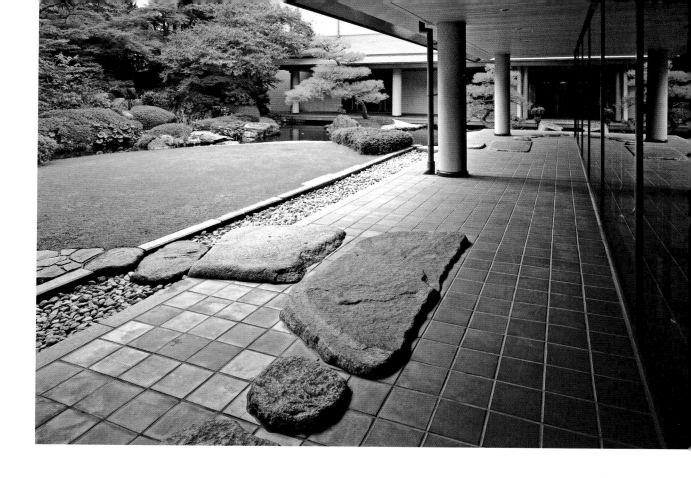

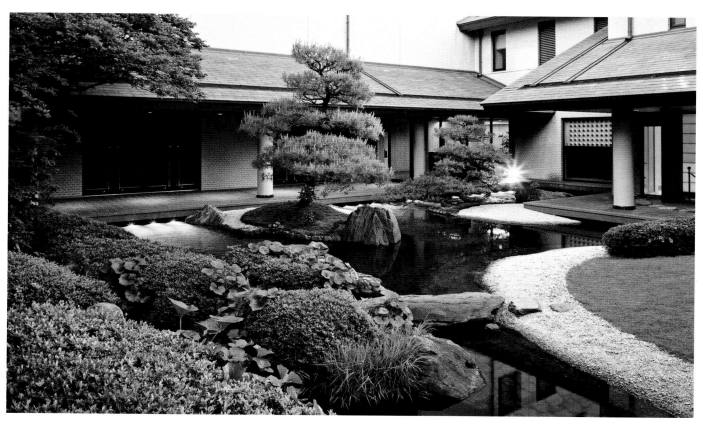

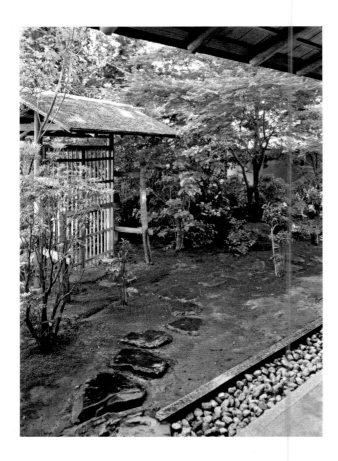

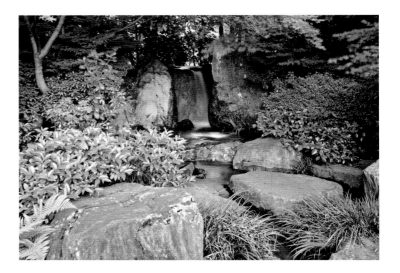

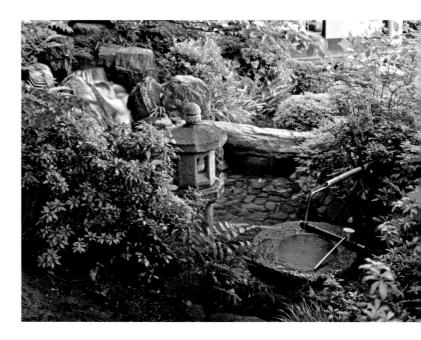

the slightly rolling grass-covered lawn and then among the layers of rock and shrub groupings, past the stream and waterfall to the teahouse waiting bench and the teahouse itself. At certain points along the path, the garden is designed for glimpses back to the reception hall, creating a continuous experience of changing yet familiar views.

The garden of the Kyoto Prefectural Reception Hall is planned with one especially unusual element. As the hall often is used at night, the garden is designed to be viewed both in the daylight and with artificial light. But rather than a static series of spotlights within the garden, a computer-controlled sequence of lighting effects provides a continually changing experience. In a fifteen-minute cycle, soft lights lead the eye to different focal points throughout the garden—emphasizing in turn the waterfall, rock groupings, arrangements of closely clipped azalea

bushes, a *tōrō* (stone lantern) and *chōzubachi* (wash basin), and the like. The lighting is another device skillfully used to connect the interior space of the formal reception hall with the exterior spaces of the lush, welcoming garden. Through this integration of contemporary technology and traditional techniques, the design of the Kyoto Prefectural Reception Hall garden also reinforces Masuno's goal of creating spaces that engage the viewer's imagination and sense of self-awareness.

Top left Stepping-stones lead from the gate to the teahouse. Moving carefully from stone to stone emphasizes the transition from the everyday world to the mindset of the tea ceremony.

Top For nighttime viewing, strategically placed lights illuminate the main elements of the garden, such as the *ryūmonbaku* ("dragon's gate waterfall"), in sixteen different scenes.

Above Both carved from stone, the *chōzubachi* (water basin) expresses refined symmetry and the *tōrō* (lantern) contrasts the precise geometry of a circle within an irregular shape.

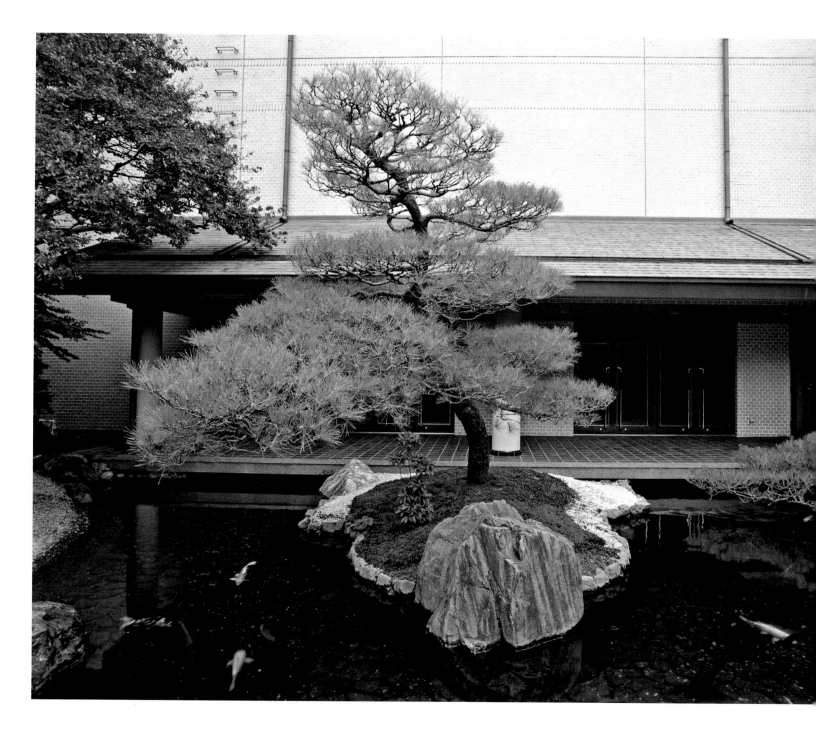

Above Carp add color and movement within the pond—another element that expresses the temporal quality of nature within the garden.

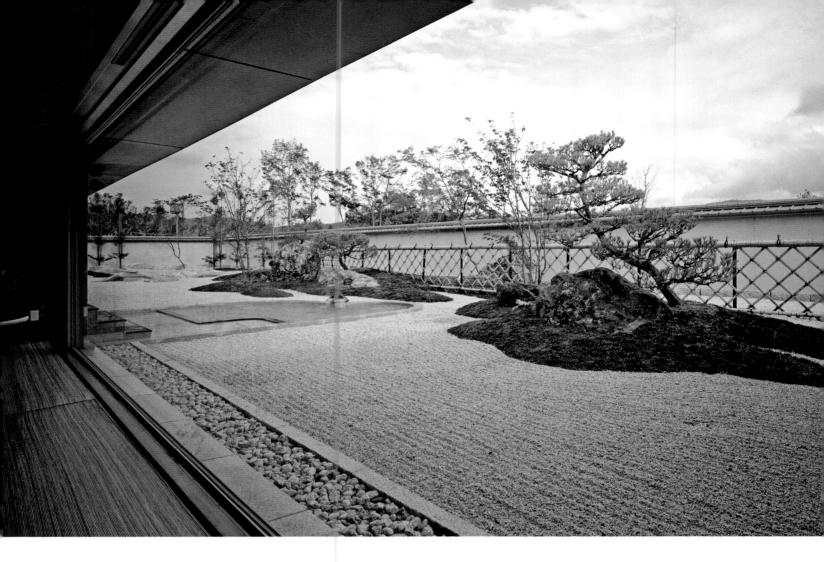

アートレイクゴルフクラブの庭
ART LAKE GOLF CLUB

NOSE, HYOGO PREFECTURE, 1991

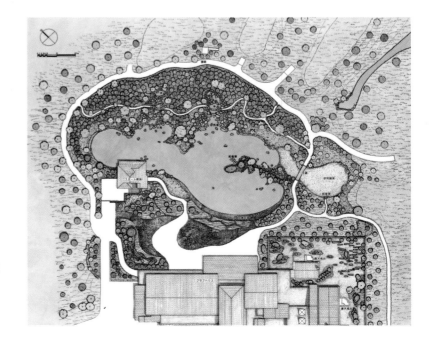

Above An outdoor bath constructed of smooth granite is set within the raked pea gravel of the enclosed *kare-sansui* (dry) garden adjacent to the locker rooms and bathing areas.

Right The main garden encircles the pond, with the golf course extending beyond it, while the private *karesansui* (dry) garden wraps the northeast corner of the clubhouse.

Exiting the cavernous clubhouse of the Art Lake Golf Club toward the golf course, the visitor is met with a powerful scene of a large pond with a strong, tall waterfall at the opposite shore. The sight and sound of the water flowing quickly over the rocks into the pond is at once energizing and calming. This balance of contrasts—the Zen principle of creating a single unified whole from seemingly opposing parts —is fundamental to this garden.

The expansive garden is made of two distinct parts. The main garden is focused on water—the waterfall, stream, and pond—with islands of granite planted with black pine trees evoking the scenery of the Japanese Inland Sea. The second garden is a secluded *karesansui* (dry) garden, which wraps a corner of the clubhouse building, allowing intimate views from the locker rooms and the traditional Japanese baths.

Two primary concepts, both intended to establish a sense of calmness and freedom, drove the overall garden design. First, rather than a direct view from the clubhouse to the golf course, as is typical, the vista should be toward the garden, with the golf course initially our of sight. Here tall "mountains" of earth and stone—artificially constructed in the mostly flat landscape—conceal the golf course behind them. The mountains appear quite natural, but a concrete foundation supports the enormous rocks that define the waterfall and buttress the earth. These rocks, used in their natural state, were excavated when creating the golf course. The second concept stems from an important Zen notion, which in Shunmyo Masuno's words is present in any "true Zen garden." The principle is to create "a 'world free of a sense of imprisonment,' full of beauty and tranquility, and completely devoid of any sense of tension."[1] This freedom and tranquility allows the viewer to let go of the cares of everyday life and focus on the beauty and enjoyment of being in natural surroundings. Masuno's ability to create tranquil harmonious compositions with juxtaposed and contrasting elements—a calm pond and a roaring waterfall or a flat bed of pea gravel interrupted by layers of rough rocks—is the result of his long Zen training.

On entering the garden from the clubhouse, the land is flat with a wide path leading in two directions, some low ground cover, and a beach-like crescent of stone at the edge of the pond. The path continues to the left to the tea-room café, with its own small garden nestled

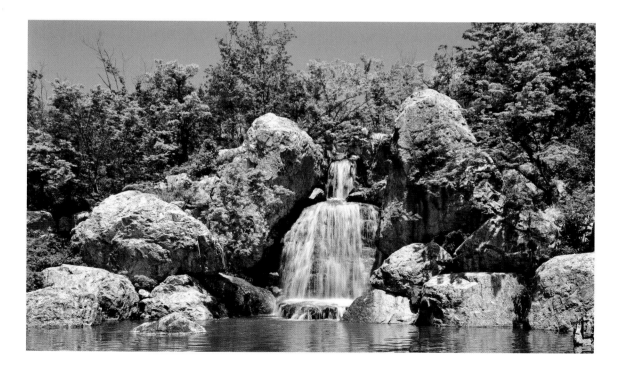

Above Surrounded by large rough boulders, the powerful waterfall commands the attention of the eyes and the ears, as water gushes over the rocks into the pond.

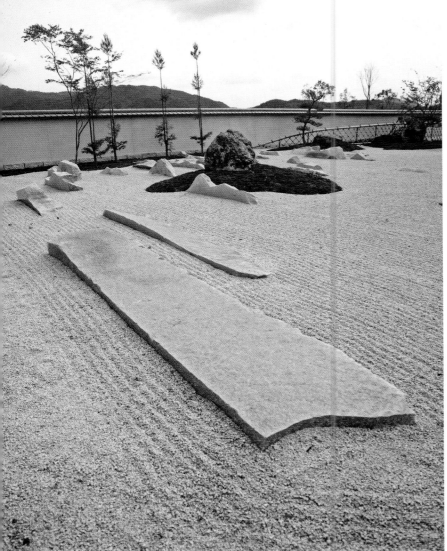

within one end of the main garden. A glance in the direction of the café reveals a second, smaller waterfall across the water. The power of the primary waterfall guides the visitor to the right as the path narrows, crosses a wood bridge, and winds through the layers of clipped shrubs and over stepping-stones, following the perimeter of the pond and circling back to the café. Adjacent to the café is a robust *chōzubachi* (wash basin), with the bowl carved out of a large roughly textured rock, and stone lanterns and trees emerging from thick clipped hedges of azalea and evergreen.

While the views of the main garden from the clubhouse are appropriately expansive, the dry garden is revealed in a series of contained

scenes only visible from the private bathing areas. Islands of stone and lush green ground cover dot the surface of the expanse of carefully raked white *shirakawa-suna* pea gravel. The islands slowly transform into long strips of stone emerging from the gravel sea, emphasizing movement and creating layers of space in the garden. A tall plastered wall bounds this refined dry garden while separating it from the lush green garden beyond. Although very different in their conception and composition, both gardens at the Art Lake Golf Club invite the visitor to leave behind the day's troubles and regain a tranquil mind.

Above left The raked pea gravel expanse of the private garden is punctuated by islands of long flat stones and mossy mounds topped with rough dark rocks.

Above right A pond of *shirakawa-suna* (white pea gravel) winds its way through a grassy expanse within the main garden at the Art Lake Golf Club.

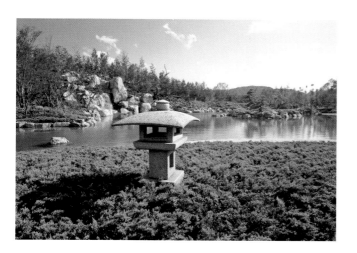

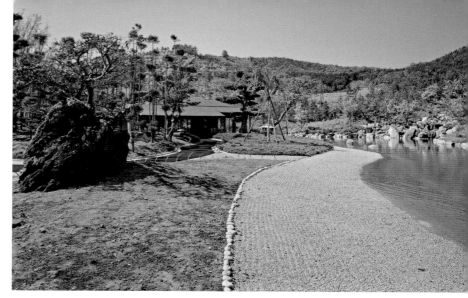

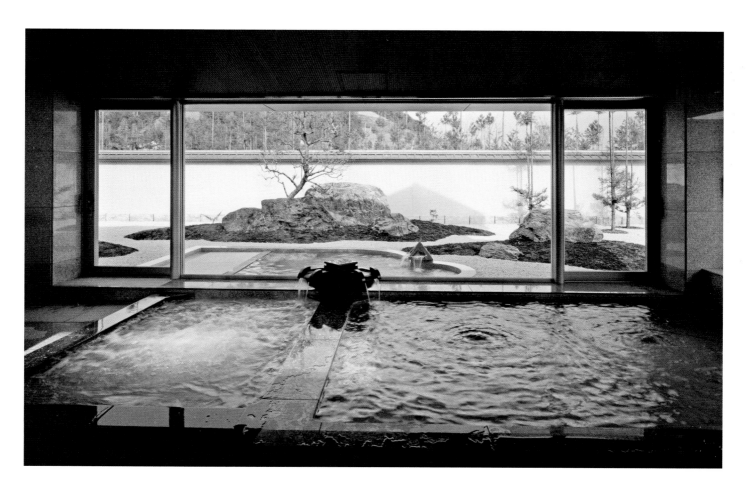

Top left The gently curving cap of the carved stone *tōrō* (lantern) and the closely trimmed hedges contrast the rough landscape of the mountain and waterfall beyond.

Top right The raked gravel "beach" draws the eye along the pond past the tea room and toward the mountains in the distance.

Above Interior and exterior are connected with a large window opening out to an outdoor bath in the private *karesansui* (dry) garden.

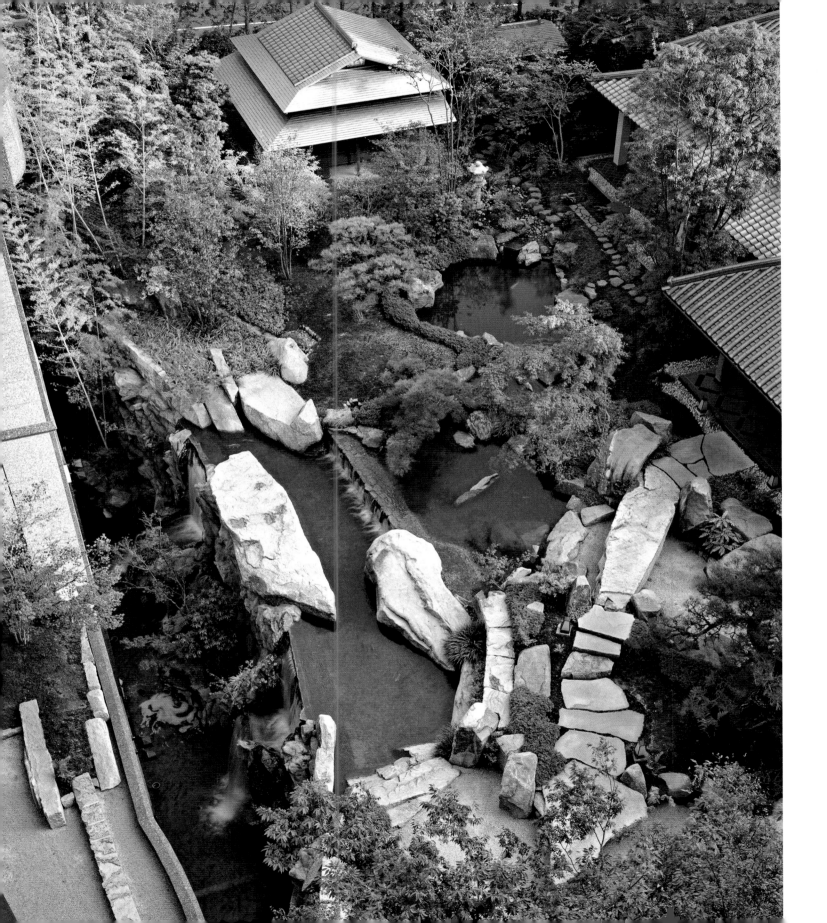

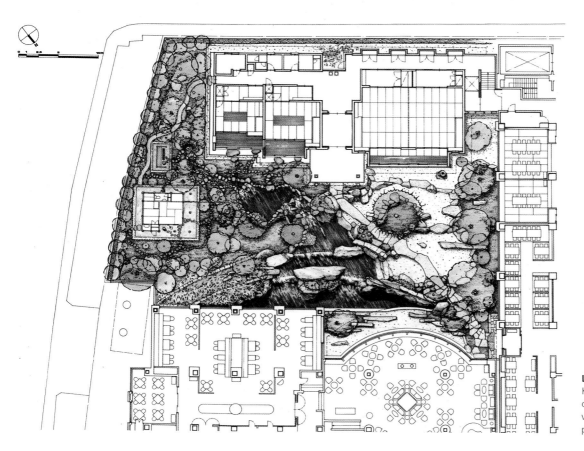

Left The garden at the Imabari Kokusai Hotel completely fills the outdoor spaces, connecting the various hotel spaces visually and physically.

瀑松庭 BAKUSHŌTEI

IMABARI KOKUSAI HOTEL

IMABARI, EHIME PREFECTURE, 1996

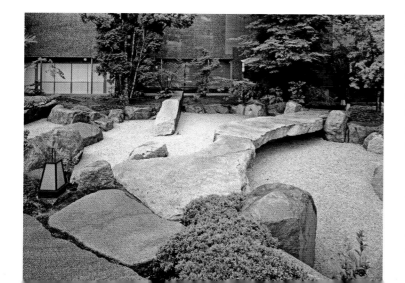

The lobby of the Imabari Kokusai Hotel affords a view of two parts of the Bakushōtei, or Garden of the Great Waterfall and Pine Trees. Immediately adjacent is a *karesansui* (dry) garden designed as an extension of the lobby. A polished granite curb contains the white *shirakawa-suna* (literally "White River sand," or pea gravel) weaving between the rough strips of *aji-ishi* (a type of granite from Shikoku Island, also known as diamond granite). Low mounds with ground cover and maple trees anchor the dry garden to the building, as the main garden expands out from a level below and slopes upward toward the opposite traditionally designed wing of the hotel.

The strips of rough rock in the dry garden are mimicked in the horizontal layers of pea gravel, rock, and falling water of the main garden. Taking advantage of the natural steep slope of the land, the garden is designed with three separate waterfalls. Shunmyo Masuno designed the movement of the water across the site to have a calming effect. This relaxing atmosphere is punctuated by the largest fall, the thundering Great Waterfall, which "produces echoes deep in the body."[1] This

Left Two enormous stone planks join together to create a bridge over the river of pea gravel, allowing visitors to move through the garden to the traditional *washitsu* (Japanese-style rooms) of the private dining wing.

Previous page Many powerful elements—the long waterfall in the lower left, the large rock islands and bridges, and the refined traditional teahouse—come together to create a garden full of movement and energy.

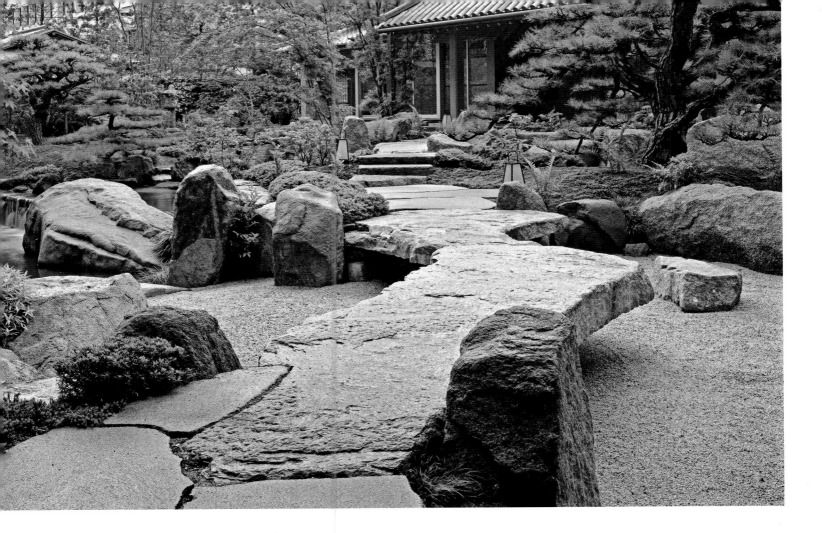

combination of dynamism and calmness is a hallmark of the garden.

Inspired by the landscape of the Inland Sea, the plantings and rock groupings are arranged among the waterfalls and streams to suggest the nearby scenery. The hotel building surrounds the garden on three sides, with a traditional teahouse tucked into the greenery in the upper garden on the open side. Standing symbolically near the center of the garden, a beautiful red pine acts as focal point. When viewed from anywhere within the hotel or while moving through the garden, the composition of water, rocks, and plants is well balanced and evokes a strong sensory response. The garden is created to change with the seasons—the azaleas bloom in the late spring and early summer, the maple trees from Kyoto turn red in the autumn, while the pine trees remain green throughout the year.

The garden is designed for strolling as well as seated viewing, and a path pieced together with large stones leads through it over a sturdy

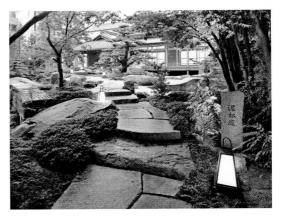

Top left The stone path and bridge meander through the garden past the smooth gravel river, rocky coastlines, and mossy hillsides toward the traditional wing of the hotel.

Above Small metal lanterns cast a soft glow over the garden, illuminating the path and creating a picturesque evening scene.

aji-ishi bridge and through smooth expanses of pea gravel among the rocks and trees. Stepping-stones mark the way through the foliage to the teahouse, where the garden becomes denser and more inwardly focused, and views back to the hotel are blocked by the trees. The design of the *roji* (inner garden path) leading to the teahouse emphasizes tranquility and simplicity within the dynamism of the larger garden. Near the teahouse, water springs forth from a low carved rock reminiscent of a *chōzubachi* (water basin) and flows down into the garden, winding through streams and passing over the various waterfalls. At the lowest part of the garden, tucked under the dry garden that extends out from the lobby, the water gathers its force in a thunderous drop over a tall wall of rough rock. The Great Waterfall is framed in the windows of the restaurant on the level below the lobby, visually revealing to patrons what others above can only hear and feel but not see, and creating yet another changing view of this expansive garden.

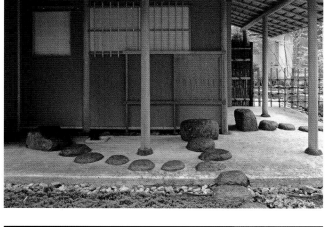

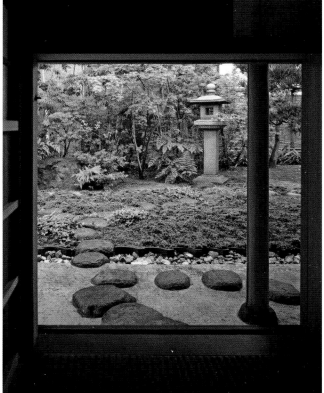

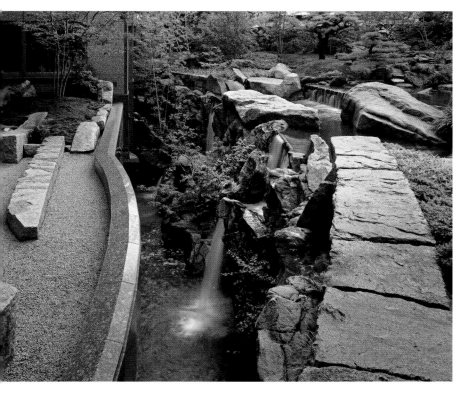

Above Conveying a strong sense of movement, the powerful waterfall is juxtaposed with the black pine trees expressing stillness.

Top right Rounded stepping-stones move from the garden under the eaves of the traditional teahouse and up to the small square *nijiri-guchi* ("crawl-in entrance").

Above Connecting the interior of the teahouse to the garden, stepping-stones progress through multiple layers of space embodied by different materials on the ground.

龍門庭 RYŪMONTEI
GIONJI TEMPLE
MITO, IBARAKI PREFECTURE, 1999

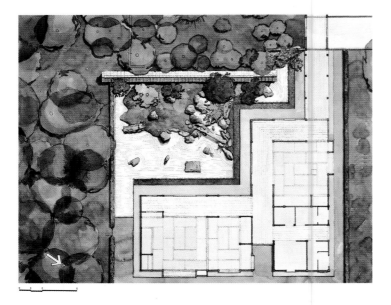

Set within a larger garden at the Gionji Zen temple, a plastered garden wall and trimmed tall hedges contain the space of the smaller Ryūmontei garden. The garden features an arrangement of rocks suggestive of a *ryūmonbaku* waterfall, from which the garden gets its name. Literally meaning "dragon's gate waterfall," the *ryūmonbaku* represents a carp trying to climb up the cascades and pass through the "dragon's gate" (*ryūmon*), an expression referring to disciplined Zen training on the path to enlightenment. The waterfall is one of many typical design devices of traditional Japanese gardens in Ryūmontei, which also include an ocean of raked *shirakawa-suna* (white pea gravel)

Above A river of raked gravel gives the feeling of expanding beyond the boundaries, while the tall garden wall and a closely trimmed hedge separate the Ryūmontei garden from the main garden at the Gionji temple.

Right Raked pea gravel follows the contours of the rock "islands" and moss "shoreline," creating movement and pattern in the foreground of the garden.

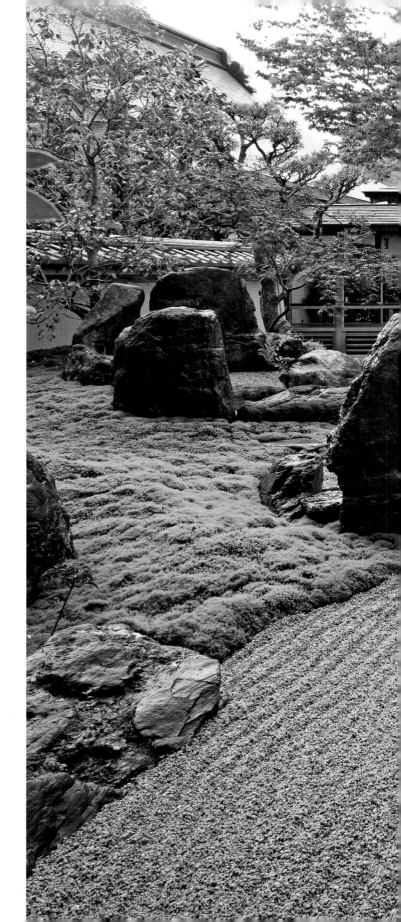

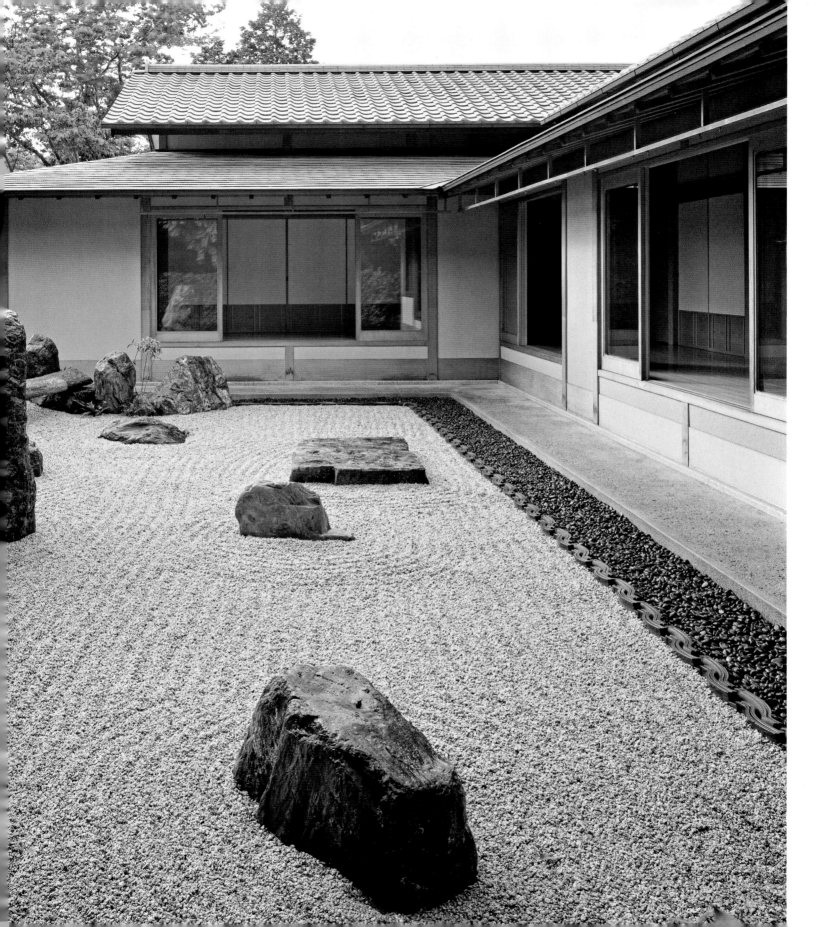

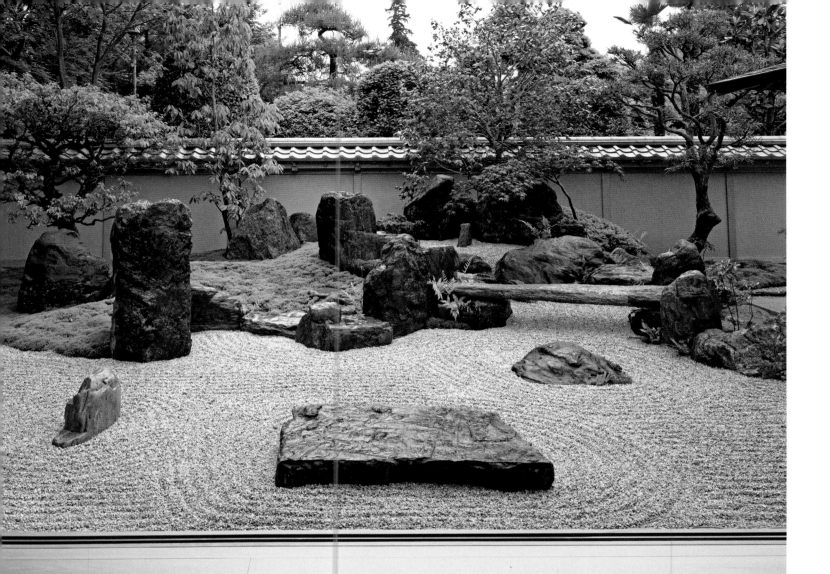

dotted with islands of contrasting rough rocks and varied plantings to give color throughout the different seasons. The garden incorporates an additional layer of symbolic meaning, relating specifically to the founding of Gionji. The main *tateishi* (standing rock) represents the temple founder, Toko Shinetsu, lecturing to his disciple Mito Mitsukuni, also a monk and temple founder. This layer of symbolism, represented through the physical form of certain stones and incorporated into the overall garden design, ties the garden to the history of the temple and makes it unique to that place.

The garden, designed to be viewed while seated on the tatami (woven grass mats) floor of the *sukiya*-style Shiuntai reception hall, opens out in front of the viewer in a series of spatial layers connecting the interior of the building to the outside. The exposed wood column-and-beam structure, together with the floor and the eaves of the structure, frames views of the garden. Sliding shoji (wood lattice screens covered with translucent paper) panels at the edge of the tatami-matted room slip away to reveal the deep wood floor of the veranda-like *engawa*, which aids in connecting the inside space of the building to the exterior space

Above The river of gravel in the *karesansui* (dry) garden starts from the *ryūmonbaku* ("dragon's gate waterfall") near the garden wall and flows under the stone plank bridge toward the temple building.

Opposite page left The *tateishi* ("standing stone") symbolizing Toko Shinetsu, the founder of Gionji temple, teaching Zen Buddhism to his followers is softly weathered and wrinkled, expressing the wisdom of age.

of the garden. Running parallel to the building, a row of dark gravel is partly hidden from view by the *engawa*. A double row of roof tiles, standing on end, separates the dark gravel from the expanse of smaller white *shirakawa-suna* that creates the foreground of the garden. The raked pea gravel, flowing around the rock islands and lapping at the edge of a low artificial mound, is an extension of the dry waterfall. Located in a far corner of the garden, on the highest point of the mound, the dry waterfall is a dynamic element, giving a strong sense of movement starting at the high point and flowing down into the white sea of pea gravel. Of the rocks placed within the gravel sea, one low stone is shockingly square in form—the contrasting geometry heightens the viewer's senses, allowing a deeper awareness of the juxtaposed yet unified nature of the various elements of the garden.

The low mound, which borders the raked pea gravel, is covered with moss and carefully placed ferns, bushes, and trees, as well as groupings of rocks including the Toko Shinetsu *tateishi*. The mound is backed by the tall wall faced in white lime plaster with an exposed wood frame and ceramic tile roof. The stark white of the wall draws attention to the colors of the plants—the green and red leaves of the maple trees and the pink azalea blossoms, while the hard verticality of the wall plays off the softness of mound in front of it and the horizontality of the pea gravel sea. The viewer's eye follows the raked gravel as it skims along the edge of the mound and under a stone plank bridge, disappearing out of view as the garden turns a corner—a suggestion of something beyond.

Right A simple stone plank spans the narrow point of the gravel river, bridging between the mossy banks and adding a horizontal element within the vertical standing stones.

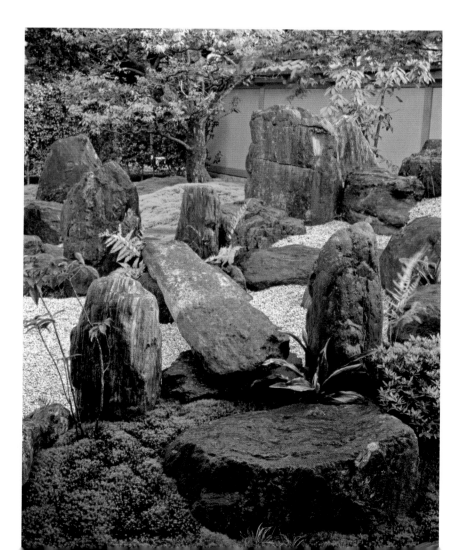

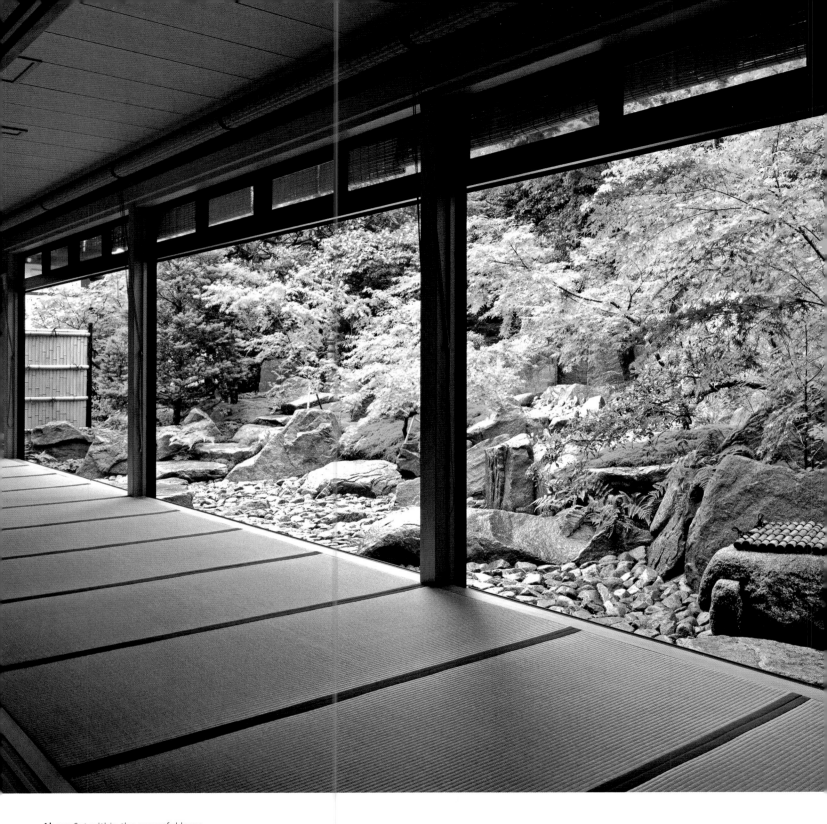

Above Set within the powerful large-scaled rocks of the garden, the carved stone representing a well, with its protective bamboo cover, connects to the *engawa* (veranda) with a single large stepping-stone.

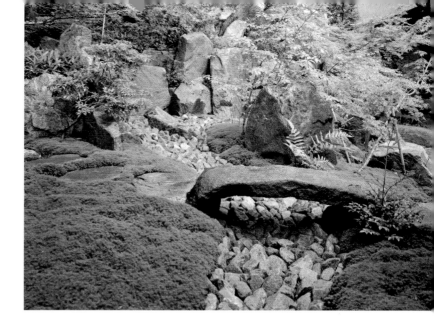

普照庭 FUSHOTEI

RENSHŌJI TEMPLE GUESTHOUSE

YOKOHAMA, KANAGAWA PREFECTURE, 1999

Constructed within a tight vertical slot of space immediately adjacent to the reception rooms in Renshōji temple, the Fushotei garden is a powerful example of the spatial potential of traditional Japanese gardens. Although the space of the garden is quite constricted, it appears much larger than its actual size, through its connection to the interior space of the adjoining hall and the skillful use of perspective and layering in the garden design. The temple reception hall, built in the traditional *sukiya* style, has three adjacent tatami rooms facing the garden. A wide tatami-matted *engawa* (veranda) runs the length of the rooms —the depth of the veranda equaling the length of one tatami mat (1.8 meters or about six feet). Long low roof eaves stretch over the *engawa* and the garden. Together the *engawa* and the eaves extend the interior space out to the garden, effectively connecting them as one.

Top A fast-moving stream of fist-sized rocks flows between mossy banks and under an asymmetrical stone plank bridge toward craggy rock cliffs.

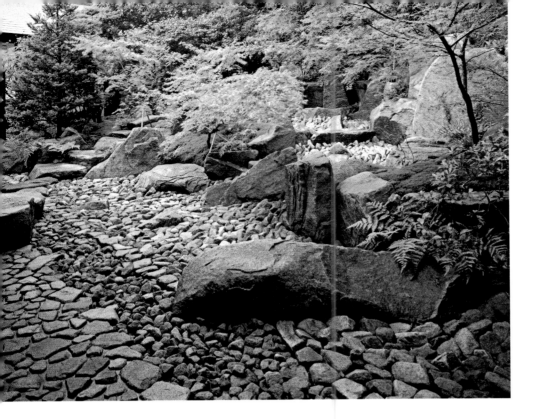

The depth of the garden itself is only about twice that of the *engawa*, with a tall concrete retaining wall holding back the earth that was excavated to make space for the reception hall. The rock arrangements and plantings in the *karesansui* (dry) garden completely conceal the concrete wall while creating visual depth and a strong sense of movement. The main feature of the garden is a dry waterfall, constructed at one end of the narrow slot of space. Large rocks, set one atop the other, compose the falls and give an impression of the movement of water. This movement is picked up by smaller rocks that also give a sense of tumbling down into a stream. The stream is formed by river rocks, winding among larger boulders and grassy mounds and under a stone plank bridge. As the "water" flows away from the waterfall, the space appears to open up. The skillful use of differently sized rocks—with the rocks growing in size as they move away from the waterfall—tricks the eye into perceiving a greater depth of space than actually exists.

Although the garden is carefully composed in a very constricted site, it is full of movement and constantly in flux. With a blend of evergreen and deciduous trees combined with shrubs, ferns, and ground cover,

the shadows on the rocks created by the leaves are ever-changing. As the seasons turn, so do the leaves, with different plants becoming focal points at different times of the year. These feelings of movement and flux are important to the designer's concept of connecting the garden to history through the passage of time observed in the seasonal changes and the continuously flowing "water."

Renshōji, a *jōdoshū* (Pure Land Buddhist) temple, has a history of almost seven hundred years and continues to be a guiding authority for the people of the area. Shunmyo Masuno designed the garden to build on that history by expressing the value of the flow of guidance that

Top left Layers of variously sized rocks enhance the sense of spatial depth of the narrow garden.

Above right A tall stone *chōzubachi* (water basin) placed immediately adjacent to the *engawa* (veranda) connects the garden to the interior space of the temple guesthouse.

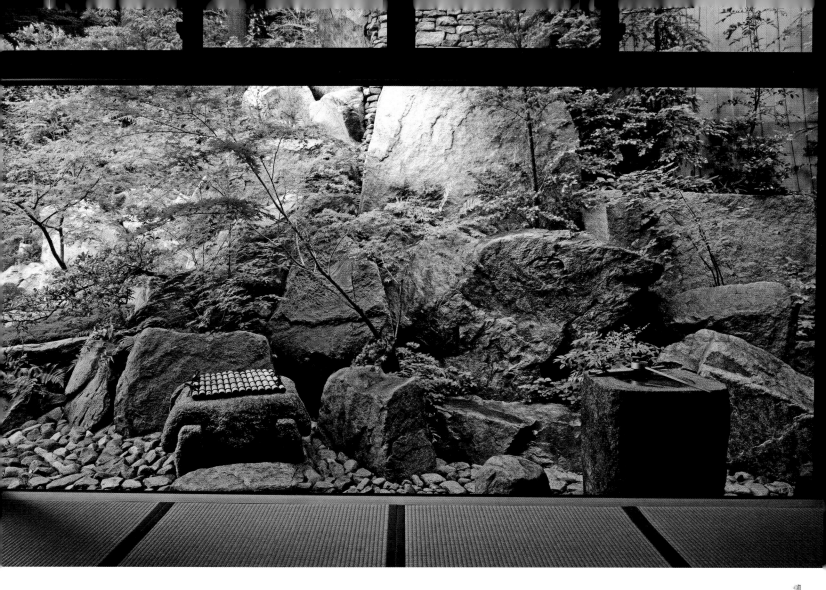

comes from our ancestors. The dry waterfall and stream represent that flow, particularly the guiding teachings of the temple founder, Renshō Shōnin. The main *tateishi* (standing stone) represents Renshō Shōnin himself, as he watches over the single strands of water—or individual teachings—coming together to form the stream. It is easy for an individual to get swept away in the current of contemporary cares, but Fushotei ("Garden of Broad Illumination") is designed to provide a quiet place of contemplation, a place to receive insight based on the ancient and ageless teachings.

Above Delicate trees and enormous boulders combine to create a feeling of *shinzan-yukoku* (depths of mountains and deep secluded valleys) in the compressed space of the garden.

Right Views of the huge rocks and carefully placed greenery hiding the concrete retaining wall were carefully designed to be controlled from both sitting and standing positions by the height of an adjustable bamboo blind.

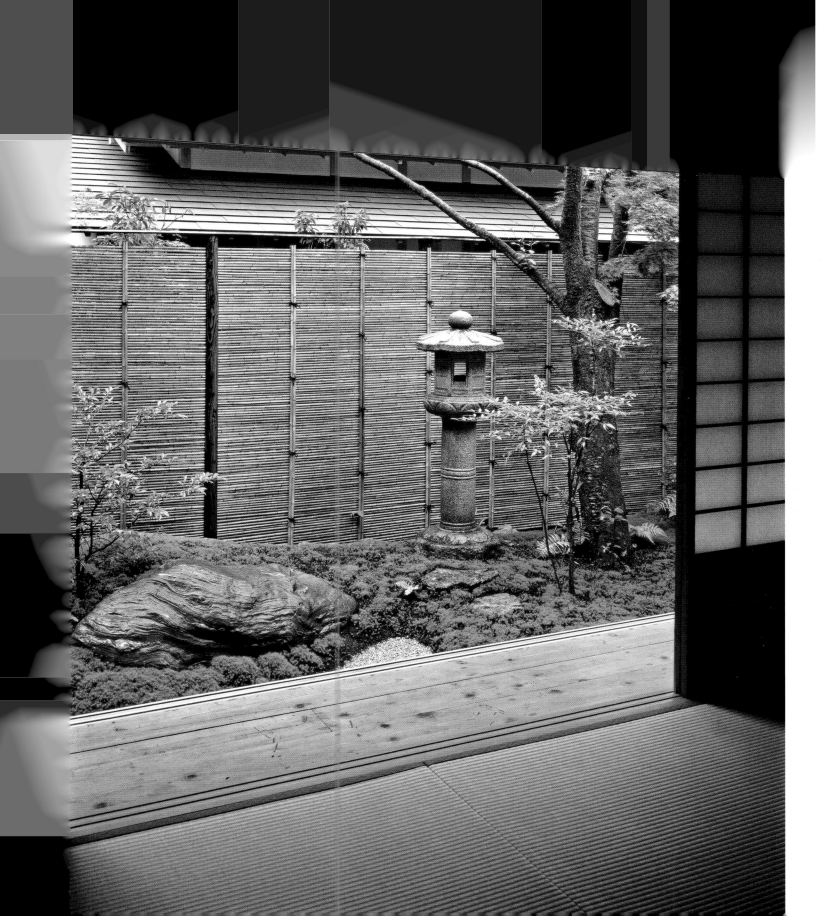

残心庭 ZANSHINTEI

SANKEIEN KAKUSHOKAKU RECEPTION HALL

YOKOHAMA, KANAGAWA PREFECTURE, 2000

In 1909, the wealthy businessman Hara Tomitaro built a sprawling traditional-style residence for his family. He called his expansive estate Sankeien, utilizing his nom de plume, Sankei, and filled the grounds with gardens and historically important buildings moved from places like the former capitals of Kyoto and Kamakura. Sankei was well known for his fine hospitality, and he entertained countless famous people in his home, which he called Kakushokaku.

After World War II, the property was given to a preservation group, Sankeien Hoshokai Foundation, which restored the buildings and opened the estate to the public. Kakushokaku is now available to the public for special ceremonies and events. When Shunmyo Masuno was asked to redesign the gardens surrounding the residence, he wanted to build on the strong connection that Sankei created when hosting his guests. Sankei's hospitality was based on the traditional sense of *mote-nashi*, the spirit of service without expectation of anything in return. It also related to *ichi-go ichi-e*, literally "one time, one meeting," an expression associated with the tea ceremony and the concept of transience in Zen Buddhism. *Ichi-go ichi-e* conveys the newness of each meeting—every time a guest visits, the setting and circumstance should be fresh and different.

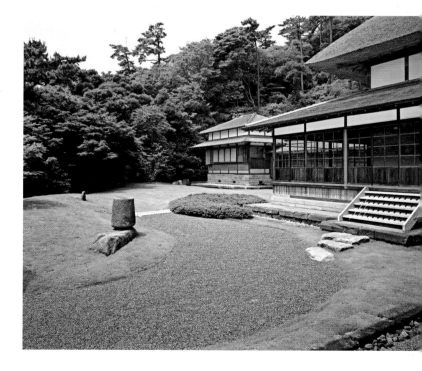

Opposite A carved stone *tōrō* (lantern) by Nishimura Kinzō is positioned in front of a tall fence made with thin horizontal strips of bamboo held between vertical bamboo poles.

Top Plants, rocks, and paved areas connect the garden and the reception hall in the Zanshintei garden.

Above The main garden outside the reception hall provides space for outdoor gatherings with its broad expanses of grass and gravel.

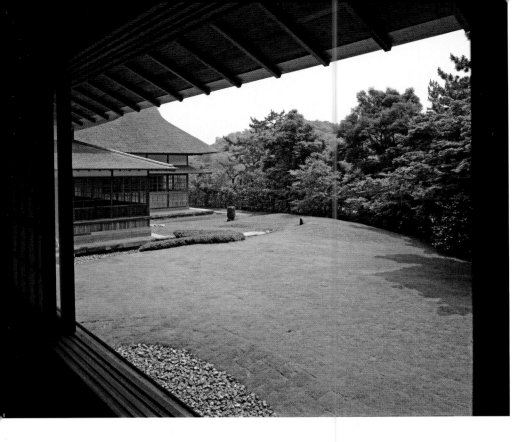

Masuno named the garden Zanshintei, connecting *tei*, meaning garden, with the Zen word *zanshin* (literally "remaining mind"), referring to the moment when an act is completed and the mind must prepare itself for profound understanding. Here that understanding comes from the particular expression and memory of Sankei's hospitality, as it is manifest in the garden design. It is Masuno's hope that through their experience of the garden, visitors will be able to feel the depth and contemporary relevance of Sankei's *motenashi* and that this sense of hospitality also will be handed down to future generations.

Starting from the stone foundations of the residence, the garden moves out in layers. Close to the building, a curb of uneven stones creates an edge for a trough of rough gravel, with its surface at a level slightly below the stone curb. The gravel is contained on the opposite side by another similar stone curb, which in turn also bounds the grassy lawn. The grass extends out, divided in places by a wide gravel path, until it meets a mound of closely cropped azaleas or a line of trees carefully selected for their mix of leaf color and shape. Each room in Kakushokaku has a different view of the garden with a particular focal point—a beautifully shaped tree or a carved stone pagoda, for example.

Some views are expansive; others are constricted, like those of the courtyard garden with its surface of rough rocks punctuated with stepping-stones leading to a *chōzubachi* (stone basin), concealed behind a lace of green leaves.

Another narrow part of the garden features a beautifully figured rock set into a low mound of moss. A carved stone lantern, a single tree, and a few delicate shrubs add a sense of height without overwhelming the space. Taken as a whole, Zanshintei is unpretentious and peaceful. The simplicity of the garden creates a sense of calm and quiet, allowing the focus to be on Sankei's collection of carved stone lanterns, basins, and objects, which are carefully positioned in the garden to catch the eye and remind the viewer of Sankei and his renowned hospitality, thus bringing the mind back to the concept of *motenashi*.

Top left Trees border the spacious lawn in front of the stately traditionally designed Kakushokaku residence.

Above right The original *chōzubachi* (water basin) and stepping-stones from the garden are reused in a compact *tsuboniwa* (courtyard garden).

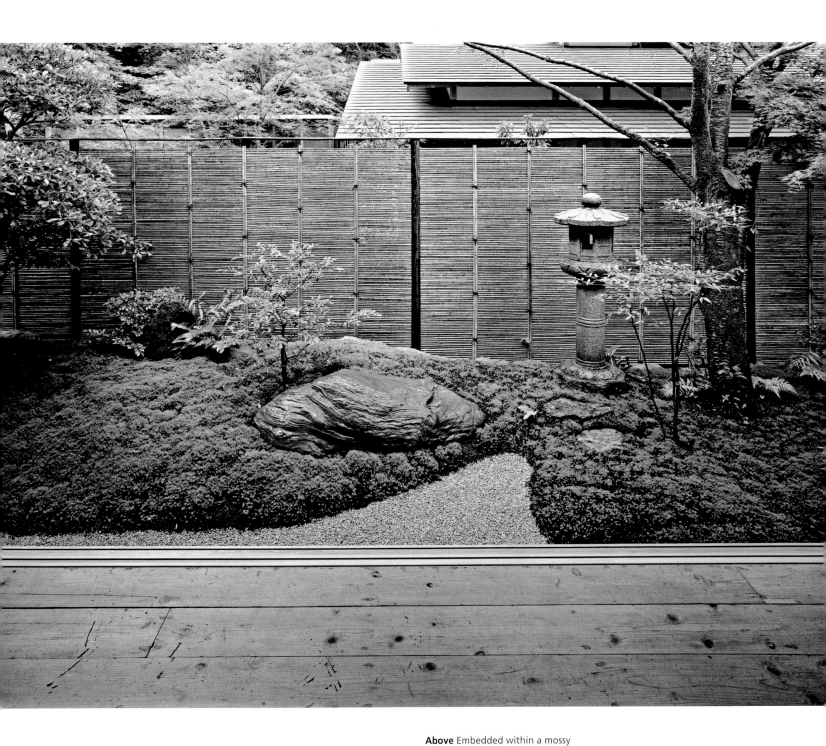

Above Embedded within a mossy mound and set off by the bamboo fence in the background, the carved stone *tōrō* (lantern) by Nishimura Kinzō is a focal point in the carefully composed garden.

参道 SANDŌ
KŌENJI TEMPLE

KŌENJI, TOKYO, 2001

Maple trees arch over the smooth stone path that leads to the *hondō* (main hall) of the Kōenji temple. The edge of the wide pathway is marked by a simple low bamboo fence, which separates the walkway from the adjacent landscaped garden spaces on the right and left. These gardens vary in width, as the temple is located in an urban residential area, and the approach fills the interstitial spaces. Beds of raked gravel expand and contract according to the size of the space. The gravel beds are interspersed with low flowing "island" mounds cloaked with lush green ground cover. Large rocks anchor the islands and provide focal points along the path, while shrubs and trees add height and visual interest. A closely cropped hedge at the outer boundary of the garden creates a separation between the spaces of the *sandō* and the neighboring houses. The line of hedges breaks only to allow narrow offshoots of the stone path to slip through to the back entrances of the houses.

A *sandō* typically runs on axis from south to north toward the most important sacred space of the religious precinct—the *hondō*. The *hondō* is the place where the principle deity of the faith is located and where visitors come to offer their prayers. The interior space of the *hondō* cre-

Top Visitors to the Kōenji temple pass through the majestic *sanmon* (main gate), an important threshold along the approach to the temple.

Opposite page top left Adorned with carvings of the temple's crest, the heavy wood doors of the *sanmon* (main gate) open to the view back to the city.

Opposite page top right The wide stone-paved approach crosses a neighborhood street before reaching the main gate and the enclosed garden beyond.

Opposite page bottom Ripples of raked pea gravel around softly weathered rocks set in beds of thick ground cover create an atmosphere of serenity.

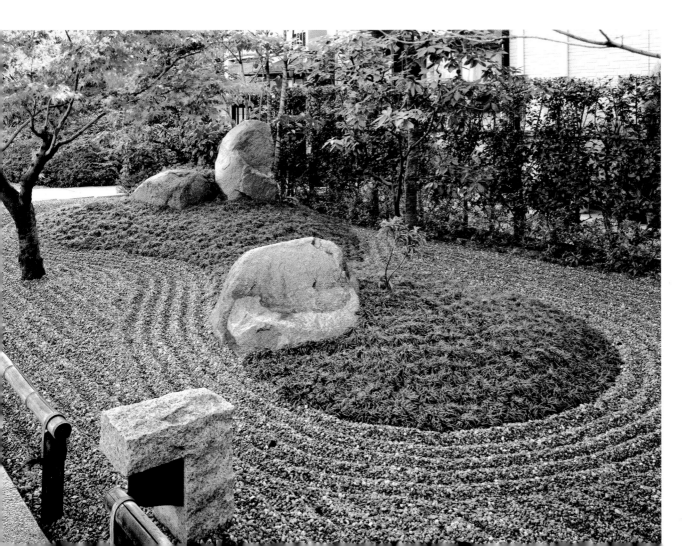

ates an atmosphere of calm that helps to bring forth our humanity and aid us in resolving our self-doubts. Shunmyo Masuno points to the important role of such places. He understands that these kinds of spaces also can be found in nature and that the *sandō* can be a designed series of natural spaces encompassing these same strengths.

The Kōenji *sandō* starts from a typical residential street in Tokyo, the entrance marked by a gateway—a tall wall constructed in the traditional Japanese manner with panels of white plaster within an exposed timber frame and capped with a ceramic tile roof. The *sandō* is designed as a series of thresholds, which allow the visitor to leave behind the cares of daily life and enter into a mindset appropriate for a visit to a sacred place. Passing through the gate from the street into the space of the *sandō*, the approach stretches about half a block and then crosses a narrower street to a gate that marks the entrance to the second, more sacred part of the *sandō*. The room-like gate is an important threshold. Three steps lead up to the platform of the gate, where the slightly rough texture of the granite used in the path and steps beneath one's feet changes to a highly polished surface. This space provides a

moment of pause and self-reflection before the stone texture changes back as the steps lead down the other side and the path continues toward the *hondō*.

For the Kōenji *sandō*, Masuno builds on the ability of natural spaces to calm and purify the spirit and the idea of the *sandō* as a series of thresholds leading to a sacred space. His concept behind the approach to Kōenji was to create a space that allows visitors to sense the purification of their spirits and clarification of their thoughts as they draw closer to the main hall of the temple. Masuno felt that the *sandō* should not be too strong or too assertive, as it is not the most important space in the temple precinct, but it should create an environment separate from the surroundings. Because the *sandō* is the approach and not the main temple garden, Masuno chose not to call attention to it by naming it but simply to call it "*sandō*." The Kōenji *sandō* is a distinct environment in a contained yet continuous space. Masuno's design succeeds in slowing the visitor's pace to emphasize self-reflection while enjoying the healing power and calming strength of the surrounding nature.

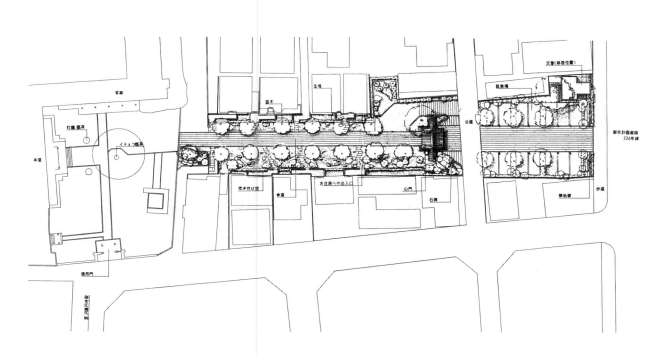

Above The approach to the temple starts from the south, with a wide stone-paved passage crossing a neighborhood street and passing through the *sanmon* (main gate) before narrowing and moving through the enclosed approach garden.

Opposite page top An opening in the highly crafted wall, with a low hedge in front of its tall stone foundation, marks the start of the approach to the Kōenji temple.

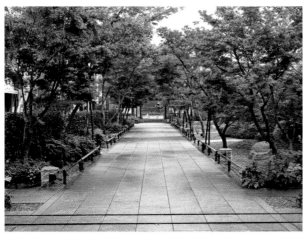

Above The view from the temple toward the main gate shows the introspective quality of the tranquil approach garden.

Right Tall hedges and trees in the background, along with trees trained to arch over the path, shield the view of the nearby residences.

無心庭 MUSHINTEI

GUESTHOUSE SUIFŪSO

NAMEKATA, IBARAKI PREFECTURE, 2001

Top Rough rock walls line the smooth stone-paved approach, which passes by two carved stone sentries marking the entrance to the Suifūso guesthouse.

Above The stark *karesansui* (dry) garden complements the bold combination of traditional and contemporary architecture of the main reception hall.

Every room at the Suifūso Guesthouse has a different view of the surrounding garden. Designed together, the buildings and garden provide a seamless experience of architecture in nature. The level of the floors as they relate to the exterior ground surfaces, the specific position of each window, and the exact length of the overhanging roof eaves—these details were carefully considered to create a continuous experience of space from inside to outside. Conceived as a place for people to retreat from their busy contemporary lives, Suifūso gives guests the opportunity to reconnect with nature in order to heal and revive their spirits.

Shunmyo Masuno believes that quiet places in nature—the mountains, seas, and forests—have the power to give us strength to find the energy within ourselves to make positive change in our feelings and to calm our hearts. His intention for the design of the Mushintei garden was to create these kinds of spaces of "great" nature—abundant and vast—for the guests at Suifūso. By basing his design on traditional Japanese concepts of beauty and refinement, Masuno aimed to connect to the value inherent in traditional Japanese culture. To reflect this aim, he named the garden, Mushintei, a combination of the word for garden, *tei*, with the Zen Buddhist word *mushin*. *Mushin* typically is translated as "without mind" or "no mind." It does not mean that the mind is

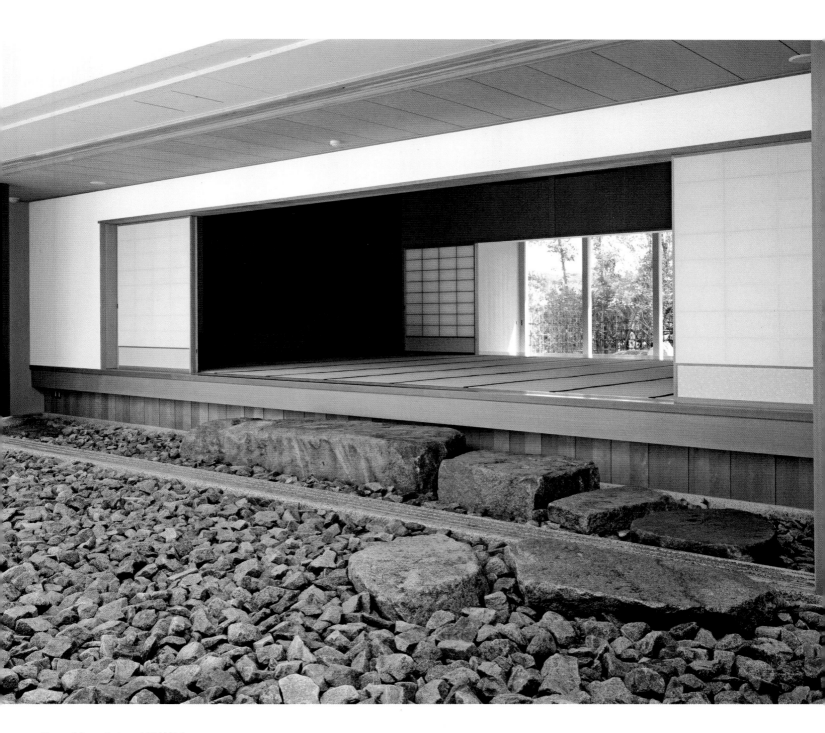

Above A large *kutsunuki-ishi* ("shoe-removing stone") and adjacent stepping-stones create a transition between the reception hall and the garden and a place to pause to remove one's shoes before entering the hall.

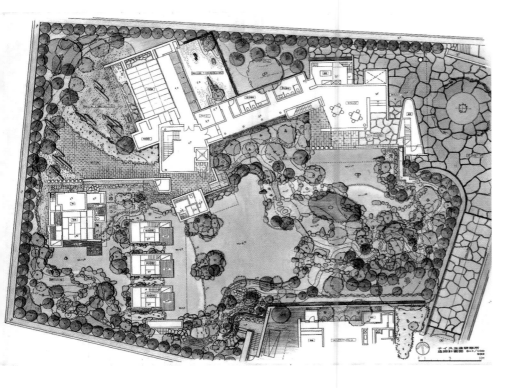

Above The expansive Mushintei garden surrounds the Suifūso guesthouse, creating varied scenery for the different interior spaces.

Above Rough dark rocks flank a large stone plank bridge connecting two moss-covered banks of the pond.

empty rather the mind is uncluttered and open to receive. It is the state of mind necessary to allow the subconscious mind to flow freely, to reconnect with our inner spirit. Buddhist scholar Daisetz T. Suzuki explains *mushin* as when the "mind is in complete harmony with the principle of life itself."[1]

To achieve the experience of great nature and the *mushin* mind, the expansive garden integrates three separate waterfalls as focal points. With their respective streams and ponds, the falls create spaces of positive tension—dynamic yet calm. The first waterfall, called Haku-un no Taki or White Cloud Falls, is seen from the lounge upon entering the guesthouse and is the guest's first view of the garden. This moment of pause in front of a powerful waterfall gushing into a quiet pond sets the tone for the visitor. A background of greenery sets off groupings of large rocks. A few tree branches sweep across the framed view, and a single carved stone lantern anchors one end of the scene.

Stone walks, some smoothly polished and others made from rough stepping-stones or gravel, lead guests throughout the complex and link the various parts of the garden. Water is ever present in the garden as an important soothing element. From the guestrooms, the other two waterfalls, Shōfu no Taki (Autumn Breeze Falls) and Baika no Taki (Plum Blossom Fragrance Falls), offer both visual and auditory connections to water. Arrangements of rocks and plants support the water elements in the garden, and carved stone basins, lanterns, and benches add touches of the human hand in the naturalistic scenery. Terraces extend out from the guestrooms toward or over the ponds, expanding the interior space outward, while the long low overhanging eaves bring the garden inside through large window openings. This careful manipulation of these inside-outside spaces is fundamental to traditional Japanese architecture and is the key to Masuno's connection to traditional values and integration of nature for the guests at Suifūso.

Top right Seen from the Haku-un no Taki (White Cloud Falls), large stepping-stones draw near a low waterfall, with the guesthouse lounge in the background.

Opposite page top left The strong geometry of a stone lantern set into the steep slope contrasts the softness of the moss in a view toward the annex from the Baika no Taki (Plum Blossom Fragrance Falls).

Opposite page top right Shoji screens slide open to reveal a framed view from the traditionally constructed annex to the Baika no Taki (Plum Blossom Fragrance Falls).

Right A *nobedan* (stone walkway) and stepping-stones lead to the *shihō hotoke tsukubai chōzubachi* (four-sided Buddha water basin) set into the narrow stream.

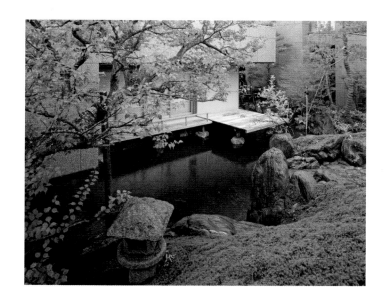

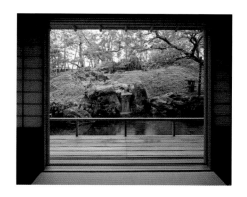

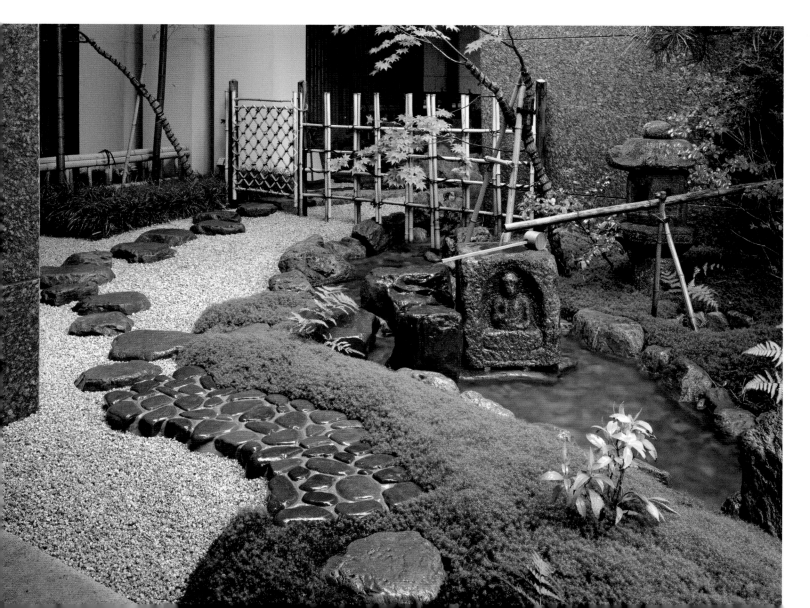

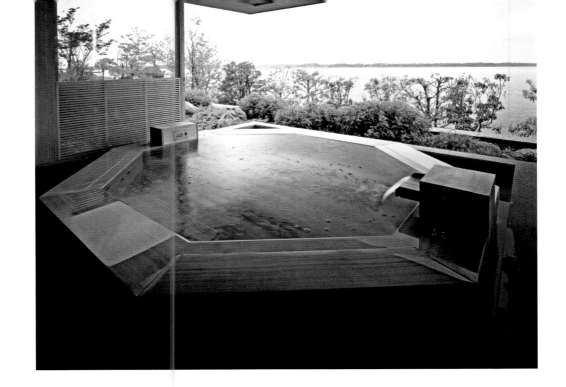

Left The steps leading to the main garden combine formal and informal elements, with the edges constructed of finished stone and an infill of smaller rocks interspersed with larger flat rocks.

Above Large stepping-stones rounded by moss lead throug garden to a thick stone-plank

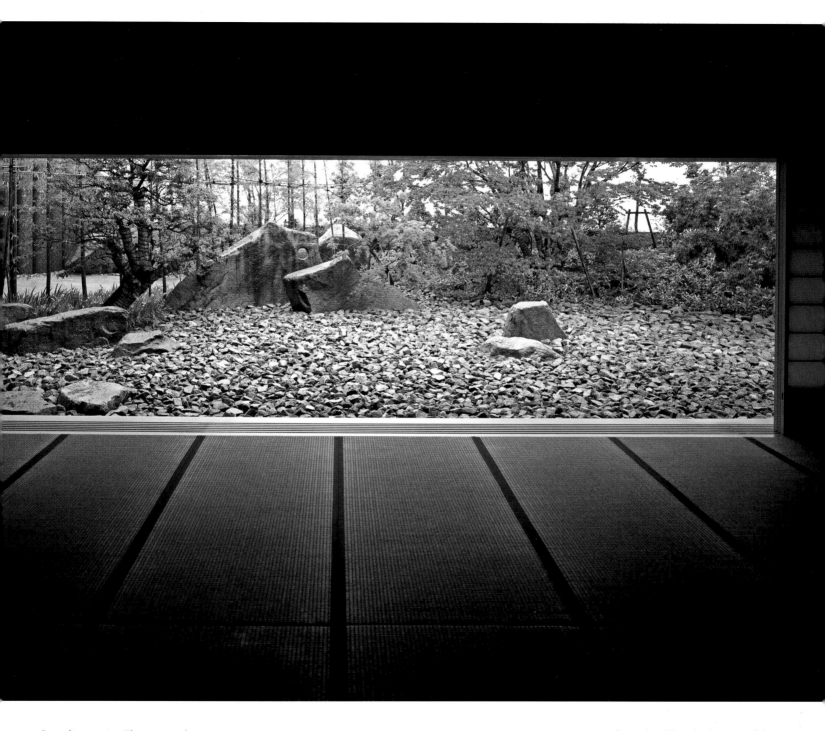

Opposite page top The octagonal
wood soaking tub affords views of
a strip of the carefully manicured
garden in the foreground and the sea
in the distance.

Above The sliding shoji screens of the
reception hall open to frame the view
of the *karesansui* (dry) garden.

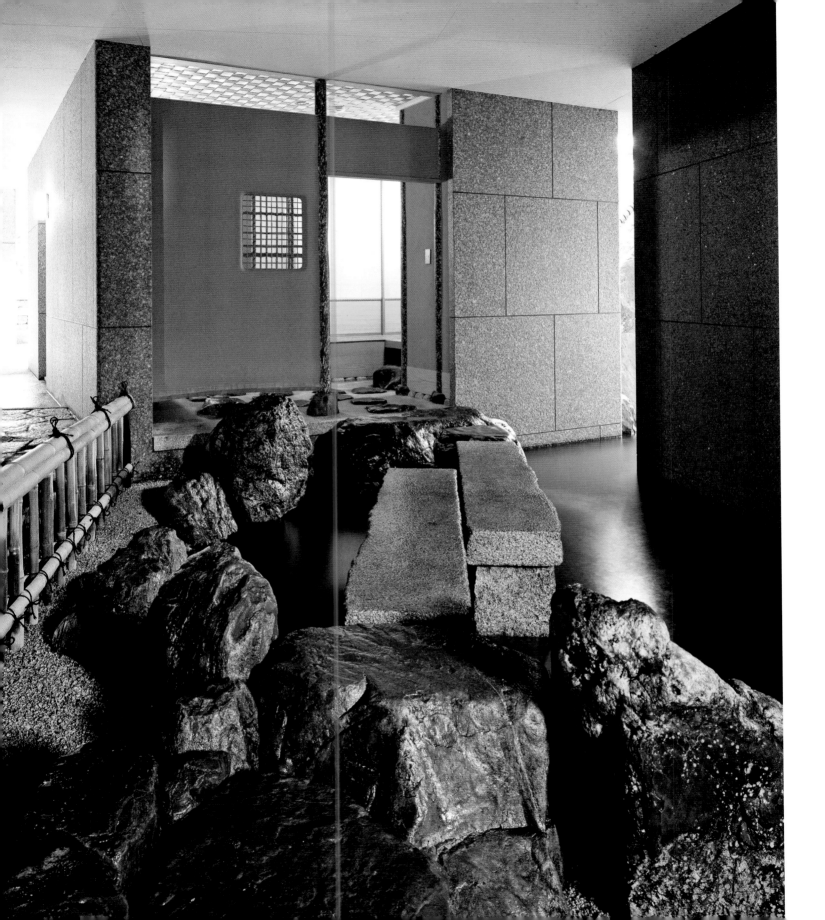

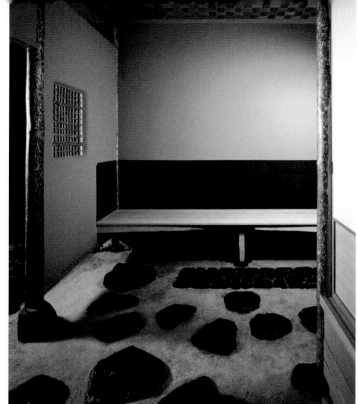

Below An enormous carved stone with roughly finished sides and a polished top surface appears to float within the tokonoma (decorative alcove).

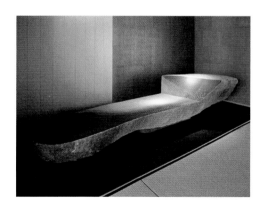

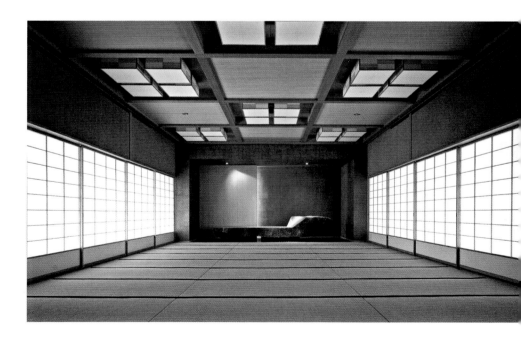

Opposite page In a combination of traditional and contemporary styles, stepping-stones and a bridge of two shifted stone planks lead to the entrance to a guest room.

Top left Simple lanterns create a serene atmosphere and provide light along the long *nobedan* (stone-paved walkway) on the way to the tea ceremony space.

Top right Contrasting the light-colored floor, the dark stepping-stones and *nobedan* (stone-paved walkway) guide visitors to and from the teahouse *koshikake machiai* (waiting bench).

Above Integrating contemporary and traditional elements, the reception room features a large tokonoma (decorative alcove) with a sculptural stone art piece as the focal point.

正受庭 SHŌJUTEI

RIFUGIO

PRIVATE RESIDENCE
OKU, OKAYAMA PREFECTURE, 2002

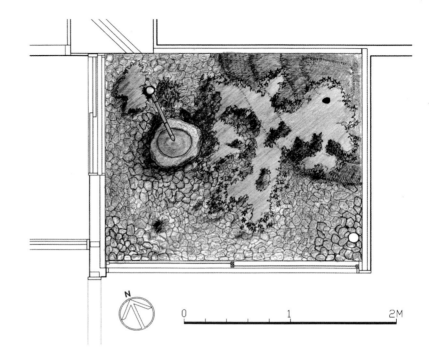

The essence of the infinite universe represented in a single small contained space—this is the basis for a *tsuboniwa* (a small interior courtyard garden based on the measurement of one *tsubo*, the size of two tatami mats—a square about 180 centimeters or six feet on a side). A few carefully chosen elements join together in a unified composition that draws in the viewer and connects the mind and spirit to the greatness of nature. Shunmyo Masuno explains that when Zen teachers of yore tried to give form to things that are inherently formless, such as religion, philosophy, and spirit, the *tsuboniwa* was born. When one observes and meditates on the garden over time, a sympathetic connection between the viewer and nature is achieved. The mind moves from the interior viewing position to the garden outside and eventually to the sky—the vast infinite nature beyond. The spirit is set free, and the viewer experiences peace of mind. These are the grand goals for this tiny garden.

The concept of this *tsuboniwa*, Shōjutei, is the creation of a philo-sophical space, a space for confronting oneself and one's own realm of consciousness. *Tei* is "garden," while *shō* literally means "correct" and *ju* means "receive." Thus *shōju* refers to one's spirit being in a unified, peaceful, receptive state. The inspiration for the name and the design of the garden came from the owner, in the letter he wrote to Masuno requesting him to design the *tsuboniwa*. The owner's field of specialty is the philosophy of religion, and he was well attuned to the potential role of the *tsuboniwa* in the center of his house. More than simply a garden that allows light and air to pass into the house, his desire for the space was more multifarious. He wanted the garden to evoke a subtle condition of light, a feeling of being outside while inside, a sense of sympathy with nature, a connection from the small space to the metaphysical world through the infinite sky, and a reflection of his own internal being. For Masuno, distilling these complex ideas into a simple design was a welcome challenge.

The rectangular garden can be viewed from only two points. A large

Above The plan of the Shōjutei garden expresses the carefully designed balance of "empty space" (the light-colored rock base) with the composition of three-dimensional elements (the plants and the water basin).

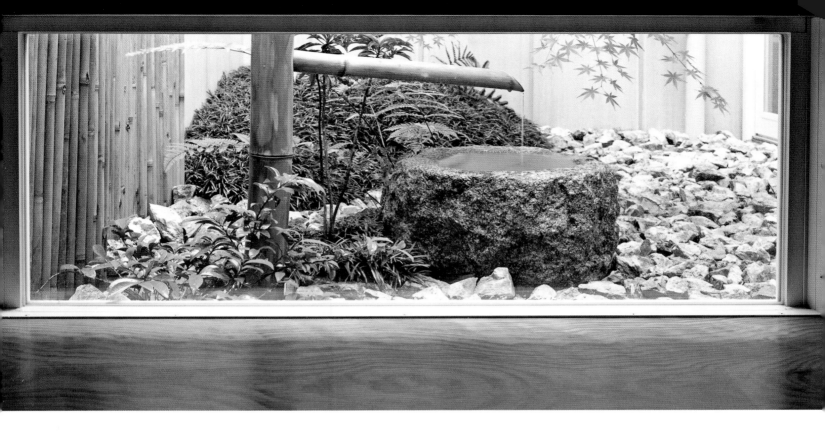

window faces north into the garden and runs the length of the long south side of the rectangular space, and a low horizontal window (about half the length of the larger window) placed at floor level at a corner of the garden looks into the garden from the west. The two windows afford very different views of the garden, despite its diminutive size and straightforward design. The garden incorporates just a few elements, each carefully positioned to create a balanced and unified total composition. The focus is a carved stone *chōzubachi* (basin) with water dripping from a bamboo spout and a bit of dark green ground cover at its base. The basin is set within a bed of rough, light-colored, fist-sized rocks and backed by a tall bamboo wall. In the northeast corner of the garden, shaggy ground cover envelops a mound, drawing the eye upward. A few plants provide a variety of leaf colors and shapes—a low camellia, a single fern, and a lacy *yama-momiji* (mountain maple tree). The garden is full of colors, textures, and sounds—allowing an endless exploration of nature and self.

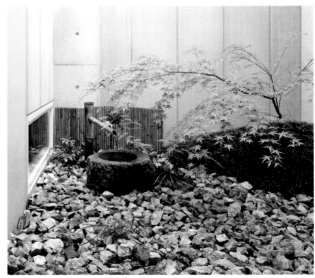

Top A low window focuses the view on the thin stream of water pouring from the simple bamboo spout into the rough stone *chōzubachi* (water basin).

Above A single mountain maple tree growing on a raised mound adds an element of verticality in the confined space of the *tsuboniwa* (courtyard garden).

聴楓庭・水到渠成　CHŌFŪTEI AND SUITŌKYOSEI

GIONJI TEMPLE RECEPTION BUILDING

MITO, IBARAKI PREFECTURE, 2004

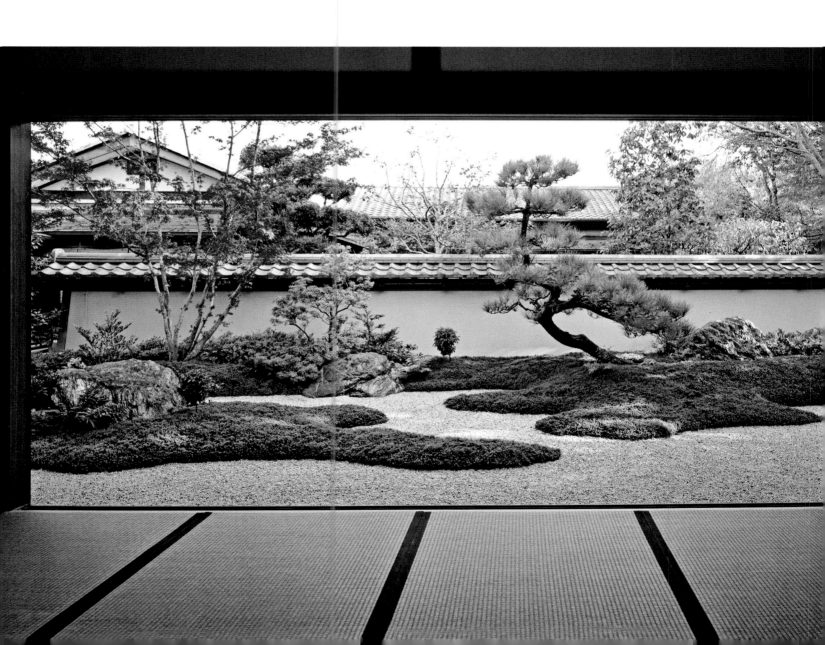

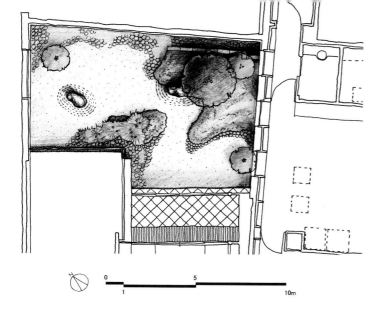

0 5

1 10m

When a new reception hall was planned for the Gionji temple, two separate new gardens also were envisioned. A small courtyard garden functions like an extension of the head priest's office and study room. A larger garden, designed especially to be viewed from the new reception hall, shares a wall with the previously constructed Ryūmontei garden, designed by Shunmyo Masuno in 1999. Both new gardens provide a place where the viewer can be at ease while confronting and contemplating ideas from deep within the self.

The head priest's courtyard garden, Suitōkyosei, is designed around the concept of water. Water represents the knowledge and teaching of the priest's predecessors that has been handed down through the ages, and the name of the garden refers to this continuous handing down of history like the flow of water. It is the head priest's duty to continue the flow of knowledge by passing it on to the next generation. The garden is slightly L-shaped with two primary viewing positions—both face the same direction but offer very different experiences of the garden. From the office, with its contemporary style and slick polished stone floor, the view of the garden is defined by a long low window. The glass runs from wall to wall in the small room, starting at the floor and rising only about one meter (three feet) before a translucent shoji (paper-covered lattice screen) obscures the view. The glass seems to disappear into the garden, as the window frame is concealed in the floor, and the gravel surface of the garden continues from outside into the room. The second viewpoint is from the adjacent traditional tatami (woven grass floor mat) room, tucked back slightly in the stem of the L-shaped plan, which allows both rooms to feel secluded from the other. Following tradition, the floor of the tatami room extends toward the outside with

a wooden veranda-like *engawa*. From the *engawa* the floor steps down to a tiled patio bordering the garden, separated by sliding glass doors that protect from the weather yet allow the view to continue.

The design of the courtyard garden features a surface of pea gravel, representing the water of knowledge. Edged with larger gravel in a contrasting color, the pea gravel leads into mounds covered with vegetation. The placement of the mounds, near the walls of the garden to give height and the impression of the extension of space, defines the views from each of the two rooms. Large dark rocks, placed prominently within the gravel, allow the flow of the water to continue around them. The plantings of trees, shrubs and bamboo vary for each viewpoint, giving variety and the impression of spatial depth.

While Suitōkyosei is very contained, the larger garden, Chōfūtei (which means to calmly listen to the cheerful sound of the wind in the maples), gives the impression of expanding infinitely. Using similar elements—a bed of pea gravel, finger-like mounds of moss, and carefully positioned arrangements of rocks and plantings, the garden

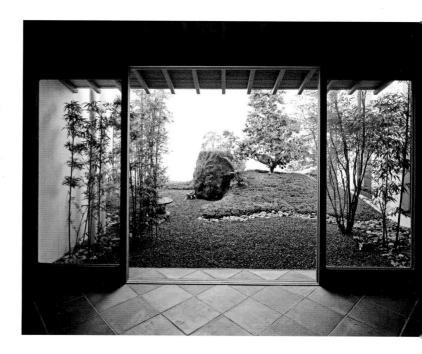

Opposite page Designed to be viewed from a seated position, the Chōfūtei garden is framed by the traditional wooden structure of the reception room.

Top left Representing water as the ever-flowing stream of knowledge, the gravel surface of the Suitōkyosei *nakaniwa* (courtyard garden) connects the varied elements of the L-shaped garden.

Above The tiled floor of the head priest's room extends out to the Suitōkyosei garden, creating a strong connection between the interior space and the garden.

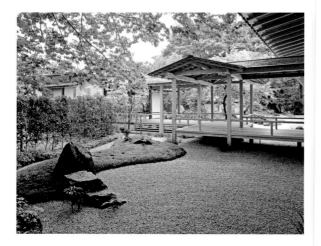

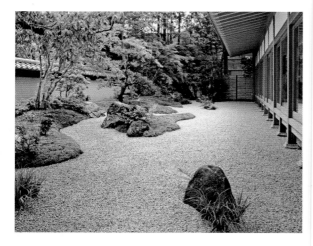

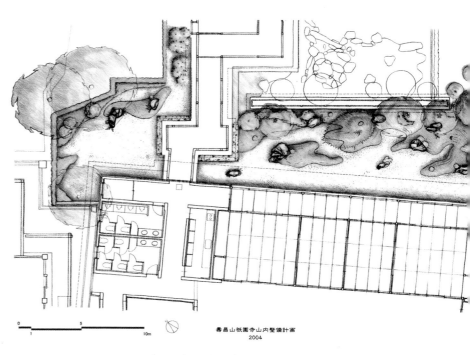

Above The rocks and pine trees in the garden were present on the site in a previous garden and were reused, creating a connection to the memory of what existed previously.

arrangement of two gardens sharing one special wall allows each to be viewed individually with little hint that the other is there.

Like the courtyard garden, Chōfūtei is designed only for viewing. Visitors sit on the tatami floors in the traditionally constructed reception rooms and view the garden through the frames of the wood column-and-beam structure. The water-like gravel surface winds through the moss-covered mounds. The mounds grow slightly in height as they near the back wall, suggesting more spatial depth than actually exists. The contrast of the deep green of the locally sourced moss with the gravel and the white background wall is intense. This contrast is softened by the plantings, trees and shrubs of varying heights and sizes, which add color and visual interest. Textured and patterned rocks, previously existing elsewhere on the temple grounds, are interspersed among the plants—including pine trees also from the site—giving visual emphasis and grounding the design. The branches from the maple trees move with the slightest breeze, reminding the viewer of the transience of all living things. The vast nature represented in Chōfūtei allows a deep understanding of the self and a connection to the profound spirituality embedded in the garden.

incorporates several other features that add to the sense of continuation. A bridge-like covered corridor runs through the garden, connecting the new reception hall to the older temple buildings. The "bridge" separates the garden space in two, but the gravel "sea" flows underneath it, creating continuity between the two parts. On the north side of the space, the garden turns a corner and continues out of view—giving the impression of going on further. At the other end, the same effect is achieved when the garden slips between two walls, allowing the view to continue beyond the barriers. One wall is shared by the Ryūmontei garden, previously designed by Masuno. This clever back-to-back

Top left The gravel "ocean" of the Chōfūtei garden flows under the covered corridor, which connects the reception hall to the main temple building.

Above left The Chōfūtei garden extends along the length of the reception hall, continuing under the covered corridor and separated from the adjacent garden with a tall wall on the northeast side.

Opposite page top left A low window along the wooden floored corridor affords a view into the Suitōkyosei *nakaniwa* (courtyard garden) outside the head priest's office.

Opposite page bottom Whether open or closed, the sliding glass doors at the edge of the wide tatami-matted *engawa* (veranda) allow for a strong connection between inside and outside.

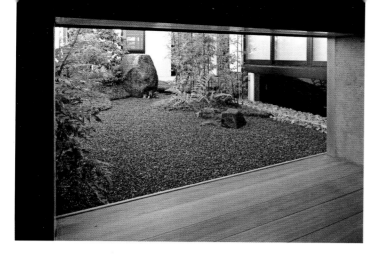

Above The Chōfūtei garden is designed to be viewed both as a single continuous panorama and as a series of framed scenes.

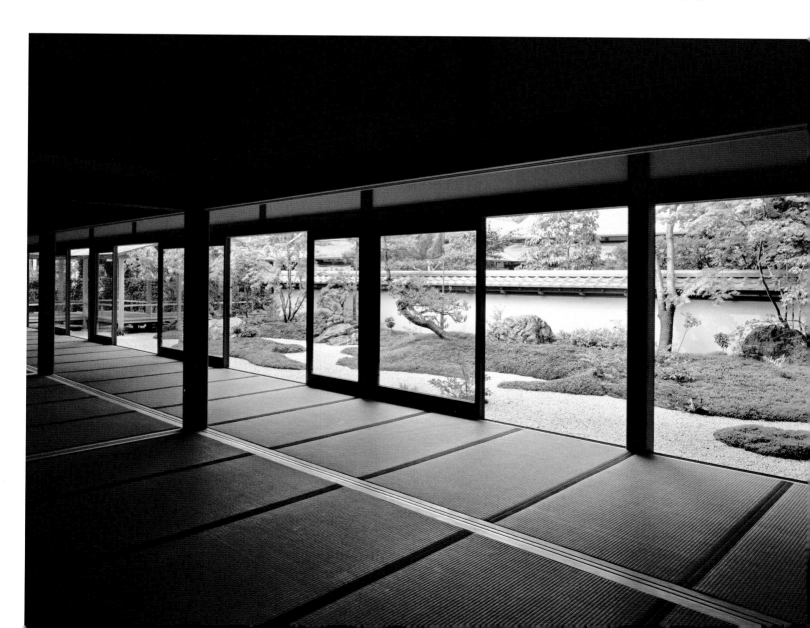

梅華庭 BAIKATEI
SAIKENJI TEMPLE
HAMAMATSU, SHIZUOKA PREFECTURE, 2005

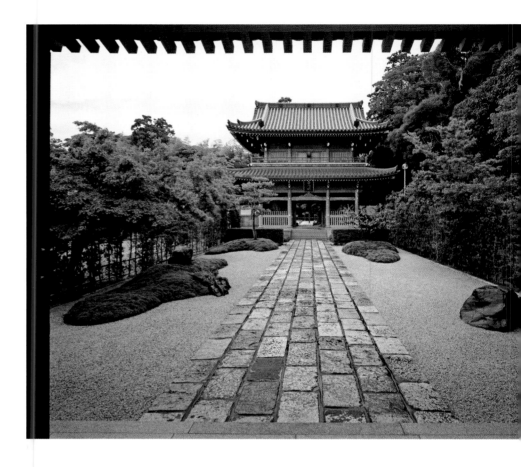

In Japan, temples typically remain in the place they are founded. Saikenji is unusual in that it moved from downtown Hamamatsu to the outskirts of the city. After the reconstruction of the temple, the head priest asked Shunmyo Masuno to design the temple *sandō* (approach). The wedge-shaped site is narrow at the entrance from the adjacent road and widens toward the temple complex. A generous rectangle of space allowed for the garden to flank a straight walkway to the *hondō* (main hall), while the remaining triangular side area already was filled with mature plum trees. When Masuno first visited the site, he noticed one especially old plum tree and was reminded of the old plum tree (*rōbaiju*) that appears often in Dōgen Zenji's thirteenth-century book, *Shōbōgenzō*. In the book, as with every plum tree, once a year according to the season, the tree blooms proudly with strongly fragrant blossoms.

Left A stone marker carved with the name of the temple signifies the entry area, while a tall white plastered wall flanking the *sōmon* (front gate) conceals the garden.

Top Viewed from the *sōmon* (front gate), hedges and maple trees bound the garden, which parallels the central stone walking path leading to the *sanmon* (main gate).

The old plum tree was twisted into a shape reminiscent of sitting in *zazen* (seated Zen meditation). In Zen Buddhism, *zazen* and other forms of spiritual training are indispensable in the process of reaching satori (enlightenment). *Zazen* and *satori* go hand-in-hand, and the role of the head priest of a temple is to teach as well as practice spiritual exercises. For Masuno, the form of the old plum tree in the garden and the image of the head priest of Saikenji in Zen training overlapped in his mind and inspired him to name the garden Baikatei—*bai* means "plum tree," while *ka* means "flower," and *tei* is "garden."

The approach stretches between two gates, from the smaller *sōmon* (front gate) on the south end to the majestic *sanmon* (main gate) on the north. The gates are more than just entryways—they serve as important thresholds for the visitor in the process of entering into the spiritual mindset. The garden also aids in this process, providing a calm atmosphere of refined nature to aid in profound thought.

The *sōmon* creates an opening in the thick plaster wall that borders the temple grounds. Maple trees surrounded by beds of pygmy bamboo mark the space in front of the gate. The wooden gate features a slightly raised stone floor surface and a large roof covered with ceramic tile. To pass through the gate, the visitor must step up one level and then back down. This intentional act of physically leaving the ground while pass-ing under the space of the roof is the first threshold prompting the mind to let go of everyday thoughts. From the *sōmon*, the garden extends along a straight axis to the second, more elaborate gate of tra-ditional design, the *sanmon*. The view along the straight stone path to the *sanmon* creates a strong perspective, with living fences of shrubs contained within bamboo trellises emphasizing the edges of the view. These sharp edges are softened by the overhanging branches of maple trees planted behind them.

Within the space created by the hedges, the slightly rough stone path leads the visitor between beds of raked white *shirakawa-suna* (pea gravel). A few moss-covered mounds emerge from the gravel sea, with several large rocks anchoring the mounds or sitting separately within the *shirakawa-suna*. Near the *sanmon*, two trees, a pine on one side of the walk and an old plum tree on the other, punctuate the space enclosed by the side shrub-fences. A narrow path, next to a low hedge that borders the gravel beds, runs perpendicular to the main path and connects to the parking area on the east and the triangular plum grove with its own meandering path on the west. Between this path and the main gate is a closely cropped low hedge of azaleas, the last layer before the steps of the stately *sanmon* lead the visitor through yet another threshold of physical space and spiritual reflection.

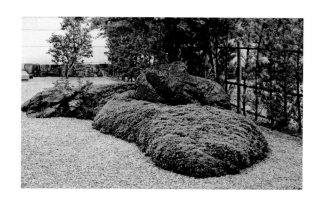

Above Raked *shirakawa-suna* (pea gravel) follows the contours of a moss-covered mound studded with large roughly textured rocks.

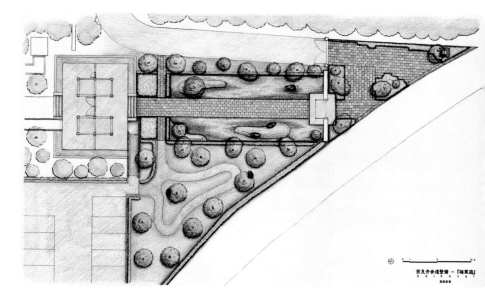

Above The odd-shaped property allows for three distinct garden areas—the mostly paved triangle creating the entrance from the road, the rectangular formal main garden contained between the two gates, and the tri-angular plum grove with a meandering path.

Above The main garden with an expanse of lawn and a stone-paved patio provides ample area for play and entertaining.

Opposite page right The *nobedan* (stone-paved walkway) winding toward the *genkan* (entrance hall) is constructed of variously shaped large stones set within a bed of moss.

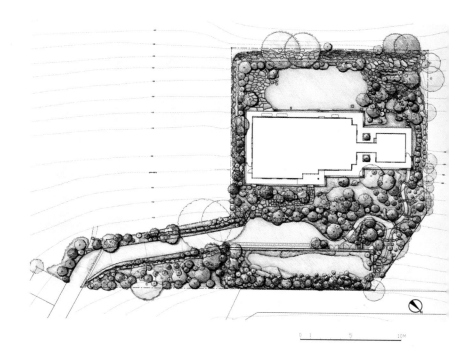

月心荘庭園

GESSHINSŌTEIEN

PRIVATE RESIDENCE
YAMANAKA-KO, YAMANASHI PREFECTURE, 2005

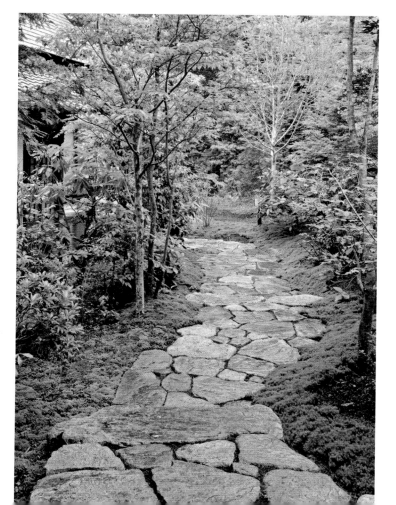

A gently meandering path, surfaced with roughly textured stone of many shapes, snakes its way through a lush green landscape. On both sides, a carpet of moss presses at the edges of the stones and seeps in between them. Mountain maple trees and low bushes define the enclosed space of the path, giving a feeling of being surrounded by nature.

This sense of being totally embraced by nature was the request of the owner, who lives during the week in Tokyo and frequently travels the world for business. The Gesshinsōteien is a tripartite garden that surrounds the owner's weekend house, an old *minka* (folk house) that was moved from another area of Japan, rebuilt near Lake Yamanaka, and renovated. The owner determined the name of the garden, combining the kanji characters for moon (*getsu*), *kokoro* (mind/heart, *shin*), villa (*sō*), and garden (*teien*).

The approach garden with its puzzle-like stone path is the first stage of experiencing that embrace of nature. Leading from the driveway to the *genkan* (entrance hall), the path is the final stage in the journey from the bustling dense city to the richness and serenity of nature. The materials and design of the path embody those qualities and quietly reawaken the senses, preparing the owner or visitor to appreciate and savor the main garden, which is first visible after entering the house.

Top right From the driveway, the entrance path meanders through lush greenery to the *genkan* (entrance hall), while the open expanse of the main garden flanks the opposite side of the house.

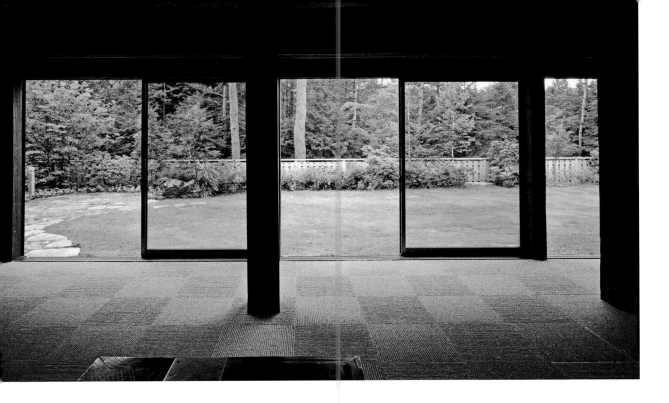

The main garden surrounds the house but has an especially strong relationship to the living spaces. The living-room wall facing southeast to the garden opens up with large sliding glass doors that allow the interior and exterior spaces to merge. The view of the grassy lawn is defined on the left side by a stone patio, reminiscent of the approach path. Two low wooden background fences come together at the south corner, forming an edge for the curving patio. Small shrubs in front of the fence and tall trees behind it soften that edge and create the sense of the garden extending far beyond the fence. The trees are mostly on an adjacent property but are brought into the garden as borrowed scenery (*shakkei*). The lawn is used for outside dining, entertaining guests, and playing badminton, the owner's hobby. Trees frame the layers of space surrounding the lawn, giving that desired sense of being enclosed within nature while allowing glimpses through to the revered Mt. Fuji in the distance.

The main garden continues around the house, with a narrow gravel path leading through dense foliage. In some areas, banks of moss flank the path and single rows of rock cross the path intermittently, creating thresholds that require the visitor to step up and over the rocks. This device slows down the pace and makes the movement more intentional. Bushes and trees push up against the path and pull away, creating small spaces within the larger space of nature.

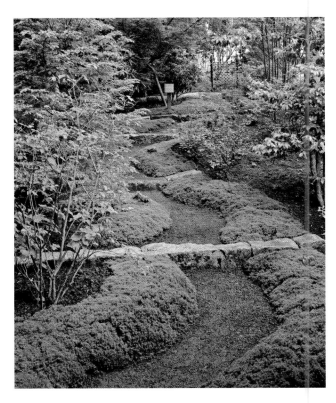

Above The garden path, crisscrossed by raised rows of stone, snakes through moss-covered mounds and dense foliage.

Top Large glass doors slide open to connect the interior living space directly to the broad space of the main garden.

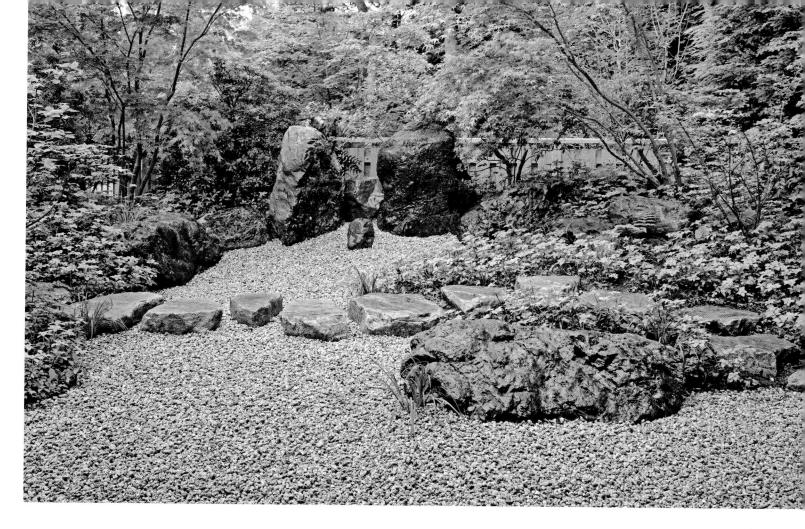

Set within the dense foliage of the main garden, the third garden relates specifically to the traditional Japanese bathing area in the house. Designed to be viewed while soaking in the deep bathtub, the *karesansui* (dry) garden represents a scene of water tumbling down a waterfall and flowing toward the bath. A low wood fence, like those used in the main garden, also provides a back edge in this garden, with tall trees behind it again giving the sense of space and great nature beyond. In front of the fence, tall dark rocks create the falls, and contrasting light-colored gravel represents the flowing water. Several large rocks and mounds veiled with lacy ground cover act as islands or peninsulas in the gravel "river." A line of stepping-stones winds through the gravel, linking the two sides of the garden. This sense of connection, both on a small scale as between different areas of the garden and on the grand scale between man and nature, is the objective of this tranquil private garden.

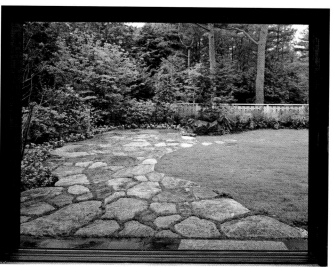

Top The *karesansui* (dry) garden outside the bath room features stepping-stones across a river of pea gravel flowing from a *ryūmonbaku* ("dragon's gate waterfall").

Above The patio in the main garden is constructed of variously shaped large stones, similar to the stone-paved walkway leading to the entrance.

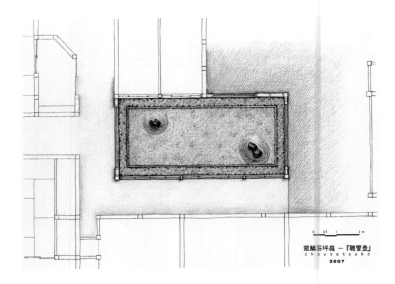

銀鱗荘坪庭 ―『聴雪壺』
c h o u s e t s u k o
2007

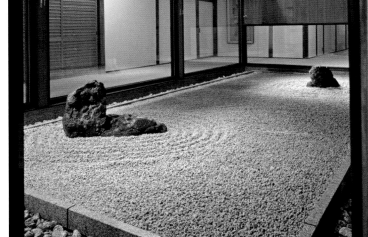

聴雪壺 CHŌSETSUKO
GINRINSŌ RYŌKAN
OTARU, HOKKAIDO, 2007

The Ginrinsō Ryōkan is a traditional Japanese inn built in 1873 and moved to its current location in 1938. Situated on a hilltop just outside the city of Otaru on the northern island of Hokkaido, the inn offers an expansive vista from its grounds—looking back toward the city and Ishikari Bay, with mountains in the distance. This grand view of the city and unrestrained nature contrasts the controlled and contained view of nature that greets the visitor upon entering the inn.

From the *genkan* (entrance hall), the visitor comes face-to-face with the Chōsetsuko *nakaniwa* (literally, "inside garden," or courtyard garden). Bounded by four walls of the inn, the garden allows light and air into the rambling structure but also creates an important connection to nature. Although the space of the garden is small (about 3.6 meters by 7.2 meters, or 12 feet by 24 feet) and contains only a few elements, it

both represents and impresses a sense of infinite space and the profound sanctity of nature.

A thin curb of dressed stone separates a band of small light-colored rocks, which runs the perimeter of the garden, from the main bed of *shirakawa-suna* (pea gravel). The curb creates a sharp edge between the contrasting sizes and colors of the gravel and small rocks. The surface of the *shirakawa-suna* is smooth, except where it flows around two islands of rock. At these two locations the gravel is raked with ridges encircling the rocks, like ripples in a pond.

The three rocks that form the islands are dark and weathered, imparting a sense of history and time. On the side of the garden closest to the *genkan*, two rocks form one island. One rock is taller and gives the sense of vertical motion, while the other sits low and anchors the

Above left The Chōsetsuko *nakaniwa* (courtyard garden) brings light into the surrounding rooms, while providing views of the simple yet profound garden and glimpses of the sky.

Above right When first encountered from the *genkan* (entrance hall), the austere garden comes as a surprise and creates an immediate connection to nature.

Right Looking back toward the entrance hall through a long low window, the many layers—physical and metaphysical—of the *karesansui* (dry) garden become visible.

composition. The second island consists of a single rock, set in the opposite end of the garden. This rock is slightly larger than the others and appears to be growing out of the gravel "sea." The careful composition of the two islands in the gravel bed is balanced and harmonious from any viewpoint—whether looking from the *genkan* with its view extending the length of the *nakaniwa*, or from the glass-walled corridor adjacent to one long side of the garden, or from the low window on the side opposite the *genkan*, which allows only a partial view of the garden.

Although the Chōsetsuko *nakaniwa* is not large, it has a sizeable role as the welcoming face of the inn. Shunmyo Masuno designed the garden with the spirit of Japanese hospitality, *motenashi*, in mind. The garden should relax weary travelers and remind them of the enjoyment of the journey and the anticipation of arriving at a place like Ginrinsō. The sight of this garden, with its simple yet complex space and symbolism created from so few elements, purifies and lifts ones spirit.

The space and symbolism of the garden become even more complex in the winter. Snow covers the gravel and rock arrangements, filling the courtyard to just under the roof eaves. The impression of tranquility in the serene *karesansui* (dry) garden shifts to the tranquility imparted by the accumulating snow. Layers of snow build up against the windows facing into the garden. Each layer seems to create a space moving toward the sky. When Masuno first visited Ginrinsō, it was winter, and the snow was piled high. He was taken by the beauty and purity of the snow and how it sharpened his senses and spirit. He designed the garden to have that same effect, whether summer or winter, and named it Chōsetsuko. *Chō* means "listen," *setsu* is "snow," and *ko* is "pot" or "jar" but also can be read as *tsubo*. It is a play on the word *tsubo* in *tsuboniwa*, another term for a courtyard garden, with *tsubo* (a square space about 1.8 meters or 6 feet on a side) written with a different character. In this way, in both name and design, Chōsetsuko is a space for listening to the sound of falling snow.

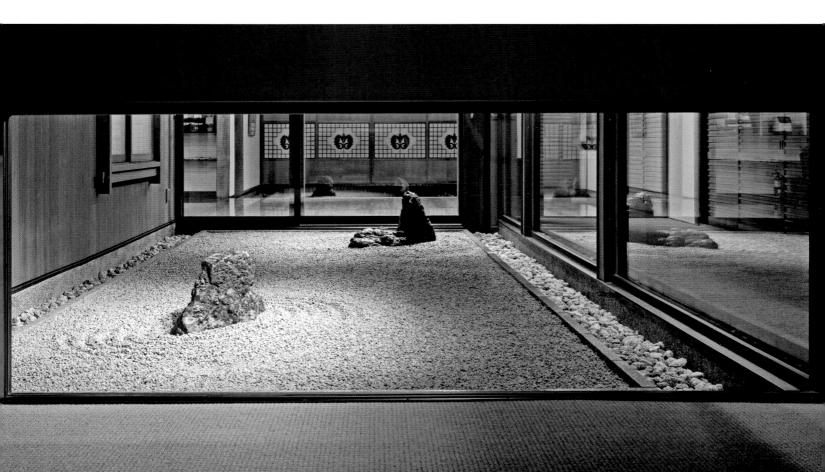

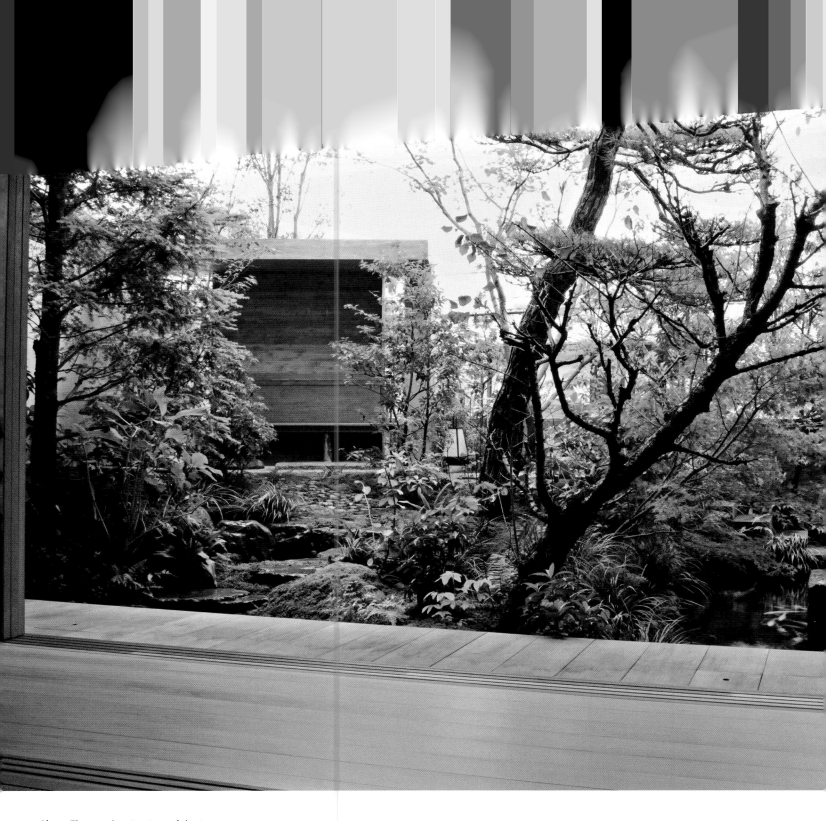

Above The wooden structure of the tea ceremony room frames the view of the garden, with the *chōzubachi* (water basin) in the foreground on the right and the *koshikake machiai* (waiting bench) in the background on the left.

聴籟庭

CHŌRAITEI

PRIVATE RESIDENCE
MEGURO-KU, TOKYO, 2008

Built for a couple who are leading professionals in the medical field, Chōraitei provides a place of calm and tranquility in their busy everyday lives. The owners wanted a garden with a waterfall, stream, and pond that could be viewed from both the living room and the adjoining *washitsu*, the traditional four-and-a-half-mat tatami (woven grass floor mat) room which they use for tea ceremonies. The garden space is in a corner of their property, surrounded by tall concrete walls on two sides and the *washitsu* and living room on the other two sides.

The design of the garden incorporates elements of both a *kanshōshiki-teien*, a garden that is viewed from a fixed position, and a *roji*, a path leading through a garden to a teahouse. The ground of the garden is built up slightly toward the back wall, where a *koshikake machiai* (waiting bench) is nestled into the trees near the back corner. A line of simple concrete steps leads along the side wall to the waiting bench, which is constructed with a concrete roof and walls to match the concrete walls surrounding the property and the contemporary style of the house. The seat and back of the bench—the parts that touch the human body—are faced with wood and relate to the traditional style of the *washitsu*.

Guests arriving for a tea ceremony first follow the concrete steps to the *koshikake machiai*, where they enjoy the garden and wait to be called to the teahouse. A carved stone *tōrō* (lantern) and *chōzubachi* (water basin) located near the waiting bench show the marks of the

Above A geometric carved stone *chōzubachi* (water basin) is positioned atop a contrasting rough stone base in a corner of the pond near the teahouse.

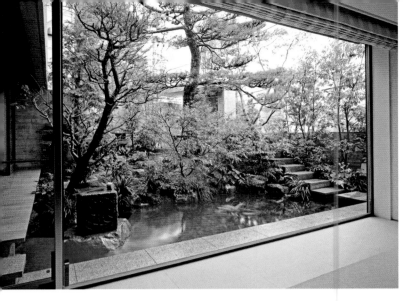

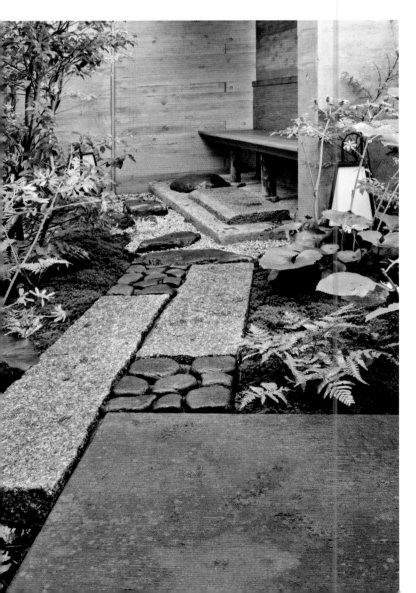

hand of man within the naturalistic garden. A path created by many small light-colored stones moves from the front of the bench out into the lush greenery of the garden. Moss covers the ground and seeps in between the stones. As the ground descends, the path changes to stepping-stones that move through the stream to the veranda-like wooden *engawa* of the *washitsu*.

The waterfall also starts near the corner of the site, close to the *koshikake machiai*, and water flows through the stream diagonally across the site to the pond. The pond appears to extend under both the *engawa* of the *washitsu* and a similar stone-covered extension from the living room. A square carved stone *chōzubachi* placed in the pond near the corner where the living room and *washitsu* meet anchors this more open corner of the garden. The wall of the living room facing the garden is simply glass set within a concrete frame, creating a continuous space from inside to out. When the sliding shoji (paper-covered wood lattice) and glass screens of the *washitsu* wall adjacent to the garden are removed, nature enters into the interior space. In this way, the garden and the house have a reciprocating relationship of views and space.

Plants and trees of many different sizes and shapes fill in the spaces not occupied by the path, stream, and pond. The effect of the composition is a space filled with abundant greenery yet containing a feeling of openness created by the pond. A craggy *kuromatsu* (black pine) tree planted at the edge of the pond gestures from the garden to the house. The name Chōraitei (*chō* means "morning," *rai* is "sound" (of the wind), and *tei* is "garden") comes from the refreshing sound of the wind moving through the branches of the *kuromatsu*. The rustling of the branches in the wind embodies the designer's wish to create a place of repose and serenity for the owners.

Top The glass wall of the dining room affords a strong visual connection between the exterior space of the verdant garden and the starkly contemporary interior space.

Left The traditional design of the *nobedan* (stone-paved walkway) contrasts yet complements the contemporary style and materials of the *koshikake machiai* (waiting bench).

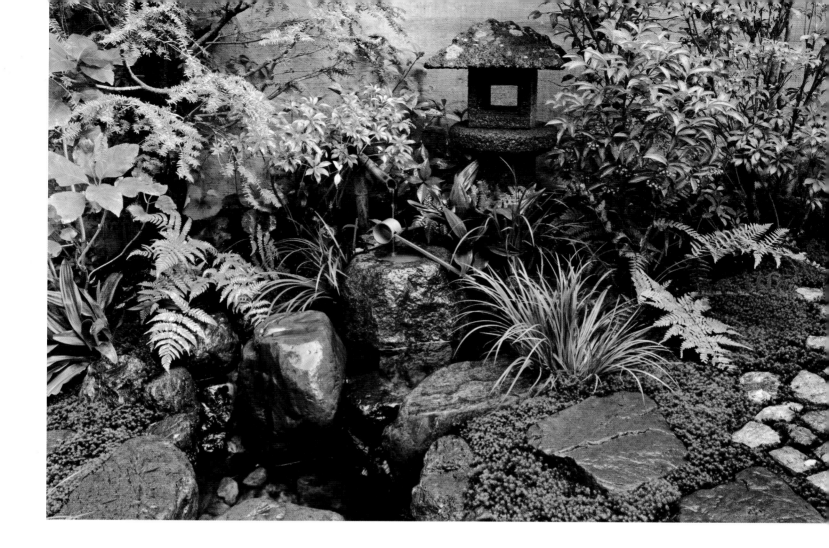

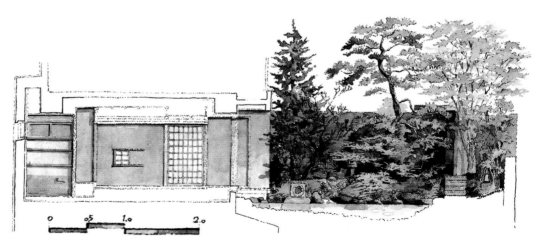

Top Near the waiting bench, a *tōrō* (lantern) and a *chōzubachi* (water basin) are set into the foliage in the most densely planted part of the garden.

Above The section drawing shows the relationship between the contained tea ceremony space and the bounded area of the garden.

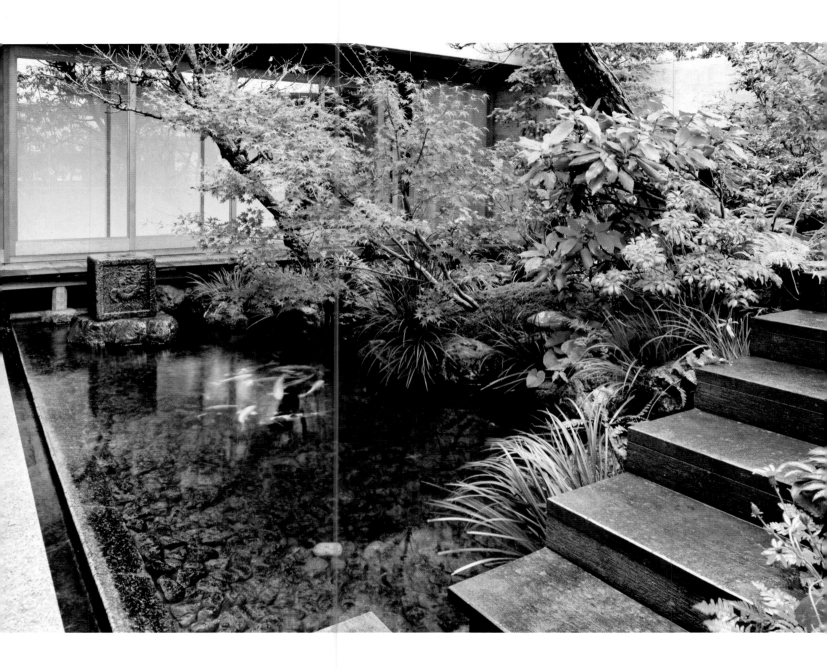

Above Looking across the pond to the tea ceremony room from the simple concrete stair leading toward the *koshikake machiai* (waiting bench), the surface of the water expresses the conscious mind while the bottom of the pond represents the subconscious.

Opposite page top left The tokonoma (decorative alcove) is the focal point of the tea ceremony space, with its traditional four-and-a-half-mat floor area and wood detailing.

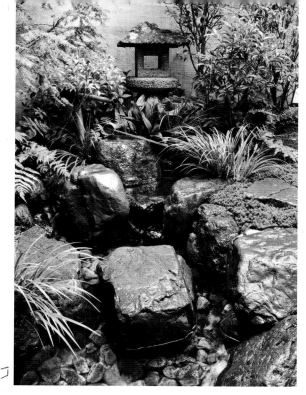

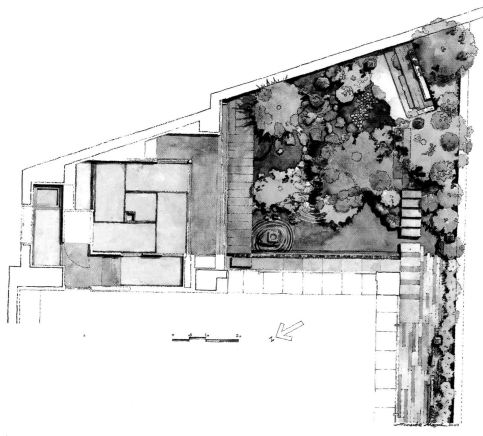

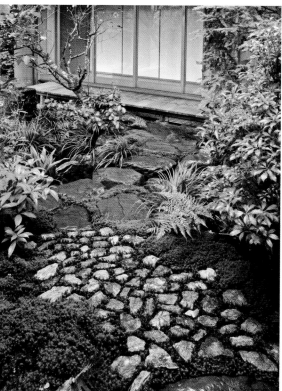

Above Filling all the open space, the garden occupies the southeast corner of the site, with the densest part of the garden furthest from the house.

Top right A stream of water starts near the *tōrō* (lantern) and *chōzubachi* (water basin) in front of the *koshikake machiai* (waiting bench) and flows through the garden into the pond.

Above A path with many transitions, the stone walkway moves the visitor slowly through the garden to the tea ceremony room, allowing time and multiple thresholds to prepare the mind for the tea ceremony.

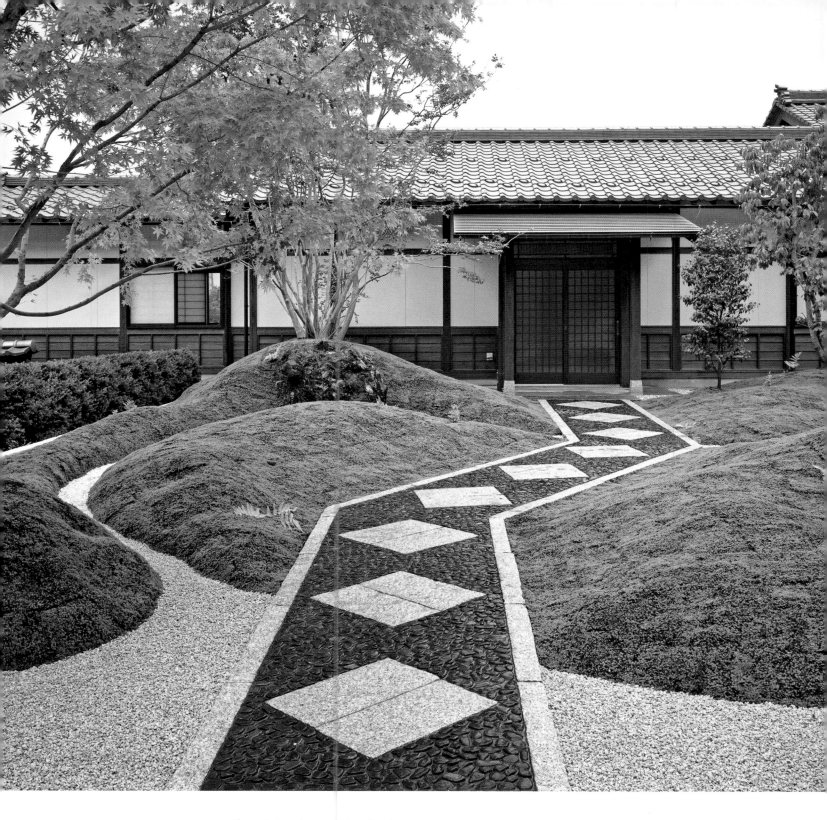

Above A strongly geometric path cuts across the gravel stream and through the moss-covered mounds of the garden toward the *genkan* (entrance area) of the monks' dormitory.

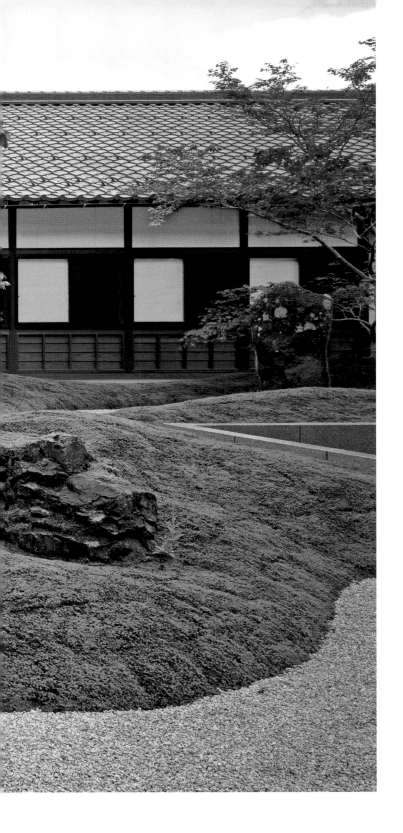

瑩山 禅師　転法輪の庭
KEIZAN ZENJI TENBŌRIN NO NIWA

GOTANJŌJI TEMPLE

TAKEFU, FUKUI PREFECTURE, 2009

In an L-shaped space adjacent to the newly constructed *hondō* (main hall) of the Gotanjōji temple, the Keizan Zenji Tenbōrin no Niwa connects the *hondō* with the monks' dormitory and the *zazendō* room for Zen meditation. Keizan Zenji, a thirteenth-century Zen priest revered for spreading the teachings of Sōtō Zen throughout Japan, was born in the region where Gotanjōji is located. He was influenced at an early age by his mother, who was a devotee of Kannon Bosatsu, the bodhisattva (enlightened deity) of compassion. Keizan Zenji began his Zen study at age eight and learned from two priests who were disciples of Dōgen Zenji, who brought Sōtō Zen to Japan from China. While Dogen Zenji's teachings were very internally focused, Keizan Zenji disseminated the ideas of Sōtō Zen to all corners of Japan. Gotanjōji temple was founded to revive his ideas and commemorate his birthplace.

Keizan Zenji Tenbōrin no Niwa is an abstract yet literal representation of important aspects of Keizan Zenji's life. Much of the garden is covered with undulating moss-covered hills. The thick carpet of moss is interrupted by two elements—a meandering stream of white *shirakawa-suna* (pea gravel) and a straight-edged formal pathway paved with stone. The source of the gravel stream is one of three freestanding *tateishi* (literally, "standing stone") in the garden. The most prominent *tateishi* represents the priest Keizan Zenji, and the stream that emanates from the base of the stone signifies his teachings flowing out to his dis-

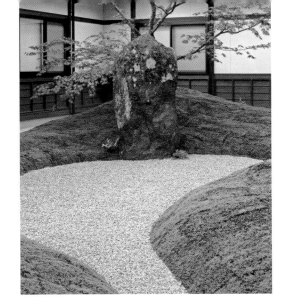

Above A perspective sketch shows how the garden increases in height and density of elements as it moves closer to the buildings.

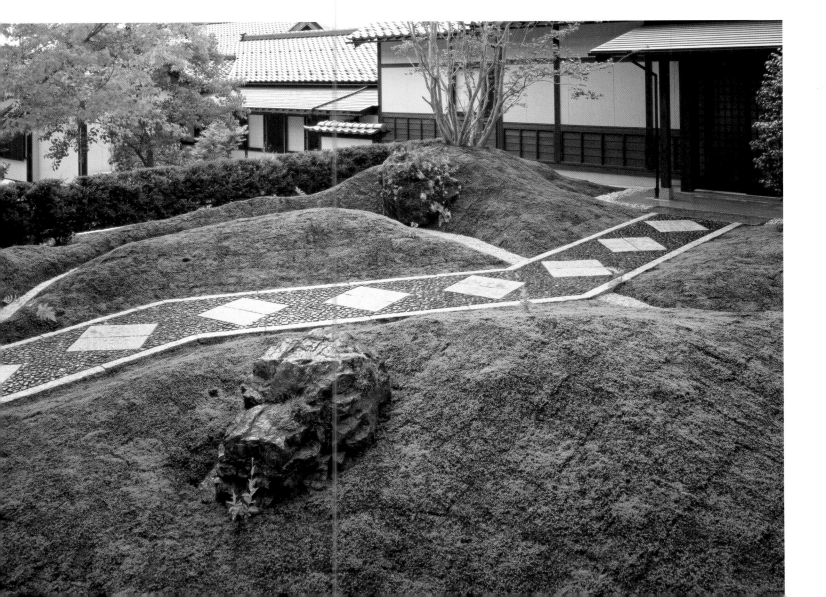

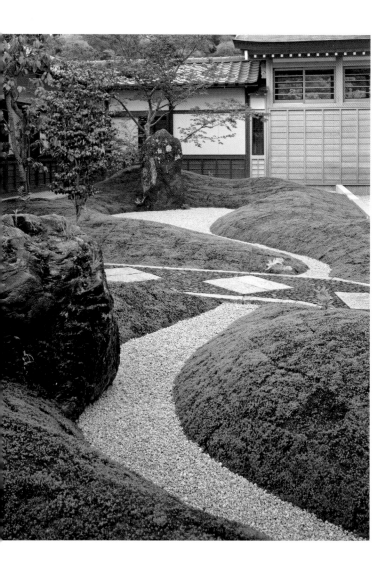

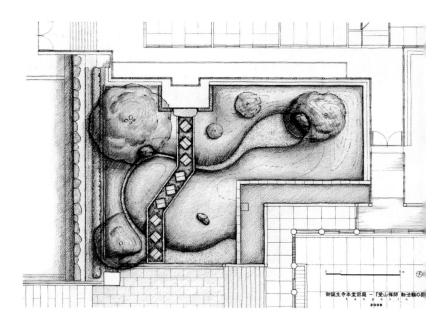

The stone walkway cuts across the gravel stream and through the hills of the garden, connecting to the dormitory entrance. It changes direction twice—first it is perpendicular to the dormitory, then it turns slightly to the right, presenting a view to the Keizan Zenji *tateishi*, before turning back in the original direction. The straight edges and bold diamond patterning of the *shin* (formal) path are a strong contrast to the soft meandering *sō* (informal) quality of the hills and stream. They set the path apart as a distinct element while allowing visitors to view the garden.

The image of the garden is simple, clear, and strong. The power of its message is carried by the graphic quality of its composition. Although the Keizan Zenji Tenbōrin no Niwa uses only a few elements—three rocks, a pea gravel stream, mossy hills, five trees, and a stone path—to create an image of simplicity and strength, the edges of the garden show subtle complexity. Each edge is different, in some places connecting to the adjacent building with a thin curb of dressed stone and in others with a band of gray gravel. Just as each edge receives the garden in a slightly different way, each practitioner of Sōtō Zen must individually receive the teachings of Keizan Zenji.

ciples, prompting the contemplation of the sacred quality of all living things.

As the stream of *shirakawa-suna* passes through the undulating landscape, it flows in front of the second of the three separate *tateishi* in the garden. This second *tateishi* represents Kannon Bosatsu. Closer to the garden entrance, the third *tateishi*, embedded within the largest mossy mound, denotes Keizan Zenji's mother, praying to Kannon Bosatsu. Five trees punctuate the vertical space of the garden, each a different size and species. An eye-catching red-leafed maple planted behind the Keizan Zenji *tateishi* adds a burst of color and signifies the most important point in the garden—the *tateishi* representing the Zen priest, from which the source of Zen knowledge flows.

Opposite page left Contrasting elements—rough rocks, soft mounds of moss, the meandering gravel stream, and the geometric path—come together in a unified composition.

Opposite page top A river of gravel streams forth from the *tateishi* (standing stone) representing Keizan Zenji, signifying his teachings flowing out to the world.

Top left Embedded in a mossy mound, the rock symbolizing Keizan Zenji's mother praying to Kannon Bosatsu is touched by the gravel stream.

Top right A single maple tree in the corner of the garden where a covered corridor connects the dormitory to the *hondō* (main hall) marks the place of the Keizan Zenji *tateishi* (standing stone).

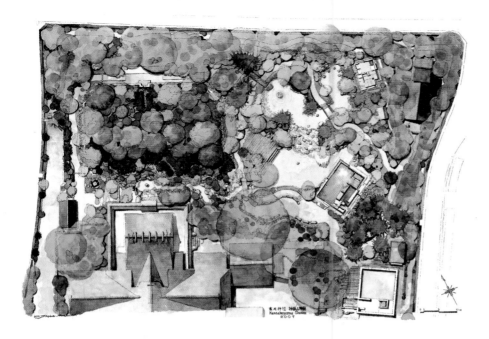

神嶽山神苑 KANTAKEYAMA SHINEN
SAMUKAWA SHRINE
KŌZA, KANAGAWA PREFECTURE, 2009

The Kantakeyama Shinen at the Samukawa shrine is an unusual example of a traditional Zen garden. First, the Samukawa shrine is not a Buddhist place of worship; rather it is Shintō, the native spiritual practice of Japan that long predates Buddhism and features qualities of animism and a strong respect for nature. Shintō shrines often are situated within unrefined nature, but it is rare to have a garden at a Shintō shrine. However, as nature plays such an important role in Shintō beliefs, the focus on nature characteristic of a Zen garden is not a difficult fit.

Kantakeyama is the name of a sacred hill within the shrine precincts. When the new main hall was built in 1997, the view to the existing *chinju no mori* (sacred grove) around the local shrine was blocked. To once again give the shrine a prominent position, the land was cleared (with all trees two meters (about six feet) or more in height moved to a temporary location), and earth was added to create a "mountain" more than eight meters (about 25 feet) high. The previously existing large trees were replanted, and additional trees were added to create the feeling of a sacred place deep in the mountains.

Above The verdant foliage draws the visitor into the garden through the outer gate, marked with the characters for "Kantakeyama" in the traditional right to left order on the wooden name plaque.

Top The site plan of the garden shows the pond with the dense foliage of the new mountain and the sacred grove on its northwest side, the teahouse on the east side, the tea pavilion on the south, and the museum in the southeast corner of the site.

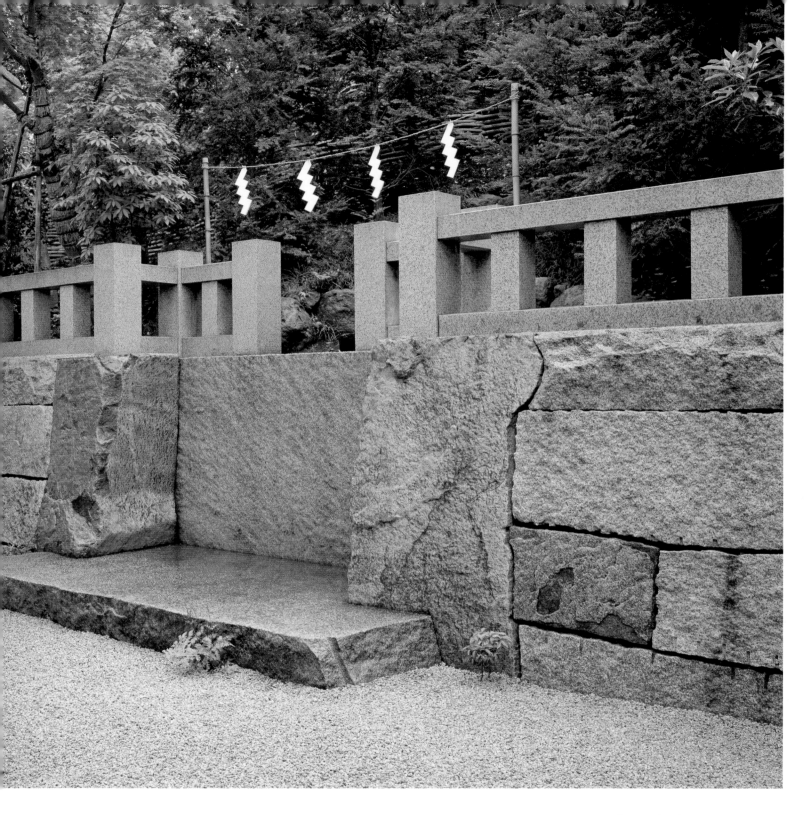

Above Within the heavy rock wall along the back edge of the sacred grove, a thick stone slab marks the place of prayer at the center point of the shrine.

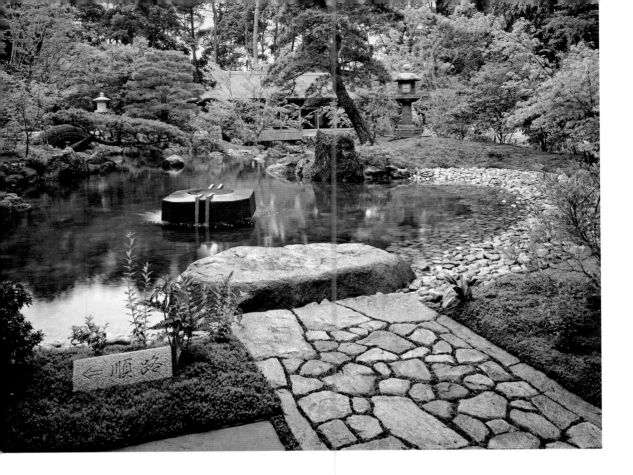

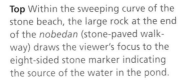

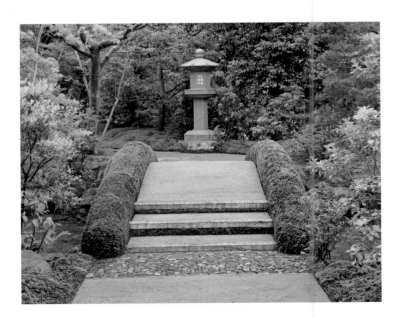

Top Within the sweeping curve of the stone beach, the large rock at the end of the *nobedan* (stone-paved walkway) draws the viewer's focus to the eight-sided stone marker indicating the source of the water in the pond.

Above Placed on axis with the *dobashi* (earthen bridge), the octagonal *tōrō* (lantern) contrasts in its color and lines with the surrounding plants.

Above right Flanked with rocks of many colors and forms, large stepping-stones lead to the irregularly shaped stone-plank bridge.

Opposite page left Stepping-stones of varied shapes and sizes embedded in the thick moss move toward the stone *chōzubachi* (wash basin) and *tōrō* (lantern).

The existing pond, Namba no Koike, also was restored and enhanced. The well that is the water source was renewed so water could flow freely. The banks of the pond were reinforced with rock arrangements and plantings of coniferous trees. The area around the pond and the newly heightened Kantakeyama was prepared for visitors. Inside the entry gate, Masuno designed a *temizusha*, a water source used to rinse the hands and mouth for purification before entering the sacred precinct.

The second phase of the project is the Shinen or garden for the *kami* (Shintō deity). Constructed adjacent to Kantakeyama, this *kaiyūshiki-teien* (stroll-style garden) includes several buildings as well as a waterfall, ponds, rock arrangements, and plantings. A traditional teahouse, a pavilion for *ryurei*-style tea ceremony (performed while sitting on a chair rather than the floor), and a small museum are located at intervals along the path. The goal of the project was no less than to create a contemporary *bunkazai* (important cultural asset). Shunmyo Masuno searched all over Japan to find the proper plants, stones, and other materials, and many highly skilled traditional carpenters and craftsmen collaborated on the project. The result is a place with a pervading sense of calm, where the cares of everyday life can be forgotten.

The garden path is designed to provide ever-changing views, so no scene is duplicated, and the visitor experiences a wide variety of spaces. The first view from the entry gate gives a sense of *shinzan-yukoku* (being deep within mountains and secluded valleys). As the visitor

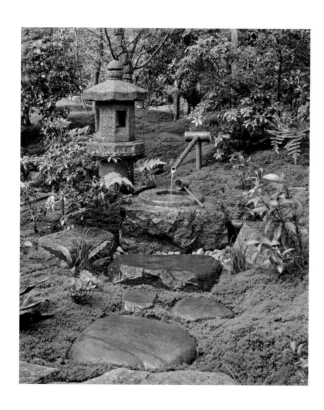

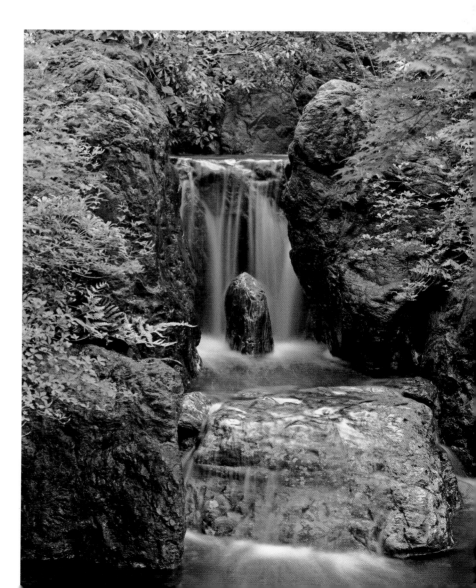

Right Water from the powerful *ryūmonbaku* ("dragon's gate waterfall") moves through the garden to fill the pond.

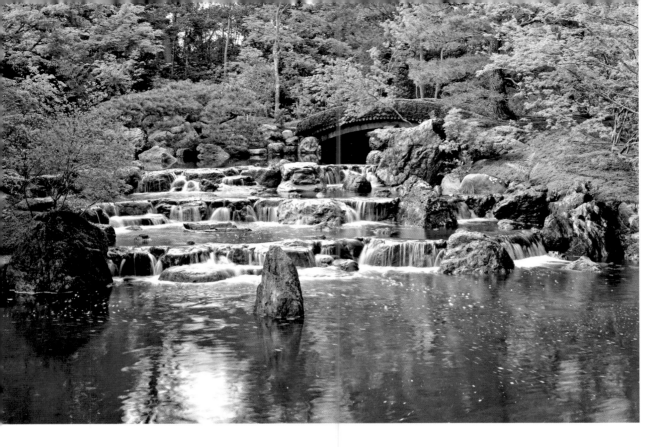

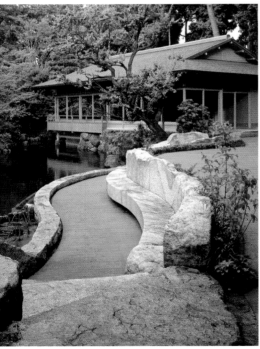

Above The walking path follows a curving stone bench on the way to the Warakutei tea pavilion at the edge of the lower pond.

Top A three-tiered waterfall separates the lower pond from the upper pond, with the gently arched *dobashi* (earthen bridge) in the background.

Above Strips of multicolored stone guide visitors to the entrance of the contemporary concrete structure housing the shrine historical museum.

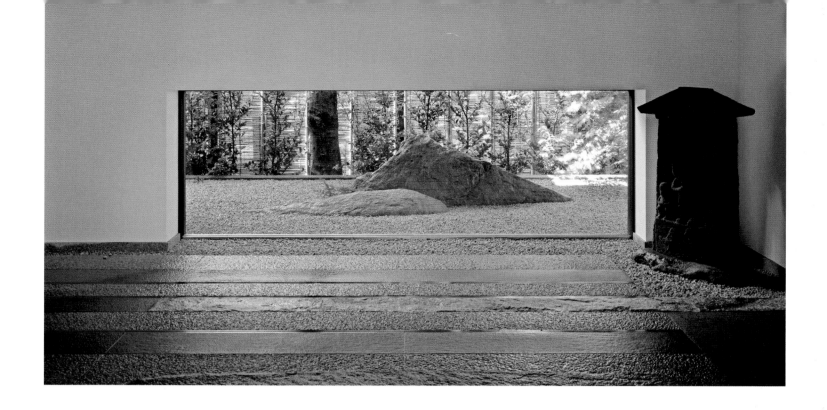

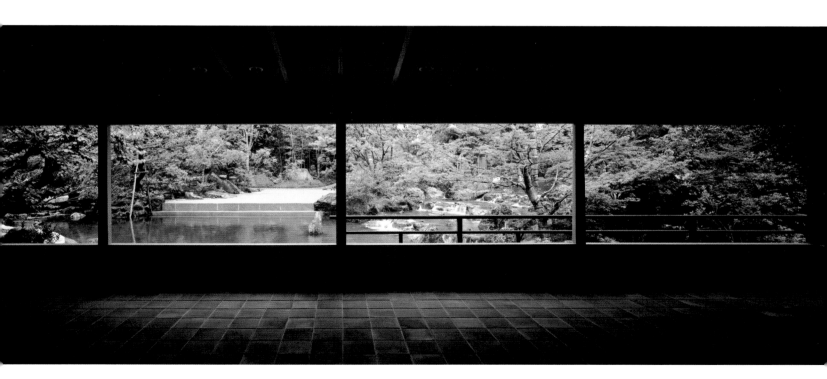

Top A low window in the museum
foyer frames a view of a scene of
perfect stillness—two rocks carefully
arranged in a bed of gravel.

Above Looking through the wooden
structure of the tea pavilion, the view
expands across the pond to the stone
stage and the tiered waterfall.

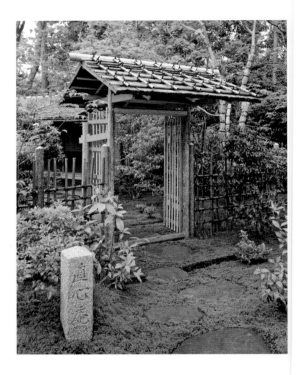

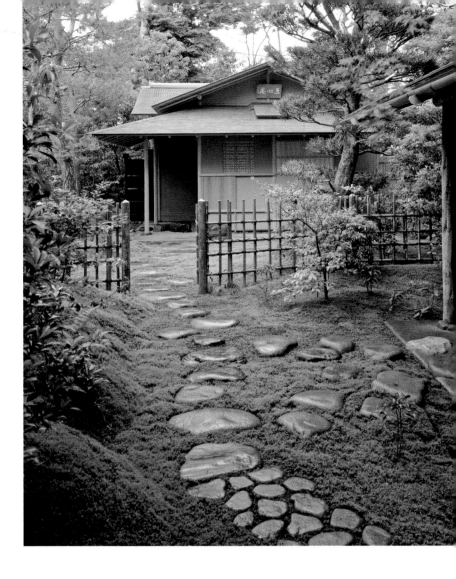

moves throughout the garden, the spaces along the path open and close, and the ground and water levels vary. The garden features an upper and a lower pond connected with a wide three-tiered waterfall. The tea pavilion offers a broad view across the lower pond to the falls and to a stone stage, which is used for performances of traditional court music (*gagaku*) and ritual dances.

Along the path, the many different plants offer a great variety of colors and leaf shapes, of heights and density. The layers of space created by the two ponds and the incorporation of secluded areas as well as very open areas create a multitude of experiences and make the garden seem much larger than its actual size. A clever combination of newly conceived and clearly traditional elements allows the viewer to see the

garden in many different lights. A contemporary styled eight-sided stone marker, which refers to a famous purification ritual of the eight directions, is carved from the foundation stone of an old torii (Shintō shrine entrance gate) and indicates the point of the water source in the pond. The edges of the stone stage are treated with special care—the dressed stone strips of the stage platform transform from being flat and smooth to rough and three-dimensional as they move toward the edges of the stage. Carefully constructed details such as these add meaning to the garden and create moments of *mitate* (re-seeing or seeing anew) where the viewer is surprised and suddenly sees the garden with fresh eyes and new-found clarity. This awakening of perception in the garden simultaneously enables a clear and new awareness of the self.

Above left The simple bamboo and wood Baiken-mon ("Plum View Gate") marks the entrance to the teahouse inner garden.

Above right Stepping-stones within the thick moss lead through the garden, connecting the *koshikake machiai* (waiting bench) with the Chokushinan teahouse.

Opposite page top The interior of the traditional Chokushinan teahouse features a simple yet sophisticated wood and bamboo structure and refined mud plaster walls.

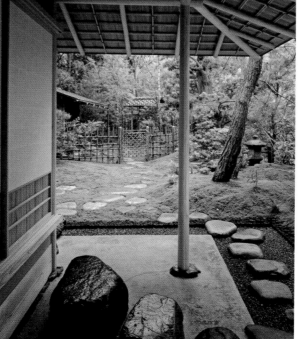

Right Moving though the inner garden and under the eaves of the teahouse, the stepping-stones grow in size and height as they approach the teahouse door.

Above A simple gutter made from bamboo poles catches water running off the roof of the *koshikake machiai* (waiting bench).

DESIGN AND CONSTRUCTION PROCESS:
THE KANTAKEYAMA SHINEN AT THE SAMUKAWA SHRINE

When someone decides to create something, they are not aware of what [they are going to make] and how they are going to make that thing until the moment that they actually begin. However, once they have started, they become completely absorbed in what they are doing and the unconscious mind instantly takes over. In other words, when the mind, hand, body, time, and materials merge into one, then an unconsciousness, which goes beyond the bounds of consciousness, is responsible for creating things.[1]

Shunmyo Masuno's process of designing and constructing Zen gardens is a direct result of his apprenticeship with garden designer Saito Katsuo and his Zen ascetic training. For Masuno, the

unconscious mind is actually a well-trained tool for creative thinking. "First and foremost I must calm my mind."[2] This is Masuno's initial step for both designing and constructing gardens. He seeks mental tranquility through meditation, which may be sitting meditation (*zazen*) or standing meditation (*ritsuzen*), depending on where he is. A calm, clear mind allows him to completely focus his concentration on the specific tasks at hand.

The first step in the design of the Kantakeyama Shinen at the Samukawa Shintō shrine was a visit to the site. Masuno met with the client and walked throughout the area designated for the garden. He made notes and sketches of existing features that could be integrated into the garden design and observed the surrounding context. "The whole garden becomes balanced with the surrounding scenery, and is formed by becoming

as one with its surroundings. If there is no surrounding scenery, the garden cannot be formed."[3] He learned from the client who the visitors to the garden were expected to be and the different ways the garden would be used. He also studied the history of the place, as "the site, and its history, must be itself engaged as a part of the whole garden which is in the making."[4]

Once armed with an understanding of the site in terms of its history, present conditions, and its immediate context, along with information regarding the intended uses and users of the garden and the clients' wishes for the design, Masuno commences his work on the garden design. Because he recognizes his design work to be part of his Zen practice, Masuno undertakes this work with the same discipline and focus that is required in all Zen training. From his training

Opposite page Each major element of the stroll garden (clockwise from top left: the stone path focused on the eight-sided stone marker, teahouse, tea pavilion, stone bench, and stage) has a specific relationship to the pond. Above: The eight-sided stone marker denotes the source of water for the Namba no Koike pond.

of his conscious mind with rote repetition through meditation, Masuno is able to tap into his unconscious mind in the design process[5] to "express the underlying spirit that prevails in a given space."[6]

As the goal of the garden is the expression of this "underlying spirit," Masuno imagines the atmosphere that he wants visitors to experience in each part of the garden. "I am always questioning myself how I want the viewers to feel when they gaze into the garden."[7] His focus is on the atmosphere of the garden, not on the forms of the spaces he creates or the shape of the elements he uses. Depending on the size of the garden, he may create a single ambiance for the garden—as is often the case in a small garden that is viewed from an adjacent building, or he may incorporate a variety of feelings into different spaces within a larger garden, as is the case at the Samukawa shrine.

The site of the Samukawa shrine encompasses three hectares (30,000 square meters or 7.4 acres), with the Kantakeyama Shinen occupying about 5,000 square meters (or 1.24 acres) of the property. The size and desired uses of the garden made it clear to Masuno that it should be a stroll garden (kaiyūshiki-teien). The extensive garden site includes land forms (such as a sacred mountain and rock groupings), water elements (including a stream, a pond, and waterfalls), and built elements (such a teahouse (chashitsu), a tea pavilion (chaya), a museum building, a temizusha (pavilion for ritual purification of the hands and mouth), a stage, gates, paths, bridges, benches, lanterns, lighting fixtures, etc.). The size of the garden and the number and variety of elements allow for varied experiences in different parts of the garden.

In order to determine the layout of the garden, Masuno starts with jiwari, the way of proportion-ally dividing land to determine the boundaries of the major elements—hills, ponds, and paths. For the Kantakeyama Shinen, many important elements already existed in the surrounding context, including the shrine buildings and a sacred grove of trees (chinju no mori), which had to be considered in the design. Masuno determined that the sacred grove would remain, of course, but it needed to be raised to have the proper significance in the garden. Having a hill in a garden makes "the garden appear more spacious," and "sometimes, by blocking the field of vision in the garden, artificial hills make people imagine what is behind the hill."[8] Increasing height in one part of the garden created the opportunity for a contrasting yet harmonious lower area that could utilize views of the new "mountain." The pond is this contrasting element, with its upper and lower areas separated by three tiers of waterfalls. Historically, when ponds were created in gardens, the earth that was removed for the pond was piled up to provide a hill in another part of the garden—creating contrast but also using the materials efficiently. Therefore, Masuno used the earth dug out for the pond to create Kantakeyama, the new hill for the chinju no mori. Due to the vast scale of the site, the garden construction had to be completed in two phases, with the excavation of the pond area and the building of the mountain for the sacred grove comprising the first phase. The second phase encompassed the remainder of the garden, including the rock arrangements and plantings, as well as the construction of the teahouse, tea pavilion, and a small museum relating the history of the shrine.

The balance of the spaces and elements in a garden is always foremost in Masuno's mind. He incorporates the principle of yohaku no bi, "the beauty of blankness or emptiness," designing spaces where "an invisible power exists, creating a deep mutual relationship between the items or parts."[9] Not only must the composition of elements form relationships and be harmonious, but the elements must relate to the sun and the form of the land as well. "Implementing designs while being conscious of the relationship between the sun and the typography [sic] of the land is an extremely important factor."[10] For example, Masuno notes that waterfalls facing north are always in shadow, so the depth of the arrangement is always visible. The depth of south-facing cascades, on the other hand, is hidden by the sun, so the horizontal distance between the levels of the cascades must be exaggerated in order for the depth to be understood.

The ways viewers perceive the elements in the garden are imperative to the design. Masuno incorporates aesthetic principles learned from his study of traditional Japanese arts into his designs. The principle ten-chi-jin (literally, "heaven-earth-human") is best known in the art of flower arrangement (ikebana). Ten-chi-jin is a method for creating a balanced composition with a central tall element representing heaven, a middle element symbolizing humankind, and a lower element in the front signifying earth. Although it is most often understood at the scale of flowers in a vase, the principle works just as well at the scale of plants in a garden, and allows a group of plantings to be appreciated independently as well as within the greater framework of the garden.

Another principle that Masuno employs in his gardens is known as shin-gyō-sō (literally, "formal-semi-formal-informal"). It is a system of categorization that allows a range of styles to coexist in a single harmonious composition. In garden design. The most obvious use of shin-gyō-sō is in the construction of paths. A straight path created

with cleanly cut rectangular stones of the same size is formal (*shin*). A winding path of rough stepping-stone of varying sizes is informal (*sō*). A path that is somewhere between these two extremes is semi-formal (*gyō*). The same goes for different types of stairs and walls—even plantings. Working with existing aesthetic principles such as *shin-gyō-sō* allows Masuno to be creative within an understood visual structure that can be applied to any design.

For projects like Kantakeyama Shinen that are located within a reasonable distance from Masuno's base at Kenkohji temple in Yokohama, he is able to visit the site multiple times and develop the design slowly. However, when he is designing a garden outside of Japan (or far from Yokohama), Masuno does not always have the luxury of time at the site. In the case of the garden at the Canadian Museum of Civilization in Ottawa, Masuno's initial visit was brief but very productive.

He was greeted at the airport by those assigned to meet him and escort him and his crew to the future garden site for a brief "get-acquainted" visit, and then take him to his hotel. He was dressed in his Sōtō Zen robes, his head shaved bald, and wearing glasses. It was late afternoon, a typically frigid day in late autumn with the temperature below freezing. He arrived at the site, studied it closely, and sat down immediately to survey the future garden area. The daylight was fast disappearing, and his reception committee asked if it was time to make their way to his hotel room. Focused on the site, and already making mental notes and plans, he informed them that he would not be needing a hotel room for he

would spend the night at the site. They insisted that it was to be an uncomfortably cold night, that snow was predicted, but he assured them that he would be fine, and that it was imperative that he begin his work at once.

The reception committee returned early the next morning, fearing that an international incident might well be brewing because of the untimely death of a landscape architect from Japan, who was left to freeze at the Museum of Civilization. What they actually found was a priest-designer, not only comfortable, but eager to show them the sketch that he had completed of the garden plans. Astonished as they were, there was still more to come. Not only had he sketched out the initial design, but he had sketched as well the shape, size, and estimated weight of each of the rocks that would be required. Together with his associates from Japan and the museum officials, he set out to locate the right rocks for the garden. He recalls that this was no easy task, but eventually the proper rocks for the project were identified. To the later surprise of the Canadians, the rocks, some of them weighing many tons, weighed-in at the weight he had anticipated in his sketch, within a few kilograms. Furthermore, he next indicated whether the rocks were to be placed in the garden right side up or upside down, and his sketch of what he wanted matched the unseen undersides almost as though he had been able to turn them over before transport. His imagination was accurate, as though he had an intimate acquaintance with each of the rocks that would adorn the museum garden.[11]

The intense mental focus and complete understanding of the nature of the materials used in the garden exemplified by this story demonstrate both Masuno's utilization of his Zen training in his design work and the creative capacity that he has developed from that training. These abilities come into play at every step of every garden design he completes. In the case of Kantakeyama Shinen, Masuno did not have to complete the design within the first twenty-four hours of visiting the site, but he did apply a similar energy and focus to each aspect of the design.

Once Masuno completed the initial design of the entire complex, including the basic design of the teahouse, tea pavilion, and museum, he met again with the client to explain and discuss the design. Based on the client's feedback, Masuno revised and continued to develop the design until both the designer and the client were satisfied with the results. At this point, the working drawings were completed and sent out to selected contractors for cost estimation, and the search for appropriate materials could commence.

Material selection is of utmost importance, as each element—each rock, each plant—is understood to have a spirit (*kokoro*). "How does one bring out the spirit, which lies within? The spirit must be tapped out through Zen philosophy held by the landscape designers, and utilized to create the special art."[12] Masuno's training and experience allow him to recognize and maximize the spirit of the garden elements. When designing, he is able to imagine the sizes, types, and spirits of each element. He then must locate the important rocks and plants. Some must be found in nature—like rocks that have been well weath-

DESIGN AND CONSTRUCTION PROCESS:
SAMUKAWA SHRINE WATERFALL

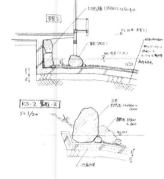

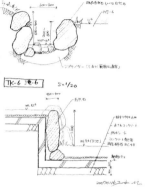

1

2

3

ered and trees that have been formed by the wind, and Masuno travels to the mountains to search for appropriate materials. Others, like stones that are used for benches or bridges, which can show the mark of the human hand, can be found at quarries.

Plants that are appropriate for traditional Japanese gardens are grown in nurseries in Japan. Therefore, certain plants are purchased from nurseries. In the case of Kantakeyama Shinen, some appropriate plants already existed on the site and were moved to fit with the new design. This was especially the case for the large trees in the sacred grove. Masuno and his team walked the site and selected the trees that would be replanted on the new "mountain." The trees were carefully wrapped for protection, painstakingly

dug out of the ground, and moved by crane to a temporary location.

Once the trees were safely out of the way, the various areas of the garden, as determined in the *jiwari* process, were outlined on the ground using lime. Because the designer works to bring out the unique qualities of the site, some elements were adjusted during this on-site outlining process, and the design drawings were then revised to reflect the changes. At this point the major land work could begin. Earth was dug out for the ponds and piled up for the mountain. As the mountain grew higher, a rock retaining wall was put into place to hold back the earth on one side and a concrete retaining wall (that later would be faced with stone) was constructed on the other side.

As this work progressed, the underground infrastructure such as wiring and piping was completed. Once the mountain was raised to the desired height, the large trees that had been moved from the sacred grove were replanted, and additional trees were also added. Masuno notes that "when planting trees, it is not sufficient to just plant the tree anywhere, one must appreciate the heart of the tree and listen to it to find out where it wants to be planted."[13] Using the principle of *shin-gyō-sō*, trees of one type are planted together to form, for example, a grouping of *shin* trees. Trees also are used to create shadows or to express contrast or elegance, especially in the ways they are trained and pruned to bring out their distinguishing characteristics.

Above Before the on-site garden construction begins, Shunmyo Masuno selects and measures the rocks to be used in key areas (1), constructs full-scale mock-ups of the most important components, such as the *ryūmonbaku* ("dragon's gate waterfall") (2), sketches the major elements (top: *ryūmonbaku*, above: three-tiered waterfall) and creates numerous drawings of the construction details (3).

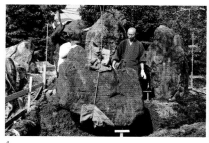

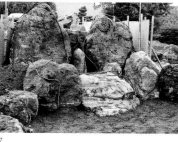

4 5 6 7

8

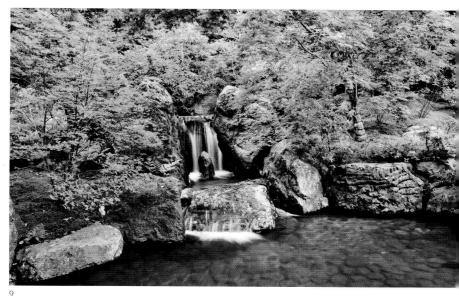

9

While the work continued at the garden site, the stone to be used for important elements such as the face of the retaining wall at the front of the sacred mountain, the stone plank bridge, and the stone bench were selected at the quarry. These elements, which reflect their shaping by hand rather than by nature, serve both specific functions and as scenery in the garden, often—as is the case of the bench—in contrast to the naturalistic elements. Masuno spent time with the workers at the quarry to select the stones and mock up the various elements. He drew a full-scale version of the stone retaining wall for the sacred mountain, so that the shapes and textures of the stones could be fashioned exactly as he designed them. These later were moved to the garden and erected in place.

While the stonework was under way at the quarry, Masuno oversaw the placement of the important large rocks in the garden, including the major rock groupings as well as the rocks that create the framework for the pond, stream, and waterfalls.

> The various expressions that can be found in Japanese gardens—power, calmness, tranquility, and elegance—all change depending on rock arrangements. . . . Because designers must stand at the scene and 'converse' with the space in the garden, it is hard for the design to turn out as planned. Japanese gardens never can be formed by drawing up a plan alone. When arranging rocks, one must "converse" with the rock and wait until it seems to speak and say where it wants to be put.[14]

As the rock groupings were positioned, the stone plank bridge was moved into place, with large rocks used to hide its base and create an edge where the stream flows beneath it. Masuno also supervised the placement of the stone basin (*chōzubachi*) for the *temizusha*, checking the height of the basin and the spacing of the stepping-stones leading to it. The placement of the stepping-stones is crucial, as they control both the visitor's walking speed and the view while walking on them.

Above Shunmyo Masuno supervises the placement of each major rock in the mock-up of the *ryūmonbaku* ("dragon's gate waterfall"), as they are lifted into place with a crane (4, 5, 6). Once placed, the rocks are marked with a chalk line to show the intended water level (7) before the arrangement is disassembled and trucked to the site. At the construction site, Shunmyo Masuno supervises the reassembly of the rocks, adjusting them for the view from the Warakutei tea pavilion (8), so that the final composition creates the intended feeling of a powerful mountain waterfall (9).

DESIGN AND CONSTRUCTION PROCESS:
SAMUKAWA SHRINE POND

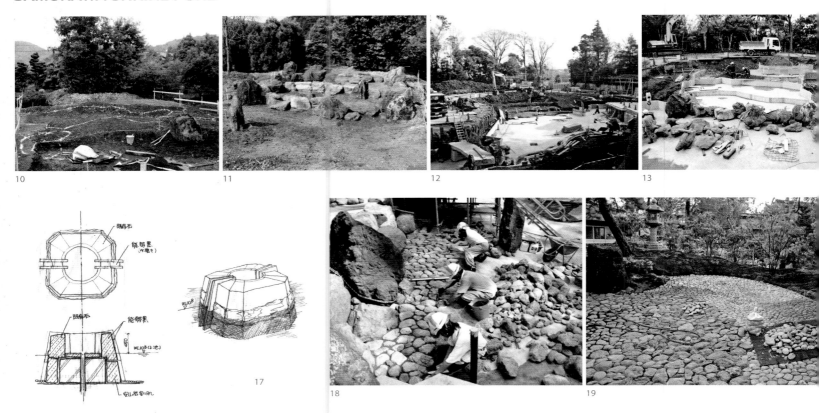

10

11

12

13

17

18

19

After the major elements were positioned, the concrete base and low walls for the pond were poured. As the concrete work continued on the upper level of the pond, the rocks for the waterfall were moved into place with cranes. At this time, all other concrete foundations—for buildings and paths—also were constructed, such as for the pavilion for *ryurei*-style tea ceremony at the edge of the lower pond. Concrete work also continued for the floor and walls of the small museum building.

While all this work was under way at the construction site, the wood buildings included in the design—the teahouse and waiting bench, the *ryurei*-style tea pavilion, the entry gates, and the *temizusha*—were being fabricated by carpenters off-site. Based on the initial designs by Ma-suno, the carpenters cut each wood member to size and temporarily assembled the buildings. Masuno and the clients visited the carpentry shops to check the proportions and design of the *temizusha*, the teahouse waiting bench together with the stepping-stones leading to it, the teahouse, and the pavilion *for ryurei*-style tea ceremony.

Masuno worked with specialty stone masons at their workshop to design and fabricate a stone lantern for the garden. Based on Masuno's sketches, a full-scale drawing of the lantern was completed and used for the production of the lantern. Such a stone lantern serves two functions in a garden. One is practical—to create a soft light for viewing the garden at night, and the other is aesthetic—to accent the design and "raise the elegance of the garden in all parts people view."[15]

After the completion of the concrete work on the site, the next layer of elements was staged to be put into place. Scaffolding was erected in the areas where the buildings were to be constructed, such as the *temizusha* and the entrance gate. Gates and doors play important roles in the garden and must relate to human proportions. They can express grandeur if they face out from the garden, or they can be designed to be lighter and less formal, if they are sited within the garden.[16] The built elements were disassembled in the carpentry workshop, trucked to the site, and reassembled in place. As the construction of the

Top row A key element of the pond, the three-tiered waterfall, is modeled on a temporary site, starting with basic excavation and an outline of the rocks (10). The completed mock-up allows the designer to check the spacing and proportions of each tier as well as the waterfall as a whole (11). At the garden site, the pond and waterfall are excavated and a concrete foundation is poured before the rocks are placed in the predetermined arrangement (12, 13). As the construction of the three-tiered waterfall continues, trees and major plantings are added (14), with additional greenery added in the final steps to create the complete composition of rocks, water, and plants (15).

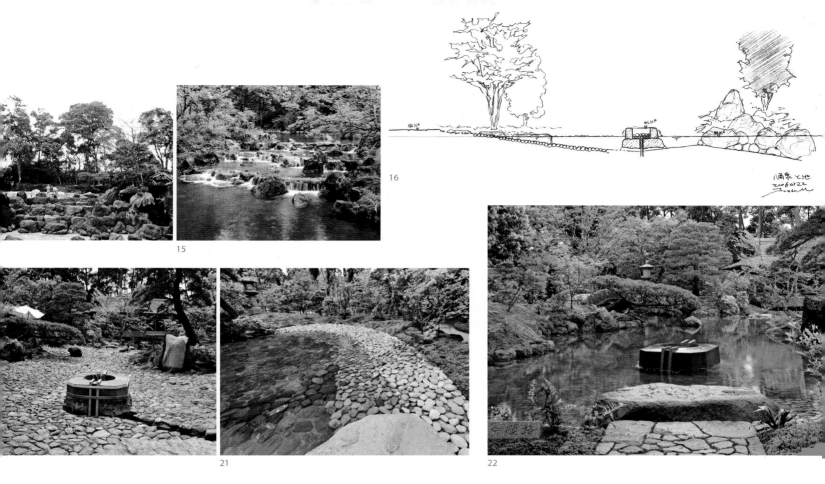

15

16

21

22

buildings was concluding, Masuno supervised the placement of additional plants, such as large, very visible trees, and the fabrication of the earth-covered bridge (*dobashi*). For the bridge, first the form was mocked up using a plywood template, then the structure was built out of wood, and finally the wood structure was covered with layers of earth.

With each consecutive step in the construction of the garden, the scale of the work decreased and the level of detail increased. Medium-sized and small rocks were arranged around the waterfalls and bottom of the pond, and plants were used to balance rock arrangements and fill in gaps. Lighting equipment was installed, concealed as much as possible, such as in and

around the stone bench, and tested. Objects such as the stone lantern were installed in their proper places, and the water levels in the ponds, streams, and waterfall were checked. The final details—small plants, gravel for paths, ground coverings such as moss on the earthen bridge, light bamboo fences and moss in the garden leading to the teahouse, and signage—completed the garden.

These final elements create focal points and unify the various parts of the garden. For example, Masuno chose moss as a ground covering to give the impression of "wet" (as opposed to grass which is perceived as "dry")[17], to connect the image of the planted areas of the garden with the water elements. The fences and hedges

divide and define space, but they also serve as scenic elements, especially in the case of the bamboo fences in the garden leading to the teahouse. The stone basins and lanterns create moments of focus in the garden, where the mark of the human hand contrasts the natural scenery of the garden.

For Shunmyo Masuno the process of garden design and construction is both practical and spiritual but always tied to Zen. Even the moment of completion he understands through his Zen training. "I always feel at one with the plants when I am planting them and the stones, when I am arranging them. This is the moment when you know instinctively that everything is right, the moment of realization."[18]

Bottom row The eight-sided stone marker denoting the source of the water is designed to appear as a man-made element within the naturalistic pond (16, 17). Workers lay rocks over the concrete base of the pond (18), with smaller rocks toward the edge and larger rocks in the middle (19) and around the stone marker placed near the center of the pond (20). For the completed composition, river rocks cover the base to create a beach-like edge (21), and water fills the pond around the eight-sided marker (22).

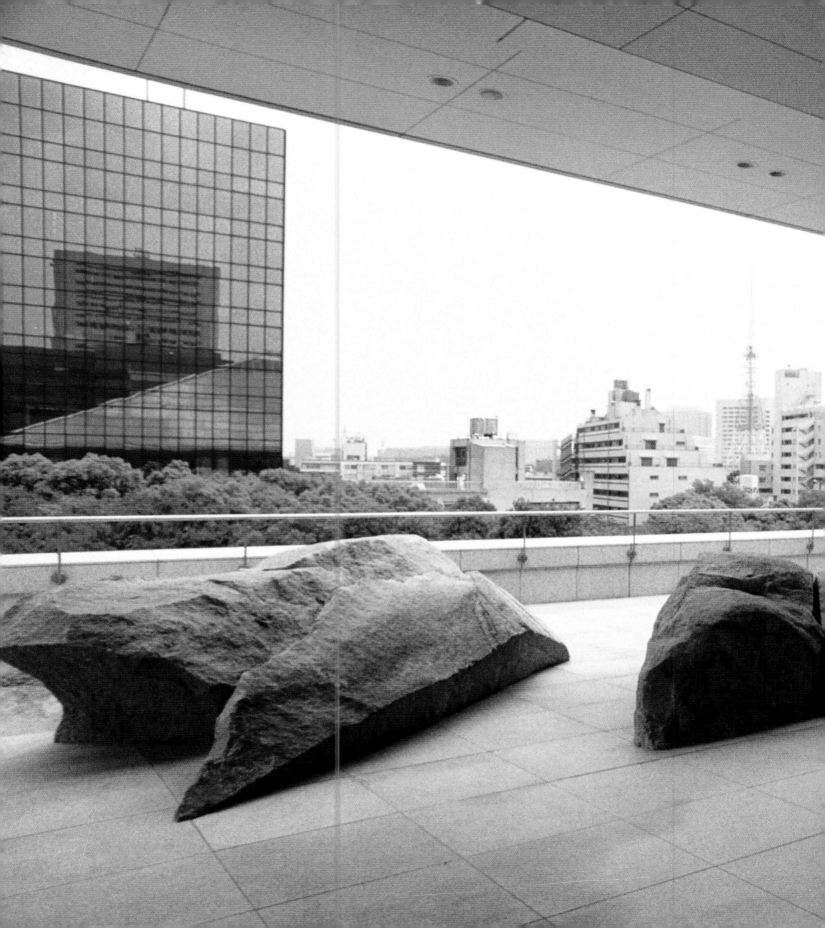

CHAPTER 2

MODERN
GARDENS

MODERN ZEN GARDENS:
THE ESSENCE OF EMPTINESS

"It is impossible to talk about Japanese gardens or beauty in Japan without mentioning 'empty space.'. . . This 'empty space' has its origin in Zen thought. In Zen the state of one's mind is not conveyed through letters or words, but attempts are made to condense everything through silence."[1] Silence and empty space anchor every garden that Shunmyo Masuno designs and are particularly vital in his contemporary gardens. This understanding of silence as a concentration of all one's thoughts while also being mute or wordless, is mirrored in the Zen concept of emptiness. In his seminal text *Zen and Japanese Culture*, Zen master Daisetz T. Suzuki explains emptiness as "an intuitive or experiential understanding of Reality [that] is verbally formulated as 'All in One and One in All.'"[2] This is an emptiness that is at once both empty and full.

In Zen gardens, this emptiness or silence is concentrated in the spaces between elements such as rocks and trees. "In this space an invisible power exists, creating a deep mutual relationship between the items or parts. When the parts are trimmed back as far as they can go, . . . the essence of the work appears, and 'empty space' comes to hold a great deal of meaning."[3] By being a container of meaning, the empty space also can be understood as being full.

In traditional Zen gardens, this empty space or silence is most easily understood visually through the use of white pea gravel (*shirakawa-suna*) as a foreground element or a white plaster wall as a background element. These formal compositional elements are treated as two-dimensional planes that connect and offset the three-dimensional elements in the gardens. Although a bed of white pea gravel may contain meaning as being representative of a stream or ocean, it also takes on meaning as

the connector of the other elements in the garden. In the same way, a wall has meaning as an edge or a boundary, yet it also serves as a silent backdrop for the composition of elements in front of it.

In his modern Zen gardens, Masuno does not always employ a bed of gravel or a white wall to express this connection—this silence or emptiness. He may use a grid of stone pavers, such as in the Canadian Embassy garden or the National Institute for Materials Research, or an expanse of grass as at the Niigata Prefectural Museum of Art. When space is limited, such as in the residential garden Yui no Niwa Shinshōtei, Masuno incorporates the sky into the garden as the element of silence.

Just as the concept of silence or emptiness may take different physical manifestations in Masuno's modern Zen gardens than in his traditional designs, typical elements such as waterfalls, streams, and ponds also may take unusual forms. While his traditional Zen gardens utilize variations of forms developed over centuries, Masuno's modern Zen gardens often employ unusual forms for these elements. For example, the gravel stream in the garden at the National Institute for Materials Science starts in a triangular bed of gravel and ends in a rough circle around a large rock "island." The meandering form of the stream allows it to be understood as a stream, albeit a very abstract version of an element that already is an abstract representation of nature in a typical traditional Japanese garden.

These abstractions, whether traditional or modern, are understandable because they exhibit the essential qualities of the element as it exists in nature. In the *Sakuteiki* (*Memoranda on Garden Making*), an eleventh-century text on garden design, an important point is to observe nature to understand its essence. The way to create a naturalistic element in a

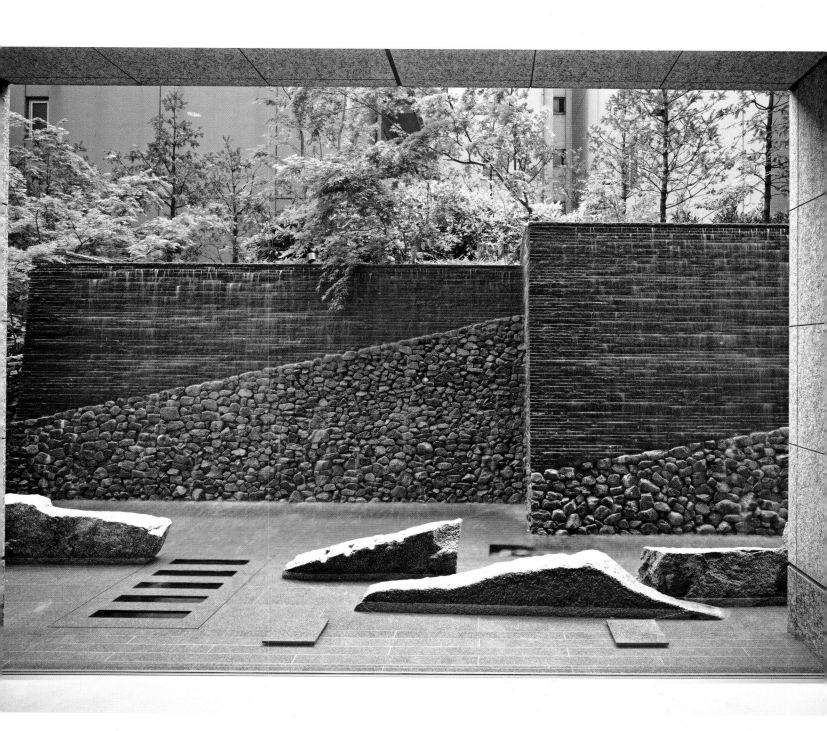

Previous page With views to the city beyond, the large, stark rocks in the garden on the fourth level of the Canadian Embassy in Tokyo appear to grow out of the stone-tiled floor.

Above Framed within the structure of the Hotel Le Port building, the composition of the tall walls of water and stone, backed with layers of greenery, and the carefully positioned rocks in the foreground create a moment of serenity within the bustling city of Tokyo.

garden then is to express that essence of the element in nature. In traditional Japanese gardens, these elements already are abstractions, but in Masuno's contemporary gardens, he pushes the abstractions even further—yet he carefully retains the essence of the element, so it is still understood as what it is meant to represent.

This idea of expressing the essence of a natural element in a garden is another aspect that Masuno pushes in his contemporary designs. In some cases, he emphasizes the essence of an element by accentuating the natural qualities of its physical material. For example, several of the rock "mountains" that move across the garden at the National Institute for Materials Research feature long grooves carved into their sides. This intentional marking of the rocks underscores the weight and density of the material. A more extreme example is the design of the pyramid-shaped stone "mountains" at the Canadian Embassy garden. Sheathed with the same grid of stone that covers the floor surface, the mountains are at once heavy and solid yet also can be understood as thinly coated—a very contemporary understanding of the quality of stone made possible only by industrial processes.

Another variation from tradition in some of Masuno's modern Zen gardens is the incorporation of broad layers of horizontal space. Historically,

Top left Delicate stalks of bamboo grow within the rock-covered base of the entrance garden to Yui no Niwa Shinshōtei.

Above Within the expansive Fūma Byakuren Plaza of the National Institute for Materials Science, enormous etched boulders are focal points.

Top right The granite curbs in the Seifū Kyorai no Niwa rise out of the ground as they curve toward the library building.

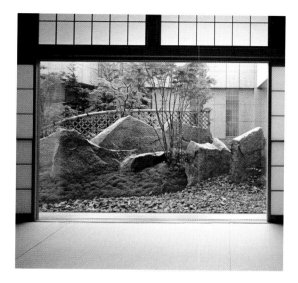

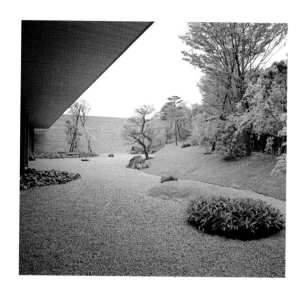

a large Japanese stroll garden was designed as a series of scenes, often based on images from literature or renowned actual landscapes. The point of the experience was entertainment, similar to reading a book or traveling. The viewer moved through the scenes by following a path linking the spaces of the scenes in a planned sequence. Several of Masuno's contemporary gardens are expansive enough to be designed as consecutive scenes, but instead he created a sequence of spaces utilizing horizontal layers. For example, in the garden at the Niigata Prefectural Museum of Art, the landscape connects the museum building to the nearby river by means of a progression of horizontal spaces—almost tiers —that move between the level of the riverbank and the rooftop garden. Rows of stones and varied plantings define the layers along the ground plane, rather than expressing spatial divisions with vertical elements. Therefore, instead of perceiving discrete, complete garden scenes, the viewer sees long vistas comprising multiple layers, which increases the senses of distance and connectivity in the garden.

Traditional Japanese gardens typically are constructed on the ground, but many of Masuno's modern Zen gardens are located in places that do not touch the ground. The Canadian Embassy garden is four stories above the street level, and the main gardens in the Yui no Niwa Shinshōtei are on multiple levels of rooftops. Although Masuno could design traditional gardens in these locations, because of their siting as well as their uses, he instead chose to incorporate contemporary design elements.

Although many traditional gardens were designed for entertaining, Masuno has been asked to incorporate new uses that correspond to a changing contemporary lifestyle in some of his gardens. For instance, the garden at the National Institute for Materials Research includes areas for researchers to gather informally to discuss their work. The dining and sitting terraces in the Yui no Niwa Shinshōtei are another example. Because of the diminutive size of these garden spaces, the main feature is a dining table or patio. Yet Masuno manages to incorporate these contemporary functions into a unified design and still focus on the essence of a Zen garden.

The essence is the silence, the emptiness that holds the true meaning of the garden. Contemporary forms and uses may alter the initial perception of a garden, but the power of the empty space always is predominant. Whether it is the sky in the dining patio in the Yui no Niwa Shinshōtei, the grid of stone creating the ground plane at the Canadian Embassy garden, or the traditional *shirakawa-suna* (white pea gravel) at the Hofu City Crematorium, the "empty space" is always fully present.

Top left Sliding shoji screens open to reveal a framed view of the Seizan Rokusui no Niwa at the Hotel Le Port.

Top right One of the eight gardens within Yūkyūen at the Hofu City Crematorium, the Shizume no Niwa creates a feeling of calm.

首都大学のキャンパス
NEW CAMPUS FOR TOKYO METROPOLITAN UNIVERSITY

TAMA NEW TOWN, TOKYO, 1991

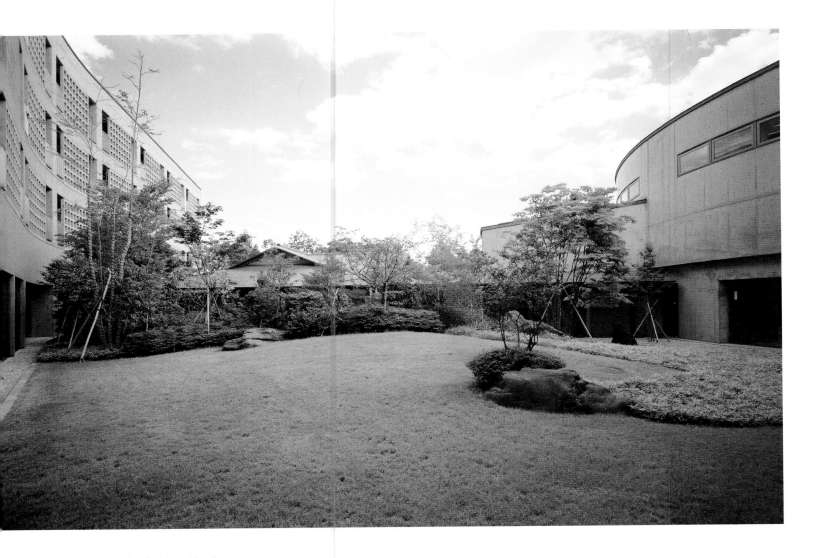

Above The garden for the International House features an open expanse of lawn and an area of dense greenery adjacent to the traditional teahouse.

When the Tokyo Metropolitan University moved out of central Tokyo to a larger campus in the southwest suburbs, it provided an opportunity to connect the university with nature in ways that were impossible in the crowded center of the city. Moving northward through the extensive new campus from the formal quadrangles of the Arts buildings at the southwest end, the visitor is drawn through the site by trees, which provide a feeling of comfort and a continuous tie to nature.

Shunmyo Masuno's design for the outdoor spaces of the campus is based on the "Five Elements of Buddhist thinking"[1]—soil, water, fire, wind, and air. Air is wide-ranging; it embodies the other four elements and represents the "world of enlightenment," which Masuno likens to the world of the university as a place of learning. The remaining four elements, soil, water, fire, and wind, are the design themes for each of the zones of the campus—Arts, Sciences, Common Facilities, and Sports.

"Soil" is the theme for the Arts Zone, where the undulations of the ground surface allow for a physical sensation of the abstract idea. For the Sciences, "water"—the basis of all life—is used to connect the formal architectural elements in the center of the campus to the gentle yet wild beauty of unrestrained nature at the edge of the campus. The energy of the students when they gather in the Common Facilities Zone generates the "fire" needed to maintain balance on the campus.

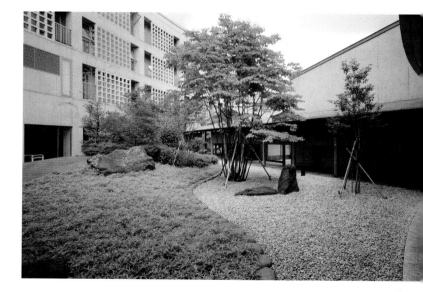

Top The expansive new campus for the Tokyo Metropolitan University combines formal paths and gardens leading through the center of campus with more naturalistic gardens at the edges.

Above Designed to be viewed both from the ground level and from the rooms above, the gravel area of the garden at the International House is carefully balanced with trees, rocks, and ground cover.

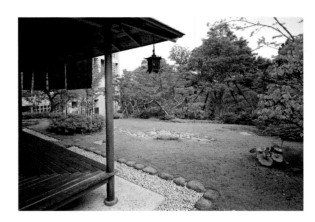

"Wind" is the theme for the Sports Zone, where the weight and immobility of the earth and the infinite lightness of the sky represent the athletes' ultimate competition.

As one enters the campus at the Arts Zone in the southwest end, the plantings both reinforce the formal layout of the buildings and create a soft edge at the boundary, blending the greenery of the campus into the surrounding nature. Flanked by trees, the main path slopes slightly down to the rest of the campus. Rough stone curbs, angling out of the ground and expressing the undulation of the earth, define the spaces of the trees planted along the walkway and point toward the common facilities in the center of campus.

The library and student center are two of the common facilities that connect the Arts Zone to the Sciences. In this area of the campus, the buildings and path are closer together, creating a sense of a critical mass of energy—the fire of the students' vitality and power. The International House with its traditional teahouse sits at the southeastern side of the Commons Zone. Here the open landscape swells into a lush traditional Japanese garden, giving the international students and faculty a sense of the historic culture of Japan. The naturalistic landscape that surrounds the campus edges pulls in close to the buildings, while a long double line of trees connects to the Science Zone.

A sculptural pool of water set symmetrically between the buildings housing the Faculties of Science and Technology is the principal feature of the Science Zone. On axis with the geometric pool, the view to the southeast reveals a large naturalistic pond adjacent to the Science and Technology Lecture Hall. The curved wood deck under the Lecture Hall is a popular spot for students to gather and enjoy the views across the pond. A few arrangements of rocks and prominent trees, such as willows and red maples, are dispersed along the grassy bank, set off from the thick forest backdrop. The scene is tranquil and gives a feeling of openness while being softly enclosed by nature.

From the Science Zone, the row of trees continues to the Sports Zone at the northeast end of the campus. Along the way, the spaces between the gymnasium buildings reveal glimpses of long vistas over the surrounding landscape. Tall trees arch over the walkway and frame a view at the end of the axis. A hill slopes gently upward, and the vertical columnar stone elements of the Kaze no Gekijo ("Wind Theater") sculpture march up the slope, drawn by the wind to the sky.

Top left Water is the theme of the formal courtyard garden at the Faculty of Urban Environmental Sciences, with its central reflecting pool featuring an abstract metal sculpture.

Top right The *engawa* (veranda) and overhanging eaves of the traditional teahouse extend out to connect to the garden at the International House.

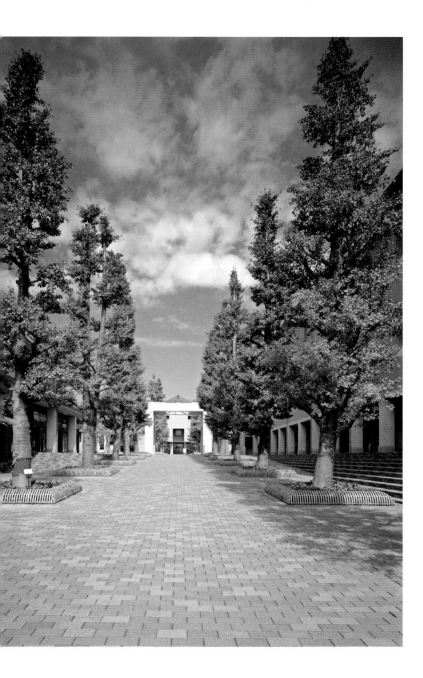

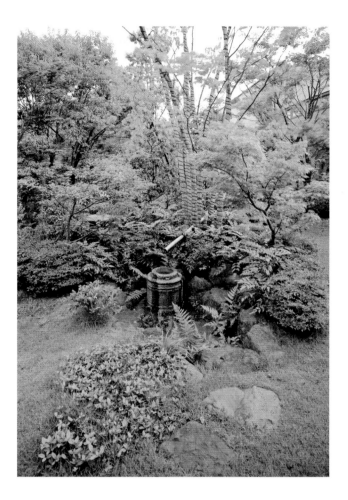

Above Ginkgo trees that were moved from the old campus line the main approach from the south gate between the Student Support Center and the Auditorium buildings.

Top right Rough stepping-stones lead to a sculptural stone *chōzubachi* (water basin) in the teahouse garden at the International house.

Above The geometric columns of stone in the Kaze no Gekijo ("Wind Theater") sculpture march up the hillside at the northeast edge of the campus.

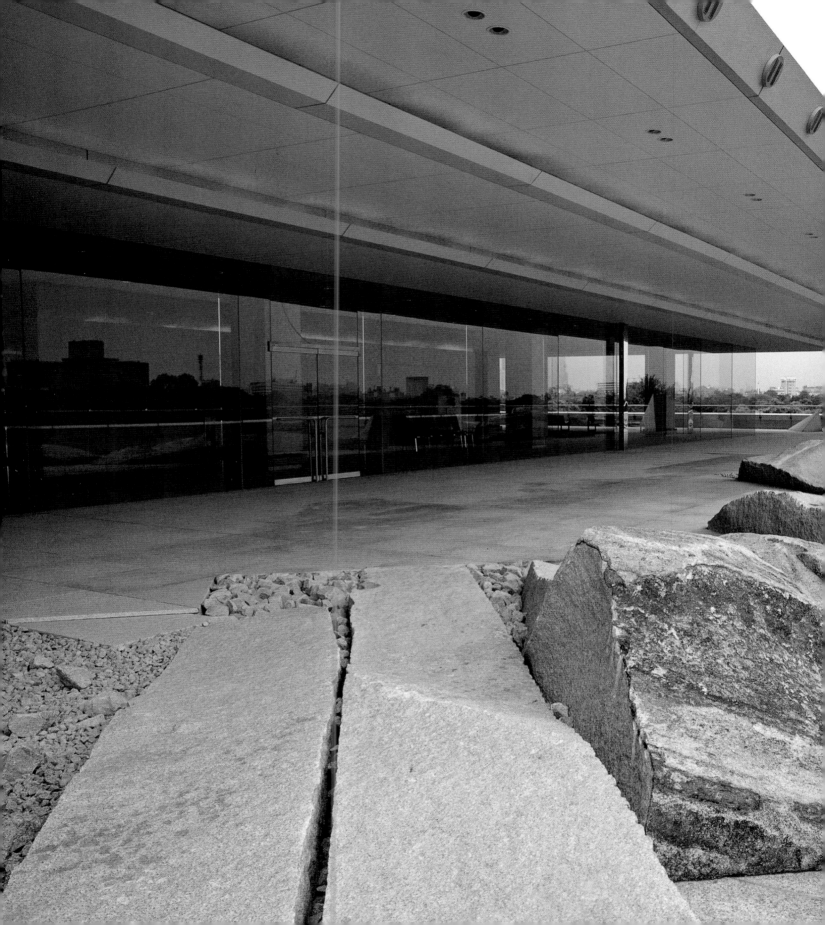

カナダ大使館の庭
THE CANADIAN EMBASSY, TOKYO
MINATO-KU, TOKYO, 1991

The Embassy of Canada is located on a major road in a busy area of Tokyo. Built in 1991, the contemporary building rises four stories and features a long sloping roof. Across a busy road on the north side of the embassy is the verdant foliage surrounding the Akasaka Palace, while the tall trees of the Takahashi Memorial Garden flank the east side of the building.

Located on the fourth floor reception level, the garden is not apparent to passersby. A long narrow escalator on the east side of the building is the only hint of something unusual above. At the top of the escalator, the granite floor surface leads the eye to the garden wrapping around the glass-enclosed lobby and reception areas. The long low canopy of the roof shelters and contains the garden, which represents the countries of Canada and Japan. The design incorporates geographic references from the Atlantic Ocean in the southeast corner near the top of the escalator, to the Pacific Ocean in the northwest corner, and on to Japan along the west side of the building.

The main idea of the design was to create a space where people who visit or work at the embassy—the people who link the countries of Canada and Japan—could contemplate their roles in connecting the two different lands. These differences are represented in the garden with the stark grandeur of Canada's landscape and Japan's delicate detail. The garden is designed for contemplation, whether viewed from the glass-enclosed interior spaces or while walking through it to experience the various landscapes it embodies.

Left Connecting the fourth-floor embassy reception rooms to the outside garden space and views beyond, the contemporary symbolic landscape representing the mountains of Canada is an austere and highly crafted composition in stone.

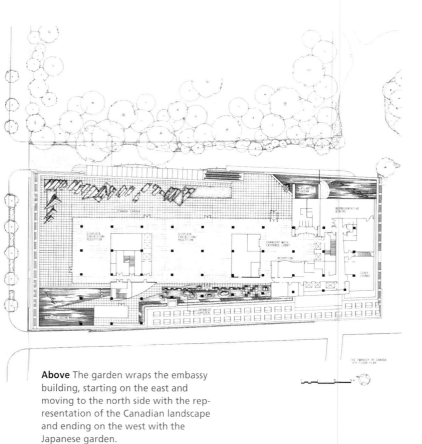

Above The garden wraps the embassy building, starting on the east and moving to the north side with the representation of the Canadian landscape and ending on the west with the Japanese garden.

The grid of granite pavers connects the diverse parts of the garden to each other and to the interior spaces of the lobby, exhibition, and reception areas. From the pond and wide waterfall in the southeast corner symbolizing the Atlantic Ocean and Niagara Falls, the surface continues outside on three sides of the building. Moving north along the east side of the garden, the geometric grid of the stone flooring peels away to reveal a bed of gray gravel, representing the indigenous Canadian culture. The unpretentious rectangular bed of gravel is broken by the sudden emergence of rough strips of granite rock, set at a forty-five degree angle.

The granite strips start out low to the ground but slowly build in height as they move along the east side of the garden toward the north-east corner. The stones were used just as they came out of the quarry in Hiroshima Prefecture, with drill marks and broken edges exposed to show the rough quality of the Canadian landscape. At the corner, dark rocks piled high represent an Inuksuk, a stone landmark symbolizing the native Inuit culture of the Canadian arctic. As the garden turns along the north side, the angled granite strips become very geometric, changing into slanted pyramids rising from a bed of gravel set into the granite floor. These are the majestic Canadian Rockies, pointing out to the grand vista beyond the space of the garden. The thick green tree-tops of the adjacent gardens serve as a backdrop for the stone and water Canada garden—an excellent example of *shakkei* (borrowed scenery).

The mountains diminish in size as the space continues to the northwest corner, where the second pond represents the Pacific Ocean. The walkway narrows next to the pond and leads to three cantilevered stone steps. At the top of the steps are circular stepping-stones that cross the water to a triangular peninsula within the "ocean." A steady stream of water gushes from a high spout, blocking out the noise of the street, invisible four stories below.

The triangular peninsula points north toward the Akasaka Palace grounds, but the path continues to the south, moving along a curved wall of the building with no specific view but hinting of something in the distance. The curved wall leads to the more enclosed Japanese garden, representative of the country of Japan. With no view to nature beyond the building on the west side, the Japanese garden is inward-focused. A tall hedge marks the western boundary of the garden, containing the view and adding the only element of greenery. In front of the hedge is a curved bamboo fence, which conceals the parapet of the building and adds another layer of space to the garden. The garden itself is a composition of rock and stone. The granite grid of the floor surface continues, flanking the garden on the east side and connecting it to the reception space inside the embassy. Adjacent and set within a bed of raked light brown gravel, a checkerboard of the identical dressed granite stones is interspersed with same-sized squares composed of gray river stones. Carefully chosen to contrast yet harmonize, several prominent rocks with striking markings are set at intervals within the gravel. At the far end of the garden, two separate large rocks in a balanced composition complement each other—and represent Japan and Canada in their ideal relationship.

Opposite page top In the Japanese garden, the stone-tiled floor gives way to *nobedan* (stone-paved walkways) set into a bed of raked gravel studded with beautifully figured *tateishi* (standing stones).

Opposite page bottom right An aerial view of the Canadian Embassy shows its location along a busy road in the Aoyama area of Tokyo and the expansive roof over the fourth floor garden.

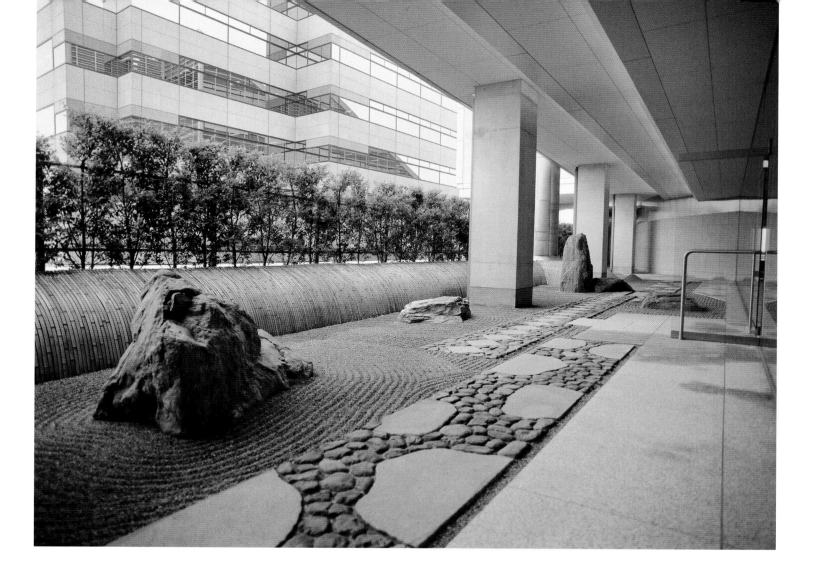

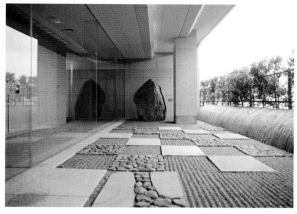

Above The *nobedan* (stone-paved walkway) and tiled floor give way to a checkerboard pattern at the southern end of the Japanese garden.

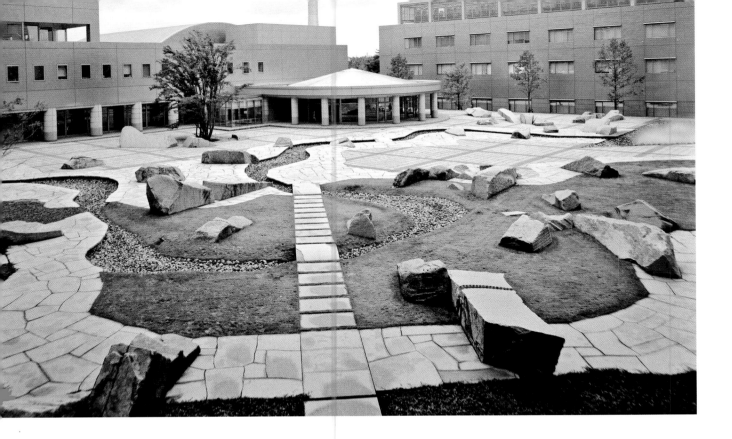

風磨白錬の庭
FŪMA BYAKUREN PLAZA

NATIONAL INSTITUTE FOR MATERIALS SCIENCE

TSUKUBA, IBARAKI PREFECTURE, 1993

Although the plaza garden for the National Institute for Material Science (formerly known as the National Research Institute for Metal) bears no resemblance to a traditional Japanese garden, it does share one fundamental rule—the garden is an "'expression of spirit,' . . . the essence of traditional Japanese art."[1] Shunmyo Masuno identified the appropriate spirit for this garden based on man's first encounter with metal. He imagined the prospectors during the gold rush in the United States and the rough nature they encountered. He envisioned a landscape with dry earth, little greenery, few trees, and very scarce water and pictured the prospectors gathering around the source of water to renew themselves and share stories. He observed a connection between the great individual efforts of the prospectors of yore and the researchers of today, both fighting a "solitary battle."[2]

Surrounded by research buildings on all sides, the organic shapes of the garden elements create a strong contrast to the rectilinear forms of the buildings. From the main exit of the research institute into the garden, the garden appears as a series of horizontal layers. A geometric grid of stone pavers covers the ground surface, broken here and there by huge thick strips of rough rock or an occasional tree. As the pavers approach a dry stream bed, the rigid geometry changes, and the size of

Above A straight path of rectangular stepping-stones leads from one corner into the heart of the expansive courtyard garden, cutting through irregularly shaped layers of stone and ground cover.

Opposite page top The dry stream of river rocks winds through the garden, punctuated at one end by a large boulder.

Opposite page bottom The design of the Fūma Byakuren Plaza relates to the geometry of the National Institute for Materials Science buildings as well as to both the rational and creative minds of the scientist.

the paving stones grows and creates a less formal surface. To the viewer, this transformation of materials suggests movement and change over time.

Filled with river rock and set slightly below the ground surface, the dry stream bed winds through the plaza, narrowing and widening as if formed over centuries by the forces of nature. The source of the stream is a triangular bed of the same river rock. A light mist emanates from the within the rocks, creating a moment of softness in the hard landscape. This represents the spring where the prospectors gathered to refresh themselves. The stream bed cuts through the pavement, flowing past boulders that appear to have been placed by nature's force long ago and crossing into a grassy area tucked into a corner of the site. The stream ends near the opposite corner from its origin, with a large boulder set in the middle of it.

The chunky strips of rock interspersed throughout the plaza are oriented in predominantly the same direction, like mountains formed by the forces of wind and water long ago. These rocks and the few trees in the plaza add height to the composition, and the enormous rocks radi-

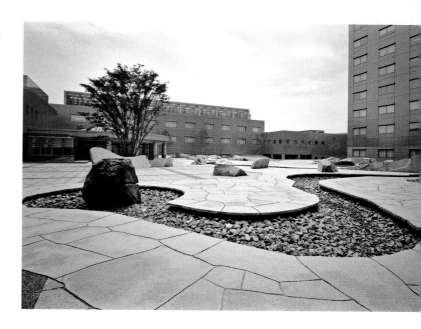

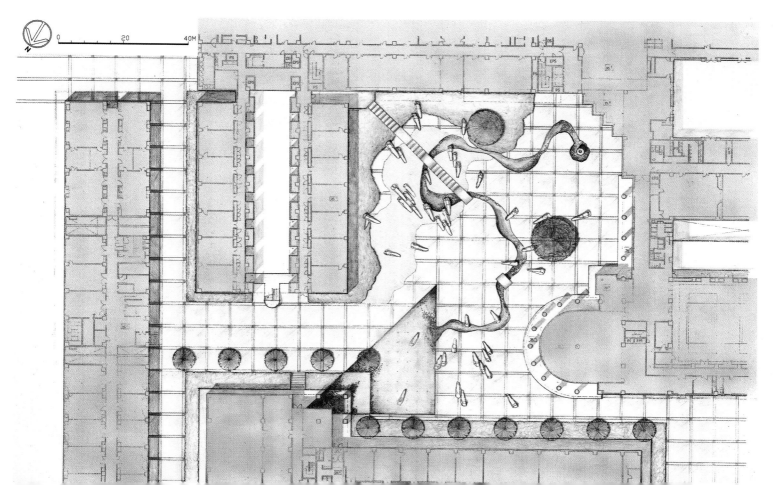

ate the power and grand scale of nature. The surfaces of the rocks are rough, expressing the broken edges as they were quarried. Some show the drill marks from the quarry, while others have been chiseled to express the hand of man. These details draw in the viewer and, through their contrasting size, add to the grand scale in the garden. As one follows the rocks, progressing from the stone surfaced plaza, across the stream bed and into the corner area blanketed in green, the endpoint is a casual, inviting place where the researchers can gather and share ideas. The name of the garden, Fūma Byakuren, relates to the rough and smooth surfaces of the rocks and refers to the wind polishing and penetrating the pure *kokoro* (mind/heart) of the researchers.

Two narrow stone paths cut across the grass and ground cover to connect secondary entrances to the stone-paved surfaces in the garden. One path is organic in form, with softly rounded stepping-stones curv-ing slightly through the greenery and stopping just at the edge of the paving. The other path is straight and fast—rectangular stones cutting straight from one corner toward the main entrance in the opposite corner. This path is a strong element, continuing unbroken through a strip of the organic stone paving that snakes through the grass and over the dry stream bed in two places. Rather than stopping short of the paving at the end, it carves into the paving with its final rectangular stone bridging over the stream bed. This straight path and the triangular bed that is the source of the stream are two inorganic forms—the mark of human intervention—within the naturalistic landscape. The scale of the path allows for only one person to traverse at a time, and the misty rock bed also discourages gathering. The places to gather are in nature, where the hard rock gives way to vegetation—where the researchers can find respite and camaraderie in the landscape.

Above Representing the contrast of the man-made and the natural found throughout the plaza, this enormous wedge of stone is polished to a reflective surface on one side and left rough on the other.

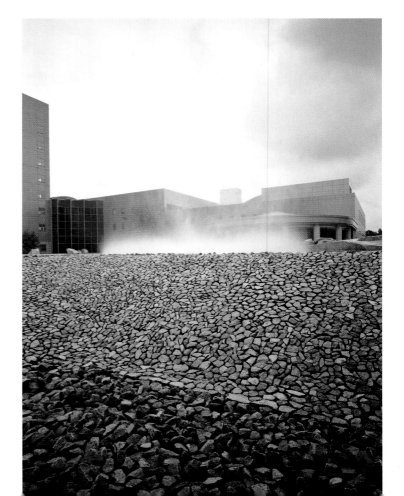

Right A mist rises from a corner of the garden, moistening the dry landscape and creating a sense of the unknown.

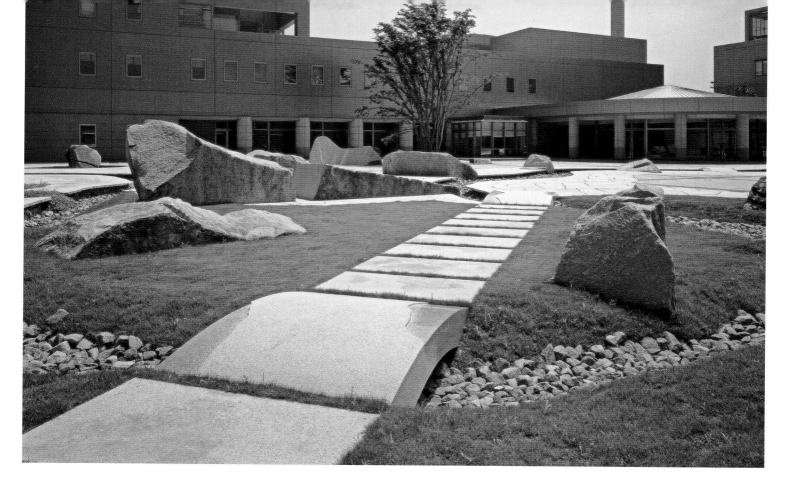

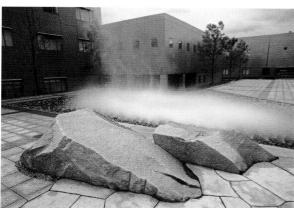

Top Relating to the rational mind, the straight path of rectangular stepping-stones crosses the rock stream with a gently arching granite slab.

Above Juxtaposed with the adjacent weighty rough boulders, the thick mist mysteriously emerges from the triangular bed of rocks.

Right Viewed from above, the combination of man-made and naturalistic forms and geometric and organic patterns in the design of the plaza connect to both the rational and the intuitive nature of science.

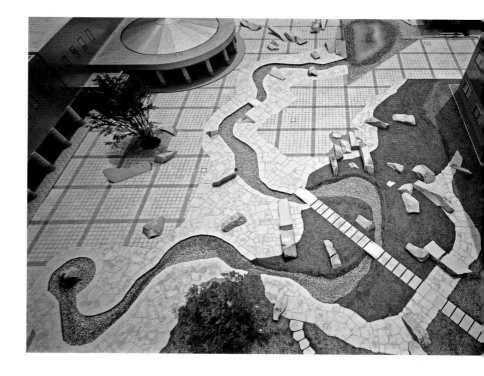

新潟県立近代美術館の庭
NIIGATA PREFECTURAL MUSEUM OF MODERN ART

NAGAOKA, NIIGATA PREFECTURE, 1993

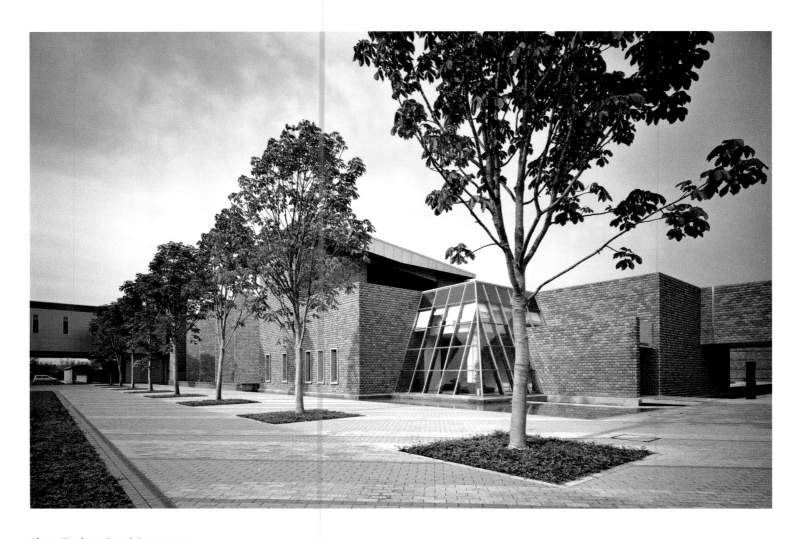

Above The formality of the entrance plaza, with its diagonally striped pavement surrounding a line of trees planted in square beds, harmonizes with the geometry of the museum building.

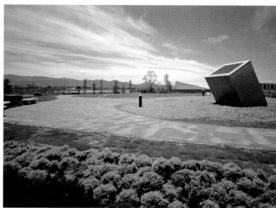

The formal design of the landscape in front of the entrance to the Niigata Prefectural Museum of Art, with its diagonally striped stone pavers and double row of trees, belies the complexity and organic quality of the expansive landscape on the south and east sides of the museum. When it was first built on its site adjacent to the Shinano River, the museum was located at a distance from Nagaoka City, but the growing city has encroached upon the museum. In his design of the landscape, Shunmyo Masuno anticipated the museum's role as a mediator between the human-built city and nature as embodied by the river.

Masuno's design concept is rooted in utilizing the two axes of time and space to create harmony for man and nature, with the river as the starting point. The river represents time—time flowing from the past to the present and on to the future. It also suggests the reverse flow, from the present back to the past, which humans cannot physically achieve but can accomplish mentally. The idea of movement both forward and backward in time on a single axis was a theme embedded in the design of the landscape.

The museum buildings seem to grow out of the earth, especially when viewed from the riverside. Half of the museum space is built underground, allowing the building to keep a relatively low profile on the land. From the walking path that parallels the river, the broad landscape appears to be designed in layers gently sloping upward. Tall skylight towers on the planted roof of the museum act as strong vertical elements reaching for the sky.

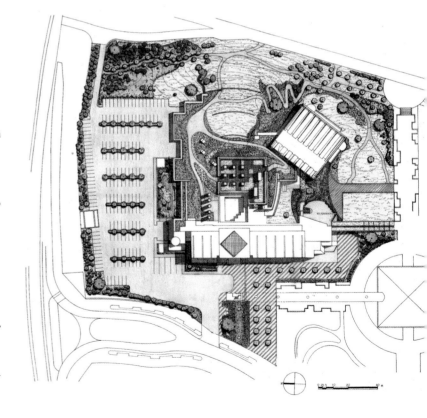

Top left Looking up from a path near the riverside, the low rows of rock holding back layers of lawn and plantings focus the eye toward the museum, with its sculptural skylight towers.

Top right Wide walking paths lead throughout the landscape, uniting the building and garden and allowing visitors to enjoy the broad views toward the river and distant mountains.

Above The garden wraps the museum building, with the formal entrance plaza on the west side, the meandering walking paths through the garden on the south and east, and the private curator's garden separated with a tall wall from the parking lot on the north.

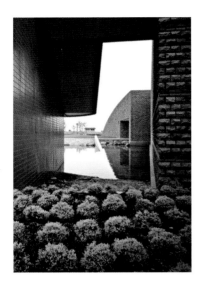

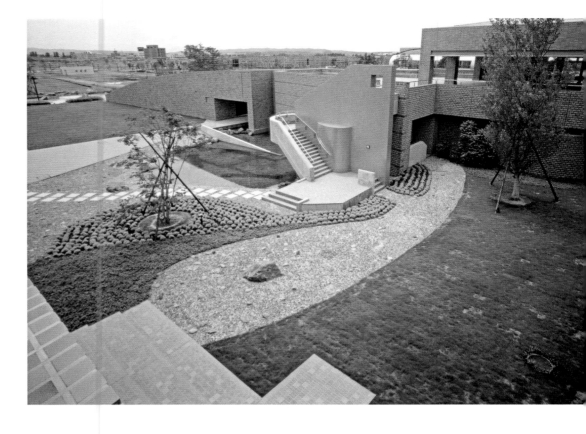

Walking paths wind through the museum grounds, connecting the river to the building and the formal walks to the less formal landscape. Areas further from the museum are more open, with expanses of grass and other ground cover bordered by rows of rocks that march across the land and demarcate its contours. Closer to the museum, the landscape is more detailed, with tighter groupings of plantings and carefully constructed stone elements. Water runs over offset strips of stone interspersed with rounded river rocks and travels right to the lobby windows, while a rock-lined pond slips under an over-scaled bridge. With a shape reminiscent of a traditional *dobashi* (earthen bridge), it arches gently from the entrance level up to the roof.

Layers of grass and low ground cover in contrasting colors envelop the slopes leading to the roof. The roof garden includes a formal area where the skylights act as sculptural elements in a confined space within the less formal grounds. Rectangular lengths of stone pavers interspersed with grass playfully engage the formality of the grid of nine skylight towers. The view from the roof garden to the river again

expresses the layers of the landscape—the connection of time and space through the ever-flowing river and the seasonal transformations of the garden.

Walking paths snake down from the roof onto the grounds and wrap around the building. Tucked into an enclosed courtyard on the north side, between the museum and the parking lot, the curator's garden surprises. Stepping-stones set into a bed of *shirakawa-suna* (white pea gravel) progress from the patio of the curator's office into the traditionally styled garden, while a second set of stepping-stones lead into the garden from a side gate. A long rectangular *nobedan* (stone-paved walkway) made from many river stones placed close together links the two lines of stepping-stones and runs parallel to an astonishingly large rock positioned in the center of the garden. The pea gravel bed and surrounding moss-covered mounds frame the long low boat-like rock. The effect is awe-inspiring. The space around the rock seems to disappear, and—for a moment—time seems to stop.

After that first moment of awe, the viewer's focus slowly moves from

Top left Looking through an opening between the building components, a small pool of water reflects the image of the museum and the sky.

Top right Layers of grass and beds of rock and ground cover with varied colors and textures fill the spaces in and around the museum with ever-changing scenery.

Opposite page top left Near the entrance, water flows over strips of stone—some more roughly textured than others—interspersed with smooth rounded river rocks.

Opposite page top right Set apart for privacy with walls and tall hedges, the garden outside the curator's office features an enormous carved stone set into a cloud-like bed of gravel.

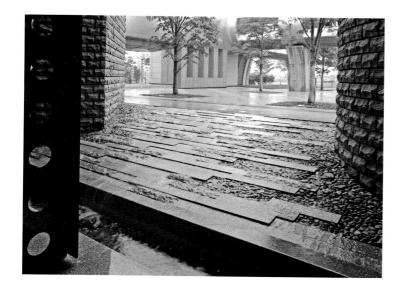

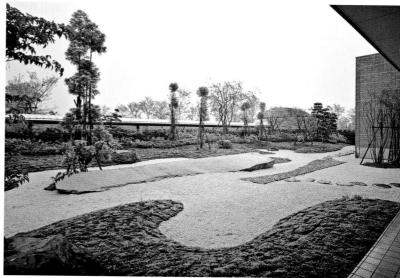

the central rock to the rest of the garden. A few single smaller—yet still sizeable—rocks adorn the mossy mounds, and tall carefully pruned trees add height and contrast. In front of the enclosure wall, the back edge of the garden builds up vertically with layers of hedges. Although the design of this private corner of the expansive garden is very different from the rest, the undulating movement of the *shirakawa-suna* triggers the memory of the river and the flowing of time, and the enormous scale of the predominant central rock gives perspective to the relationship of humankind to nature.

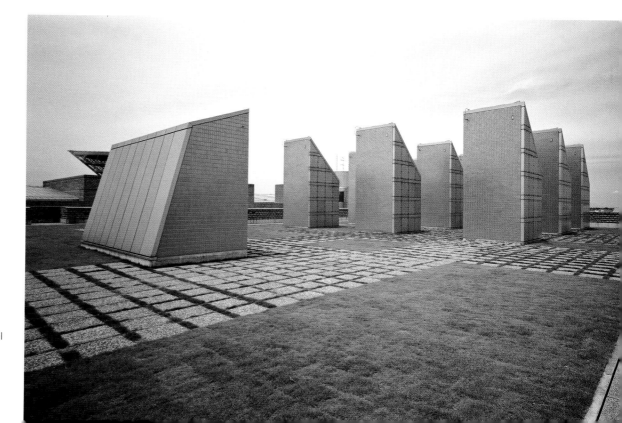

Right The gridded path of pavers interspersed with grass creates a playful composition with the skylight towers in the museum roof garden.

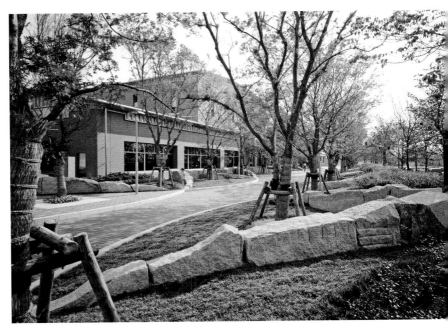

清風去来の庭 SEIFŪ KYORAI NO NIWA
KAGAWA PREFECTURAL
LIBRARY TAKAMATSU, KAGAWA PREFECTURE, 1994

The site of the Kagawa Prefectural Library is a former airport runway, a place that Shunmyo Masuno describes as where "the memories, sorrows, and hopes of many people passed through."[1] It is a place of arrival and departure, where the heavens and the winds created dreams of things to come and allowed for moments of introspection of what has passed.

Masuno saw the site as a peaceful place for reflection on the blowing winds and gave the garden the name Seifū Kyorai no Niwa or "The Garden Where Fresh Winds Blow In and Blow Away." The garden is designed to envelop the visitor with a canopy of trees, a view of the sky, and the songs of birds. The aim of the design is to create a place where "people who experience the breath of the wind . . . will never lose their way."[2]

Located in a suburban site once surrounded by wheat fields, the garden wraps the library in a swath of green. Buildings and parking lots that have sprung up nearby seem drab in contrast, and the library feels strongly connected to nature. The western half of the building is the public area of the library, with the book stacks located in the center of the space. Tables and chairs line the perimeter of the room and look onto the greenery through large windows. The effect is like sitting in the garden, with the layers of rocks, hedges, and trees outside creating spaces for watching the wind blow through the foliage, dreaming of the past and future, and feeling at home with the books.

Thick rows of trees hide the parking lot, which is easily accessed from the road in the northeast corner of the site. The main walkway moves east-west across the site, connecting a side street on the east with an adjacent lot on the west. As a starting point, the path encircles a single Chinese elm tree—one of many in the garden. A stainless steel bench follows the perimeter of the path as it circles the tree, providing a wide space for people to gather.

The walkway continues in front of the library building, lined by rows of Chinese elms. The tall trees have many small leaves that quiver with

Top left Looking out from the reading area, the garden seems to envelop the library with layers of foliage, and the thick stone curbs rise out of the ground to greet the viewer.

Top right Rough blocks of stone are pieced together to create the heavy arcing curbs, which grow out of the ground and define the space around the Chinese elm trees.

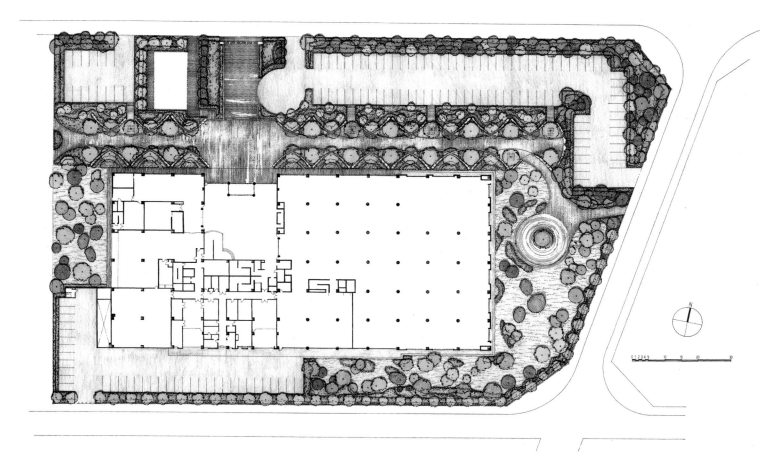

the slightest breeze. Curved stone curbs create scalloped edges on both sides of the wide walkway. The curves turn away from the path to emphasize the space of the trees and separate the greenery from the walk. The stone curbs are finished smoothly where they border the walkway, but as the arcs of the curbs move away from the path and overlap one another, the textures change. From the point that adjacent arcs cross, the stones slowly get rougher and larger, rising from the ground like the back of a dragon. The rough rocks grow wider and taller than the stones used in the curbs. They are lined up end-to-end, following the arc of the curbs as they extend onto the grass surrounding the trees.

Some rocks show the drill marks from the quarry; others lift off the ground with simple carved ends as they draw near to an adjacent arc. The effect is subtle but impressive—the stones seem to come alive with a slow but powerful life force. The view from the library windows gives a strong clear impression of the undulations of the arcing curbs and rocks.

The walkway, slightly reminiscent of a typical tree-lined approach to a temple, continues past the front of the building to the west edge of the site with its arcing curbs and Chinese elms. On the west side of the building, administrative offices look out over a gently rolling landscape of grassy hills dotted with trees and shrubs. A similar scene can be viewed from the east and south sides of the library space. Maple and pine trees punctuate the undulating landscape, while taller trees mark the side and back edges of the garden. Glimpses through the trees reveal mountains about thirty kilometers (almost nineteen miles) away. In between, where there once were only wheat fields, now stand many buildings. As the city creeps up on the Kagawa Prefectural Library, the garden gives the place a sense of tranquility and freshness, enhanced by the subtle sound of wind blowing through the leaves of the Chinese elms.

Top The approach walkway cuts through the formal line of Chinese elm trees and curving stone curbs on the north side of the library, while the gardens to the east, south, and west feature less formal arrangements of trees and shrubs.

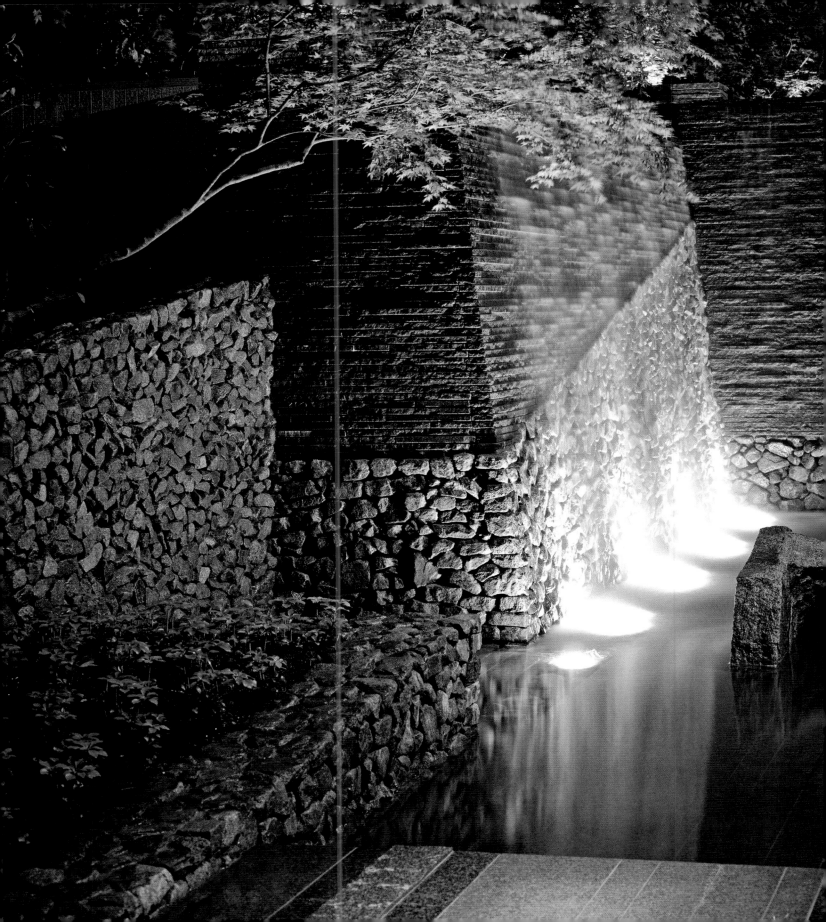

青山緑水の庭
SEIZAN RYOKUSUI NO NIWA

HOTEL LE PORT

CHIYODA-KU, TOKYO, 1998

Tokyo is a dense chaotic city of hard-edged buildings and tight urban streets. Here and there a few bushes or trees soften the edges, or a park offers a sprawling green space for people to gather. Although these places give respite from the fast pace of the city, they typically do not offer the sense of serenity found in wild nature. Located in the heart of bustling Tokyo, the three small gardens at Hotel Le Port (formerly the Kohjimachi Kaikan), together named Seizan Ryokusui no Niwa, the "Garden of Blue Mountains and Green Water," are designed to provide the tranquility and calm found in wild nature.

Shunmyo Masuno describes the gardens as "spiritual space designed according to Japanese aesthetic principles that evoke and celebrate nature. . . . The gardens adhere to the traditional Japanese sense of beauty and the spirit of Zen, to which we applied a modern understanding."[1] With a palette of water, rocks, and plants, Masuno employed the Zen principle of emptiness to create moments where people and nature can come together. In Japanese aesthetics, this principle is known as *yohaku* or blankness (literally "extra white"), which is understood as the space where the mind can rest, and "the convergence of natural and man-made objects creates an experience that reveals the cosmos."[2] This connection to the cosmos that allows the viewer total relaxation and a strong union with nature is the aim of these three gardens.

The main garden on the ground level of the hotel is viewed through

Left Dramatic nighttime lighting emphasizes the water cascading over the textured stone walls in the main garden, as viewed from the side patio.

floor-to-ceiling windows from the lobby and coffee shop. Large columns punctuate the view and frame the space of the long narrow garden, which features an elongated waterfall. Water cascades over two stone-covered walls, one slightly higher than the other. The top section of each wall is faced with long thin strips of stone. The texture is uneven yet continuous—the surfaces of the strips are rough, and some stones protrude slightly from the wall, but they provoke a sense of horizontal motion. Rounded rocks of different sizes and shapes cover the lower sections of the walls, which meet the stone strips at a diagonal. As the water falls over the rocks, the uneven surfaces create variety in the cascades, just as in natural waterfalls.

Trees and shrubs back the waterfalls and shield the view of the adjacent buildings. In front of the falls, slabs of rock emerge from the stone-covered base like a line of mountains emerging from the ocean. Running parallel to the windows, the rocks create layers of space in the garden and play with the viewer's sense of scale. The space between the naturalistic rocks and the visibly man-made waterfall is "empty," exhib-

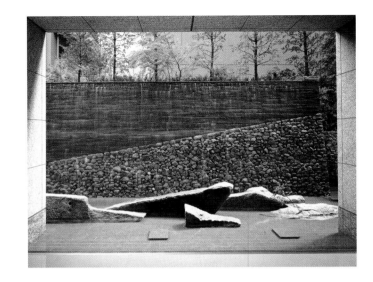

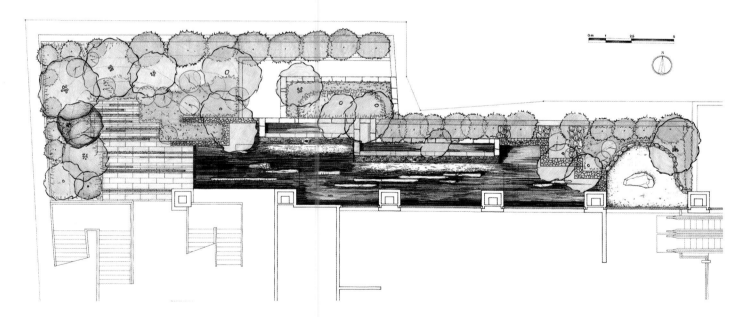

Above The plan of the main garden shows the waterfall flanked by the small rock garden on the right and the stone-paved patio on the left.

Top right The thick columns and ceiling of the lobby frame a view of the main garden, with its tall cascade and lower mountain-like rock slabs emerging from the water.

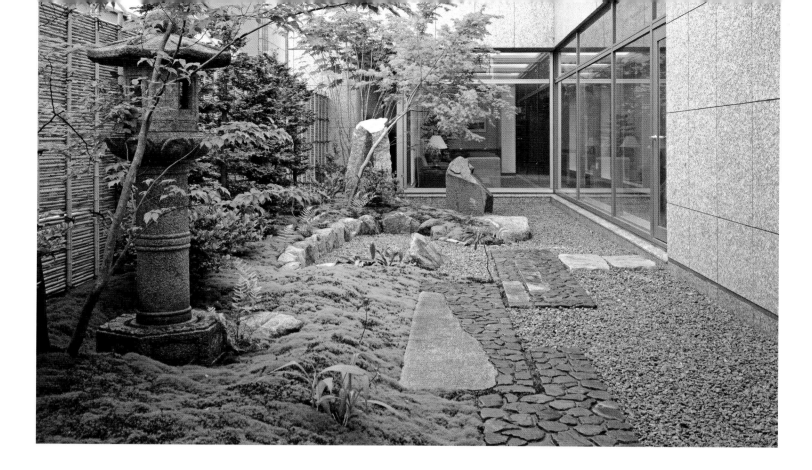

iting *yohaku no bi* ("beauty of white space")—not true white space but rather the void between the objects. It is these voids that draw in the viewer, giving the feeling of being within the landscape of the waterfall itself.

The two ends of the main garden are anchored in different ways. Near the hotel entrance, the garden steps down to a small bed of gravel lined with rocks, shrubs, and trees. A single well-figured rock marks the center of the gravel bed. At the opposite end, the garden steps up to a patio-like space. Strips of green ground cover are interspersed with lines of stone that continue the layers of the garden and end in thick foliage. Here visitors can enjoy the greenery and view the waterfall from the side, parallel to the tall cascades and the mountain-like rock slabs.

The two smaller gardens are located on the fourth floor. A long narrow terrace holds a composition of rocks and plants with a tall bamboo fence as the backdrop, blocking the view of the adjacent building and enclosing the garden. Trees and shrubs in front of the fence form the next layer, with a thick carpet of moss moving from the fence into the garden. Several large rocks and a carved stone lantern act as focal

Top Vertical elements such as the *tōrō* lantern, trees, and bamboo fence combine with horizontal elements like the *nobedan* (stone walkways), gravel bed, and stepping-stones, creating a sense of depth in the long narrow garden on the fourth-floor terrace.

Above Set against a tall bamboo fence, an intricately carved stone *tōrō* lantern by Nishimura Kinzō stands on a mossy mound within a composition of trees and shrubs.

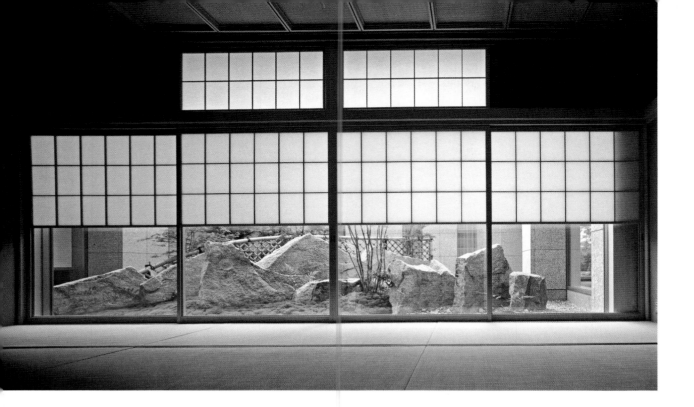

points within the space. The foreground is gravel, with a path combining stepping-stones and raised *nobedan* (paved stone walkways) that invite the viewer to move into the garden.

Across a small lobby is a square *nakaniwa* (courtyard garden) designed to be viewed from three sides. A low stone curb runs parallel to two walls of the garden and demarcates the back. A *kōetsuji-gaki* ("lying cow–style" bamboo fence) starts low to the ground and rises in an arc in front of the angled stone curbs. Trees before and behind the fence add to layered depth of space. Slabs of stone, similar to those in the ground floor garden, slip diagonally through the *nakaniwa*, reinforcing the spatial layers. Some are embedded in the lush moss mounds in the center of the space, while others move through the gravel bed that contains the garden. The size of the gravel shifts from small at the edges of the garden to medium in the center, adding to the illusion of depth.

Hidden within the chaos of the city, these three gardens provoke memories of deep mountains and swiftly flowing rivers. At the end of a busy day or before setting out into the crowded city, visitors can experience the tranquility and profundity of nature and the accompanying sense of calm.

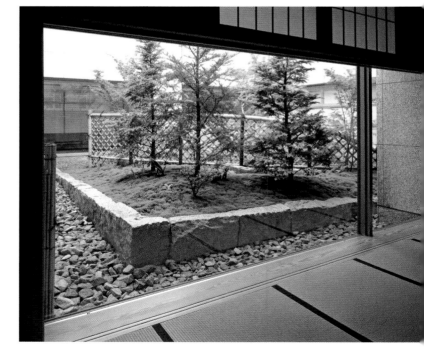

Top *Yukimi-shōji* ("snow-viewing" shoji) in a traditional reception room open to reveal a framed view of the fourth-floor *nakaniwa* (courtyard garden).

Opposite page top Shoji screens in the traditional *washitsu* (Japanese-style room) slide to the side, opening the view to the southwest corner of the fourth-floor courtyard garden.

Above Designed to be viewed from the adjacent reception spaces or from the guestrooms above, the fourth-floor courtyard garden features vertical slabs of stone layered in front of a *kōetsuji-gaki* ("lying cow–style" bamboo fence).

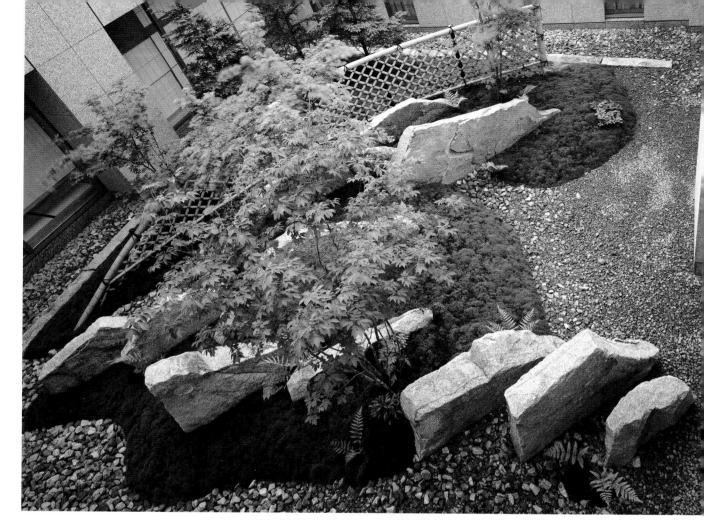

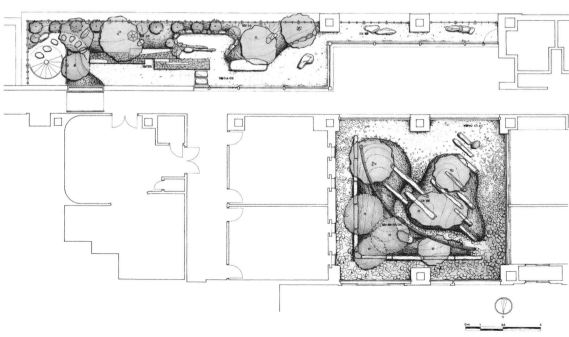

Left On the fourth floor of the hotel, a rock-studded gravel bed merges with mossy mounds planted with trees and shrubs in the narrow terrace garden, and slabs of stone march across rock-covered surfaces and mossy mounds in the *nakaniwa* (courtyard) garden.

閑坐庭 KANZATEI

CERULEAN TOWER
TOKYU HOTEL

SHIBUYA-KU, TOKYO, 2001

The principle behind the Zen expression "*kanza shite shōfū o kiku*," or
"sit quietly and hear the breeze in the pines," is the concept for the
design of Kanzatei ("Sit Quietly Garden") at the Cerulean Tower Hotel.
With daily urban life overloaded with information and sensations,
Shunmyo Masuno wanted to create a place where visitors could experi-
ence the feeling suggested by the expression—a place where nature's
restorative powers can provoke the memory of the beauty in small,
simple things.

The high-rise hotel is located in central Tokyo, partway up a hill in
the bustling business district of Shibuya. Pedestrians, bicycles, cars, and
trucks pass by the hotel at a frenzied pace all day and into the night.
Within this constant commotion, the grounds of the hotel transform
into a quiet oasis. Rock walls, about one meter (three feet) high, embrace
verdant plantings of trees, bushes, and ground cover. The curving walls,
some made of large slabs of rock and others of stacked medium-sized
rocks, guide the visitor along the paths beside and behind the hotel.
Moving away from the busy street, the visitor enters another world,
where the sounds of traffic diminish and the pace slows considerably.

This upper garden connects the hotel to the residential neighborhood
behind it and provides a pleasant means to move up the hillside. It also
creates a thick green backdrop for the lower main garden, designed to
be viewed from inside the hotel lobby and adjacent restaurant. The

Right Curving lines of stone, holding
back gravel, pygmy bamboo, and
moss, transform from a rough to a
smooth texture as they move through
the garden.

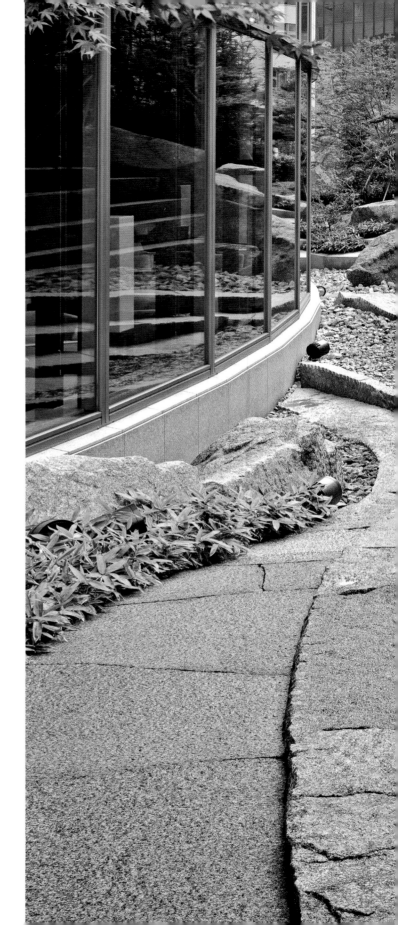

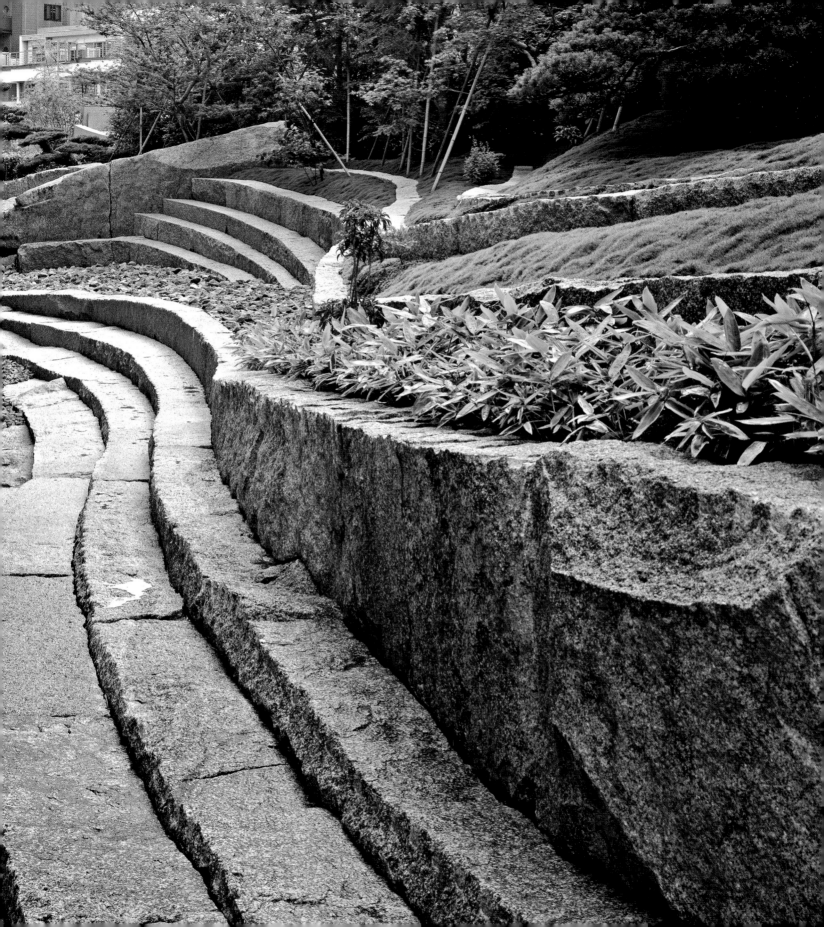

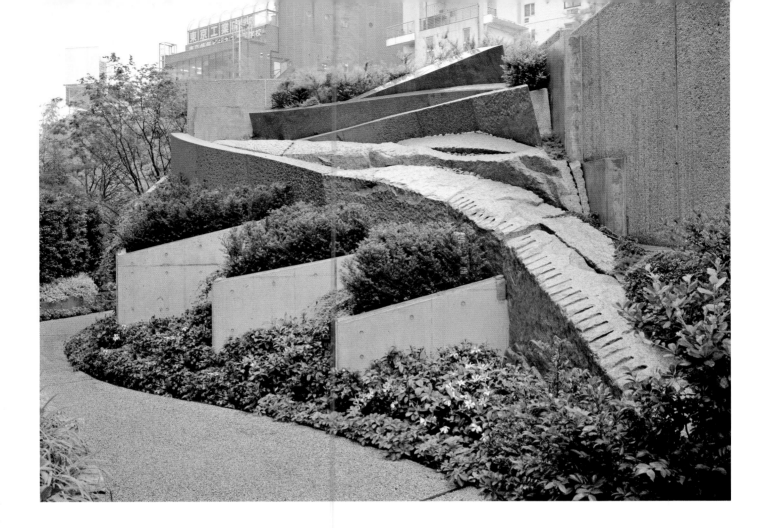

trees give height to the garden, which steps down to the lobby level with undulating layers of rock and vegetation.

From the upper path, a sweep of steps follows the tall curving rough stone wall of the hotel chapel and leads down to an entry area. From this entry, the path approaches the lower garden and then disappears at its edge. The point where the path dissolves into the garden allows visitors a singular view along the length of the sinuously curving layers of rock.

From the side nearest the chapel, the layers are close together—acting as a compact series of stone walls holding back terraces of green foliage. As the garden snakes in front of the hotel lobby, the layers begin to peel apart, and the ground cover on the terraces slowly changes to chunks of light brown rock. The coarse rock of the terraces flattens, as the light brown chunks transform into gray gravel. Two large roughly textured rocks cut across the waves, marking the transition

inside the hotel between the lobby and the restaurant.

In front of the restaurant, the garden moves right up to the windows with the gray rock diminishing in size, and the rock layers giving way to a sloped composition of polished and roughly hewn stone. After sunset, strategically positioned lights wash across this composition, bringing out the varied textures and accentuating its three-dimensionality. In the darkness, the garden lighting emphasizes the curving rock walls and reveals the true tranquil character of the garden.

This tranquility and the curves of the garden walls continue into the lobby in a unique merging of interior and exterior. Shunmyo Masuno worked with the hotel's interior designers to construct two gently curving stone walls in order to bring the geometry of the garden inside the lobby. The two walls, offset from each other, separate the formal lobby space from the lobby lounge and create an entry down to the lounge. The ends of the stone walls are rough and slowly transition to a smooth

Top Concrete, stone, and plantings come together in a unified composition of man-made and natural materials and geometric and organic forms in the upper part of the garden.

Above Adjacent to the neighboring residential area, the walkway meanders between rough stone retaining walls and lush plantings in the upper garden area, creating the feeling of a mountain path.

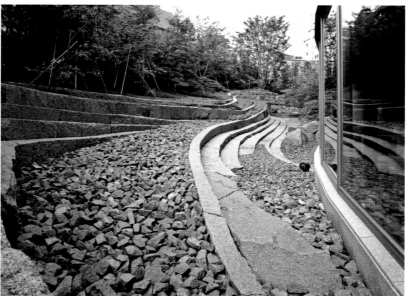

Above Looking from the east, the smooth curves of the granite steps contrast with the beds of rough granite and lead the eye through the garden.

Above Set off by layers of concrete planters containing closely trimmed hedges, textured stone cladding covers the curving walls of the sunken hotel chapel.

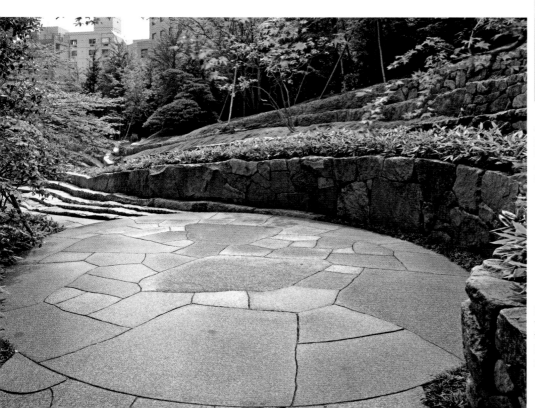

Left As the stone layers move away from the lobby area and farther into the garden, they dissolve into a circular space paved with stone, perfect for picture taking.

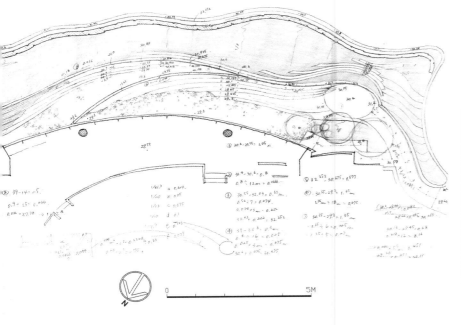

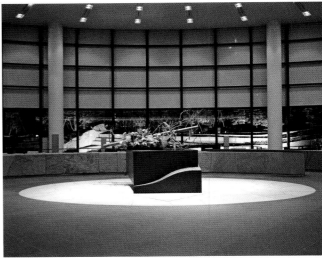

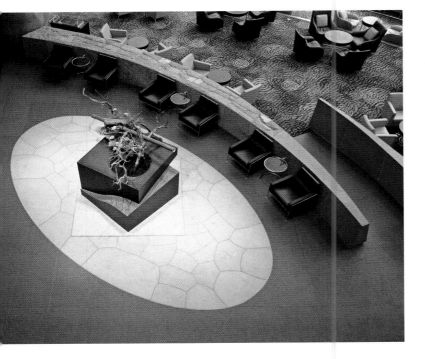

texture where the walls pass near each other and border the ramp to the lower level of the lounge.

In the formal lobby area, the curves continue in the patterning of the polished stone floor. A large oval of light stone—a puzzle of random sizes and shapes carefully fitted in the oval form—is set within a simple grid of dark granite. A sizeable square of matching light stone marks the center of the oval. A large sculptural stone flower vase, a cube of smoothly polished granite, sits at a forty-five-degree angle on the light stone square. The cube is split horizontally with a curving cut, allowing the top and bottom pieces of the cube to be offset. Where the split occurs, the faces are roughly textured, contrasting the polished surfaces elsewhere. On the top surface, two circles carved into the stone hold water and flowers, connecting to the nature in the garden just outside and providing another moment of peace and serenity—and, as the name of the garden suggests, a chance to remember the sound of the breeze in the pines.

Top left A rough sketch shows the concept of using curves to connect the interior space of the hotel (at the lower part of the sketch) with the garden just outside.

Above Gently curving stone walls separate the lounge from the lobby with its eye-catching sculptural stone flower vase, reminiscent of a traditional *chōzubachi* (water basin) found in a garden.

Top right A nighttime view of the lobby showcases the sculptural flower vase in front of the curved stone walls and wall of windows, with the gently illuminated garden visible beyond.

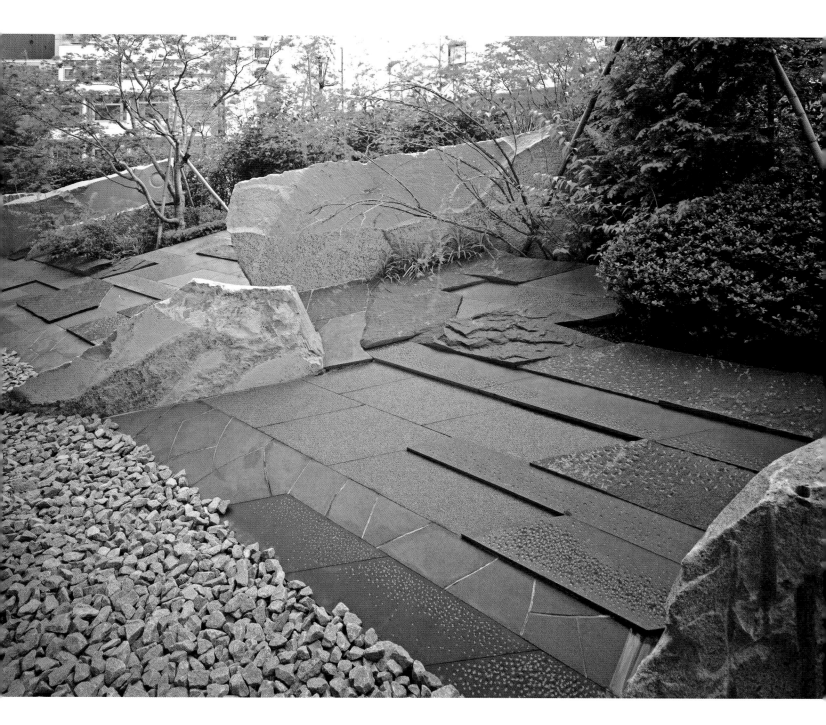

Above In front of the hotel restaurant adjacent to the lobby lounge, the rows of stone adjoin and flatten into strips with rough slabs of stone cutting across them to connect the lower and upper parts of the garden.

悠久苑 YŪKYŪEN
HOFU CITY CREMATORIUM
HOFU, YAMAGUCHI PREFECTURE, 2003

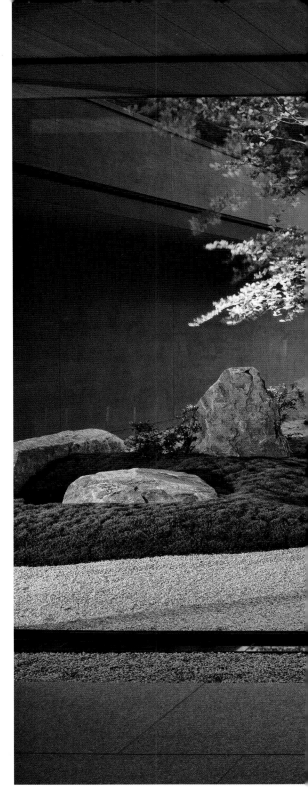

In Japan, when a person dies it is typical for the body to be cremated and for close friends and family to accompany the deceased to the crematorium to bid farewell and participate in a final ritual. After the cremation, family members use special chopsticks to remove the remaining large fragments of bone and place them in an urn that often will stay on the family's Buddhist altar until the forty-ninth day after the person's death. On the forty-ninth day, it is thought that the deceased has left the world of the living and entered the afterlife, and at that time the urn is moved to the family grave.

Yūkyūen (the "Garden of Eternity," named by the owner of the Hofu City Cremato-rium) consists of six gardens of varying sizes, each of which plays a particular role in the process of saying goodbye to a loved one. Upon approaching the crematorium, solid doors in a textured concrete wall open to reveal a view of the first garden, the Tabidachi

Above left A sketch of the Shizume no Niwa ("Soothing Garden") expresses the changing views of the garden as the visitor walks slowly along the hallway toward the crematorium.

Above right From the entrance hall, the Tabidachi no Niwa ("Garden for Setting Off on a Journey") opens out in front of the viewer, connecting the present moment to a place in the future through its many layers of space and intrinsic meaning.

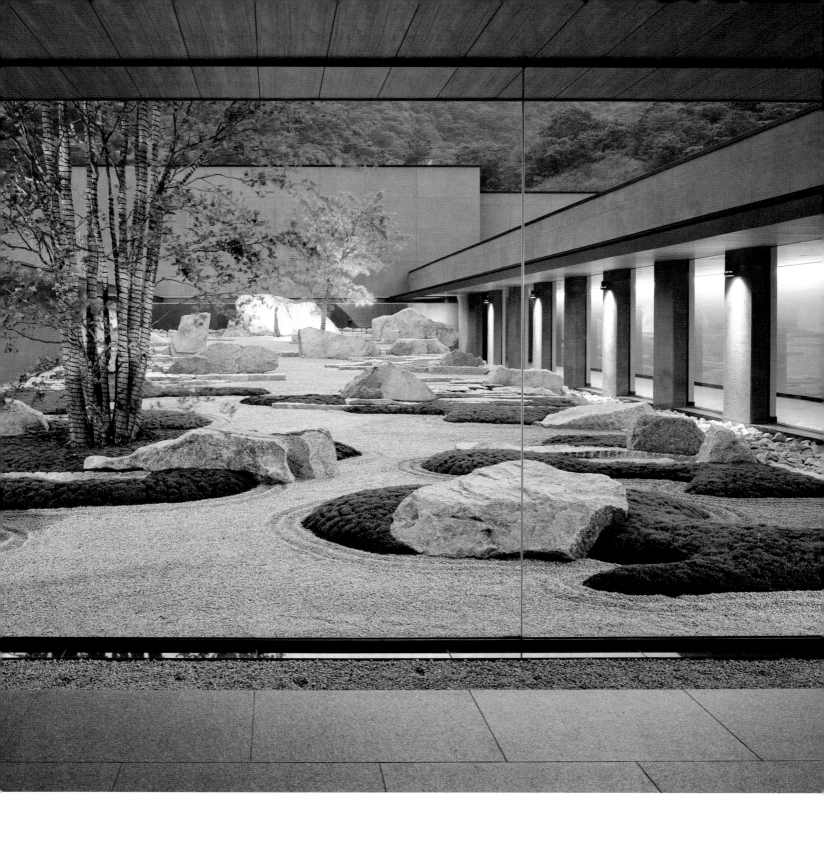

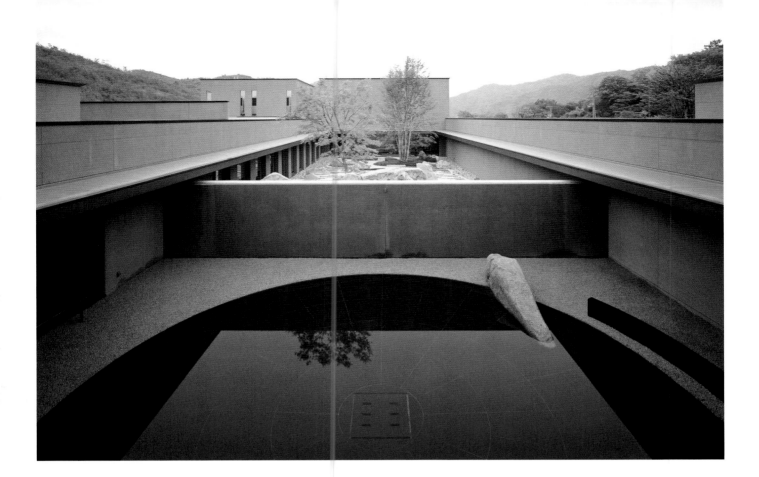

no Niwa, or "Garden for Setting Off on a Journey." The thirty-meter-deep (almost one hundred feet) garden is the front two-thirds of a large *nakaniwa* (courtyard garden). The *nakaniwa* is bounded by the entrance lobby to the east, a long corridor on the south that connects to the crematorium on the west side, and a second long corridor on the north leading from the crematorium to the waiting and reception spaces north of the lobby.

The front of the Tabidachi no Niwa has cloud-like, low, moss-covered mounds interspersed with swirling beds of white *shirakawa-suna* (pea gravel) and large rocks—some low to the ground and others projecting upward. This front part of the garden, which slips past the windows into the space of the lobby, represents the present life, while the rear part of the garden, which features only a single tree among the rocks and gravel, is the afterlife. The white *shirakawa-suna* that connects the front of the garden to the back represents the *sanzu no kawa*, a mythical river where the dead move to the afterlife, similar to the Styx. Tall triangular stone slabs at the back of the garden create the mountainous image of the world beyond.

Visitors first contemplate the Tabidachi no Niwa and then proceed

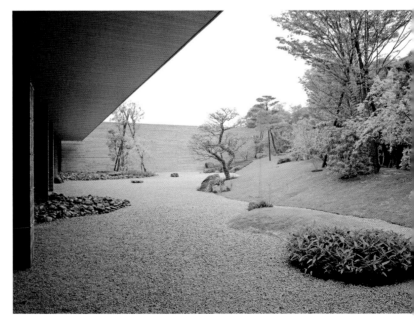

Top Enclosed within the courtyard space, a simple wall separates the Shōka no Niwa ("Ascension Garden") and the Tabidachi no Niwa ("Garden for Setting Off on a Journey").

Above Outside the corridor leading to the crematorium, the Shizumu no Niwa ("Soothing Garden") creates a tranquil atmosphere through a gentle landscape with a flat bed of gravel transforming to a grassy tree-topped mound.

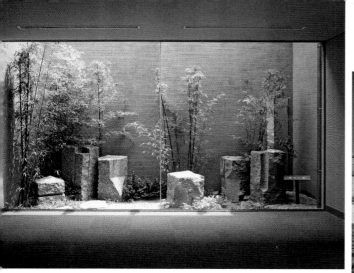

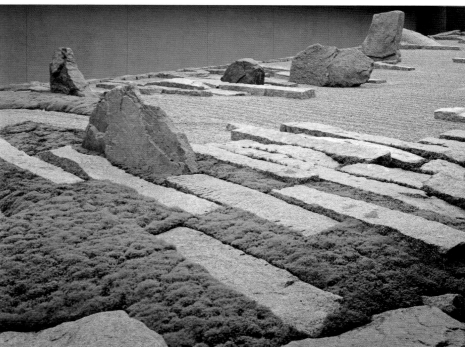

down a long slow corridor toward the crematorium. The view from the corridor looks to the Shizume no Niwa, the "Soothing Garden," on the south. The space of the corridor blends with the space of the garden, framed by the long overhanging eaves and separated only by transparent glass walls. The foreground of the garden is defined by gravel, with larger chunks of rock used to create transitions in scale. Groupings of large rocks and trees mediate between the gravel and the sloping grass bank. The garden draws in the view of trees beyond, an example of the traditional design principle of *shakkei* (borrowed scenery).

The Shōka no Niwa, or "Ascension Garden," shares a wall with the Tabidachi no Niwa and occupies the rear one-third of the central *nakaniwa* space. This striking garden, first revealed only in a long low window from within the crematorium building, is the most contemporary in style of the six gardens. After completing the ritual of selecting bones for the urn, the family of the deceased moves past the low window, catching a glimpse of the sky reflected in the Shōka no Niwa pond. As they start down the north-side corridor toward the reception rooms, the view opens up to show the square space of the garden. Gravel covers the ground around the central circular pond of water. Six low arcs of dark polished granite curve around the pond, and a single rough natural rock positioned between the gravel and water anchors

the composition. These seven rocks represent the forty-nine days until the deceased reaches the afterlife. The garden is a place to bid farewell to a loved one while watching the constantly changing sky reflected in the pool—a reminder of the transience of life.

The corridor leads from the Shōka no Niwa past the Jihi no Niwa, or "Garden of Compassion." A narrow *tsuboniwa* (small courtyard garden), the Jihi no Niwa features a few simple plantings interspersed with rectangular columnar rocks, which have been partly cut away to show the mark of the human hand. It provides a moment of pause on the way to the waiting and reception rooms, where the view opens up to the Suioku no Niwa, "Reminiscence Garden," which envelops the rooms in a lush green cloak evoking feelings of serenity and tranquility.

The final garden, the Seijō no Niwa, or "Garden of Purity," is viewed from the funeral hall and represents the last step in a person's death as depicted through the six gardens. The Seijō no Niwa is a composition of different shapes and sizes of leaves and different shades of green with a contrasting red maple and seasonal pink azalea blossoms. It features trees surrounding a mound swathed with leafy ground cover and gives a feeling of freshness and calm. By experiencing nature in different forms in all six gardens, the visitor can perceive and appreciate the transience of all living things and contemplate how to live a full life.

Top left The Jihi no Niwa ("Garden of Compassion") *tsuboniwa* (small courtyard garden) incorporates the motif of six *jizō* (guardian bodhisattvas) with its six vertical stone elements.

Top right In the Tabidachi no Niwa ("Garden for Setting Off on a Journey"), thick moss, strips of textured stone, rough rock slabs, and beds of raked gravel unite in a balanced composition.

清風道行の庭
SEIFŪDŌKŌ NO NIWA

OPUS ARISUGAWA
TERRACE AND RESIDENCE

MINATO-KU, TOKYO, 2004

Above A curving stone path leads from the street to the building entrance, allowing residents to enjoy the landscape and slowly move from city to garden.

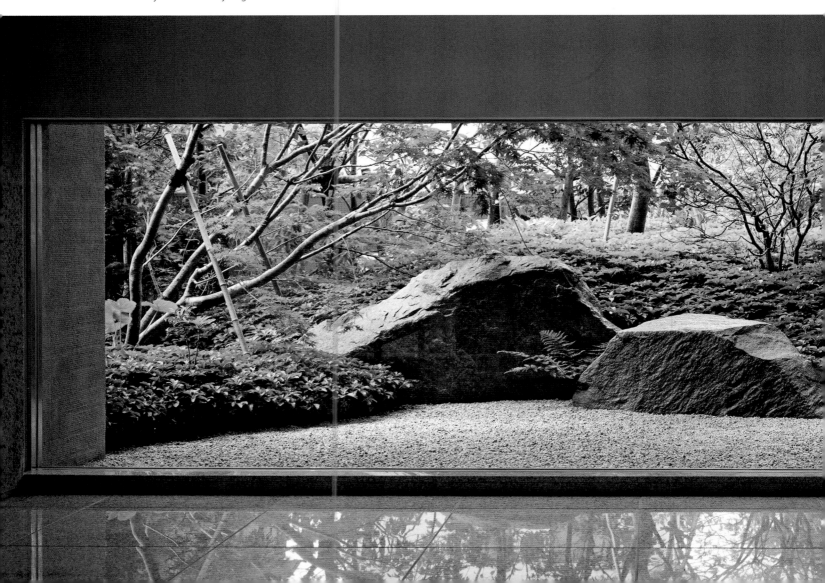

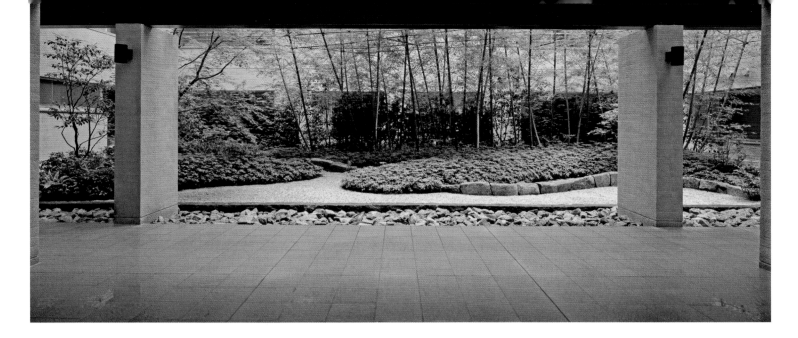

The Seifūdōkō no Niwa wraps the Opus Arisugawa Terrace and Residence in verdant foliage. The name of the garden refers to a clear refreshing breeze (*seifū*) in a scene of traveling (*dōkō*). Here the scene starts with a curving entry path leads from the edge of the property, past a cascading waterfall to the front door of the lobby. The design concept is based on the distance and time necessary to forget the cares of the day and the din of the city, to relax and feel at home. Shunmyo Masuno notes that when entering a Buddhist temple, traditionally one must pass through three gates. Each gate is a threshold that serves to transform one's mindset. Similarly, this garden is designed to provide a multisensory experience featuring changing scenery to enjoy on the way home.

Near the sidewalk, a sculpture combining rough and polished stone marks the entry path to the residence. The carefully fitted, variously shaped stones lining the entry path draw the resident in along two curving rough stone walls. Both walls are elegantly capped with polished black stone. The wall on the right is tall and hides the view beyond, while the left wall is low and serves as a bench. The thick greenery behind the bench reflects on its polished top, softening the hard surface with its mirrored image moving gently in the wind.

Following the curving path, the sound of water pulls the visitor forward under the tall entry roof canopy toward a long waterfall. Sheets of water cascade over thin strips of stone stacked to create two large falls. The cascade on the left is higher but not as wide as the cascade on the right, which is much longer. The two sizes balance each other well and create a focal point within the space. The sound of the waterfalls erases

Left The polished stone floor in the contemporary lobby reflects a calm garden scene visible through the long low window.

Top Layers of rock, gravel, and ground cover lead to a forest of bamboo and create a sense of spaciousness and serenity within the core of the building.

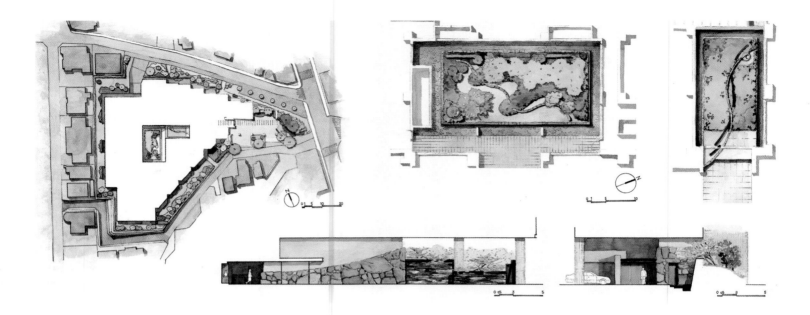

the sounds of the city outside and slows down the pace with its ines-
capable sense of calm.

The carefully choreographed entry path follows a powerful rock wall
next to the waterfall to the glass-enclosed foyer. The scale and strength
of the enormous rocks comprising the wall contrast with the human
scale and delicate quality of the glass entry. The rock wall moves
through the entry, just entering the lobby and bringing the outside in.
The lobby space focuses on a tokonoma-like decorative alcove. A large
slab of polished stone creates a slightly raised floor surface, while the
backdrop of the niche is faced with thick handmade *washi* (traditional
Japanese paper) coated with persimmon tannin. A black lacquered
shelf floats in the alcove, offset to one side. The warmth of the dark red
color and slightly rough texture of the *washi* add to the welcoming
ambiance of the lobby.

The space of the lobby shifts to the left, revealing a long low window
with a view to a side garden. A foreground of *shirakawa-suna* (white
pea gravel) is set against two large rocks in a very stable composition
backed by thick foliage. The scene is calm and serene, inviting the
viewer to pause and contemplate this gift of refined nature. The pol-
ished stone floor reflects the outside light and gently moving trees. As
the lobby space shifts again, this time to the right, another framed view

is revealed. The upper level of a tiered L-shaped *nakaniwa* (courtyard
garden) creates a strong connection between inside and outside—
another layer in the transition from the city to home.

Two undulating strips of stone—one rough and the other polished—
cut through the thick green ground cover of the garden and move into
the lobby space, unexpectedly passing through the wall of glass that
separates the exterior and interior. The separate lower tier of the garden
is revealed only from the multipurpose and fitness rooms, one story
below the lobby. It too features a low serpentine stone wall that mean-
ders through the garden. In some places the wall holds back the earth
and dense ground cover, in other places it breaks free and snakes
through the white *shirakawa-suna* in the foreground of the garden.
Many thin trunks of bamboo and shrubs with lacy foliage create a soft-
edged backdrop for the garden.

Although the actual length of the journey from the city street to one's
home in the Opus Arisugawa Terrace and Residence is not a great
physical distance, the changing scenery and sensory experiences of the
Seiryudōgyō no Niwa create a great mental distance. The textures of the
rock walls and the sound of the waterfall combine with the lush vegeta-
tion to give a strong impression of abundant nature and with it a sense
of tranquility and a welcoming embrace.

Top The site plan (left) shows gardens surrounding
the building and the two interior courtyard gar-
dens (detailed plans on the top middle and right).
The section drawings (bottom middle and right)
show two views of the carefully choreographed
entry sequence.

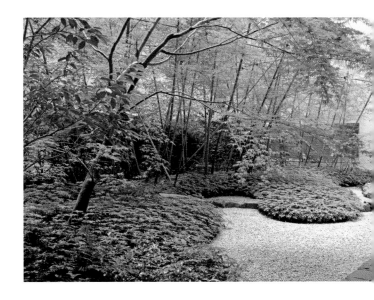

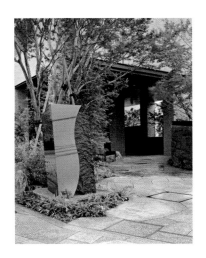

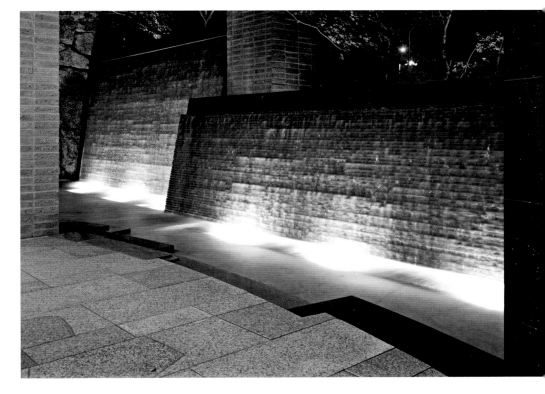

Above Marking the entrance to the building, the sculpture of rough stone meeting highly polished stone in an S-curve is symbolic of the S-motif found through the garden.

Top left Continuing from outside to the interior, the heavy stone clad wall serves to connect the lobby to the outdoor garden space.

Top right Bamboo, trees, and thick ground cover create a serene composition with the contrasting gravel bed and bring nature into the center of the building.

Above The sight and sound of the waterfall obscures views and thoughts of the city, creating a strong sensory experience when approaching the building entrance.

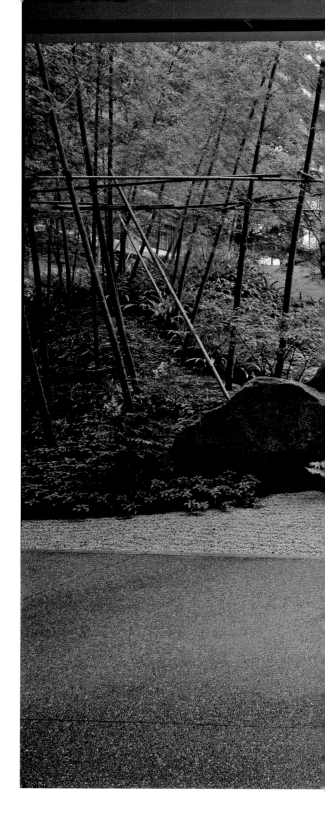

三貴庭 SANKITEI

MINISTRY OF FOREIGN AFFAIRS

CHIYODA-KU, TOKYO, 2005

When the building housing the Ministry of Foreign Affairs underwent a seismic retrofit in 2002, the courtyard was used as the staging ground for construction materials. After the renovation was completed, Shunmyo Masuno received the commission for the design of a garden in the courtyard. Since the Foreign Ministry serves as Japan's "window to the world,"[1] Masuno felt that the garden should express the traditional spirit of the Japanese people and chose the theme of *sanki*, or "three values," for the design. The three long-held values from which the garden gets its name, Sankitei ("Garden of Three Values"), are harmony (*wa*), gratitude (*rei*), and respect (*kei*). These abstract concepts are represented by the three main rocks in the garden. Using the traditional material palette for a *karesansui* (dry) garden—rock, gravel, and plants—Masuno creates a contemporary garden that is rooted in the past to bring the traditional spirit of the Japanese people to the present day.

The garden has two separate functions. The front part is a *kanshō-shiki-teien* (garden for viewing) that welcomes ministry employees and guests, visible initially from the main elevator lobby of the building. The rear section of the garden serves as a rest and gathering area for the

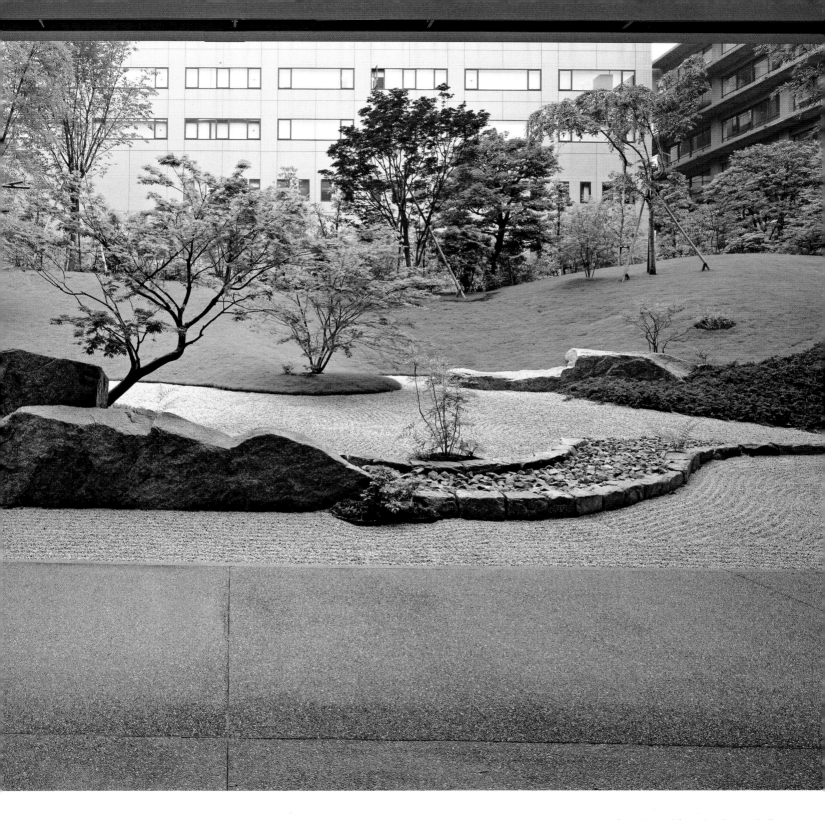

Above Viewed from the elevator hall, the large *nakaniwa* (courtyard garden) is a balanced composition from the bamboo forest and rock arrangement near the front to the rolling hills dotted with trees beyond.

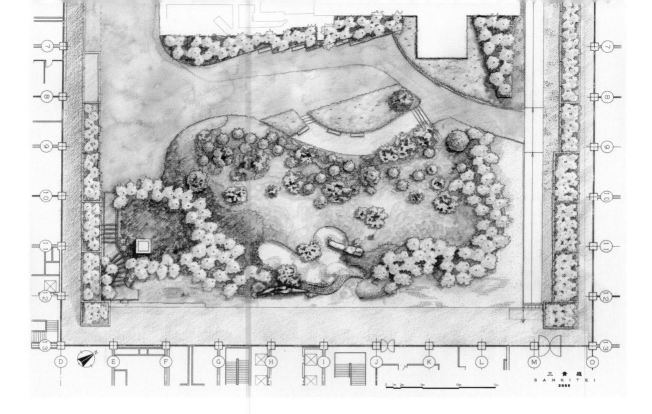

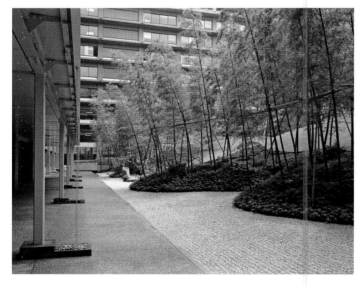

employees. The two different functions led naturally to a physical separation of the garden, which was achieved by the inclusion of a central *tsukiyama* (literally, "constructed mountain"). The broad *tsukiyama* takes up nearly one-third of the space of the large courtyard and creates an inviting scene of gently rolling hills visible from the front and back sections of the garden as well as from the office windows above.

From the elevator lobby, a variety of trees dot the grass-covered *tsukiyama* backdrop of rolling hills, which adds verticality to the horizontal view of the garden. Planted to seem random, red maples draw the eye along the undulating top of the hill. The eaves of the patio roof frame the garden and help obscure the view of the building across the courtyard. In the foreground, raked *shirakawa-suna* (white pea gravel) extends the space of the building's stone patio toward the main focal point—the *sanki* rock arrangement.

The three *sanki* rocks are grouped together in a powerful yet serene composition. A single maple tree planted immediately behind the rocks adds a vertical element to the arrangement. The rocks are flanked on

Top Tree-covered hills in the center of the courtyard separate the park-like gathering spaces on the northwest from the more traditional garden on the southeast.

Above With an undulating edge adjacent to the building, the raked gravel, soft mounds, and lacy bamboo create a quiet setting.

Opposite page top Contrasting the roughness of the granite, the raked *shirakawa-suna* (pea gravel) leads the eye from the front of the garden to the large stone near the back, which symbolizes a feeling of gratitude.

Opposite page right Viewed from above, the undulating forms of the garden elements create a sense of movement within the tranquil courtyard.

the left by a grove of bamboo and anchored into the white gravel in front. From behind the three main rocks, a river of broken rock contained between low, roughly textured curbs flows across the raked *shirakawa-suna* and disappears into the vegetation as a single line of rocks. A second rock arrangement at the edge of the *tsukiyama* extends into the white gravel, as it flows behind the *sanki* rocks. The front left corner of the courtyard features a stair moving up the hill adjacent to a bamboo grove, leading to the gathering space behind. On the right side of the garden, curving groves of bamboo with thick ground cover push into the lines of white gravel wrapping the corner.

For visitors, Masuno equates the first view of the garden to the welcoming scene of a tokonoma, the decorative alcove in a traditional teahouse that typically contains a scroll and an arrangement of flowers related to the season. It is a convivial sight that calms the mind and the spirit, setting the tone for the diplomatic relations between Japan and foreign countries with a foundation of harmony, gratitude, and respect.

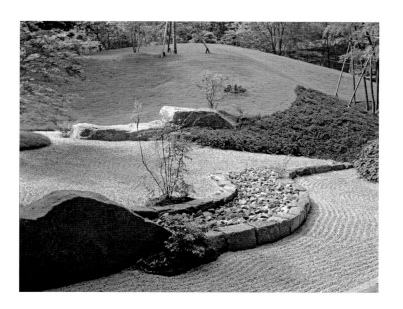

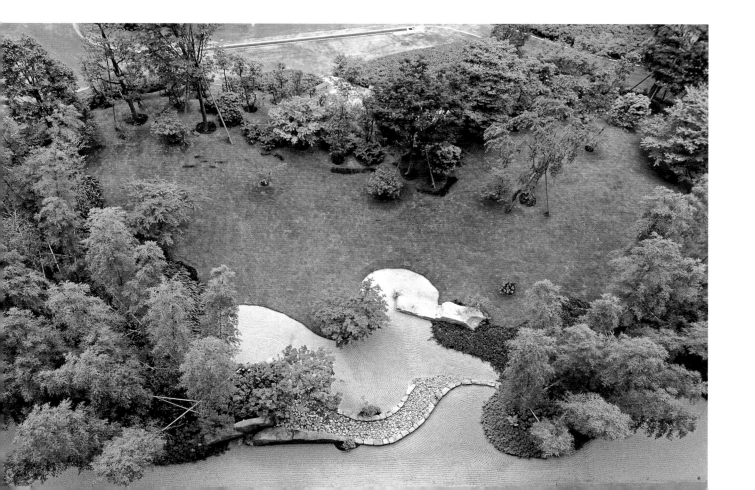

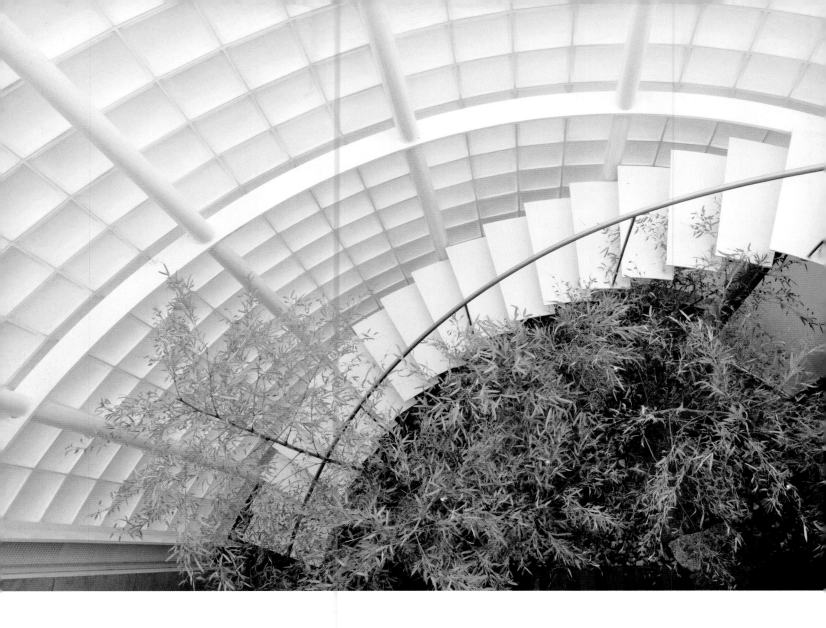

結の庭・心清庭
YUI NO NIWA SHINSHŌTEI

PRIVATE RESIDENCE
MINATO-KU, TOKYO, 2010

Top Within the cylindrical *genkan* (entrance area) with its curving metal stair, the lacy green leaves of the bamboo contrast the stark contemporary design.

Above Many of the rooftop and ground-level gardens that combine in the Yui no Niwa are visible from the street view of the residence.

Land in central Tokyo is highly valued, so when building a new resi-
dence in a fashionable neighborhood such as Nishi Azabu, no land is
left to waste and rarely is there room for a large garden. This particular
residence utilizes almost all the area of the lot, so little space remained
for a ground-level garden. However, Shunmyo Masuno knew that mak-
ing a garden that refreshes and purifies the mind and spirit does not
require much space. Shinshōtei ("Garden of the Pure Spirit") takes
advantage of all the small bits of outdoor space left on the lot, as well as
three separate roof terraces. Masuno's idea was to unite these gardens
with a common goal and similar design language, so he gave the uni-
fied gardens the name Yui no Niwa, "Bound-Together Garden."

From the exterior, verdant plantings soften the geometric concrete
walls of the residence. Trees and shrubs fill every open area and top
every roof. The first garden space that one encounters is enclosed in a
curved glass block wall in front of the *genkan* (interior entrance hall).
A stone path leads from the street into the cylindrical enclosure,
through a quiet bamboo grove, and into the *genkan*. The texture of the
rough gravel covering the ground and the delicate leaves of the bamboo
contrast with the smooth surface of the concrete and the slick transpar-
ency of the glass blocks. The garden sets the mood with its feeling of
enveloping tranquility.

From the interior of the residence, every window has a view of a gar-
den, giving the impression of the house being surrounded by nature
rather than in the middle of a busy city. Well-figured garden rocks
existing on the site were reused in compositions carefully designed to
be viewed through the frames of the window openings. Tall thin trees
add verticality, while shrubs, rocks, and ground cover give an impres-
sion of horizontality in the harmonious arrangements.

The three roof gardens are designed not only to be viewed from
inside but also to be occupied, used for relaxation and entertaining.
The uppermost garden, the largest of the three terraces, features a grassy
lawn surrounded by trees and shrubs. Rows of rough rocks hold back
the earth and create stepped tiers between higher and lower areas.
Rather than borrowing the scenery of distant mountains, the element of
shakkei (borrowed scenery) in this garden is the distant skyscrapers and
the roofs of the adjacent buildings. The garden gives the feeling of being
within a larger space—the city—yet being separate and protected.

One level below on the north side of the house is an outdoor dining
terrace for use in good weather. A grid of dark stone covers the floor

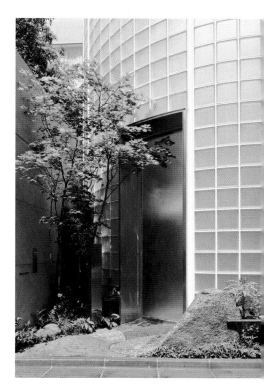

Above A tree and a rock, both sur-
rounded by ground cover, mark the
entrance and bring nature close from
the first encounter with the building.

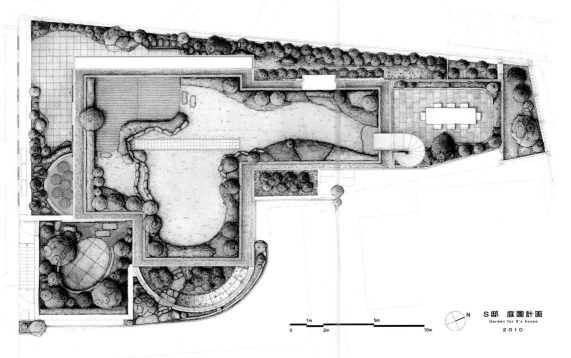

S邸 庭園計画
Garden for S's house
2010

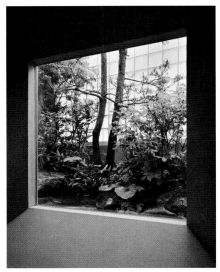

surface, and an undulating low white wall wraps the space and holds in the thick plantings of variously colored shrubs and trees. Although the terrace is exposed on three sides, when seated at the table, one feels enveloped by nature. With the views of the nearby buildings blocked by the greenery, the space of the garden opens up to the sky.

The third roof garden is above the garage near the front of the house. A thick layer of trees wraps the corner of the space, creating a buffer to the street. Two rectangular stepping-stones lead out onto the terrace toward an oval-shaped patio in the center of the space. A grid of stone covers the floor of the oval, and a low concrete wall grows out of the ground and follows the curving perimeter to give a sense of enclosure. As with the other roof terraces, this garden is both for viewing and for occupying.

The three garden spaces are unified in their material palette of plants and rocks and their multifunctionality. However, they offer diverse spaces for various times of the day that change during the different seasons of the year. Each garden offers privacy and tranquility, and together they create a place where no matter what time of day or what season, the viewer's spirit can be purified by the embrace of nature.

Top left From the half-cylinder entrance on the east side to the central uppermost roof garden, the many gardens at different levels are all visible in the roof plan of the residence.

Above Above the garage, two rectangular stepping-stones lead to the oval-shaped patio, enclosed with a curving wall and surrounded by trees.

Top right A large window opens to a small *nakaniwa* (courtyard garden), creating a strong connection between nature and architecture.

Opposite page Two elements—rock and bamboo—combine to create a serene garden scene in the *genkan* (entrance area).

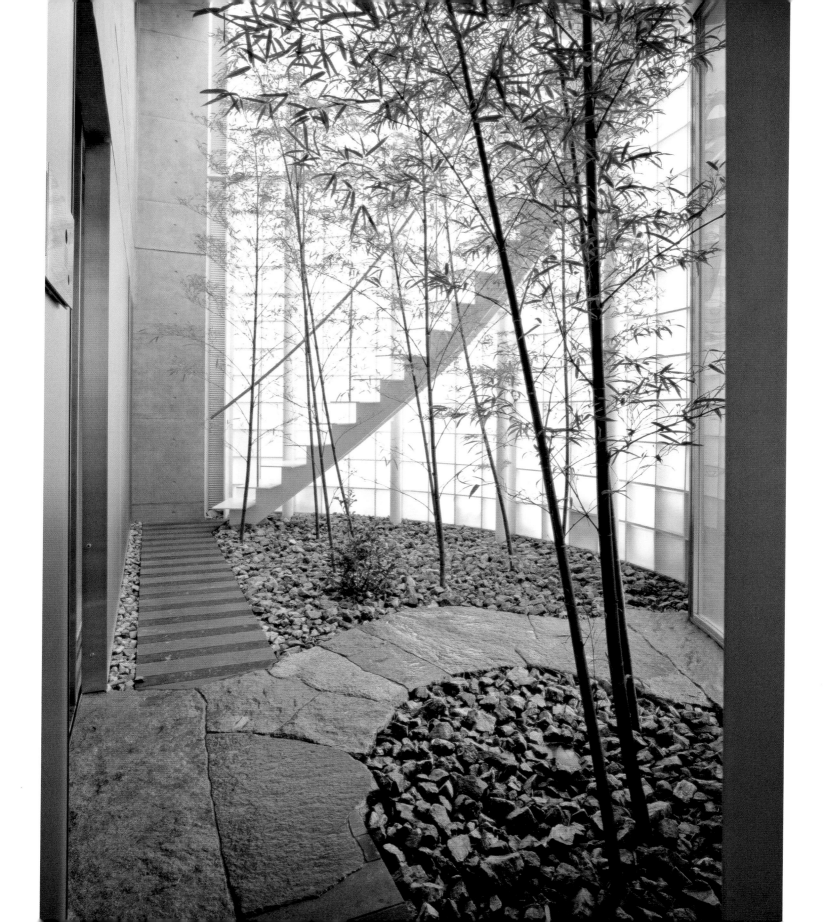

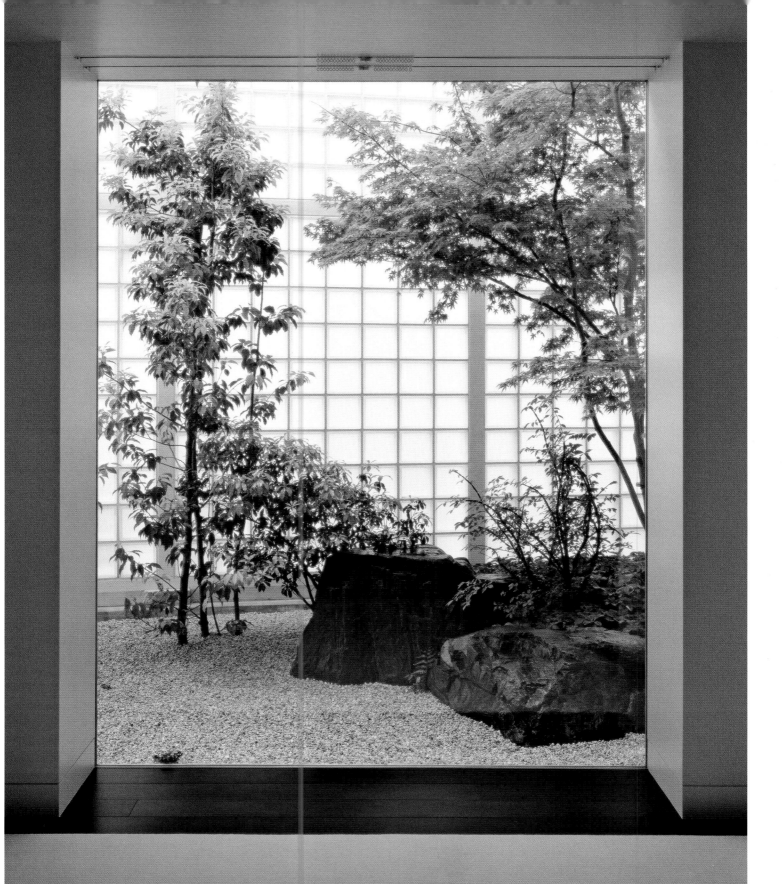

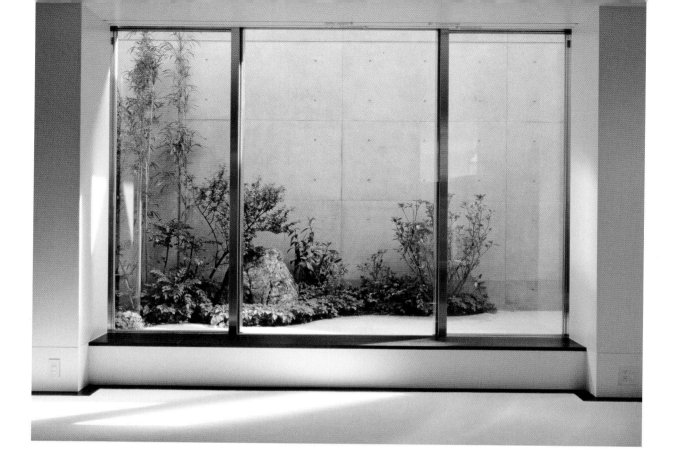

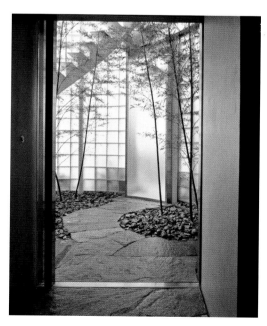

Opposite page A floor-to-ceiling opening frames a tranquil view of the *nakaniwa* (courtyard garden), connecting the interior and exterior spaces.

Above The stone-paved path in the contemporary *genkan* (entrance area) curves through the bamboo grove from the outside door to the inner entry.

Top Tucked into a corner of a deep *nakaniwa* (courtyard garden), a bed of white gravel abuts a balanced composition of a single main rock surrounded by trees, shrubs, and ground cover.

Above Utilizing the principle of *shakkei* (borrowed scenery), the city becomes the backdrop for the large rooftop garden.

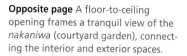

MONDŌ:

A DIALOGUE WITH
SHUNMYO MASUNO

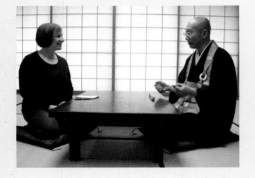

(ML)
When you began your Zen training at Sōjiji, what were some of the tasks or trainings that later helped you develop your design process?

(MASUNO)
No matter where one does Zen training, Sōjiji included, first of all it begins with thoroughly clearing away everything that one had considered ordinary. It must be mentally and physically discarded to an extreme degree. Things that had been considered ordinary are all stolen away, and one becomes aware of a sense of gratitude. For example, at a Zen temple you absolutely cannot eat until your stomach is full. Immediately after starting training, you feel like you will go crazy from hunger. You can only think about eating. Of course you get "beriberi" or malnutrition, but before you know it, every one of us naturally recovers from this. Also, at the beginning of training, we were not allowed to stretch out our legs. Our legs were always in a state of numbness and didn't move freely as we wished. From this, we personally will know the gratitude of being able to stretch our legs. This is simply one example. To illustrate this example, all freedom and desires are cleared away from one's daily life. If you experience this [clearing of desires], attachment is stripped away. We get to know firsthand the gratitude of living here now, of being able to eat, of being able to stretch out our legs, and so on. It is completely different from knowledge ob-tained rationally. Instead, you begin to understand the importance of physically grasping the meaning of those gratitudes one at a time.

While in training, a halfhearted effort is absolutely unacceptable. One-by-one, without fail, one step at a time, each task must be completed and understood. In every single action one must wrestle with all one's heart and mind. Furthermore, if we failed—if the failure came subsequent to that effort, and we apologized to everyone (*sanja*), we were excused. More than any consequence, coming to grips with that attitude is regarded as important. Everyone makes mistakes. It's best to put effort into not making the same mistake twice.

This kind of experience gained from Zen training is of great use for that fighting attitude while designing. First of all, feeling gratitude for being able to design; then not being attached to the desire to make something myself; beginning to listen to the earth and the unique qualities in nature; and thoroughly considering the state of mind of the people who will use the place—the design will flow forth spontaneously. In the act of carefully carrying out these tasks one by one, Zen training truly has a strong effect on my attitude toward design. Without Zen training, my current design would be impossible.

(ML)
You have said, "In Zen the state of one's mind is not conveyed through letters or words, but attempts are made to condense everything through silence."[1] How does this "silence" manifest itself in your gardens?

Above Zen priest and garden designer Shunmyo Masuno and author Mira Locher in conversation at Kenkohji temple in Yokohama.

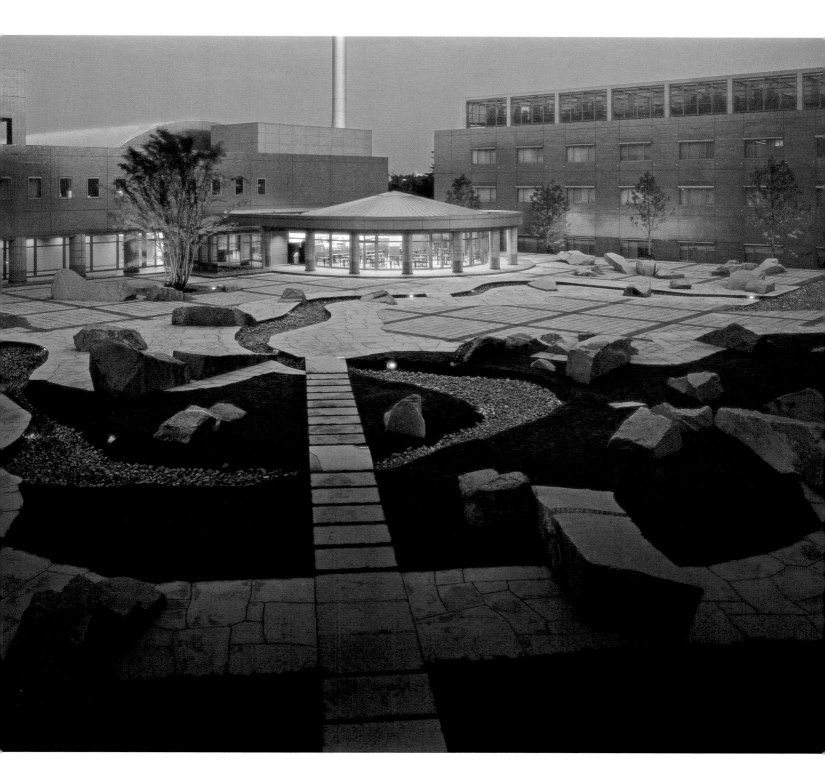

Above A balanced composition is created from diverse elements in the Fūma Byakuren Plaza at the National Institute of Materials Science.

(MASUNO)

Zen advocates Buddhist revelation through intuitive discernment (*furyumonji*), that spiritual awakening can be attained only by means of communion of mind with mind (*kyōge-betsuden*). The most important element of this is that it cannot be conveyed with words or letters. Even if disciples themselves have the opportunity to become aware, it is impossible to teach that awareness. Therefore "silence" (*chinmoku*) is created and produces the opportunity for people to think.

By no means do my works emphasize form. I aim to produce gardens that people continuously want to observe intently. The act of gazing fixedly is the act of creating the opportunity to think—that is, to wonder introspectively. One's own way of living, current lifestyle, one's existence, and so on—one after the other a variety of questions well up in one's heart/mind (*kokoro*), I think. I always wrestle with how my works can provide that "time and place." Therefore, the works must strongly emphasize intention. The intention is there of course, but where it exists cannot be perceived. The beauty that can be felt in nature—this point is more important than anything else. I aspire to create that kind of space, a beautiful refreshing place, where people always want to go. It's satisfying if each person can feel something from that space.

(ML)

In *Zen and Japanese Culture*, Suzuki Daisetz relates how Sōtan, the grandson of acclaimed tea master Sen no Rikyū, related the aesthetic principle of *wabi* (a concept incorporating the understanding of beauty in humbleness and imperfection) in tea ceremony to Buddhism. He explained *wabi* in correspondence to the Buddhist practice of moral discipline (*jikai*), one of the six *paramitas* (*ropparamitsu*) or practices that describe the path toward enlightenment. How do these six practices—generosity or giving of oneself (*dāna pāramitā*, or *fuse*), virtue or moral discipline (*śīla pāramitā*, or *jikai*), patience or perseverance (*kṣānti* [*kshantī*] *pāramitā*, or *ninniku*), diligence or vigor (*vīrya pāramitā*, or *shōjin*), meditation or single-

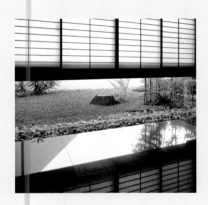

pointed concentration (*dhyāna pāramitā*, or *zenjō*), and wisdom or insight (*prajñā pāramitā*, or *chie*)—guide your garden design work?

(MASUNO)

Ropparamitsu is the basic teaching of Buddhism. Each practice must be observed completely—this is the foundation for a Buddhist. However, within that understanding my feeling when designing a garden is that I am especially conscious regarding generosity or the giving of oneself (*fuse*). That also is an act of discourse. This is different from giving money as charity. I put the teachings of Buddhism into the garden, which I work on with the feeling of enabling people to sense the joy of living. It is the feeling of wanting people to sense something like this state of mind [of the joy of living] when they come face to face with the gardens I designed.

Also, for me garden design is the setting of devotion itself. Through the daily act of making steady effort, in this place everything comes into existence as a single expression. It is a very tense moment. For that, I must maintain my *kokoro* (mind/heart) in meditative concentration. Of course, moral discipline (*jikai*) is not only in garden design, it also is a matter to be conscious of continuously every day. I concentrate on that sentiment, utilizing that wisdom. When designing gardens, there also are times when I must fight with my own feelings. Even if physical fatigue becomes extremely intense, when I am able to concentrate on my feelings, I endure and try to continue. This is the definition of perseverance (*ninniku*). In this way, in my garden design, the teachings of *ropparamitsu* are vibrantly alive. Garden design is precisely my place of training.

(ML)

Is there a particular Zen koan (a riddle or question used to for Zen meditation) that has helped you in your garden design?

(MASUNO)

There are two types of koan: *kosokukōan* and

Above In Suitōkyosei, the courtyard garden outside the head priest's office at the Gionji temple, the contemporary interior space merges with the traditional garden.

genjōkōan. A *kosokukōan* is left behind by a well-known founder of a Zen sect as an important method to be respectfully used as a teaching tool that triggers enlightenment for disciples. On the other hand, *genjōkōan* is the world that now appears in front of one's eyes. Namely, to delve into the present state of the world to a fundamentally deep place of reality is to find the absolute truth. Both types of koan lead one to the same place. The principle of Buddhism is to become aware of "absolute truth." Through *kosokukōan* we know the moment of awareness of the founder of a Zen sect, and using *genjōkōan* we understand how we are now living. I cannot particularly specify one, but it is an unmistakable fact that both types have a strong influence on my garden design.

(ML)
You taught yourself the "Japanese sense of beauty and Japanese sense of value" through the study of tea ceremony.[2] How else did you learn these principles?

(MASUNO)
"The way of tea" (Japanese tea ceremony, or *chadō*), "the way of the brush" (calligraphy, or *shodō*), "the way of the flower" (flower arrangement, or *kadō*), "the way of the sword" (Japanese swordsmanship, or *kendō*), and the like —Japanese artistic accomplishments and martial arts, etc., which include "the way" (*dō*)—all have a deep connection with Zen. Through each art, the mastery of a way of life evolved. Therefore, within any of them, the Zen way of thinking and training and the same spirit continuously flow.

Particularly the "sense of beauty" and "sense of value" are the complete thought at the root of Zen, and they themselves are the Japanese people's sense of value and sense of beauty. That is, in "mutability" (*mujō*), "continuity" (*todomaranu*), and "changeability" (*utsuroi*), the sense of value and sense of beauty are discovered. It is that so-called "fluidity" (*koteidekinu*) [within them] that is beautiful and sacred. For that reason, the act of "living each and every moment with care" (*sono shunkan sono shunkan daiji ni ikikiru*) becomes more important than anything else. In the way of tea (*chadō*), this is a "once in a lifetime meeting" (*ichi go ichi e*). When we talk of Japanese culture, fine arts, or performing arts, we cannot speak of them without Zen. To master Zen is to master the Japanese sense of beauty and sense of value.

(ML)
Hisamatsu Shinichi has identified seven different characteristics particular to Zen arts: asymmetry (*fukinsei*), simplicity (*kanso*), austere sublimity or lofty dryness (*kokō*), naturalness (*shizen*), subtle profundity or deep reserve (*yūgen*), freedom from attachment (*datsuzoku*), and tranquility (*seijaku*). When designing gardens, do you intentionally consider these (and other) aesthetic principles, or do they naturally occur through your design process?

(MASUNO)
Regarding "Zen beauty," Hisamatsu Shinichi very thoroughly captures the characteristics and classifies them to be easily understood. It is an extremely useful classification to explain them very clearly to people. However on one hand, "Zen beauty" originally did not exist classified separately like this. It is preferable to consider that they [the seven characteristics] simultaneously are existing entirely within "Zen beauty." For example, in the world there are things having simplicity (*kanso*) as well as having symmetry (*kinsei*). Also, there are things with simplicity that are artificial (*jinkōteki*). However, it is impossible for them to be in the realm of Zen. Suffice it to say, within whichever point, beauty becomes strongly visible, I think.

Among these, especially subtle profundity (*yūgen*), simplicity (*kanso*), asymmetry (*fukinsei*), naturalness (*shizen*), and tranquility (*seijaku*) are important—if they are realized, austere sublimity (*kokō*) and freedom from attachment (*datsuzoku*) follow naturally. Pursue "Zen beauty," and as a result their beauty will be incorporated. Perhaps it is better to say that rather than wanting to create "Zen beauty," when trying to express "Zen as beauty," inevitably, with the natural flow, it finally arrives at this.

(ML)
How would you describe the traditional Japanese attitude toward nature? Has this attitude changed in contemporary Japanese society? If so, how?

(MASUNO)
For Japanese people, always living together with nature is most precious. The way of life and perception of beauty for the Japanese people lie within the changing of the seasons.

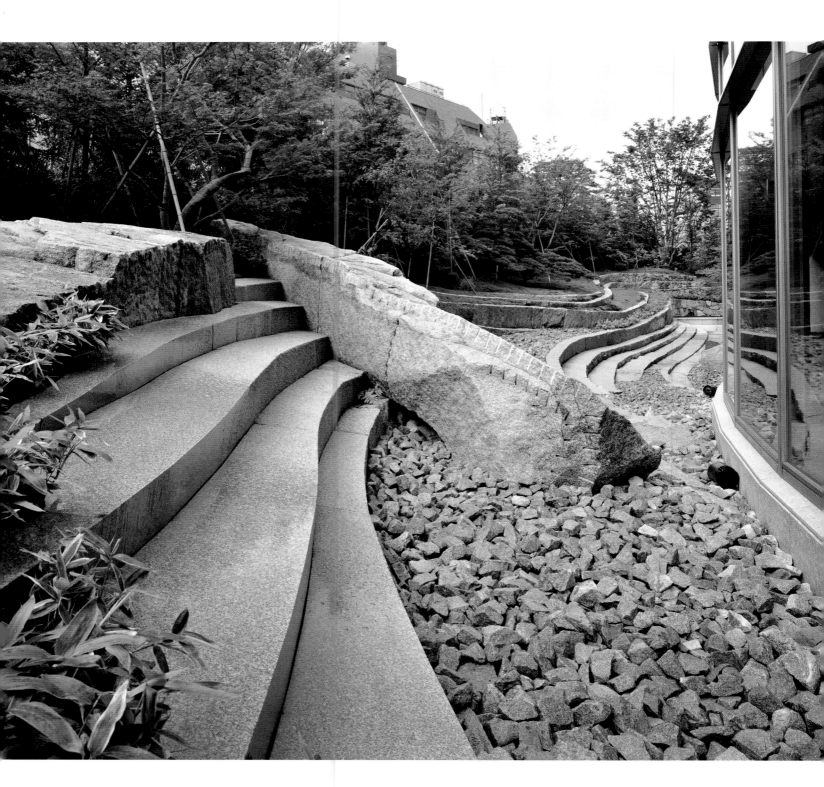

Above Layers of smooth polished stone and beds of rough rock impart the feeling of moving water in the Kanzatei garden at the Cerulean Tower Tokyu Hotel.

To perceive that seasonal variation physically and within living spaces, this "sense of beauty" and "sense of value" endure with resilience.

However, in contemporary society and urban society, the point of contact with nature is fading away year by year. In the contemporary city, spaces where nature can be felt have become much too scarce. Also, because of the increased use of air conditioning in buildings, the exterior space and interior space have become completely separated by means of walls and glass. We can no longer sense nature with our skin. Furthermore, the lifestyle of city residents is pressed for time, work quotas are constrained, and many people are living without noticing the changing exterior space. Accordingly, in order to resolve this problem, we must further the following two methods.

In cities, as much as possible, we must ensure there are places (Japanese gardens) where nature can be felt. These provisions are the incorporation of nature symbolized as a garden—regarded as the essence of Japanese gardens— in the nearby space of the city.

Another is the how architectural exterior space and interior space should be—to return to the original Japanese spatial composition. However, because from now on air conditioning is essential, even if glass exists, depending on the idea of the design, a garden in the exterior space and the interior of a room can come together. This is the recovery of the space that the archetypal Japanese people historically built.

(ML)
You note the importance of sensing the changing of the seasons, which is an example of the Buddhist principle of *mujō* (transience). With the fast pace of contemporary society and the growing dependence on ever-developing technologies, how do you see the role of *mujō* in people's lives today? How and why does *mujō* manifest itself in your gardens?

(MASUNO)
Things in this world—nothing is at a standstill as it is. Everything gradually continues to change. The fact is that it is transitory. We are apt to have the feeling that every day the same day comes, but this one moment, this one day, does not come again a second time. This is called *mujō*. The act of living while feeling *mujō*—this very thing is important to humans. This is the nature of the world. However humankind struggles, if one can live while feeling this unalterable truth, while feeling the richness of that life, this is living. The changing of the seasons is what most directly causes us to feel this. For people living in contemporary society, the development of technology, the information-oriented society achieved by it, and the fast-paced society in a way carry a dreadful poison by which the sense of awareness of human "*mujō*" becomes paralyzed. The fact is that everything has the illusion of being just as humans please. This sentiment is more dangerous than anything.

Accordingly, in order to have the feeling from gardens of "*mujō*" that is the nature of this world, to be extremely aware of beauty that cannot be immobilized, I am designing gardens with beauty that doesn't stay still. For example, the shadows of trees that cast on moss, the moon and garden scenery that reflect on the surface of water, the shadows that change every moment, and so on—all of these express fleeting beauty that cannot be brought to a standstill. Of course, it goes without saying that this is the changing of the seasons in gardens themselves. A beauty that is often overlooked—it is the awareness of it that becomes the opportunity for people to be able to sense richness. I am conscious of that point at all times.

(ML)
How would you like people to view your gardens? Is it the same for Japanese and non-Japanese?

(MASUNO)
Depending on how people encounter the gardens, I want them to see the garden as a place for observing themselves intently. Even more than the beauty of the garden, not comprehending the garden that extends in front of one's eyes as an objective target, but just considering it as one part of oneself—I want people to view the garden they are gazing on and their own selves as one. Things are as they seem. The rocks in a garden, also the trees, water—everything is there as itself. This is called truth (*shinri*); in Zen this is termed *hotoke no sō* [literally, "the Buddha itself"]. This way of seeing is not at all different for Japanese or non-Japanese.

GARDENS OUTSIDE JAPAN

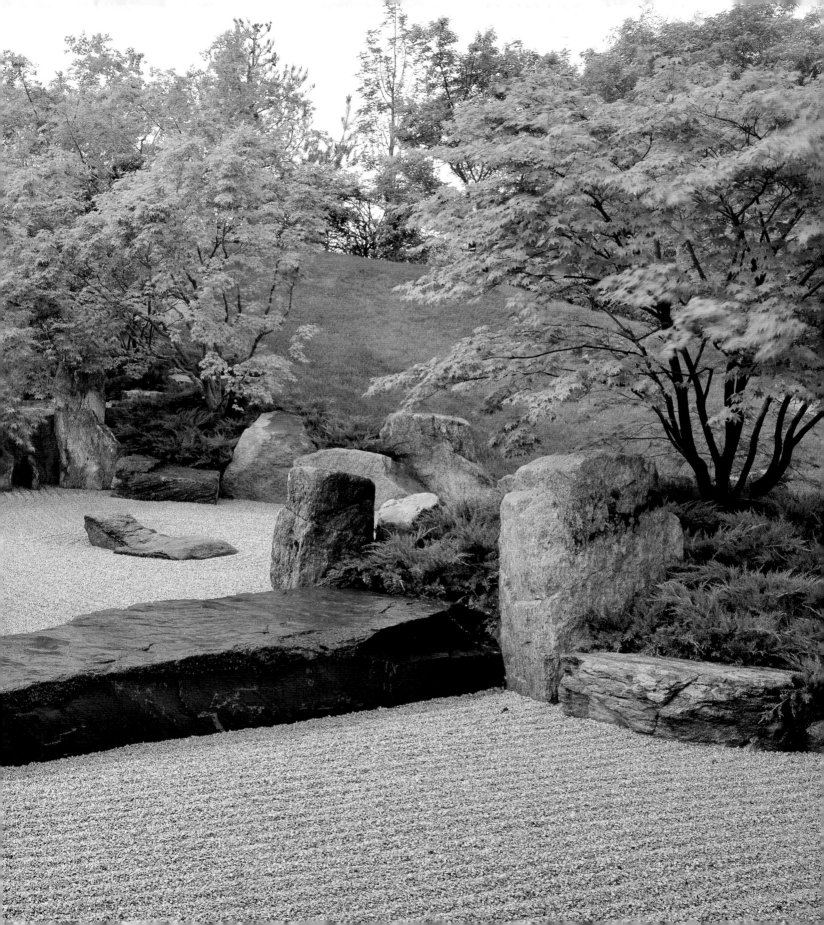

ZEN GARDENS OUTSIDE JAPAN: INTERCULTURAL COMMUNICATION

When working on the design of a Zen garden outside of Japan, Shun-myo Masuno must make two significant changes from his work in Japan. First, the consideration of the design concept must take into account the primarily (or exclusively) non-Japanese audience. Second, the selection of materials that give physical form to the ideas must reflect the specific location of the garden and its climate and environment.

The fundamental concepts behind all of Masuno's gardens, within Japan or overseas, are rooted in Zen principles. Depending on the function of the garden, the concept may relate to ideas of *motenasu* (hospitality), as in the gardens at the Nassim Park Residences in Singapore; or the concept may focus on *wa* (harmony), finding unity in disparate ideas or objects, as in the garden at the Canadian Museum of Civilization in Ottawa. These fundamental concepts do not necessarily depend on where the building is located. The difference comes in how viewers may understand the principles based on their own personal experiences. This perception is framed by each viewer's culture, as well as their familiarity or unfamiliarity with Japanese culture.

In Japan, Masuno can expect that most viewers will be familiar with basic Zen principles as well as the fundamental concepts of Japanese garden design. Even if they cannot articulate these principles with words, most Japanese will have had previous experience with them. In many of his gardens overseas, Masuno cannot be sure that viewers will have had previous opportunities to experience a Japanese garden or will be at all familiar with Zen thinking. This is especially the case in

public gardens, such as those he designed for the Canadian Museum of Civilization in Ottawa and the Japanese Garden in Berlin. In these gardens, Masuno often utilizes time-honored forms and formulas, creating gardens that fit the site and function while truly reflecting the traditions of Japanese garden design.

These overseas public gardens take on the additional roles of cultural exchange and teaching. In reality, all of Masuno's gardens are designed to teach, although the "teaching" often comes through the opportunity for the viewer to be introspective, to shed the cloak of everyday cares and confront the self with profound clarity. The gardens outside of Japan offer this same opportunity. However, they also provide the occasion for viewers to learn about Japanese culture and perhaps by doing so see their own culture more clearly. To do this, these gardens must teach at a very basic level—they must answer the question, "What is a Japanese garden?"

There is no single formal design response to this question, as a Japanese garden always responds to its particular site and environment – in Masuno's words, to "express the underlying spirit that prevails in the given space."[1] Additionally, the garden must incorporate the wishes of the client and the designer's personal response to these constraints and opportunities. Masuno notes, "It is doubly, triply more difficult to build a Japanese garden outside of Japan. It is much more difficult than one imagines it to be."[2] He does not assume or expect that a non-Japanese viewer will understand every detail of his gardens, but he hopes

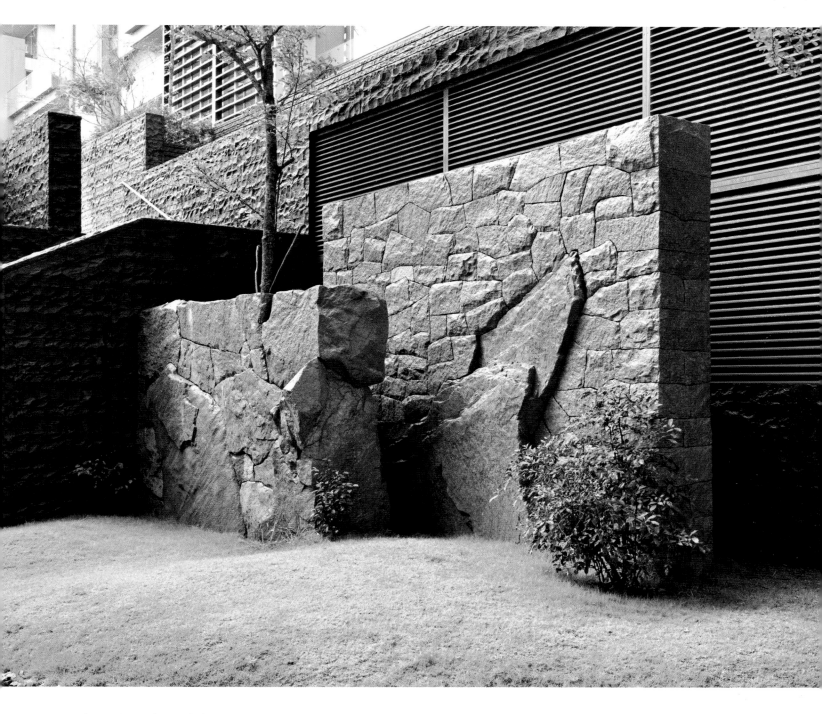

Page 173 The Yūsuien garden at Erholungspark Marzahn in Berlin combines locally available materials with elements from Japan, creating a garden that is at once familiar and new.

Above Thick stone walls interspersed with plantings give form to the many layers of space within the Wakeisei-jyaku no Niwa at the Nassim Park Residences in Singapore.

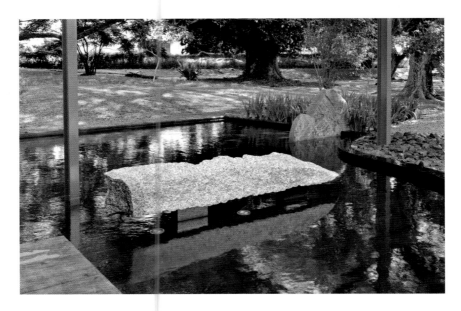

that the viewer will connect to the garden and will be moved by the design.

In his overseas designs for private clients, such as the residences in Stuttgart and New York, Masuno can be sure that the clients are familiar with the concepts behind his designs and therefore can move away from traditional forms and methods and be more innovative. He achieves this by including contemporary forms, for example the curved stacked stone walls in the Stuttgart garden, or by utilizing design devices such as connecting interior and exterior space with stone slabs that move "through" a window, as in the New York garden. Even though he is free in these projects to explore various means of communicating his ideas in the gardens, he understands that the garden simultaneously must fulfill the role of cultural exchange.

The decision to create a traditional versus a contemporary design for a garden outside of Japan is affected by the wishes of the client, the surrounding context, and the ideas to be conveyed by the garden. In the case of the Japanese Garden in Berlin, the objective of the garden as outlined by the client was to be representative of Japanese gardens in an exposition of gardens of the world. Therefore Masuno based his design on tradition. For the gardens at the Nassim Park Residence in Singapore, Masuno combined traditional and contemporary forms to complement the minimalist contemporary architecture and the requirement to create gardens for relaxation. In the garden at the Uni-

versity of Bergen, the design ideas relate to the technological focus of the research center the garden adjoins. Thus Masuno incorporated materials and forms that reflect the contemporary function of the building, yet he utilized Zen principles to create a serene and welcoming atmosphere.

While the formal communication of a Zen principle may be esoteric to some, the matter of selecting materials is much more straightforward. Still, the selection of materials and their proper use in the garden can be a stumbling block in the design and execution of any garden, but this is exaggerated in the case of gardens outside of Japan. Since rocks and plants are understood to have their own *kokoro* (spirit), it is important for Masuno to find suitable elements to support his design and then to make the most of their expression of their spirit in the garden. The ability to recognize the *kokoro* of an element comes from Masuno's Zen training and his long experience in garden design.

For his gardens in Japan, Masuno notes, " . . . when I am looking for suitable stones and other materials for a garden, I go up into the mountains and make numerous sketches in order to find stones and plants with the right degree of empathy."[3] In Japan, Masuno knows from experience the best places to visit to find certain kinds of rocks or plants. However, in a foreign country, although he may be inspired by the nature he finds, as with the fjords in Norway, he must rely on the knowledge and generosity of others to help in his quest for the proper materials.

Top A heavy slab of stone appears to float above a tranquil reflecting pool in the Zanmaitei garden at the Nassim Park Residence Showflat in Singapore.

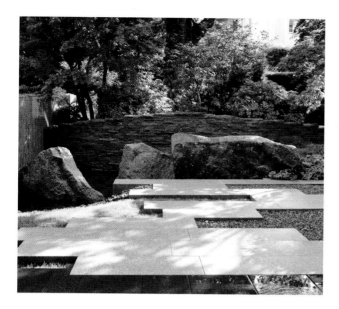

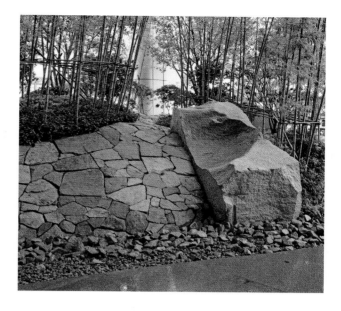

For example, although a quarry seems like a logical place to look for rocks, many of the rocks Masuno uses in his gardens must reflect their formation over time by the forces of nature. These rocks only can be found in natural settings. Someone who is familiar with the region must serve as a guide, and once an appropriate rock is located, Masuno and his team must rely on the generosity of the land owner (and sometimes the negotiating skills of the guide) to receive permission to remove the rock.

Additionally, plants native to the area are the best suited for a garden because they can withstand the local climate. In many cases, these plants vary from those familiar to Masuno in Japan. And because the Japanese aesthetic sensibility related to the forms of trees and plants often is quite different than in other countries, a visit to a nursery may yield "background" plants but may not offer plants appropriate as focal points. Nurseries often grow plants to have a uniform size and "perfect" shape, but plants used in Japanese gardens are prized for their unusual shapes. These plants must be formed by their natural surroundings— shaped by the wind and the slope of the land. To locate these plants, Masuno again must rely on the knowledge of a local guide.

In addition to finding the proper materials, the use of those materials in the construction of the garden can be especially complicated in a foreign project. Masuno notes ". . . what an important matter the supervision of the actual manual work involved in the lay out [sic] of a garden actually is."[4] However, since he is based in Japan, it is impossible for him to be available for every moment of the construction of a garden, especially a large garden like the Japanese Garden in Berlin. Masuno or a member of his design team spends as much time at the construction site as possible, but much of the work proceeds without them. If the budget allows, Masuno will use stone masons and gardeners who have experience working with him on other projects, and he trusts that they understand his objectives in the design of the garden. However, if Masuno must train local workers to set rocks or arrange a group of plantings, then the situation is more complex. Even if the workers closely follow the drawings Masuno provides, the key to the design is to convey the "empathy" inherent in the rock or tree—something that cannot be drawn and is understood only with experience. For this reason, whenever possible, Masuno utilizes rocks from Japan, so he can choose and study them carefully, and he arranges to be present to place the rocks and other primary design elements in the garden.

Although the gardens outside of Japan are more challenging to complete than those in Japan, Masuno finds them very rewarding. The added roles of the gardens for teaching and creating spaces for cultural exchange make the work exciting and "gratifying beyond comparison."[5]

Top left Naturalistic and obviously man-made elements unite in the Funitei garden at a private residence in Stuttgart, Germany.

Top right In the Sanshintei garden in Hong Kong, a grove of bamboo surrounded by thick ground cover grows atop a rock-covered mound, which swells to meet a powerful boulder.

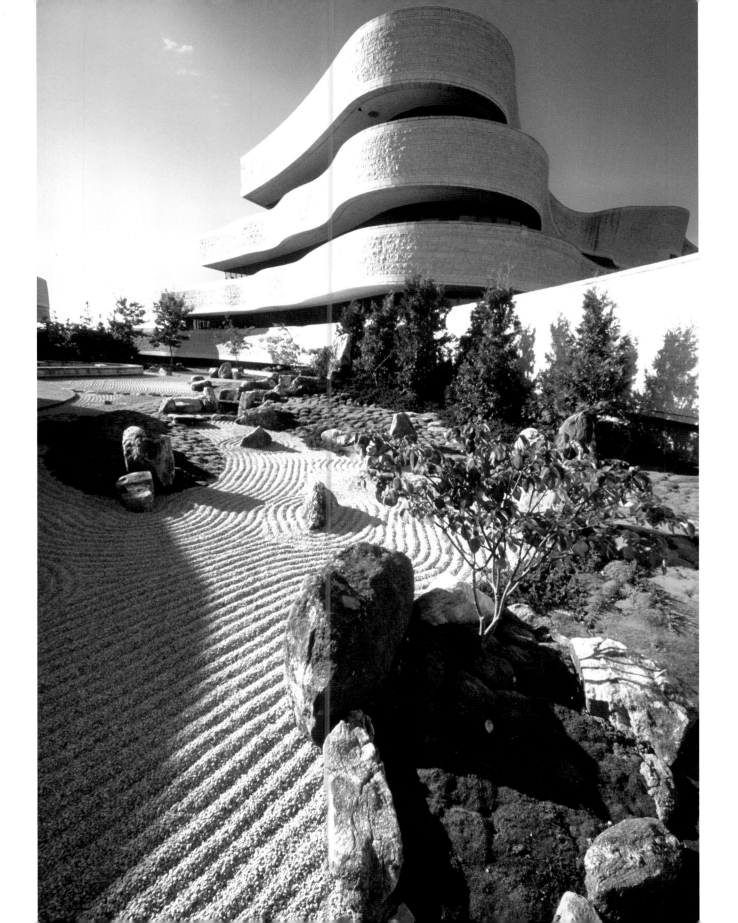

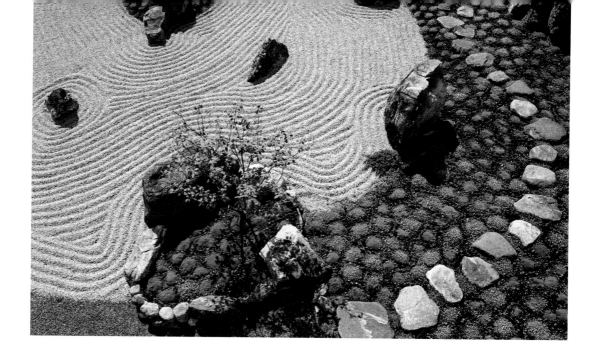

和敬の庭
WAKEI NO NIWA

CANADIAN MUSEUM OF CIVILIZATION

OTTAWA, CANADA, 1995

Situated on a hillside across the Ottawa River from the Canadian Parliament Buildings, the Canadian Museum of Civilization steps up the sloping site with layers of sinuous curves that follow the contours of the land. Dividing the museum complex into two buildings, a central plaza with a grand stair leads down from the street-level entrance area to a plaza overlooking the river. The museum is on the south side, and the administration building with the library and archives is on the north. Tucked into the curves on the north side of the complex, the Wakei no Niwa (literally "Harmony Respect Garden"), or the Garden for Harmonious Relationship with Respect, blends well with the roughly textured light-colored stone cladding of the curvilinear building.

The basic idea behind this two-level garden (a third level above is reserved for a future phase of the garden) is to create a space where visitors are able to better understand their own landscape and them-

selves. To achieve this, Shunmyo Masuno designed a spare traditional *karesansui* (dry) Zen garden using only rocks and plants sourced from the areas around Ottawa. Therefore, while the plants and the colors and types of the rocks may be familiar to most Canadian visitors, the style of the garden is new. This use of the familiar in an unexpected way is a common design device in many Japanese gardens. Called *mitate* (re-seeing or seeing anew), a typical example is the incorporation of an old millstone within a line of stepping-stones. The millstone is familiar but out of its usual context, provoking the viewer to see the entire garden, as well as the millstone, in a new way. By association, the self, too, is seen anew in this context. In the Wakei no Niwa, rather than a single element serving that purpose, the materials making up the entire garden have the role of stirring such a response.

As one generator of the design and to connect the garden with the

Opposite page Using rocks and plants found in Canada, Shunmyo Masuno created a dynamic garden that matches the exuberant sweeping curves of the Canadian Museum of Civilization.

Top A meandering path of stepping-stones set within a moss-covered bed leads visitors through the heart of the garden.

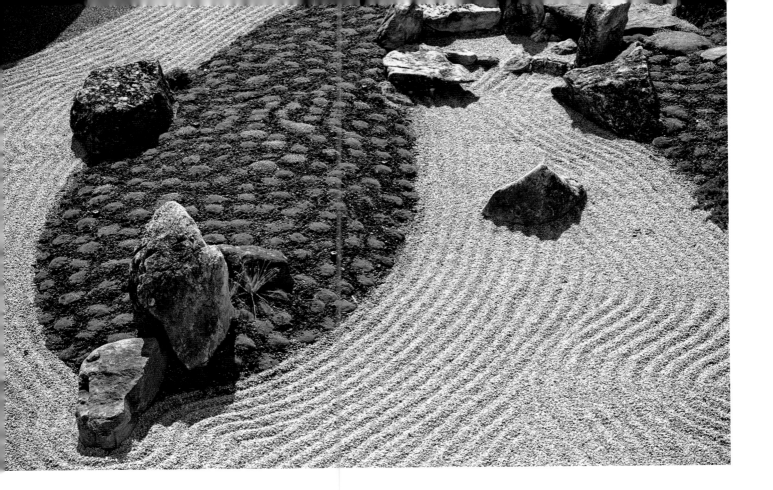

concept of linking Japan and Canada, an implied axis runs from the museum to the dry waterfall in the garden and across the Ottawa River to the Japanese Embassy. This connection also is made in the main part of the garden with the major element, a dry gravel stream, moving through the space and seeming to flow through the windows, as if to impart Japanese culture into the museum. The garden is considered both a part of the whole exterior landscape and a component of the museum collection.

The visitor first encounters the Japanese garden at the entry level, with a small garden enticing one to move up a few steps to view the main garden, and the future upper garden sited above it. The lower garden features a few carefully positioned large rocks set against a background of trees and shrubs, which contrast nicely with the color and texture of the building walls. The thick greenery of this garden connects to the plantings of the main garden just above it, which is anchored on the left side by a "peninsula" of verdure.

The main garden has three primary design elements—a waterfall, a stream, and a stone bridge, all created with local rock. The flow of the

Top Like a quickly moving river, the raked pea gravel follows the form of the land and flows around rocks as it moves from the dry waterfall throughout the garden.

Above The stepping-stone path connects to a stone plank bridge at the base of the multitiered dry waterfall.

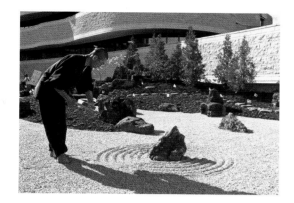

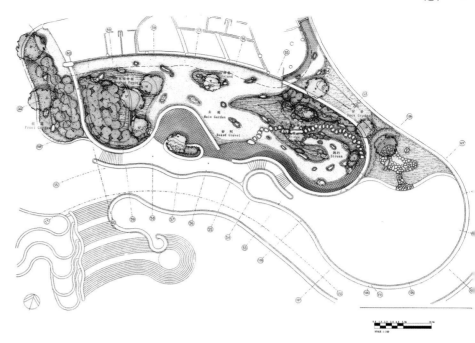

gravel stream starts from the rock waterfall set within a hill on a second "peninsula" on the right side of the garden. Two tall rocks set vertically create the top of the falls, and a grouping of lower rocks tumbles down the hill in a series of horizontal layers, evoking the image of cascading water. From the base of the waterfall, the light brown pea gravel flows under a stone bridge, around a slender spit of land, and out to the middle of the garden. The gravel is raked in a ridge pattern to emphasize the movement of the flow. In the center of the garden, where the stream widens and flows around several rock "islands," the rake pattern follows the perimeter of the rocks, to give emphasis and set them apart.

The stream flows through a stepping-stone path, which originates from a rock set into the edge of the walkway. From this point, visitors view the garden and move across the stream on the stepping-stones onto the spit of land and then over the bridge to the hill. The stepping-stones continue through the ground cover past a grove of trees—northern white cedar mixed with juniper and pagoda dogwood—and terminate at the end of the visitors' viewing path. In the center of the garden, at the widest part of the stream, an island with a grouping of rocks and a single gray dogwood tree draws in the viewer and strengthens the connection between the viewer and the garden.

The simple design of the garden necessitates a strong relationship—"a conversation"—between the various elements. The "empty" space

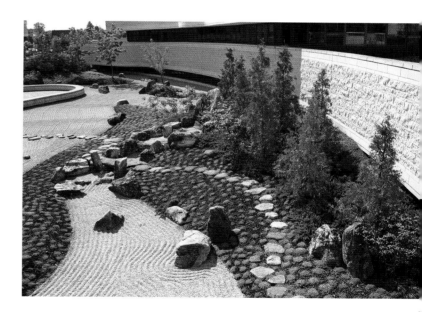

between the elements is incorporated into the design as a means to allow the viewer's eyes and mind to rest and be "at one" with the garden. This harmony between viewer and garden is the first step toward the harmony and respect inherent in the garden's name, Wakei no Niwa.

Tpo left Shunmyo Masuno at work in the garden, raking the pea gravel to follow the contours of a rock "island."

Top right The plan of the terraces shows the main garden in the center, flanked by the lower garden on the left and the proposed future upper garden on the right.

Above The curved stone façade of the museum serves as a quiet backdrop for the lively composition of gravel, rocks, moss, shrubs, and trees.

融水苑 YŪSUIEN
ERHOLUNGSPARK MARZAHN

BERLIN, GERMANY, 2003

Located in the Marzahn neighborhood of Berlin in former East Germany, Yūsuien is one of a number of world gardens open to the public as part of a large recreational park. The name, Yūsuien, refers to the aim of the garden—to utilize water as an element expressing harmony among disparate parts (*yū* means "harmony," *sui* is water, and *en* means "garden"). The name comes from a Zen expression referring to water not having its own shape but harmoniously responding and adapting to its surroundings ("*Yūgō suru koto mizu no gotoku motte watonasu.*"). Shunmyo Masuno chose this theme for the garden to express the idea of the unification of Germany, where harmony of different cultures and ideas is essential.

For this garden, which serves people who may or may not be familiar with Japan, Masuno wanted to express a strong spirit of Japanese culture and create a bold feeling of nature where visitors can reflect on the scenery and come face to face with their own thoughts. The garden therefore has multiple meanings—an emblem of harmonious relationships of people from different cultures (both within Germany but also connecting Germany and Japan), an expression of Japanese culture, and a place of reflection for the individual visitor. To achieve these separate expressions, the garden is divided into three areas—front, main, and back gardens—each having individual characteristics, yet together creating a unified design.

Right Viewing the *karesansui* (dry) garden from the east, a stone plank bridge crosses the river of raked pea gravel from a grassy bank to a rocky island representative of Mount Hōrai, the island mountain of immortals.

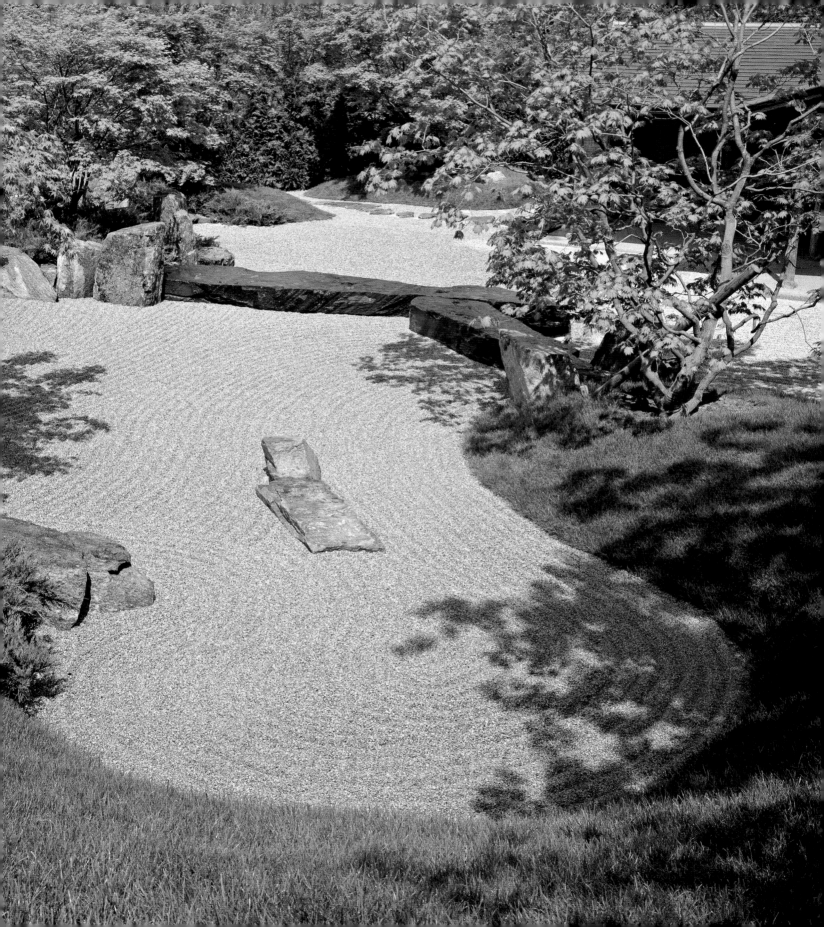

For the first-time visitor to a Japanese garden, the entry sequence is a surprise. A series of *nobedan* (stone-paved walkways) draws the visitor through a gate and into the garden. The outermost *nobedan* is created from strips of stone laid adjacent but offset from one another. It then changes to a random pattern of large oddly shaped stones, which changes again under the traditional roofed gate to a more regularized rectangular grid pattern. The random pattern picks up again after the gate and stops in front of a long tall hedge that blocks the view and forces the visitor to turn. This is the surprise—the initial view of the garden reveals only the detail of the path and the carefully cropped surface of the hedge.

The way through the garden is suggested by another *nobedan* to the right, made of many small river rocks placed close together. It leads to a stair, which follows a tall hedge on its left and is bounded by tall trees on the right. The effect is strong—suddenly the visitor is surrounded by thick vegetation, in a space grander than the human scale. It is a moment where it is impossible to ignore one's relationship with nature and self-reflection begins.

The path continues to climb and curve. At a high point, the view opens up to a bed of raked white *shirakawa-suna* (pea gravel) within the main garden below. After this expansive view, the focus shifts back to the path as it changes to stepping-stones and crosses a dry waterfall.

Tall rocks mark the top of the waterfall, and the falls cascade down the hill in a series of levels until the "water" is released into the raked gravel "pond" below. Just below the top of the waterfall is a small stone, representing a carp trying to swim up the waterfall. This is symbolic of another Zen expression in which the carp having successfully navigated the waterfall becomes a dragon—implying that with determination, huge hurdles can be overcome.

After the waterfall, the path meanders downhill to a viewing spot marked by a platform with simple benches. Tucked within a grove of trees, the sight and sounds of water surround the platform, flowing from a waterfall into a pond and through a series of cascades into a stream. This waterfall represents the origin of Germany, where the

Top left After passing through the entry gate, the path leads to the right, with rough stone stairs meandering up the verdant hillside.

Top right Just inside the entrance gate, a series of *nobedan* (stone-paved walkways) shift and overlap in the gravel court, subtly indicating the direction of the path.

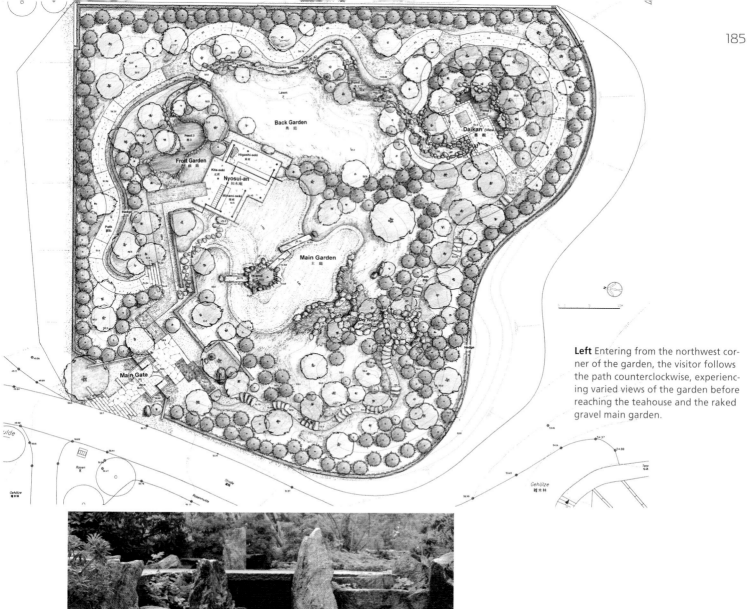

Left Entering from the northwest corner of the garden, the visitor follows the path counterclockwise, experiencing varied views of the garden before reaching the teahouse and the raked gravel main garden.

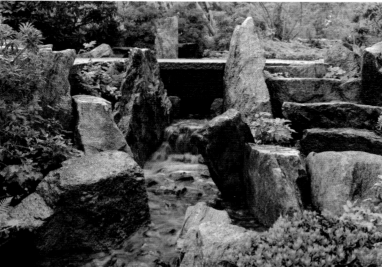

Above Before running down the hill between large slabs of rock, water flows under a platform where visitors can pause to view the garden and enjoy the sound of the rushing river.

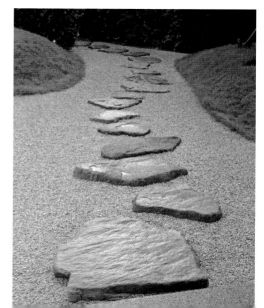

Right Stepping-stones lead through the pea gravel of the *karesansui* (dry) main garden from the teahouse toward the tall hedges guiding the visitor back to the entry area.

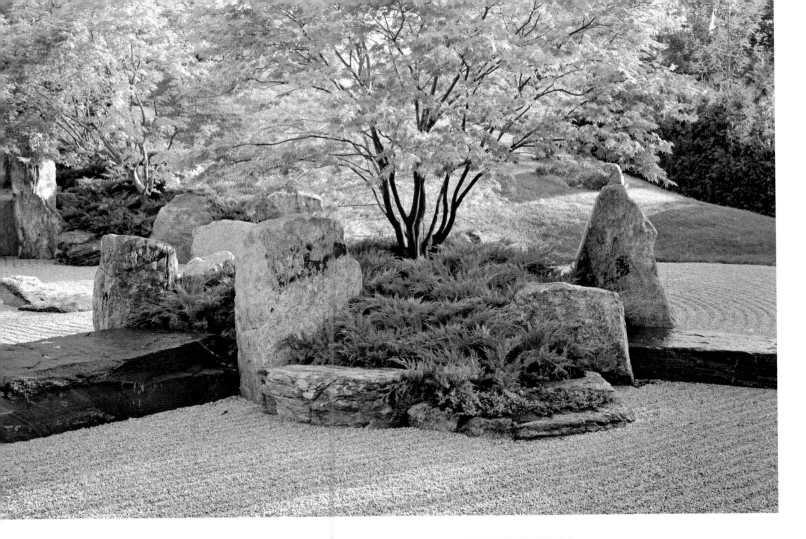

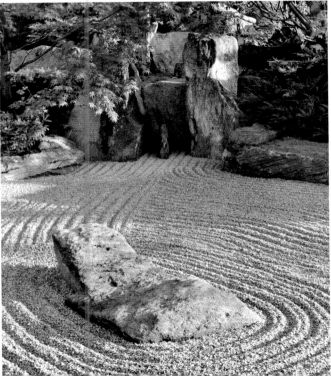

Right Raked pea gravel flows from the *ryūmonbaku* ("dragon's gate waterfall") rock arrangement around an unusually shaped rock representing a carp.

Above Set within the raked gravel of the main garden, stone plank bridges connect to the island symbolizing Mount Hōrai, the island mountain of immortals originating from Chinese Taoism.

flowing water signifies the country's history of transitions. The stream leads through the back garden to a pond in the front garden, which symbolizes a mirror reflecting the viewer's close contemporary history.

From the platform, a narrow path follows the stream and then links back to the main path to continue down the hill. The dense vegetation that surrounds the main path at the top of the hill gives way to open views across the stream to the grassy slope of the back garden. Across the grass is the Jyōsuitei teahouse, used for *ryurei* (seated) style tea ceremony. Two perpendicular central walls create three separate spaces with benches for viewing the garden. One looks out over the grassy slope of the back garden, another views the pond of the small front garden, and the third overlooks the raked gravel *karesansui* (dry) garden.

Following the path through the open space of the back garden, the visitor once again meets up with the tall closely cropped hedge. The hedge borders the path on the left side and passes through a constricted space to the *nobedan* leading to the front garden. The sound of water, a small waterfall where the stream flows into a pond, guides the visitor to the teahouse, a place to rest and consider the present. A doorway leads to another bench overlooking the *karesansui* garden, symbolizing the future. This is the last place to pause and reflect before returning through high hedges to the entry, thus completing the symbolic connection of the past, represented by the flowing water, to the future symbolized by the raked *shirakawa-suna* of the dry garden.

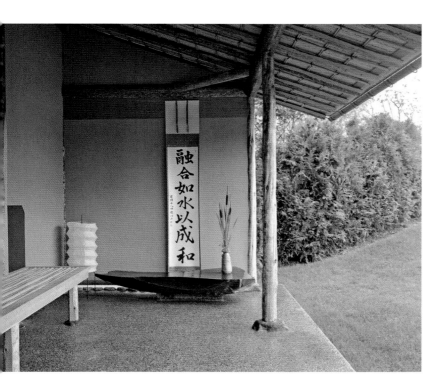

Left Used for *ryurei* (seated) tea ceremonies, the Jyōsuitei teahouse features wood columns and an overhanging eave that frame the garden when viewed from the bench.

Above right The path follows a narrow rock-lined stream of water through the grassy expanse of the back garden.

Top A wide *nobedan* (stone-paved walkway) guides visitors to the main entrance of the Jyōsuitei teahouse.

静寂の庭 SEIJAKU NO NIWA
UNIVERSITY OF BERGEN
BERGEN, NORWAY, 2003

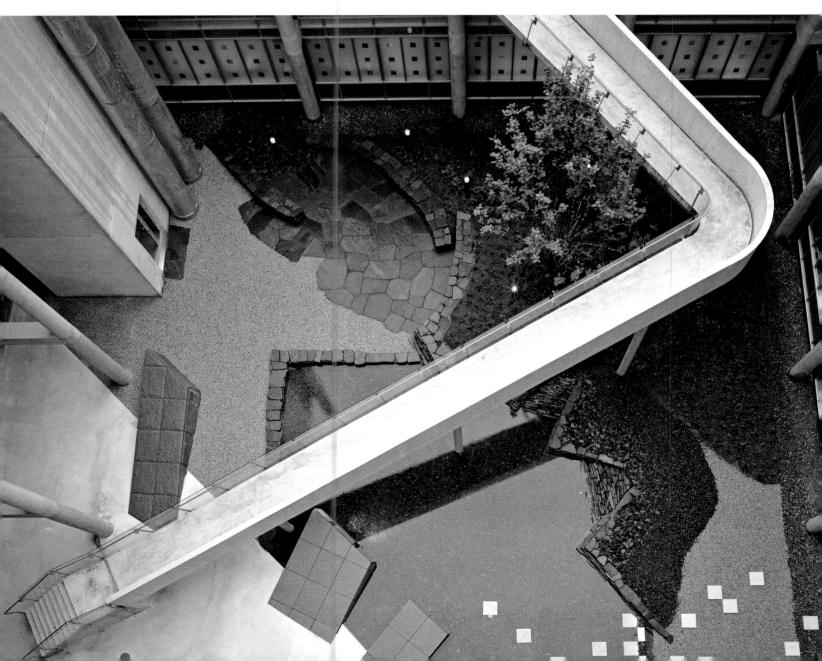

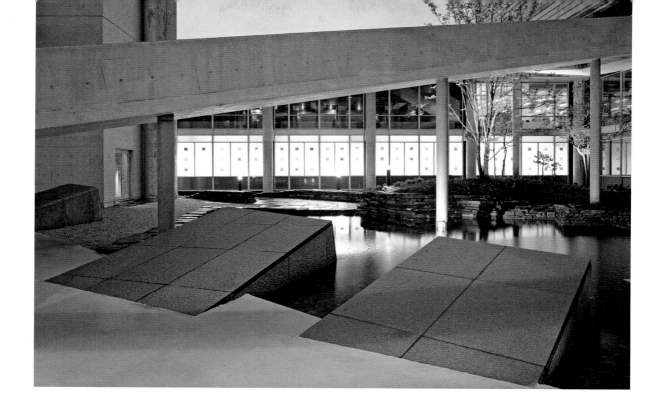

The powerful silence within the strong nature of the Norwegian fjords was Shunmyo Masuno's inspiration for the garden at the Building for Basic Biological Research, a medical research facility, at the University of Bergen. After the research buildings were constructed, an international competition was held for the design of two garden spaces. Masuno's winning entry combined forms inspired by the Norwegian landscape with ideas inspired by the human intelligence and technology associated with the research facility. The result is a garden where, amid the demands of everyday life, viewers can find calming silence for their minds and spirits. The importance of silence in this garden is reflected in its name, Seijaku no Niwa, literally "Garden of Silence."

The garden is composed of two parts. The larger space, called the atrium, is a tall almost-square space surrounded by the building. The courtyard is a long narrow space adjacent to the windows of the research laboratories. Both gardens incorporate the sense of silence but utilize slightly different means to achieve it. The atrium is mostly contemporary in style, while the courtyard incorporates somewhat more traditional forms.

Because of the long winter season in Bergen, the gardens primarily are viewed from inside the research buildings. However, they are designed not only to be viewed from a distance but also to be moved through. To ensure that the plants in the gardens grow well and to further connect the gardens with the surrounding landscape, Masuno and his team searched the area around Bergen to find appropriate trees and rocks. Thus the gardens incorporate elements that are familiar to the Norwegian researchers who view them on a daily basis, but also include components that are specific to the Japanese sense of nature and beauty.

The composition of the atrium garden combines elements that respond to the technological aspect of the research center with those that evoke nature. The tall space of the atrium includes a ramped bridge that angles down from an upper story into the garden. Although viewers can move out to the "technological" side of the garden from the adjacent multipurpose hall on the south, the ramp acts as the path through the space. Nature is represented in the atrium most clearly in the earth mound planted with thick ground cover in the northeast corner of the garden. Curved walls of stacked layers of stone, reminiscent of stone walls in the Norwegian landscape that fascinated Masuno, hold back the earth, setting off its lush ground cover, shrubs, and a few pine trees.

The stone retaining walls continue out into the space of the garden

Opposite page top The sketch expresses the varied landscapes created In the "atrium" garden and the ways viewers can interact with the garden and each other.

Opposite page bottom Designed to be viewed both from within the garden and from above, the "Garden of Silence" features a long angled ramp that connects the "atrium" garden to the upper "courtyard" garden.

Top Lighting within the garden is an important element in the overall design, allowing viewers to enjoy the garden throughout the long dark Norwegian winters.

where rough stone on the ground surface changes to gravel. Set into the gravel on the east side, a checkerboard of square concrete pavers slowly starts to fill in the space, until they completely cover the southeast corner of the garden. Within the center of the garden, another low wall of stacked stone creates the edge of a pond. The shape of the pond implies a square, but it is cut off by angular stone walls on the northeast corner, and the opposite corner is cut off by a concrete patio.

The concrete patio in the southwest corner of the garden strongly contrasts the organic quality of the earth mound. The triangular shape of the patio allows visitors to experience much of the garden, while still being on the high-tech or intellectual side. Four piers faced with stone jut out from the concrete patio into the gravel and pond and provide balance for the prominent form of the ramp. The largest pier is on the west, near the steps that lead up to the ramp. It is faced with rough stone, while the other three are faced with smooth stone and gradually decline in size. The smallest pier moves just off the patio, mediating between the gravel and the water.

The ramp leads up toward the courtyard garden, which incorporates some of the same elements as the atrium garden—stacked stone walls to delineate spaces, rough stone, gravel, and square concrete pavers on the ground, and pine trees as focal points. However, the layers in the narrow garden are compressed between the windows of the laboratory in the front and a gently curved concrete wall in the back. On the left and right sides of the garden are tall air shafts, which condense the space of the garden even further. The grid of the concrete pavers slowly changes to gravel, with several groupings of large rocks positioned in the gravel in front of the curved stacked stone retaining walls. The mounded earth held between the stone walls and the back concrete wall is covered with a thick layer of vegetation and dotted with shrubs and trees.

The designs and the relationship of the two gardens suggest a flow from the interior of the research building through the atrium to the courtyard. The movement progresses from the man-made, symbolizing human wisdom and suggested by the concrete and the geometric forms, to the natural, represented by the plants and rocks. The combination of the natural and the man-made creates an intriguing composition of contrasting colors and textures that blend harmoniously in an atmosphere of meditative and silent serenity.

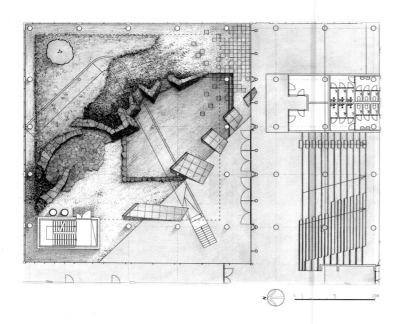

Above A wide staircase inside the building acts as seating to view out through a wall of windows to the "atrium" garden.

Right Representing the powerful nature found around Bergen, local pine trees sit atop mounds of earth faced with stacks of dark stone in the "courtyard" garden.

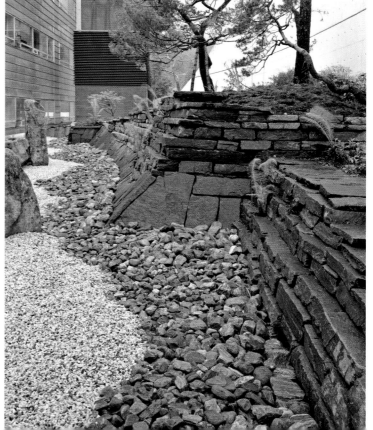

Right A sketch shows the idea of using layers of gravel, rock, and a raised planting bed to create the illusion of deep space in the narrow walled "courtyard" garden.

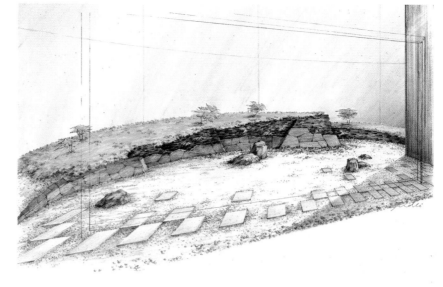

Below Square concrete pavers line the edge of the gravel bed, in front of the mound planted with pines and faced with stacked stone, which slopes up from the Corten steel-clad ventilation shaft.

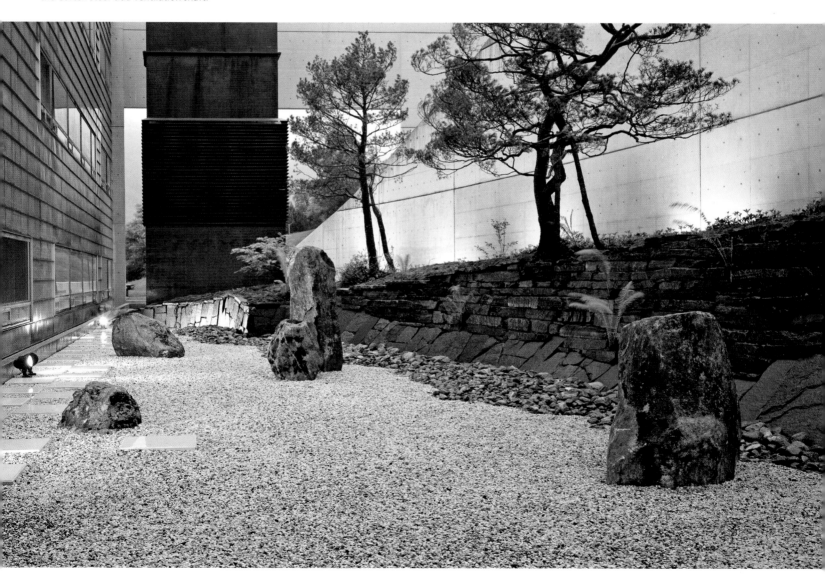

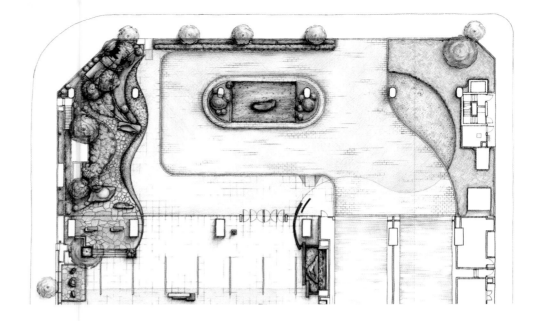

三心庭 SANSHINTEI

ONE KOWLOON OFFICE BUILDING KOWLOON BAY, HONG KONG, 2007

Using Japanese values and sensibilities to merge the exterior landscape with the interior lobby spaces was the goal of this contemporary Zen garden at a high-rise corporate office building in Hong Kong. Shunmyo Masuno gave the garden the Zen name Sanshintei (literally, "Three Spirits Garden"—*sanshin* means "three spirits," and *tei* is "garden") to reflect the values by which people traditionally lived—values that apply to companies as well as people.

Elements used in the design of the garden and the interior of the lobby lounge reflect the three spirits (*sanshin*) or senses of the Zen terms *kishin*, *rōshin*, and *daishin*. *Kishin* refers to the spirit of sympathy and is symbolically represented in the design as light. The primary physical manifestation of this symbol is a wall of light in the lobby. *Rōshin* is the spirit of sympathy, and water is the symbol of sympathy in the design, with a waterfall in the lobby standing 9.5 meters (about 31 feet) in height. The waterfall welcomes visitors to the building in the spirit of *rōshin*. Referring to a broad spirit that can envelop others, *daishin* is expressed in the garden through the use of stone. An undulating stone platform grows out from the lobby lounge to the garden, creating a strong connection between inside and outside.

For this project, Masuno designed much more than the exterior

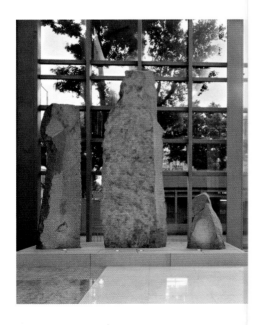

Above In the lobby, on the opposite end from the waterfall, the sculptural triad of stones features a central stone standing 4.7 meters (more than 15 feet) high.

Top With the stone pavement patterns and rock beds continuing on both sides of the window wall, the garden moves fluidly between inside and out.

Opposite page Gravel in two sizes mediates between the gently curving random rock-covered mound and the precisely gridded stone pavement.

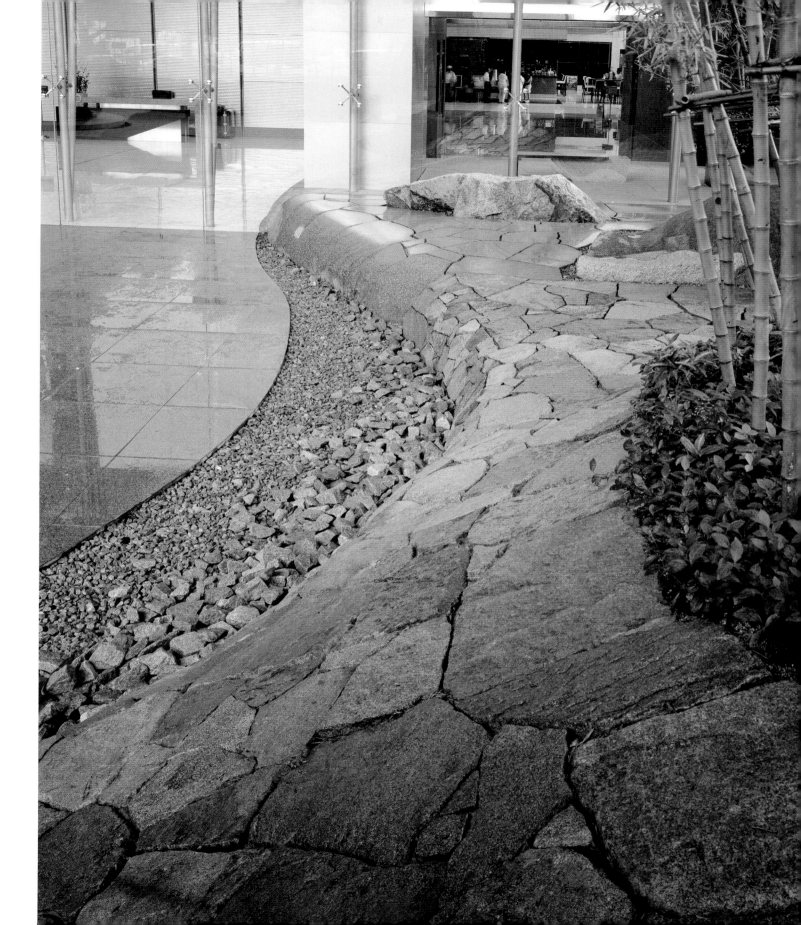

garden spaces. He also designed many elements in the lobby, including the pattern of the stone floor, the waterfall, the *daishin* stone platform with its stone and wood benches, a sculptural composition of three vertical rocks, and the contemporary styled reception counter. Every element supports his objective of connecting interior and exterior space while embodying the essence of *sanshin*.

The lobby is a tall space (13 meters or more than 42.5 feet) with a wall of windows that looks out to the garden. The floor level is consistent from outside to in, and two curves of black stone set into the gray stone floor mark the entry from the drop-off area and move between the interior and exterior. The longer curve leads directly to the waterfall

on the east wall of the lobby. From a height of 9.5 meters (just over 31 feet), water runs down the ridged surface of a tall wall of reddish stone, falling into a shallow pool containing several large rocks. The main rocks in the pool represent the Buddha with two disciples, a nod to the Buddhist faith of the owner of the building. The splashing of the waterfall provides a calming background sound for the lobby.

Opposite the waterfall, on the west side of the lobby, is the lounge area with the undulating raised stone platform representing *daishin*. The platform appears almost like a puzzle of variously shaped pieces of smoothly polished stone. A single tree marks the edge near the windows, while several steps lead up to the benches on top of the platform.

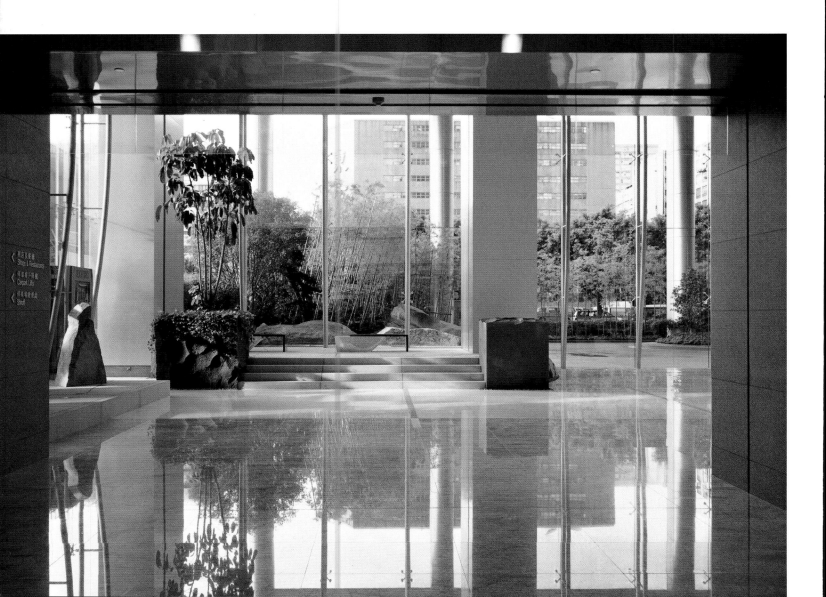

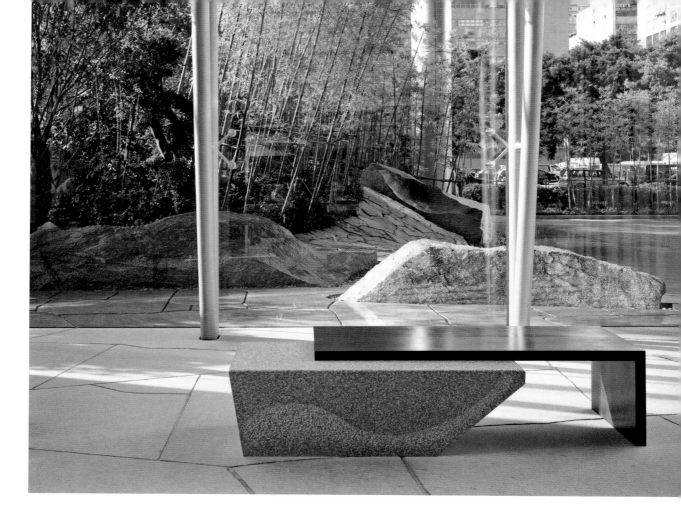

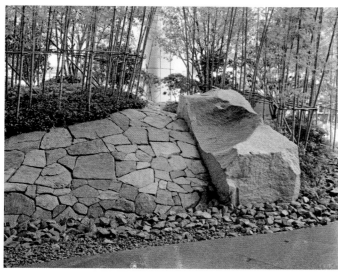

Opposite page Looking from the elevator hall through the lobby, four steps lead up to the *daishin* (broad spirit) viewing platform with two benches in a contemporary design by Shunmyo Masuno.

Above Planted with bamboo and faced with rock in a random pattern, the mound rises up to meet a single enormous roughly textured boulder.

Top Creating a quiet place to contemplate the garden, the lobby viewing platform features benches fabricated from thin planks of mountain cherry wood and heavy slabs of precisely cut granite.

Above Positioned on the polished floor of the elevator lobby, three sculpted cubes of dark stone are subtle compositions of light and shadow.

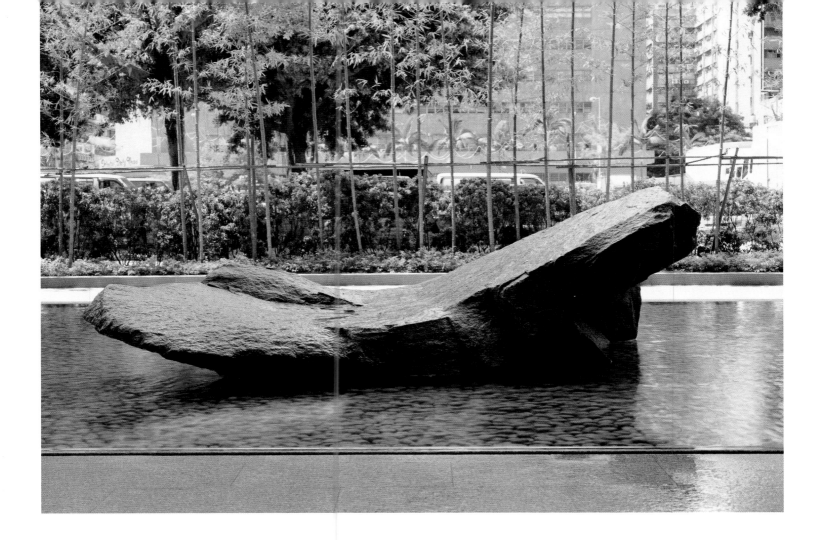

The sculptural benches provide a quiet place to sit and contemplate the garden. The raised stone platform continues through the window wall into the main part of the garden outside, creating the feeling that the interior space extends out. A ceiling canopy also transitions from inside to the exterior to further emphasize the connection.

As the platform moves further outside, the texture slowly transforms from smooth to rough. A few large rocks break through the surface, which ends with a single large powerful rock as an exclamation mark. A bed of gravel, curving to complement the undulations of the platform, mediates between it and the polished stone floor. On top of the platform, bamboo backed by trees blocks the view of the adjacent buildings and encloses the space under the roof canopy. Because the canopy limits the sun and rain on some parts of the garden, the plantings are more selective in those areas. In places where the canopy does not cover the garden, a mix of foliage with many colors and shapes of leaves contrasts the hues and textures of the rocks.

The stone surface of the lobby floor continues outside on the driveway, with the smooth polished stone changing to a textured surface. Curves designed into the stone surface demarcate the space of the driveway from the walking areas. The drive loops around a shallow pool of water lined with white river stones and set with a powerful arrangement of rocks. Four small rocks accompany a large long dark rock that lifts out of the water at both ends. Positioned directly across from the entrance to the building, the pool with the powerful stone arrangement, set against a backdrop bamboo and greenery, is a reminder of the three spirits that define the design of this peaceful garden in a bustling Hong Kong business neighborhood.

Top A focal point in the center of the circular drive, the enormous rock with its curving boat-like form appears to float on the pool of water.

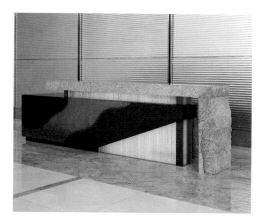

Above A three-dimensional abstract stone sculpture contrasts with the walls of textured stone in the elevator hall.

Top right Following the design concept of the garden, the lobby reception counter combines course and polished materials in a unified composition.

Above Set into the wall on one end of the lobby, water runs down the tall stone waterfall into a pool surrounding the three rocks, representing the Buddha and two disciples, the *sanshin* (three spirits).

不二庭

FUNITEI

PRIVATE RESIDENCE
STUTTGART, GERMANY, 2008

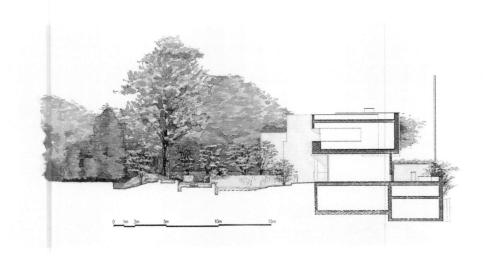

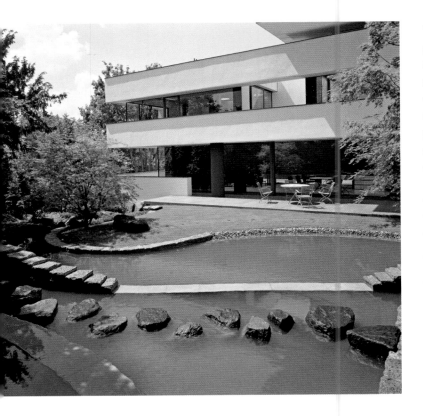

The contemporary Zen garden Funitei (literally, "Only One Garden") gets its name from a Zen expression, "*funi hōmon ni iru*," which means that everything is relative, in which the absolute state transcends oppositions. At first the garden seems to be about opposites—curved rock walls distinguish the spaces of the garden while the concrete house is rectilinear. Within the garden, cut stone contrasts natural rock, and geometric shapes are set against natural forms. However, with Shunmyo Masuno's careful composition, these seemingly opposite elements combine to form a single unified expression.

Constructed for a successful international businessman at his vacation house near Stuttgart, Germany, the residence and garden work together to create a quiet, relaxed atmosphere. The large garden wraps the house on the southeast and southwest sides and incorporates existing sycamore trees. The garden takes advantage of the slope of the land, especially on the expansive southwestern side, and moves out from the house in a progression of grass, stone, and water.

Three gently arcing stacked stone walls are the primary design elements. Together with a straight concrete wall that protrudes from the house into the garden, they create layers of space in the gently sloping land. From the long patio of the house, the garden appears as a series of horizontal layers. Each layer in succession is delineated by a curved stone wall. First a sweep of grassy lawn is dotted with a few trees, and

Above Looking from the garden to the residence, stone walls, stairs, and stepping-stones accentuate the three tiers of the pond.

Top The section drawing shows the relationship of the house and the garden, with the pond terracing up as it moves away from the residence.

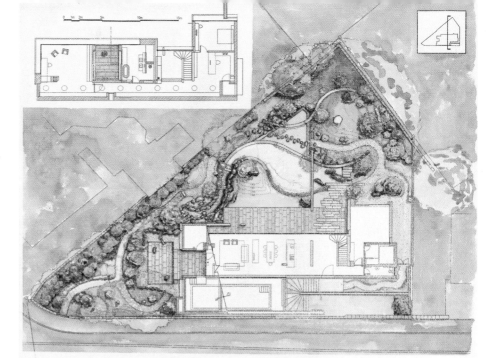

Right The residence occupies the northern part of the site, while the garden moves out from the house, filling the south and southeastern parts of the property.

Below As seen from the upper floor of the house, a tall wall creates an edge for the curving stone walls retaining the three tiers of the pond, which transform into a rock-lined stream.

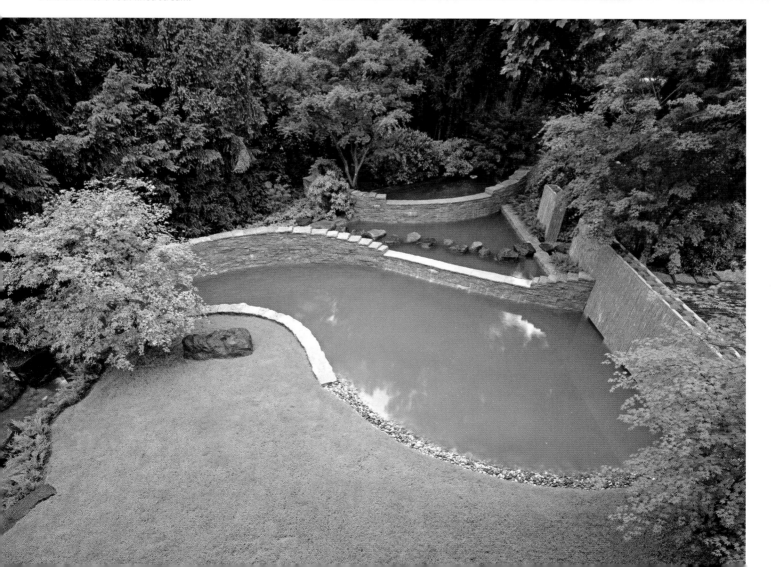

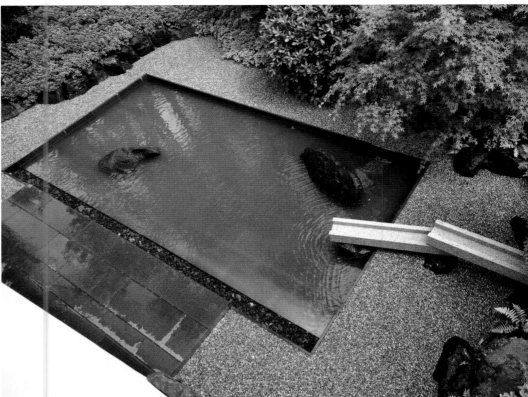

then an arcing stone wall serves as the back edge of the lower level of a quiet three-tiered pond. Between the tiers of the pond, the stone walls step down to the level of the water, creating a gentle flow from tier to tier.

The long straight concrete wall extends from the patio, intersecting the first curved stone wall and separating the front of the garden into two parts. The path into the garden starts on the right side of the concrete wall. Strips of light granite are set into the stone grid of the patio floor and move out into the space of the garden. The strips stop at the edge of the pond, which flows under the concrete wall. Several large natural rocks contrast both the smooth straight concrete wall and the curving wall of stacked stone that holds back the lower tier of the pond.

The path changes to gravel as it meanders through thickly planted vegetation. Ground cover, shrubs, and trees offer greenery of differing heights and shapes, and large rocks add visual emphasis through contrast. The path returns to the pond and changes to stepping-stones, which cross the water between the two stacked stone walls that embrace the middle tier of the pond. Once across the pond, the path changes back to gravel and continues alongside the arc of the middle

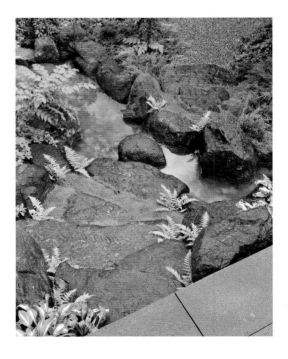

Top left From the entrance hall, strips of stone paving continue out into the garden, connecting the sharp geometry of the building with the natural forms of the garden.

Top right At the end of the stream, water pours from carved stone spouts in a rectangular pool connected to a stone-paved patio.

Above Interspersed with moss and ferns as they descend to and then cross the stream, large dark stepping-stones connect the house to the garden.

stone wall, which ends as the pond turns into a stream with natural rocks defining the edges.

The stream meanders close to the house and patio, with several tiers of low cascades providing the sight and sound of rushing water. After the waterfall, a branch of the walking path crosses the stream as a series of stepping-stones leading back to the patio. The main path continues into the southeast corner of the garden, thickly planted with a great variety of trees and shrubs. The scenery gives the feeling of being far away from daily life in a densely forested area.

Shortly after the stepping-stones cross the stream, the water disappears from view, only to reappear a short distance later moving through a sculptural spout into a rectangular pool. Rough natural rocks, dark in color, support two stacked geometric troughs carved from light stone. Water moves from the upper trough to the lower one before spouting into the pool. Rough dark rocks in the water create contrast with the straight sides and regular shape of the pool, which is connected to the house by a stone-surfaced patio.

With its varied forms and the spaces it creates, the garden provides many different views and unfolds in many different scenes as the visitor moves along the path. Spaces enclosed by trees and greenery give the feeling of being in a distant forest, while stepping-stones through the pond and stream bring the visitor close to water. The curved stone walls, formal in their shape yet less formal in their material quality, blend well with the sloping land and tiered pond while still creating a connection to the realm of man-made objects. This contrast of the natural and the artificial, which occurs in many different ways in this garden, feels harmonious and intentional. Each element supports the others, so that the garden would not be complete if any single element was missing. In this way, the garden lives up to its name, Funitei.

Above In the upper-floor courtyard, an ornately carved stone *chōzubachi* (water basin) sits in front of a large wall opening with a view to the garden.

Right A curving gravel path runs through the verdant garden to the stepping-stones leading through the middle tier of the pond.

三昧庭 ZANMAITEI

NASSIM PARK RESIDENCES SHOWFLAT SINGAPORE, 2008

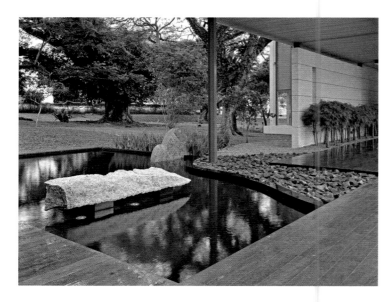

The Nassim Park Residences Showflat includes two model condominiums with a surrounding garden, designed to generate interest in the construction of the 100-unit Nassim Park Residences in downtown Singapore. The long narrow site has two enormous trees existing in the middle of the property, with a covered walkway between the trees connecting the two show flats. This arrangement creates many separate garden spaces, including two courtyard-like gardens that flank the walkway.

Named Zanmaitei (literally, *zanmai* means "concentration," and *tei* is "garden"), the garden incorporates multiple places to relax and meditate on the scenery. Rocks, water, and plants are combined to create both naturalistic and sculptural compositions. Taking advantage of Singapore's tropical climate, Shunmyo Masuno incorporated lush plantings with minimalistic arrangements of rough natural rock combined with polished stone and shallow pools of water. The result is a series of serene garden areas that harmonize with the contemporary style of the architecture and connect the interior spaces to the exterior.

For Masuno, the expression of Japanese-ness in a garden where the seasons never change was a challenge. Rather than incorporating the seasonal variations of blooming plants and autumnal leaves, he relied on large natural rocks brought in from Japan. Evoking the image of traditional Japanese rock arrangements, these rocks create a strong visual impression of a Japanese garden. Combined with gravel, rough broken rocks, and water, these large rocks are powerful elements in the understated design.

Masuno took advantage of the rolling landscape of the adjacent property, incorporating it into the design as an element of *shakkei* (borrowed scenery). Three different kinds of gardens constructed immediately adjacent to the show flats mediate the space between the buildings and the surrounding naturalistic landscape. These three garden areas have similar serene qualities, but each relies on a different primary element—stone, water, or plants.

Two *karesansui* (dry) gardens flank the covered walkway connecting the two flats. Light-colored gravel borders the wide stone walkway, contrasting the straight edges and smooth surface of the path. Here and there, a large rough rock is positioned on the gravel as a bold focal point. In some places, the gravel is edged with broken rock to create a transition to the grassy lawn dotted with trees.

Above At the edge of the connecting corridor, a rough slab of rock appears to float above the reflecting pool, creating an atmosphere of stillness and calm.

Top Expressing simplicity and serenity, a single row of shrubs and a gravel bed with a solitary large rock by the entrance flank the covered corridor connecting the two units.

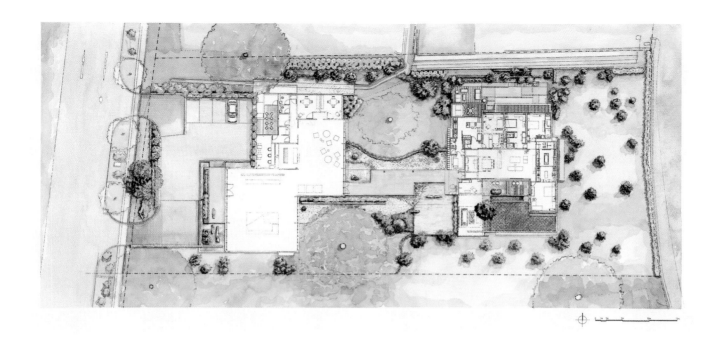

At the end of the dry garden on the south side of the walkway, a bed of broken rock overlaps a corner of a rectangular pond. A polished stone curb holds the water and creates a separation between the rocks on one side and the lawn on another, while the walkway forms the edge on the other two sides. A large rock breaks through the stone curb and mediates between the water and the greenery. A second rock floats above the pond, supported by dark stones that disappear in the water. At night this sculpture-like stone is lit from below to emphasize its floating quality. Another rock hovers similarly above the adjacent terrace. With a partially polished top surface, it serves as a sculptural coffee table.

The second use of water near the building is along the front, where a geometric pond and stream separate the residence from the driveway. The narrow stream, contained by the same polished stone curbs, wraps three sides of a patio extending west from the building. One planter box of dark polished stone filled with greenery edges the patio on the west side. The stream runs behind it and then fills a rectangular pond. Another planter box is set into the pond with two large natural rocks also placed in the water. A third rock set into the stone-faced patio completes the rock arrangement.

The third garden type is on the north side of the eastern show flat and utilizes plants set against a wall to create a tranquil minimalist garden. From the terraces on the north side, the land steps down in long rectangular tiers. Low stone curbs subtly mark the edges of the grassy

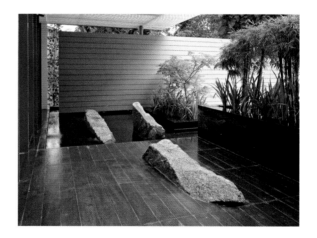

platforms. At the lowest level, the grass gives way to carefully pruned trees and shrubs. Most are planted in beds, while one line of tall grasses grows in a stone planter box. This composition creates the effect of layers of space moving from the interior of the building through the terraces to the stepped horizontal layers of the garden and finally to the vertical layers of plantings in front of the wall. The careful placement of a variety of plants and stone elements creates complexity within the simplicity of the design and allows for many moments of quiet contemplation and concentration.

Top Adjacent to the condominium units and the connecting corridor, the pools and gravel beds of the garden complement the rectilinear geometry of the buildings.

Above Contrasting the surrounding straight lines and smooth textures, three large rough rocks mediate the space of the main entry.

和敬清寂の庭
WAKEISEIJYAKU NO NIWA

NASSIM PARK RESIDENCES
SINGAPORE, 2010

The extensive gardens at the Nassim Park Residences in Singapore create a beautiful verdant landscape for the 100-unit luxury housing complex—the first in Singapore to feature a Japanese garden. From the huge rock carved with the name of the complex that marks the entrance, to the quiet path and stream that meander through a long narrow ribbon of land and connect to an adjacent street, Shunmyo Masuno considered every detail of the multi-faceted composition to ensure its balance and beauty.

The gardens of the Nassim Park Residences are for the entertainment of residents and guests. Masuno likens the act of entertaining to the spirit of *sado* (traditional Japanese tea ceremony). This spirit is reflected in the name of the garden and the theme of the four primary parts of the garden—harmony, respect, purification, and tranquility. The location of the property between the Botanical Garden and the bustling commercial district of Orchard Road further influenced Masuno to create a composition that would harmonize both with the strong nature of the Botanical Garden and the contemporary lifestyle of commercialized downtown Singapore.

The four concepts embedded in the name, Wakeiseijyaku no Niwa ("The Garden of Harmony, Respect, Purification, and Tranquility"), are represented in four different parts of the garden. *Wa* (harmony) is the concept for the central main garden, which combines a series of rectangular lap and swimming pools with a naturalistic waterfall, stream, and pond. *Kei* (respect) is embodied in the entrance area, with powerful compositions of stone and water that greet residents and visitors. *Sei* (purification) is

Above From the circular driveway, a large opening in the stone-covered walls frames the main garden, with its careful composition of geometric elements softened with greenery to create a relaxing space of harmony.

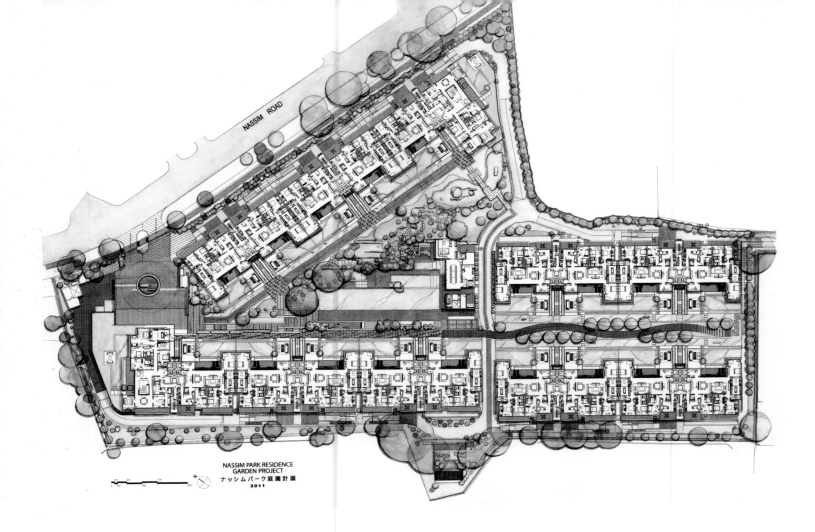

NASSIM PARK RESIDENCE
GARDEN PROJECT
ナッシム パーク 庭園計画
2011

expressed in the long passage from a corner of the site to an adjacent road, and *jyaku* (tranquility) is the theme of a small separate area with a *karesansui* (dry) garden.

From the street, the view of the entrance to the condominium complex gives a powerful first impression. The drive circles an arrangement of enormous rocks set into a shallow pool of water. Straight ahead is a large sculptural stone tokonoma (decorative alcove), typically found in a ceremonial teahouse. To the left, the stone wall of the guardhouse features an enormous brushstroke carved into the surface. These elements serve as works of art welcoming the residents and visitors to the condominiums.

Passing through the entrance, the courtyard-like space of the central main garden opens out toward the east. The sleek contemporary architecture and the naturalistic garden overlap with patios and pools that extend the interior space out and bring the outdoors into the condo-

miniums. The main garden incorporates the natural slope of the land with multiple levels of pools and paths interspersed among the greenery. The clubhouse for the complex anchors one end of the lap and swimming pools. A yoga room in the lower level seems to float on water and looks out to the waterfall, creating a serene meditation space. A rough stone wall moves from inside the yoga room to outside, connecting the interior space to the garden.

Tall rocks denote the start of the waterfall, which tumbles down the hill into a meandering stream. The sound of water negates the sound of any traffic that might waft through the site from the adjacent Nassim Road. On the grassy slope northwest of the waterfall, long strips of polished dark stone move in and out of the undulating land, and the grass is punctuated by trees and shrubs, creating cool shady areas in the landscape. A stepping-stone path moves through the grass and over the stream, leading to the clubhouse.

Above The four key concepts of *wa* (harmony), *kei* (respect), *sei* (purification), and *jyaku* (tranquility) are expressed respectively in the main garden in the center of the complex, the entrance garden in the northern corner, a long walk (not shown) starting from the southeast corner and continuing beyond, and the small garden extending out from the middle of the southwest side.

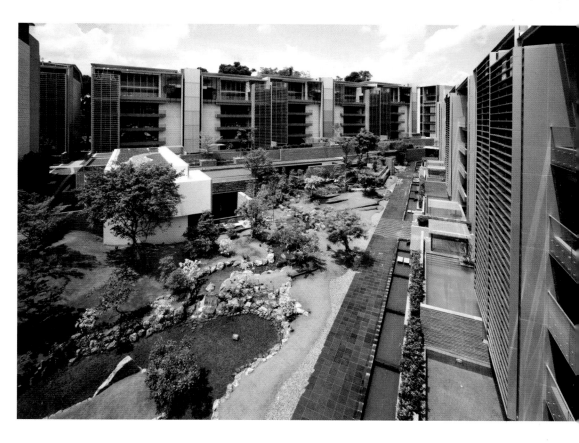

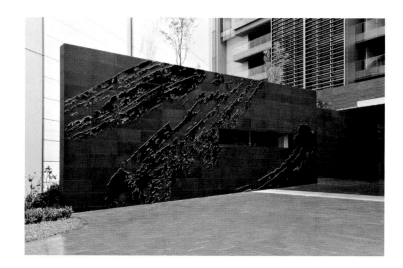

Top left Serving as a large tokonoma (decorative alcove), the entrance space near the driveway combines the lightness of louvered walls and ceilings with a heavy granite base punctuated with a sculptural stone name marker.

Above At the main entrance, the guardhouse is tucked behind a large wall faced in stone with a brushstroke design created by Shunmyo Masuno.

Above From the road, the entry drive to the sleek contemporary complex is marked with a single impressive roughly textured boulder.

Top right Viewed from the fifth floor, the main garden with rectangular pools at the edges and the central stream, waterfall, and pond set within a grassy lawn creates a cheerful atmosphere.

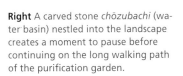

Above Irregularly shaped stepping-stones connect the various elements in the central main garden, meandering across gravel and grass to link from one side of the complex to the other.

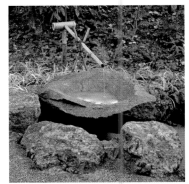

Right A carved stone *chōzubachi* (water basin) nestled into the landscape creates a moment to pause before continuing on the long walking path of the purification garden.

Large rocks line the stream as it continues downhill and flows into a pond. A path connecting the different parts of the complex crosses over the water and provides a good view of the grassy islands in the pond and a moment to pause and reflect on the harmony of the garden and the architecture.

The path that crosses the pond continues through the site to the Tranquility Garden in a triangular extension of the property on the southwest side. A wall separates the meditative garden from the rest of the landscape and creates a threshold to the *karesansui* garden. A simple viewing pavilion frames the small garden. *Shirakawa-suna* (white pea gravel) weaves among planted earth mounds to create a serene composition. Carefully positioned trees and rocks add height and visual interest. The garden creates a space for self-reflection, a place of silence within the busy workday.

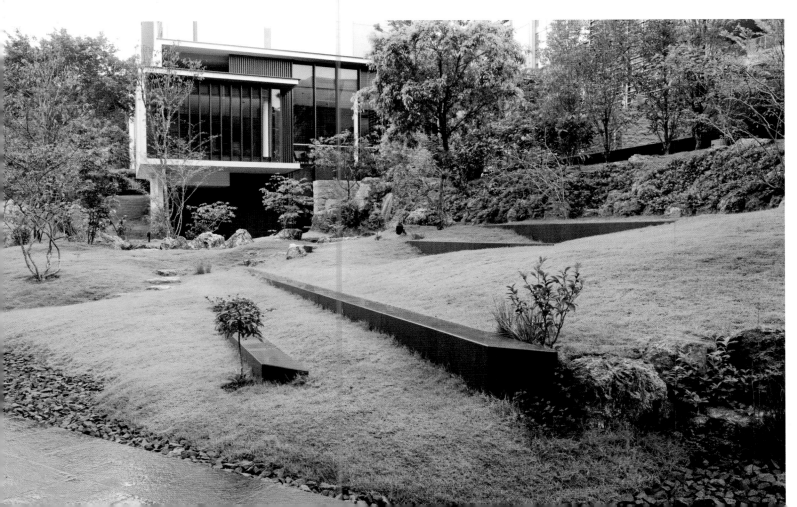

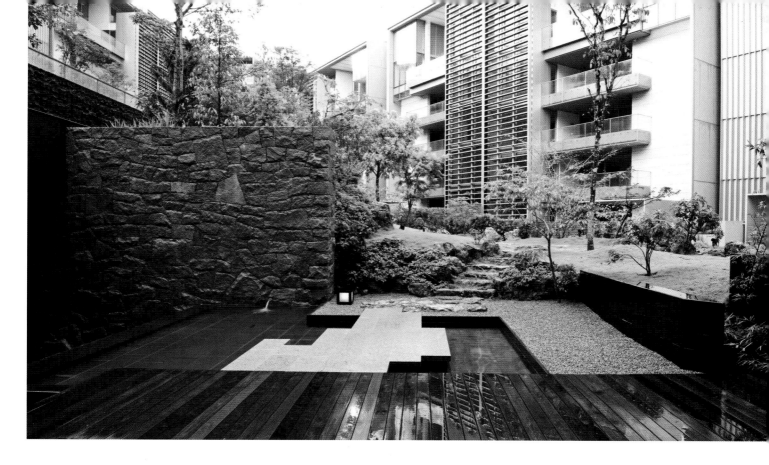

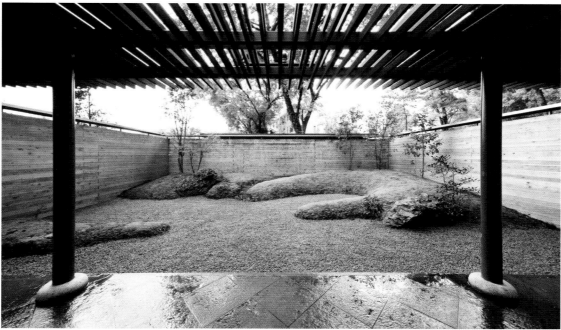

Opposite page bottom Strips of polished stone embedded in the sloping lawn stretch across the main garden toward the clubhouse.

Top A thick textured stone wall moves from inside the clubhouse out into the space of the main garden, holding back the earth to create a tranquil space of stone, wood, and water.

Abpve In the quietest part of the site, tall board-formed concrete walls surround the serene *karesansui* (dry) garden, with its moss-covered mounds interlocking the bed of gravel to create a feeling of *jyaku* (tranquility).

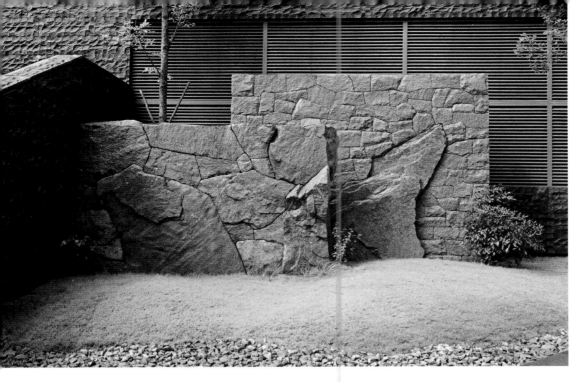

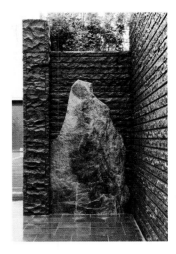

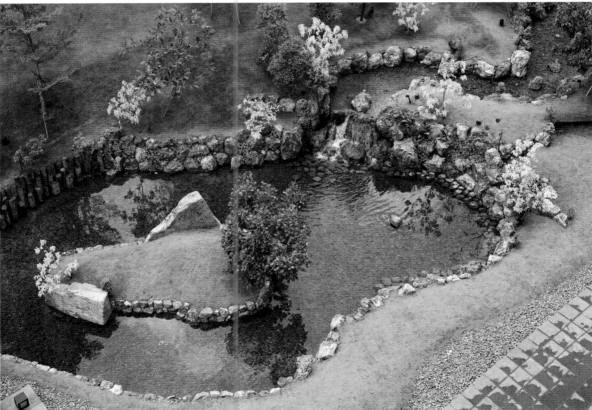

Top left Contrasting the obviously man-made metal louvers behind, two walls of carefully assembled stone mediate the natural and the artificial.

Above Designed to be enjoyed from the adjacent path as well as from above, the main garden features a winding stream connected to the pond with a cascade.

Top right Tucked into a narrow space between walls of stacked dark stone, a large rock creates a unexpected focal point.

NASSIM PARK RESIDENCE
GARDEN PROJECT
ナッシムパーク庭園計画
2011

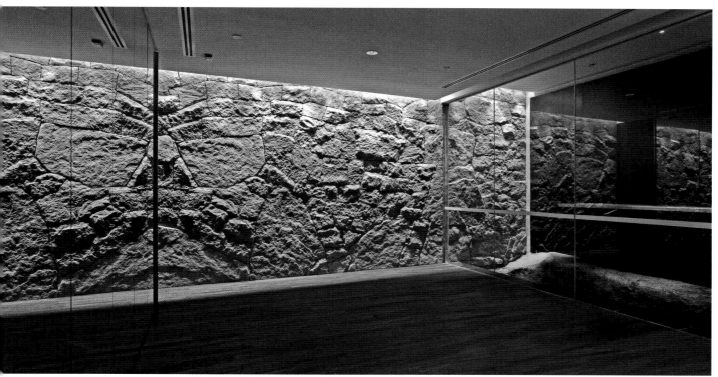

At the eastern corner of the property, the long Purification Passage is a quiet path leading to a nearby road. The walkway runs side by side with a stream, sometimes crossing over and then crossing back. Trees line the walk and groupings of rocks add to the feeling of following a winding stream along a forested path. It is a space of quiet, allowing the mind to clear and thoughts to distill while walking through nature.

With the combination of natural and man-made elements, open areas for gathering and private spaces for personal reflection, the Wakeiseijyaku no Niwa embodies the profound concepts embedded in its name—harmony, respect, purification, and tranquility.

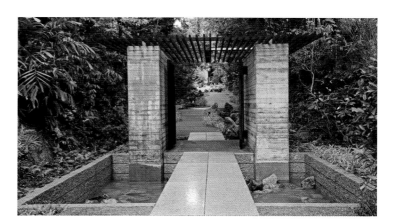

Top The long *sei* (purification) garden allows a slow transition from the condominium complex to a nearby major street—time and space between city and home to clear one's mind.

Center A heavy stone wall moves from the garden into the clubhouse yoga room, imparting a sense of silent power into the serene space.

Above Board-formed concrete walls with a louvered roof serve as the gate to the *sei* (purification) garden, an important threshold on the walking path between the city and the residential complex.

清閑庭

SEIKANTEI

PRIVATE RESIDENCE
NEW YORK CITY, UNITED STATES, 2011

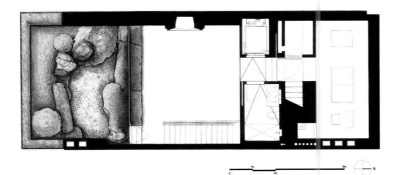

This small rooftop garden, Seikantei, is located in a typically dense Manhattan, New York, neighborhood. As an extension of the living space on the sixth floor of a more than 100-year-old townhouse, the area of the garden is only about 30 square meters (almost 323 square feet). Tall walls extend on the east and west sides of the space, while the south side looks out toward the backs of nearby buildings. The north edge is visually connected to the living space through a large glass window wall.

The floor of the roof terrace is raised three steps above the living space, allowing the garden to be viewed both from a standing position and seated in a chair. The interior space of the living area is connected to the exterior garden by three large flat rocks that move from the interior, where they function as a bench, "through" the glass wall and onto the ground surface of the roof terrace. The rocks feature polished surfaces in the living space, which transition first to chiseled finishes and then to rough surfaces at their outermost edges.

On the opposite side of the garden (the south edge), a tall boxwood hedge set in a Corten steel planter box blocks the view of the neighboring buildings and creates a back edge for the composition. The thick

Top On the roof at the south end of the townhouse, the enclosed *nakaniwa* (courtyard garden) creates a tranquil private outdoor space in the middle of the city.

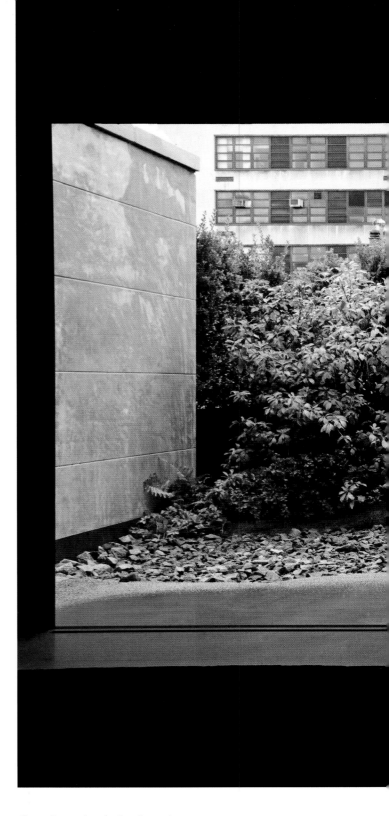

Above Connecting the interior and exterior spaces, carefully fitted large flat stones move from inside to out, the surface changing from highly polished to pockmarked to rough.

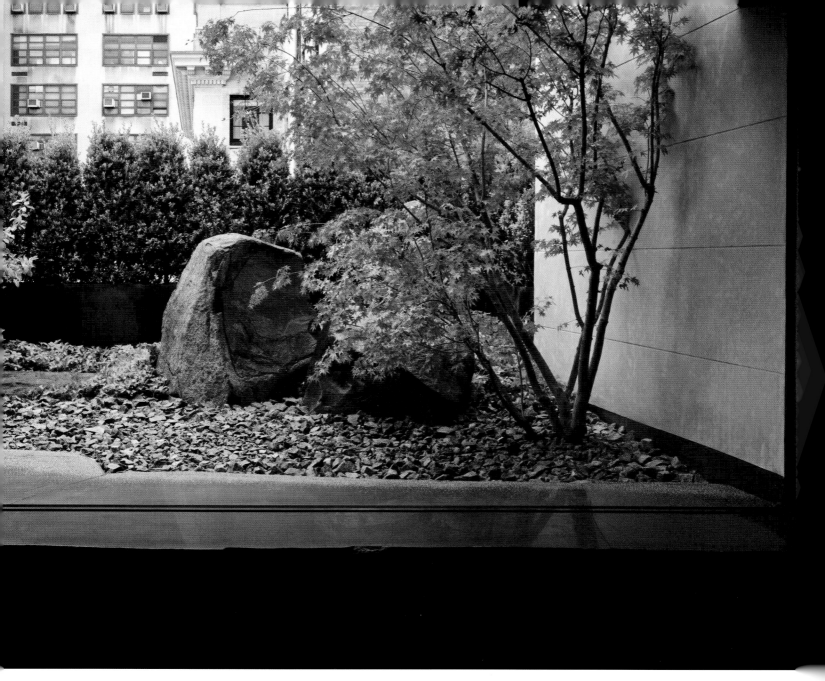

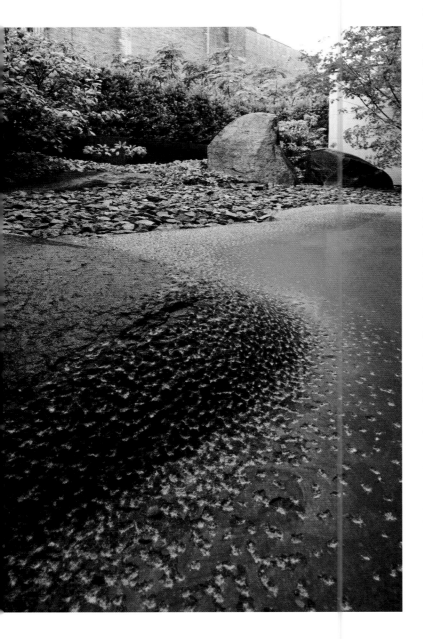

hedge wraps around the northeast and northwest corners of the garden, adjoining the side walls to completely contain the space. These constraints on the surrounding view focus the garden inward while connecting it to the infinite space of the sky.

In front of the hedges, a mound of earth planted with a dense ground cover of pachysandra slopes up to the planter boxes. On the mound, several thin trees add height to the composition and contrast the straight surface of the hedge. Between the mound and the low rocks by the window, the space is filled by a flat surface of gravel. A single maple tree emerges from the gravel in the northwest corner of the garden, while three large rocks mediate between the space of the gravel and the low part of the mound.

Shunmyo Masuno carefully selected and positioned the three rocks to create a harmonious composition utilizing the formal aesthetic principle of *ten-chi-jin* (literally, "heaven-earth-human") to balance their heights, sizes and positions. One rock—the furthest to the west—is long and low. It sits just at the edge of the mound between the green ground cover and the light brown gravel. The middle rock is the most prominent and also mediates between the earth mound and the gravel. Its size, markings, and centrality make it the most prominent of the three rocks. It connects the long low rock with the smallest rock of the three, which is located in the gravel just to the side of the central rock and underneath the maple tree. The smallest rock is taller than the low rock, which gives it presence despite its size. The careful arrangement of the three rocks is central to the garden, as they are the primary focal points and the elements responsible for creating the feeling of stillness, which was Masuno's aim for the garden.

The three flat rocks by the window and the three large rocks were brought from Japan specifically for the garden. The plants, however, were sourced locally to ensure their hardiness in the cold New York winters. This combination of Japanese elements with local elements creates a harmonious blending of the familiar and the faraway in this small garden. Although the area of the garden is physically limited, the composition with the layers of rock, gravel, and vegetation suggests a much larger space. With the view from inside looking out over the garden and up to the sky, the space extends infinitely and allows for the calm reflection of one's place in the vast yet interconnected world. The garden thus reflects the meaning inherent in its name, Seikantei, from the Zen expression "*seikan ichi nichi no raku*," referring to "tranquility and calm every day."

Above Creating visual interest with its detail, the textured stone reads like water in the foreground of the garden.

Opposite page Multiple layers—the long flat stone, a bed of small rocks, large primary rocks, a mound with thick ground cover, and trees for verticality—create a sense of great spatial depth within the diminutive garden.

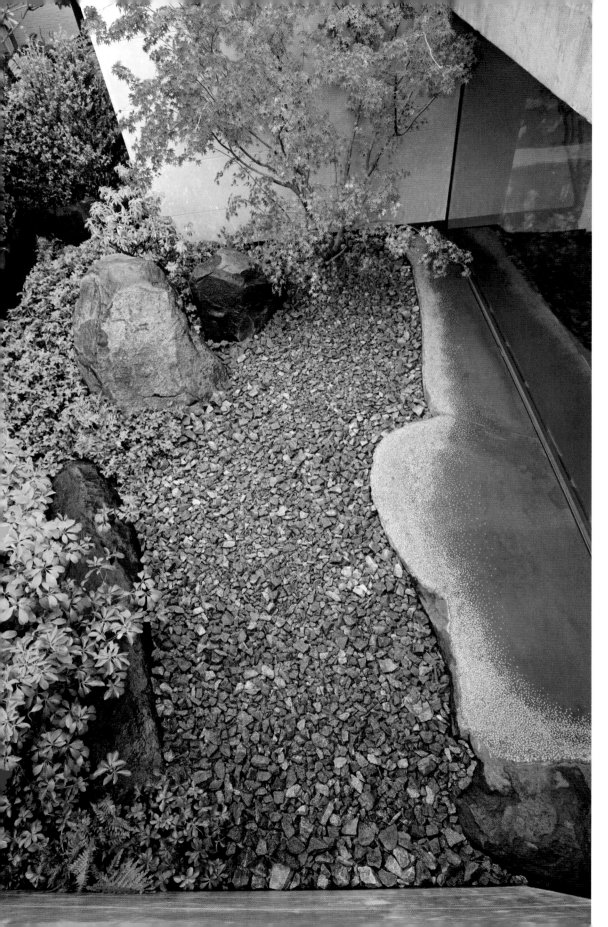

Above Designed for all seasons, the garden—as viewed from the living space—is enlivened by the fall foliage of a maple tree found not far outside New York City

MAJOR WORKS 1984–2011

1983 **Kiunji Temple Garden**, Yokohama

1984 **Sōseien**, retreat house, Kanagawa

1985 **Hōtokuen**, wedding reception hall, Iwaki, Fukushima Prefecture

1986 **Ginrinsō**, company guesthouse, Hakone

1988 **Kyoto Prefectural Reception Hall Garden**, Kyoto

1991 **Art Lake Golf Club Garden**, Nose, Hyogo Prefecture

Canadian Embassy Garden, Minato-ku, Tokyo

New Campus for Tokyo Metropolitan University, Tama New Town, Tokyo

1992 **Hotel Passage Kinkai**, Nagasaki, Nagasaki Prefecture

Takamatsu City Crematorium Garden, Takamatsu, Kagawa Prefecture

1993 **Niigata Prefectural Museum of Modern Art Garden**, Nagaoka, Niigata Prefecture

Nitobe Garden renovation, Vancouver, British Columbia, Canada

1994 **Fūma Byakuren Plaza**, National Institute for Materials Science, Tsukuba, Ibaraki Prefecture

Seifū Kyorai no Niwa, Kagawa Prefectural Library, Takamatsu, Kagawa Prefecture

1995 **Fuzōfugen no Niwa**, Hanouracho Information and Cultural Center, Anan, Tokushima Prefecture

Wakei no Niwa, Canadian Museum of Civilization, Ottawa, Canada

1996 **Bakushōtei**, Imabari Kokusai Hotel, Imabari, Ehime Prefecture

Taunustor Japan Center Garden, Frankfurt, Germany

1998 **Seizan Ryokusui no Niwa**, Hotel Le Port, Chiyoda-ku, Tokyo

1999 **Fushotei,** Renshōji temple guesthouse, Yokohama, Kanagawa Prefecture

Ryūmontei, Shiuntaiteien at Gionji temple, Mito, Ibaraki Prefecture

2000 **Zanshintei**, Kakushokaku reception hall in Sankeien, Yokohama, Kanagawa Prefecture

2001 **Kanzatei**, Cerulean Tower Tokyu Hotel, Shibuya-ku, Tokyo

Mushintei, guesthouse Suifuso, Namekata, Ibaraki Prefecture

Sandō, Kōenji temple, Kōenji, Tokyo

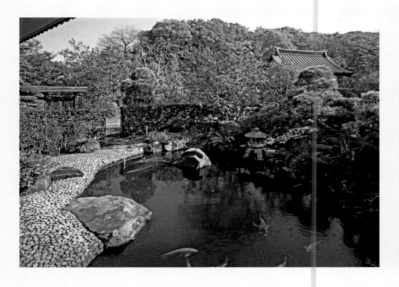

Above Kiunji Temple Garden, Yokohama (1983)

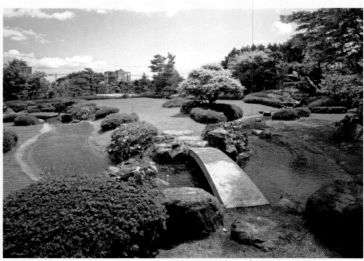

Above Hōtokuen, wedding reception hall, Iwaki, Fukushima Prefecture (1985)

2002 **Memorial of Grand Zen Master Dōgen**, Kamakura, Kanagawa Prefecture

Shōjutei, Rifugio private residence, Oku, Okayama Prefecture

2003 **Seijaku no Niwa**, University of Bergen, Bergen, Norway

Yūkyūen, Hofu City Crematorium, Hofu, Yamaguchi Prefecture

Yūsuien, Erholungspark Marzahn, Berlin, Germany

2004 **Chōfūtei and Suitōkyosei**, Gionji temple reception building, Mito, Ibaraki Prefecture

Musotei, private residence, Minato-ku, Tokyo

Seifūdōkō no Niwa, Opus Arisugawa Terrace and Residence, Minato-ku, Tokyo

2005 **Baikatei**, Saikenji temple, Hamamatsu, Shizuoka Prefecture

Gesshinsōteien, private residence, Yamanaka-ko, Yamanashi Prefecture

Sankitei, Ministry of Foreign Affairs, Chiyoda-ku, Tokyo

2007 **Chōsetsuko**, Ginrinsō Ryōkan, Otaru, Hokkaido

Kantakeyama Shinen phase one, Samukawa Shrine, Kōza, Kanagawa Prefecture

Sanshintei, One Kowloon Office Building, Kowloon Bay, Hong Kong

2008 **Chōraitei**, private residence, Meguro-ku, Tokyo

Funitei, private residence, Stuttgart, Germany

One Kowloon Interior, One Kowloon Office Building, Kowloon Bay, Hong Kong

Zanmaitei, Nassim Park Residences Showflat, Singapore

2009 **Kantakeyama Shinen** phase two, Samukawa Shrine, Kōza, Kanagawa Prefecture

Keizan Zenji Tenbōrin no Niwa, Gotanjōji temple, Takefu, Fukui Prefecture

Shōkeitei-roji, private residence, Ota-ku, Tokyo

2010 **Wakeiseijyaku no Niwa**, Nassim Park Residences, Singapore

Yui no Niwa Shinshōtei, private residence, Minato-ku, Tokyo

2011 **Seikantei**, private residence, New York City, United States

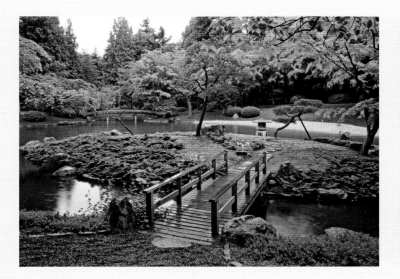

Above Nitobe Garden renovation, Vancouver, British Columbia, Canada (1993)

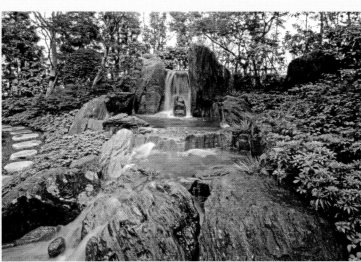

Above Fūzofugen no Niwa, Hanoura-cho Information and Cultural Center, Anan, Tokushima Prefecture (1995)

ENDNOTES

Two Pairs of Straw Sandals

1 "Shunmyo Masuno: Seigen-tei," in *Kunst for Menneskelige Basalbehov: Bygg for Biologiske Basalfag ved Universitetet i Bergen*, http://www.koro.no/filestore/BBB_kat_web.pdf, 26.

2 "Masuno Shunmyo," *Kono nihonjin ga sugoi rashii* (*This Japanese Person Seems to Be Amazing*), TV Tokyo, GB Production, December 17, 2010, television. Masuno refers to this expression by saying, "*Waraji wa futatsu atte issoku desu no de, issoku no yō de hitotsu nan desu*" ("Since two straw sandals make up a pair, one [sandal] is like one pair").

3 Interview with Shunmyo Masuno at Kenkohji on May 30, 2011.

4 *Wabi-cha* is a tea ceremony style based on the aesthetic concept of *wabi*, which incorporates the understanding of beauty in humbleness, imperfection, and loneliness.

5 "Shunmyo Masuno: Seigen-tei," in *Kunst for Menneskelige Basalbehov*, 26.

6 Ibid, 17.

7 Berthier, François, *The Dry Landscape Garden: Reading Zen in the Rocks* (Chicago: University of Chicago Press, 2000), 3.

8 Hisamatsu Shin'ichi, *Zen and the Fine Arts* (Tokyo: Kodansha International Ltd., 1971), 52–59; and Nitschke, Günter, *Japanese Gardens: Right Angle and Natural Form* (Cologne: Benedikt Taschen Verlag GmbH, 1993), 105.

9 "Shunmyo Masuno: Seigen-tei," in *Kunst for Menneskelige Basalbehov*, 17.

10 Ibid.

11 Ibid.

12 Suzuki, Daisetz T., *Zen and Japanese Culture* (Princeton, N.J.: Princeton University Press, 1959), 300.

13 Weiss, Allen S., "On the Circulation of Metaphors in the Zen Garden" (*AA files* no. 60, 2010), 89.

14 Masuno Shunmyo, *Inside Japanese Gardens: From Basics to Planning, Management and Improvement* (Osaka: The Commemorative Foundation for the International Garden and Greenery Exposition, 1990), 4.

15 Carter, Robert E., *The Japanese Arts and Self-Cultivation* (Albany: State University of New York Press, 2008), 8.

16 Takei, Jiro, and Mark P. Keane, *Sakuteiki: Visions of the Japanese Garden* (North Clarendon, Vt.: Tuttle Publishing, 2008), 4.

17 Carter, *The Japanese Arts and Self-Cultivation*, 60.

18 *Process: Architecture Special Issue No. 7, Landscapes in the Spirit of Zen, A Collection of the Work of Shunmyo Masuno* (Tokyo: Process Architecture Company Ltd., 1995), 9.

19 Takei and Keane, *Sakuteiki*, 4.

20 Parkes, Graham, "The Role of Rock in Japanese Dry Landscape Garden," in Berthier, Francois, *The Dry Landscape Garden: Reading Zen in the Rocks* (Chicago: University of Chicago Press, 2000), 90–91.

21 Kuck, Loraine, *The World of the Japanese Landscape Garden: From Chinese Origins to Modern Landscape Art* (New York and Tokyo: Weatherhill, 1989), 150.

22 Keane, Marc P., *Japanese Garden Design* (Rutland, Vt., and Tokyo: Charles E. Tuttle, 1996), 80.

23 Takei and Keane, *Sakuteiki*, 41.

24 Nitschke, Günter, *Japanese Gardens: Right Angle and Natural Form* (Cologne: Benedikt Taschen Verlag GmbH, 1993), 15.

25 "Shunmyo Masuno: Seigen-tei," in *Kunst for Menneskelige Basalbehov*, 17.

26 Keane, *Japanese Garden Design*, 56.

27 Nitschke, *Japanese Gardens*, 105.

28 Kuck, *The World of the Japanese Landscape Garden*, 112.

29 Ibid.

30 Interview with Shunmyo Masuno at Kenkohji on May 20, 2011.

31 "Masuno Shunmyo," *Kono nihonjin ga sugoi rashii* (*This Japanese Person Seems to Be Amazing*), December 17, 2010.

32 "Shunmyo Masuno: Seigen-tei," in *Kunst for Menneskelige Basalbehov*, 23.

Introduction to Traditional Zen Gardens

1 Masuno, *Inside Japanese Gardens*, 13.

2 Ibid, 11.

3 Kuck, *The World of Japanese Landscape Gardens*, 187.

Sōseien

1 Masuno, *Inside Japanese Gardens*, 13.

Art Lake Golf Club

1 *Process: Architecture Special Issue No. 7, Landscapes in the Spirit of Zen, A Collection of the Work of Shunmyo Masuno*, 45.

Bakushotei

1 Trulove, James Grayson (ed), *Ten Landscapes: Shunmyo Masuno* (Rockport, Mass.: Rockport Publishers, Inc., 1999), 23.

Mushintei

1 Suzuki, *Zen and Japanese Culture*, 94.

Design Process

1 *Process: Architecture Special Issue No. 7, Landscapes in the Spirit of Zen, A Collection of the Work of Shunmyo Masuno*, 8.

2 "Shunmyo Masuno: Seigen-tei," in *Kunst for Menneskelige Basalbehov*, 20.

3 Masuno, *Inside Japanese Gardens*, 15.

4 Carter, *The Japanese Arts and Self-Cultivation*, 69.

5 *Process: Architecture Special Issue No. 7, Landscapes in the Spirit of Zen, A Collection of the Work of Shunmyo Masuno*, 8.

6 "Shunmyo Masuno: Seigen-tei," in *Kunst for Menneskelige Basalbehov*, 17.

7 Ibid, 20.

8 Masuno, *Inside Japanese Gardens*, 109.

9 Ibid, 15.

10 Ibid, 86.

11 Carter, *The Japanese Arts and Self-Cultivation*, 60–61.

12 "Shunmyo Masuno: Seigen-tei," in *Kunst for Menneskelige Basalbehov*, 20.

13 Masuno, *Inside Japanese Gardens*, 107.

14 Ibid, 102–103.

15 Ibid, 118.

16 Ibid, 112–113.

17 Ibid, 108.

18 *Process: Architecture Special Issue No. 7, Landscapes in the Spirit of Zen, A Collection of the Work of Shunmyo Masuno*, 10.

Introduction to Modern Zen Gardens: The Essence of Emptiness

1 Masuno, *Inside Japanese Gardens*, 15.
2 Suzuki, *Zen and Japanese Culture*, 35.
3 Masuno, *Inside Japanese Gardens*, 15.

New Campus for Tokyo Metropolitan University

1 *Process: Architecture Special Issue No. 7, Landscapes in the Spirit of Zen, A Collection of the Work of Shunmyo Masuno*, 77.

Fūma Byakuren Plaza

1 *Process: Architecture Special Issue No. 7, Landscapes in the Spirit of Zen, A Collection of the Work of Shunmyo Masuno*, 12.
2 Ibid.

Seifo Kyorai no Niwa

1 Trulove, *Ten Landscapes: Shunmyo Masuno*, 45.
2 Ibid.

Seizan Ryokusui no Niwa

1 Trulove, *Ten Landscapes: Shunmyo Masuno*, 13.
2 Ibid, 15.

Sankitei

1 Masuno Shunmyo, *Zen Gardens, vol. II: The World of Landscapes by Shunmyo Masuno* (Tokyo: Mainichi Shinbunsha, 2003), 58.

Mondō: A Dialogue with Shunmyo Masuno

1 Masuno, *Inside Japanese Gardens*, 15.
2 "Shunmyo Masuno: Seigen-tei," in *Kunst for Menneskelige Basalbehov*, 16.

Introduction to Zen Gardens outside Japan: Intercultural Communication

1 "Shunmyo Masuno: Seigen-tei," in *Kunst for Menneskelige Basalbehov*, 16.
2 Ibid, 21.
3 *Process: Architecture Special Issue No. 7, Landscapes in the Spirit of Zen, A Collection of the Work of Shunmyo Masuno*, 10.
4 Ibid.
5 "Shunmyo Masuno: Seigen-tei," in *Kunst for Menneskelige Basalbehov*, 21.

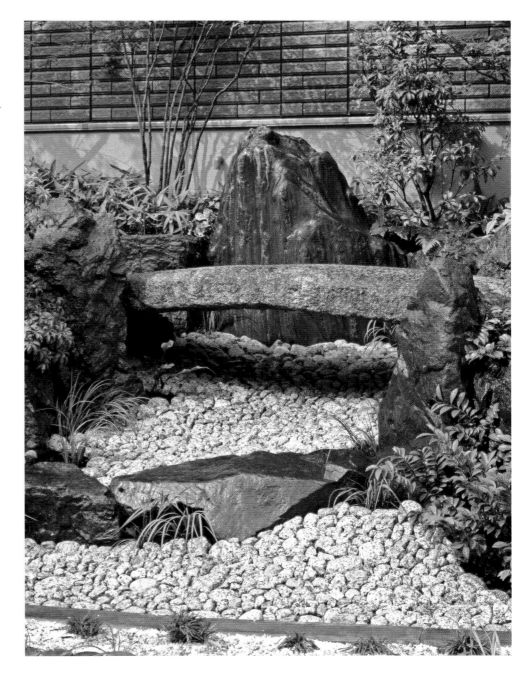

Above Shōkeitei-roji, private residence, Tokyo (2009)

GLOSSARY

aji-ishi 庵治石 type of granite from Shikoku Island, also known as diamond granite

bunkazai 文化財 important cultural asset

chadō 茶道 "the way of tea," traditional tea ceremony (also *sadō*)

chaya 茶屋 tea stall or pavilion

chashitsu 茶室 teahouse

ch'i (Chinese) 気 essential energy of the earth (also *qi* in Chinese, *ki* in Japanese)

chie 智慧 wisdom or insight one of the six Buddhist practices [*ropparamitsu*] that describe the path to enlightenment, see also *prajñā pāramitā*)

chinju no mori 鎮守の森 sacred grove

chinmoku 沈黙 silence

chisenkaiyushiki-teien 池泉回遊式庭園 stroll-style garden featuring a pond

chōzubachi 手水鉢 "hand water bowl," stone or ceramic basin used in gardens for rinsing the hands

daishin 大心 Zen Buddhist term for having a broad spirit that can envelop others (one of the three spirits (*sanshin*) of Zen Buddhism by which one should live)

dāna pāramitā 檀那波羅蜜 Buddhist practice of generosity or giving of oneself (*fuse* in Japanese)

dan-ochi 段落ち stepped waterfall

datsuzoku 脱俗 freedom from attachment

dhyāna pāramitā 禅定波羅蜜 Buddhist practice of meditation or single-pointed concentration (*zenjō* in Japanese)

dō 道 "the way"

dobashi 土橋 "earthen bridge," bridge covered with earth and moss

engawa 縁側 indoor-outdoor veranda-like extension of the floor that is protected by the over-hanging eaves

fukinsei 不均斉 asymmetry

funi hōmon ni iru 人不二法門 Zen Buddhist expression meaning that everything is relative, in which the absolute state transcends oppositions

furyumonji 不立文字 Zen Buddhist term for revelation through intuitive discernment

fuse 布施 generosity or giving of oneself (one of the six Buddhist practices [*ropparamitsu*] that describe the path to enlightenment, see also *dāna pāramitā*)

gagaku 雅楽 ancient court music

genkan 玄関 enclosed entrance area with the floor at ground level

genjōkōan 現状公案 koan or question relating to the present condition used in Zen meditation

gyō 行 semi-formal pattern (see *shin-gyō-sō*)

hondō 本堂 main worship hall at a Buddhist temple complex

hotoke no sō 仏の相 "the Buddha itself," Zen Buddhist phrase for truth

ichi-go ichi-e 一期一会 "one time, one meeting," expression associated with the tea ceremony and the concept of transience in Zen Buddhism

ikebana 生花 art of flower arranging

ishi no kowan wo shitagau 石の公案を従う "follow the request of the stone," to learn from nature, from the eleventh-century garden manual *Sakuteiki*

ishitate-so 石立僧 "stone-laying monk," Buddhist priest garden designer

iwakura 磐座 "rock seat," sacred rock housing a Shintō deity

jikai 持戒 virtue or moral discipline (one of the six Buddhist practices [*ropparamitsu*] that describe the path to enlightenment, see also *śīla pāramitā*)

jinkōteki 人工的 artificial

jiwari 地割り proportional method of dividing land

jizo 地蔵 guardian bodhisattva

jōdoshū 浄土宗 Pure Land Buddhism

kadō 花道 "the way of the flower," flower arrangement

kaiyūshiki-teien 回遊式庭園 stroll-style garden

kami 神 Shintō deity

kanji 漢字 ideogram characters based on the Chinese writing system

kankaku 感覚 feeling or sense

kanso 簡素 simplicity

kanshōshiki-teien 鑑賞式庭園 garden for viewing from a seated position rather than moving through

karesansui 枯山水 "dry mountain-water," garden type incorporating rock arrangements and beds of gravel to represent water and seascapes

kei 敬 respect (one of three traditional values (*sanki*) of Japan)

kendō 剣道 "the way of the sword," Japanese swordsmanship

ki 気 essential energy of the earth (*qi* or *ch'i* in Chinese)

kinsei 均斉 symmetry

kishin 喜心 Zen Buddhist term for the spirit of sympathy (one of the three spirits (*sanshin*) of Zen Buddhism by which one should live)

kōan 公案 riddle-like question for Zen meditation

kōetsuji-gaki 光悦垣 "lying cow–style fence," named from the bamboo fence at the Kōetsuji temple garden in Kyoto

kokō 枯高 austere sublimity or lofty dryness

kokoro 心 heart/spirit/mind

koshikake machiai 腰掛け待合 waiting bench

kosokukōan 古則公案 paradigmatic koan or question used in Zen meditation

koteidekinu 固定できぬ fluidity

kṣānti (kshanti) pāramitā 忍辱波羅蜜 Buddhist practice of patience or perseverance (*ninniku* in Japanese)

kunren 訓練 training or discipline

kuromatsu 黒松 black pine tree

kusen-hakkai 丸山八海 nine mountains and eight seas of the Buddhist universe

kutsunuki-ishi 沓脱石 "shoe-removing stone," a rock placed adjacent to the *engawa* used for removing shoes before entering the building

kyo 虚 emptiness

kyōgebetsuden 教外別伝 Zen Buddhist term for communication of mind with mind

minka 民家 "people's house," often translated as "folk house"

mitate 見立 "re-seeing," seeing something with fresh eyes

motenashi もてなし spirit of service or hospitality without expectation of anything in return

mujō 無常 Buddhist concept expressing impermanence, mutability, and transience

mushin 無心 "without mind" or "no mind," Zen Buddhist concept meaning the mind is empty (uncluttered) and open to receive

nakaniwa 中庭 courtyard

nijiri-guchi 躙口 "crawl-in entrance" of a tea ceremony room

ninniku 忍辱 patience or perseverance (one of the six Buddhist practices [*ropparamitsu*] that describe the path to enlightenment, see also *kṣānti* [*kshanti*] *pāramitā*)

nisoku no waraji wo haku 二足の草鞋を履く "wearing two pairs of straw sandals," expression meaning that two things are inseparable in one's life

nobedan 延段 stone-paved walkway (often made from many river stones placed close together in a long rectangle)

nuno-ochi 布落ち "cloth veil falls" style of waterfall

prajñā pāramitā 智慧波羅蜜 Buddhist practice of wisdom or insight (*chie* in Japanese)

qi 気 essential energy of the earth (also *ch'i* in Chinese, *ki* in Japanese)

rei 礼 gratitude (one of three traditional values (*sanki*) of Japan)

ritsuzen 立禅 standing meditation

rōbaiju 老梅樹 old plum tree

roji 露地 "dewy ground," path leading from the gate through the tea garden to the tea ceremony house

ropparamitsu 六波羅蜜 six *paramitas* or practices that describe the path toward enlightenment

rōshin 老心 Zen Buddhist term for the spirit of sympathy (one of the three spirits (*sanshin*) of Zen Buddhism by which one should live)

ryūmonbaku 龍門瀑 "dragon's gate waterfall," representing a carp trying to climb up the waterfall and pass through the "dragon's gate" (*ryūmon*), an expression referring to Zen training on the path to enlightenment

ryurei 立礼 seated-style tea ceremony using chairs or benches

sadō 茶道 "the way of tea," traditional tea ceremony (also *chadō*)

sandō 参道 approach to a temple or shrine

sanja 懺謝 apology (in Zen training)

sanki 三貴 three traditional values of Japan (harmony (*wa*), gratitude (*rei*), and respect (*kei*))

sanmon 山門 main gate (of a Buddhist temple)

sanshin 三心 "three spirits," Zen Buddhist term for the three spirits by which one should live

sanzu no kawa 三途の川 mythical river where the dead move to the afterlife, similar to the Styx

seijaku 静寂 tranquility

shakkei 借景 borrowed scenery

shinden 神殿 main hall in aristocratic residential compounds of the Heian period (794–1185)

shin 真 formal pattern (see *shin-gyō-sō*)

shin-gyō-sō 真行草 "formal-semi-formal-informal," principle/method for creating a balanced composition with a combination of formal, semi-formal, and informal elements

shinri 真理 truth

shintō 神道 "the way of the gods," faith indigenous to Japan

shinzan-yukoku 深山幽谷 depths of mountains and deep secluded valleys

shirakawa-suna 白川砂 "White River sand," white pea gravel

shizen 自然 nature, naturalness

shodō 書道 "the way of the brush," calligraphy

shōji 障子 wood lattice screen covered with translucent paper

shōjin 精進 diligence or vigor (one of the six Buddhist practices [*ropparamitsu*] that describe the path to enlightenment, see also *vīrya pāramitā*)

śīla pāramitā 持戒波羅蜜 Buddhist practice of virtue or moral discipline (*jikai* in Japanese)

sō 草 informal pattern (see *shin-gyō-sō*)

sōmon 総門 front gate (of a Buddhist temple)

sono shunkan sono shunkan daiji ni ikiru その瞬間その瞬間大事に生きる live each and every moment with care

sukiya 数奇屋 "abode of empty" or "abode of refinement," architectural style featuring the natural qualities inherent in materials that matured in the Edo period (1603–1868; also refers to a tea ceremony house)

sumi-e 墨絵 ink wash painting

tatami 畳 straw-filled woven grass-covered floor mat, now typically 90 centimeters by 180 centimeters in size

tateishi 立石 "standing stone," prominent rock in traditional Japanese garden design

temizusha 手水舎 place for the ritual cleansing of the hands and mouth when entering a shrine

ten-chi-jin 天地人 "heaven-earth-human," aesthetic principle/method for creating a balanced composition with a central tall element representing heaven, a middle element symbolizing humankind, and a lower element in the front signifying earth

todomaranu 留まらぬ continuity, as in *todomaranu kokoro* ("the mind like running water")

tokonoma 床の間 decorative alcove

torii 鳥居 post-and-beam gate marking the entrance to the sacred Shintō precinct

tōrō 灯篭 lantern

tsubo 坪 unit of measurement equal to two tatami mats (about 1.8 x 1.8 meters or 6 feet x 6 feet)

tsuboniwa 坪庭 "*tsubo* garden," small interior courtyard garden

tsukiyama 築山 "constructed mountain," artificial hill

utsuroi 移ろい changeability

vīrya pāramitā 精進波羅蜜 Buddhist practice of diligence or vigor (*shōjin* in Japanese)

wa 和 harmony (one of three traditional values (*sanki*) of Japan)

wabi 侘び aesthetic concept incorporating the understanding of beauty in humbleness, imperfection, and loneliness

wabi-cha 侘茶 "*wabi* tea," tea ceremony style based on the concept of *wabi*

washi 和紙 traditional Japanese paper made from the inner bark of the mulberry tree

washitsu 和室 "Japanese-style room" with the floor covered with tatami mats

yama-momiji 山もみじ mountain maple tree

yohaku 余白 "extra white," blankness or emptiness

yohaku no bi 余白の美 beauty in blankness or emptiness

yūgen 幽玄 subtle and profound elegance

Yūgō suru koto mizu no gotoku motte watonasu. 融合如水以成和 Zen expression referring to water not having its own shape but harmoniously responding and adapting to its surroundings

yukimi-shōji 雪見障子 "snow-viewing" shoji, the lower part of the screens slide up to reveal the view

yutakasa 豊かさ richness, abundance

zazen 坐禅 sitting Zen meditation

zazendō 座禅堂 room used for Zen meditation

zenjō 禅定 meditation or single-pointed concentration (one of the six Buddhist practices [*ropparamitsu*] that describe the path to enlightenment, see also *dhyāna pāramitā*)

ACKNOWLEDGMENTS

This book grew from the teaching, inspiration, support, assistance, and encouragement of many people over many years—they are too numerous to thank individually, but I am deeply grateful to all. For those who walked with me on the *nobedan* and stepping-stones of their gardens or sat with me on the *engawa* to observe the changing shadows when the breeze rustled a branch of the maple tree, I thank them for sharing their knowledge and insight. I am indebted to Shunmyo Masuno for his great teachings and inspiring designs and to Masuno Yoshihiko and Narikawa Keiichi of Japan Landscape Consultants for their steadfast assistance. Many thanks go to those who planted seeds and trimmed branches: Eric Oey, Cal Barksdale, June Chong and Chan Sow Yun from Tuttle Publishing; and Hannah Vaughan. But most of all, the book would not have developed without my *tateishi*, Murakami Takayuki.

The author gratefully acknowledges the following photo credits: **front flap**–Japanese Zen Garden construction, 1995, Canadian Museum of Civilization, photo Steven Darby, S2000-3621; **page 9, bottom**–Japanese Zen Garden, 1996, Canadian Museum of Civilization, photo Steven Darby, K2000-1225; **page 166**–Kenkohji temple, 2012, photo Takayuki Murakami; **page 178**–Japanese Zen Garden, Fall, 1998, Canadian Museum of Civilization, photo Harry Foster, S98-10683; **page 179**–Japanese Zen Garden, 1996, Canadian Museum of Civilization, photo Steven Darby, K2000-1225; **page 180**, top–Japanese Zen Garden, 1996, Canadian Museum of Civilization, photo Steven Darby, K2000-1229; **page 180, bottom**–Japanese Zen Garden, 1996, Canadian Museum of Civilization, photo Steven Darby, K2000-1244; **page 181, top**–Japanese Zen Garden construction, 1995, Canadian Museum of Civilization, photo Steven Darby, S2000-3624; and **page 181, bottom**–Japanese Zen Garden, 1996, Canadian Museum of Civilization, photo Steven Darby, K2000-1231.

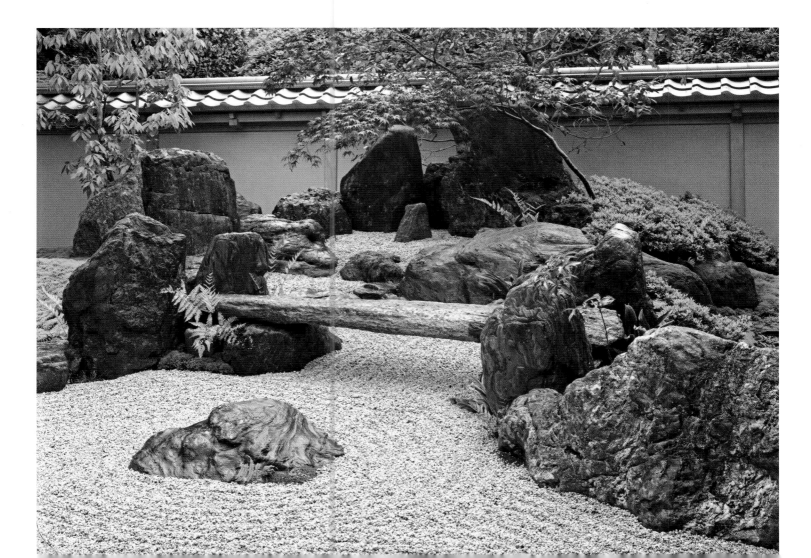

BIBLIOGRAPHY

Baroni, Helen Josephine. *The Illustrated Encyclopedia of Zen Buddhism*. New York: Rosen Publishing Group, 2002.

Berthier, François. *The Dry Landscape Garden: Reading Zen in the Rocks*. Chicago: University of Chicago Press, 2000.

Bring, Mitchell, and Jesse Wayembaugh. *Japanese Gardens: Design and Meaning*. New York: McGraw-Hill, 1981.

Brooklyn Botanic Garden Record: Japanese Gardens: Plants and Gardens. New York: Brooklyn Botanic Garden, 1990.

Callicott, J. Baird, and Roger T. Ames (eds.). *Nature in Asian Traditions of Thought: Essays in Environmental Philosophy*. Albany: State University of New York Press, 1989.

Carter, Robert E. *The Japanese Arts and Self-Cultivation*. Albany: State University of New York Press, 2008.

Conder, Josiah. *Landscape Gardening in Japan*. New York: Dover Publications, 1964 (from second revised edition of 1912, orig. 1893).

Dale, Peter N. *The Myth of Japanese Uniqueness*. New York: St. Martin's Press, 1986.

Fukuda Kazuhiko. *Japanese Stone Gardens: How to Make and Enjoy Them*. Rutland, Vt., and Tokyo: Charles E. Tuttle, 1970.

Harada Jiro. *Japanese Gardens*. Boston: Charles T. Branford Company, 1956.

Hisamatsu Shin'ichi (trans. Tokiwa Gishin). *Zen and the Fine Arts*. Tokyo: Kodansha International Ltd., 1971.

Keane, Marc P. *Japanese Garden Design*. Rutland, Vt., and Tokyo: Charles E. Tuttle, 1996.

Kuck, Loraine. *The World of the Japanese Landscape Garden: From Chinese Origins to Modern Landscape Art*. New York and Tokyo: Weatherhill, 1989, first published 1968.

Locher, Mira. *Traditional Japanese Architecture: An Exploration of Elements and Forms*. Rutland, Vt., and Tokyo: Tuttle Publishing, 2010.

Main, Alison, and Newell Platten. *The Lure of the Japanese Garden*. New York and London: W.W. Norton & Company, 2002.

"Masuno Shunmyo." *Kono nihonjin ga sugoi rashii* (*This Japanese Person Seems to Be Amazing*). TV Tokyo, GB Production. December 17, 2010, television.

Masuno Shunmyo. *Inside Japanese Gardens: From Basics to Planning, Management and Improvement*. Translated by Aaron Baldwin. Osaka: The Commemorative Foundation for the International Garden and Greenery Exposition, 1990. First published 2003 as *Nihon teien no kokoroe: kiso chishiki kara keikaku, kanri, kaishu made*.

———. *Zen Gardens vol. II: The World of Landscapes by Shunmyo Masuno* (*Zen no niwa II: Masuno Shunmyo sakuhinshu 2004-2009*). Tokyo: Mainichi Shinbunsha, 2003.

Masuno Shunmyo and Tabata Minao. *Zen Gardens: The World of Shunmyo Masuno* (*Zen no niwa: Masuno Shunmyo no sekai*). Tokyo: Mainichi Shinbunsha, 2010.

Mehta, Geeta K., and Tada Kimie. *Japanese Gardens: Tranquility Simplicity Harmony*. Rutland, Vt., Tokyo, and Singapore; Tuttle Publishing, 2008.

Nitschke, Günter. *Japanese Gardens: Right Angle and Natural Form*. Cologne: Benedikt Taschen Verlag GmbH, 1993.

Process: Architecture Special Issue No. 7, Landscapes in the Spirit of Zen, A Collection of the Work of Shunmyo Masuno. Tokyo: Process Architecture Company Ltd., 1995.

Richie, Donald. *A Tractate on Japanese Aesthetics*. Berkeley: Stone Bridge Press, 2007.

Saito Katsuo. *Designing Japanese Gardens*. Translated by Hiki Shinjiro. Tokyo: Gihodo Co., Ltd., 1961.

Saito Katsuo and Wada Sadaji. *Magic of Trees and Stones: Secrets of Japanese Gardening*. Translated by Richard L. Gage. New York and Tokyo: JPT Book Company, 1964.

Schaarschmidt-Richter, Irmtraud, and Mori Osamu. *Japanese Gardens*. Translated by Janet Seligman. New York: William Morrow and Company, Inc., 1979.

"Shunmyo Masuno: Seigen-tei." In *Kunst for Menneskelige Basalbehov: Bygg for Biologiske Basalfag ved Universitetet i Bergen* (*Art for Basic Human Needs: The Building for Basic Biological Research at the University of Bergen*), http://www.koro.no/filestore/BBB_kat_web.pdf, 12–27.

Slawson, David A. *Secret Teachings in the Art of Japanese Gardens: Design Principles and Aesthetic Values*. Tokyo: Kodansha, 1987.

Suzuki, Daisetz T. *Zen and Japanese Culture*. Princeton, N.J.: Princeton University Press, 1959.

Takei, Jiro, and Mark P. Keane. *Sakuteiki: Visions of the Japanese Garden*, North Clarendon, Vt.: Tuttle Publishing, 2008.

Trulove, James Grayson, ed. *Ten Landscapes: Shunmyo Masuno*. Rockport, Mass.: Rockport Publishers, Inc., 1999.

Weiss, Allen S. "On the Circulation of Metaphors in the Zen Garden." *AA files* no. 60, 2010, 89–93.

Opposite Raked gravel, rocks, and plantings combine in a scene of a river flowing from a waterfall in the *karesansui* (dry) Ryūmontei garden at Gionji temple.

Back endpaper Floor to ceiling windows in the Kyoto Prefectural Reception Hall provide a panoramic view of the garden, with the pond in the foreground and the teahouse in the background.

THE TUTTLE STORY

Most people are surprised to learn that the world's largest publisher of books on Asia had its humble beginnings in the tiny American state of Vermont. The company's founder, Charles Tuttle, came from a New England family steeped in publishing, and his first love was books—especially old and rare editions.

Tuttle's father was a noted antiquarian dealer in Rutland, Vermont. Young Charles honed his knowledge of the trade working in the family bookstore, and later in the rare books section of Columbia University Library. His passion for beautiful books—old and new—never wavered through his long career as a bookseller and publisher.

After graduating from Harvard, Tuttle enlisted in the military and in 1945 was sent to Tokyo to work on General Douglas MacArthur's staff. He was tasked with helping to revive the Japanese publishing industry, which had been utterly devastated by the war. When his tour of duty was completed, he left the military, married a talented and beautiful singer, Reiko Chiba, and in 1948 began several successful business ventures.

To his astonishment, Tuttle discovered that postwar Tokyo was actually a book-lover's paradise. He befriended dealers in the Kanda district and began supplying rare Japanese editions to American libraries. He also imported American books to sell to the thousands of GIs stationed in Japan. By 1949, Tuttle's

business was thriving, and he opened Tokyo's very first English-language bookstore in the Takashimaya Department Store in Ginza, to great success. Two years later, he began publishing books to fulfill the growing interest of foreigners in all things Asian.

Though a westerner, Tuttle was hugely instrumental in bringing a knowledge of Japan and Asia to a world hungry for information about the East. By the time of his death in 1993, he had published over 6,000 books on Asian culture, history and art—a legacy honored by Emperor Hirohito in 1983 with the "Order of the Sacred Treasure," the highest honor Japan bestows upon non-Japanese.

The Tuttle company today maintains an active backlist of some 1,500 titles, many of which have been continuously in print since the 1950s and 1960s—a great testament to Charles Tuttle's skill as a publisher. More than 60 years after its founding, Tuttle Publishing is more active today than at any time in its history, still inspired by Charles Tuttle's core mission—to publish fine books to span the East and West and provide a greater understanding of each.

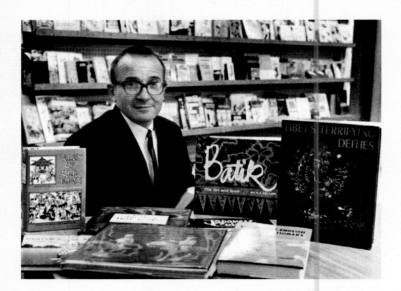

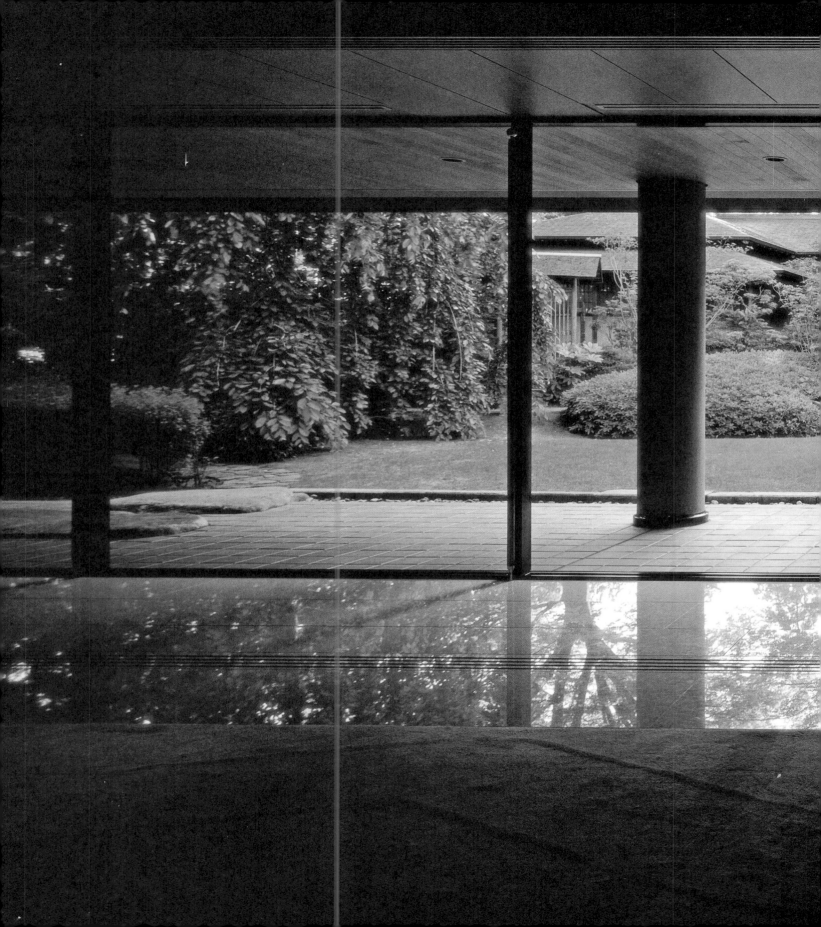